6c/6emos

10/15

Malevolent Muse

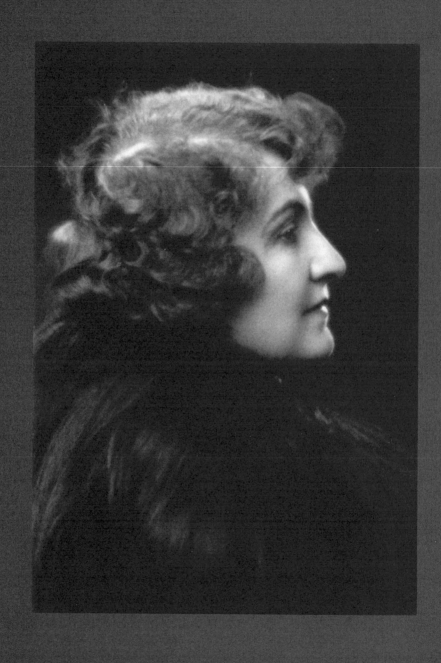

OLIVER HILMES

Malevolent Muse

THE LIFE OF *Alma Mahler*

TRANSLATED BY DONALD ARTHUR

NORTHEASTERN UNIVERSITY PRESS

BOSTON

Northeastern University Press
An imprint of University Press of New England
www.upne.com

© 2015 Northeastern University
Originally published as *Witwe im Wahn: Das Leben der Alma Mahler-Werfel*, by Oliver Hilmes © 2004 by Siedler Verlag, a division of Verlagsgruppe Random House GmbH, Munich, Germany

Library of Congress Cataloging-in-Publication Data
Hilmes, Oliver, author.
[Witwe im Wahn. English]
Malevolent muse: the life of Alma Mahler / Oliver Hilmes: translated by Donald Arthur.
 pages cm
"Originally published as Witwe im Wahn: Das Leben der Alma Mahler-Werfel. Munich, Germany: Siedler Verlag, [2014]."
Includes bibliographical references and index.
Summary: "The legendary life of the muse of geniuses, Alma Mahler-Gropius-Werfel"—Provided by publisher.
ISBN 978-1-55553-789-0 (cloth: alkaline paper)—
ISBN 978-1-55553-845-3 (e-book)
1. Mahler, Alma, 1879–1964. 2. Vienna (Austria)—
Biography. 3. Wives—Biography. 4. Mahler, Gustav, 1860–1911. 5. Gropius, Walter, 1883–1969. 6. Werfel, Franz, 1890–1945. 7. Arts—Austria—History—20th century.
I. Arthur, Donald, translator. II. Title.
DB844.M34H5513 2004
780.92—dc23 [B] 2014038724

5 4 3 2 1

I should like to do a great deed.

ALMA SCHINDLER, 1898

CONTENTS

Malevolent Muse

PROLOGUE

Alma Maria, née Schindler, widow of Mahler, divorced from Gropius, widow of Werfel, was, from early youth, an extraordinary woman, one who remains highly controversial to this day. For one camp she is the muse of the four arts; for the other an utterly domineering and sex-crazed Circe, who exploited her prominent husbands exclusively for her own purposes. How can one person provoke such paeans of love on the one hand and such tirades of loathing on the other? Was she a muse for her partners, an inspiration for their works? Doubtless that is how she would have liked to see herself. But will this self-portrait stand up to closer scrutiny? In 1995, in the *Frankfurter Allgemeine Zeitung*, the translator, author, and psychoanalyst Hans Wollschläger called for a fundamental reassessment of this femme fatale from Vienna, "so that she can be filed away once and for all. So many female companions remain silent in the shadows of the great men in their lives, unjustifiably inconspicuous, inadequately acknowledged; it's time this vain, repulsive, brazen creature went in there, too."[1]

Wollschläger, in his condemnation of Alma, could have referred to many judgments that were no less negative on the part of her prominent contemporaries. For Theodor W. Adorno—but never put in writing—she was "the monster";[2] the composer Richard Strauss diagnosed in her "the inferiority complexes of a dissolute female."[3]

The author Claire Goll wrote: "Having Alma Mahler for a wife is a death sentence,"[4] an allusion to the early demise of two of her husbands. Gina Kaus declared in an interview: "She was the worst human being I ever knew."[5] At another point she found Alma simply "conceited and stupid,"[6] and Elias Canetti saw in her "a rather large woman, overflowing in all directions, outfitted with a saccharine smile and bright, wide-open, glassy eyes."[7] Alma's fondness for drink—elegantly implied by Canetti—was likewise noted by Claire Goll: "To compensate for her dwindling charms, she wore gigantic hats festooned with ostrich feathers: it was impossible to know whether she was trying to impersonate a funeral horse pulling a hearse or a new d'Artagnan. On top of

I

that she was painted, powdered, pomaded, perfumed and polluted. That over-sized Valkyrie drank like a drainpipe."[8] No wonder, then, that this misshapen Alma, "thanks to her exaggerated makeup and her curly-topped coiffure," occasionally reminded her of "a majestic transvestite."[9] Anna Mahler, Alma and Gustav Mahler's daughter, had a lifelong ambivalent relationship with her mother. "Mommy was a big animal. I used to call her Tiger-Mommy. And now and then she was magnificent. And now and then she was absolutely abominable."[10] Marietta Torberg, Friedrich Torberg's wife, got right to the heart of this dichotomy: "She was a grande dame and at the same time a cesspool."[11]

But it is just as much a part of the phenomenon called Alma Mahler-Werfel that besides these not exactly flattering appraisals, a number of enthusiastic, downright rapturous statements are also on record. For her admirers, of which there were quite a few, the youthful Alma Schindler was "the loveliest girl in Vienna." "Alma is beautiful, is smart, quick-witted," Gustav Klimt rhapsodized to Alma's stepfather. "She has everything a discerning man could possibly ask for from a woman, in ample measure; I believe wherever she goes and casts an eye into the masculine world, she is the sovereign lady, the ruler."[12] Oskar Kokoschka, who entered Alma's life a few years later, was enchanted by her. "How beautiful she was, how seductive behind her mourning veil!"[13] The biologist Paul Kammerer wrote Alma love-besotted letters. "Your flaws are endless kindnesses, your weaknesses are incomprehensible beauties, your languors are never-satiating sweetnesses."[14] To Franz Werfel she appeared simply as "giver of life, keeper of the flame,"[15] and Werfel's mother allegedly called her daughter-in-law "the only true queen or sovereign of our time."[16] The elderly writer Ludwig Karpath assured Alma a few years before his death that, one day, "I shall take the warmest memories of you with me to the grave."[17] Carl Zuckmayer and Friedrich Torberg admired in Alma a "puzzling mixture of philanthropist and proprietress of a *maison de rendez-vous*—'a magnificent madame,' as Gerhart Hauptmann once called her while admiringly shaking his head."[18] Alma's capacity for liquid refreshment, which many found repulsive, commanded the high respect, on the other hand, of the no-less-capacious tippler Erich Maria Remarque: "the woman, a wild, blond wench, violent, boozing."[19]

Who was this woman, who for decades managed to fascinate or revolt so many more or less famous people? The list of contemporaries—husbands, lovers, hangers-on, and satellites—who crossed paths with Alma Mahler-Werfel over the course of her eighty-five years on earth is long and reads like a "Who's Who in the Twentieth Century." Here is just a selection: Eugen d'Albert, pianist and composer; Peter Altenberg, author; Gustave O. Arlt, German philologist;

Hermann Bahr, author; Ludwig Bemelmans, painter; Alban Berg, composer; Leonard Bernstein, conductor and composer; Julius Bittner, composer: Franz Blei, author; Benjamin Britten, composer; Max Burckhard, theater director; Elias Canetti, author; Franz Theodor Csokor, author; Erich Cyhlar, legislator; Theodor Däubler, author; Ernst Deutsch, actor; Engelbert Dollfuss, Austrian chancellor; Lion Feuchtwanger, author; Joseph Fraenkel, physician; Egon Friedell, author; Wilhelm Furtwängler, conductor; Claire Goll, author; Walter Gropius, architect; Willy Haas, author; Anton Hanak, sculptor; Gerhart Hauptmann, author; August Hess, butler; Josef Hoffmann, architect; Hugo von Hofmannsthal, author; Johannnes Hollnsteiner, priest; Paul Kammerer, biologist; Wassily Kandinsky, painter; Gina Kaus, author; Otto Klemperer, conductor; Gustav Klimt, painter; Oskar Kokoschka, painter; Erich Wolfgang Korngold, composer; Ernst Krenek, composer; Josef Labor, composer; Gustav Mahler, composer and conductor; Golo Mann, author and historian; Heinrich Mann, author; Thomas Mann, author; Willem Mengelberg, conductor; Darius Milhaud, composer; Georg Moenius, priest; Soma Morgenstern, author; Kolo Moser, painter; Siegfried Ochs, conductor; Joseph Maria Olbrich, architect; Eugene Ormandy, conductor; Hans Pernter, legislator; Hans Pfitzner, composer; Maurice Ravel, composer; Max Reinhardt, director; Erich Maria Remarque, author; Anton Rintelen, government official; Richard Schmitz, legislator; Arthur Schnitzler, author; Arnold Schönberg, composer; Franz Schreker, composer; Kurt von Schuschnigg, Austrian chancellor; Ernst Rüdiger von Starhemberg, legislator; Richard Strauss, composer; Igor Stravinsky, composer; Julius Tandler, physician and politician; Friedrich Torberg, author; Bruno Walter, conductor; Franz Werfel, author; Fritz Wotruba, sculptor; Alexander von Zemlinsky, composer; Paul von Zsolnay, publisher; Carl Zuckmayer, author.

A woman who, throughout her life, was acquainted with so many important people, to all of whom she had something to give, even though—impressively enough—they were as different in character as Hans Pfitzner and Arnold Schönberg, Thomas Mann and Erich Maria Remarque, or Walter Gropius and Oskar Kokoschka. As such, she was simply destined to become a literary cult figure. Hilde Berger wrote a novel on the relationship between Alma Mahler and Oskar Kokoschka, and Alma fans can refer to a few older biographies as sources of background information. It may seem surprising at first that so many writers have concerned themselves with this woman. Unlike the men in her life, Alma has not left behind any great artworks that might prompt us to concern ourselves with her—no symphonies, no paintings, no buildings, no poems or novels. Clout without creativity? She may have composed some

pretty little songs as a young girl, but she has only recently been perceived as a composer.

What remains of Alma Mahler-Werfel? Is it her tempestuous life with all its ups and downs, triumphs and tragedies, pinnacles of glory and chasms of despair? Was Alma an authentic "life-artist," someone who laid hands on her own story and turned it into an artwork? Or is all that remains of her that "bit of pelvis," as Hans Wollschläger derided her? How can one best do justice to this woman? By letting the most intimate fount of information in existence bubble up: and that can be found in her uncensored diary entries.

My own investigation of Alma Mahler-Werfel started out with *Mein Leben*— that best-seller, which is still available at bookshops, and which left its mark on our image of Alma for generations. The protagonist appears there as a muse and bringer of joy to her men, one who always had to give more than she took, and a helpmate who with wise foresight chose not to have an artistic career of her own and lived totally to support the work of her partners. These memoirs were hailed at their release as an uninhibited confession, to which the author's sexual prodigality made a sizable contibution. Forty years later they strike me as being loosely patched together and occasionally scatterbrained; worse yet, the text seems somewhat disjointed. Conspicuously, the book is not even divided into chapters. Besides this, some episodes are given specific dates, while others are only vaguely attributed seasonal descriptions like "in autumn" or "at a later time." The reader is thus not in a position to delve into a specific point in Alma's life; time and space blur into a diffuse generality. Interestingly, there are no entries in the index for Adolf Hitler or Benito Mussolini, although they are mentioned several times in the text. On the other hand, people mentioned only once are included in the index. An oversight? Or did the author possibly have something to hide? The sequence of compactly worded reflections followed by banal everyday lore seems to suggest that some portions of the text were not intended for publication. On closer inspection, this mosaic character lends the book a somewhat unintentional comical quality. Overall, I had the impression that Alma's confession is a diary with subsequently inserted comments. Might *Mein Leben* perhaps be a version of diaries long believed to have been lost to posterity?

"If you were planning to use my mother's memoirs as a basis for your research, then you should forget the whole project right here and now,"[20] Anna Mahler advised Franz Werfel's biographer Peter Stephan Jungk. The main problem of an Alma Mahler-Werfel biography lies in the more than confusing source materials. When Alma died in New York in December 1964, she left

behind a good five thousand letters written to her, countless postcards and photographs, as well as several manuscripts. Through the intercession of Franz Werfel's longtime friend and publisher, Adolf D. Klarmann, this legacy went, four years after her death, to the Van Pelt Library at the University of Pennsylvania in Philadelphia, where it remains stored to this day—largely untouched—in forty-six archive boxes. The university quarter, on parklike grounds, is only a stone's throw from downtown Philadelphia. Many of the buildings on campus exude the charm of long-forgotten times, with their typical country house architecture. Others, such as the rather unadorned Van Pelt Library, are less inviting, utilitarian edifices. Anyone pursuing studies of the humanities in Philadelphia is sooner or later destined to land in Van Pelt; a good two and a half million volumes are housed in this library on Walnut Street, in addition to which there are some thirteen thousand current newspapers and magazines from virtually every country in the world. The quest for Alma Mahler-Werfel begins at the handwritten documents department, which, strangely enough, is furnished differently from the rest of the library. While the library's façade, entrance, and catalog areas, as well as the countless magazine floors, have the cool atmosphere of the 1960s, the sixth floor of the building, where the so-called special collections are stored, is distinguished by massive wooden furnishings. I paid my first visit there in the summer of 2000. I sat down at one of the tables in the reading room and waited for the custodian of the Mahler-Werfel Collection. Diagonally across from me I discovered a bust of Franz Werfel—a work by his stepdaughter Anna Mahler. The longer I contemplated the artwork, the more intensely I was reminded of Elias Canetti's not exactly flattering description of Werfel's "froggy eyes." "It occurred to me," Canetti wrote, "that his mouth resembled a carp's, and how well his very googly eyes fit in with that."[21] A short time later, Mrs. Shawcross, the keeper of the collection, arrived, a lady of hard-to-determine age, pleasant and helpful, and—a rather astonishing factor in view of her activity here—with no knowledge of the German language. The reference guide, she warned me, was unfortunately not very reliable. The contents had been rather sketchily inventoried several years ago, but nobody ever got beyond that. An initial glance into the black notebook, listing Alma's legacy, confirmed her warning. Many of the typed pages contained handwritten additions and corrections, others were spotted with fingerprints and barely legible, and still others were coming loose from the binding. It quickly became clear that this reference guide would provide scant orientation, and I would have to go through the material itself archive box by archive box. I have now done this twice in all—once in

the summer of 2000 and three years later in the summer of 2003. During the several weeks of my stay in these special collections at Van Pelt Library, high above the campus, under the mistrustful eye of the Werfel bust, I immersed myself deeply in Alma Mahler-Werfel's life. Attentive custodians, as a rule students at the university, brought me, one after another, the cardboard cartons bearing a striking resemblance to sarcophagi—enclosing Alma's written remains. Countless letters came into my hands, among them ones written by Alban Berg, Leonard Bernstein, Lion Feuchtwanger, Wilhelm Furtwängler, Gerhart Hauptmann, Hertha Pauli, Hans Pfitzner, Arnold Schönberg, Richard Strauss, Bruno Walter, Anton von Webern, to mention but a few. Walter Gropius's and Oskar Kokoschka's letters to Alma have been preserved only as copies—the recipient appears to have destroyed the originals. Several boxes contain innumerable photos, while still others are stuffed full of memorabilia. In one of the boxes, I discovered Franz Werfel's glasses, a travel alarm clock, a letter opener, calling cards, maudlin pictures of saints, calendars, passports, baptismal certificates, a telephone directory, and, curiously enough, one of Werfel's cigarette holders, complete with tobacco remnants.

In the course of my research and excavation work I was able to determine that, of all things, Alma Mahler-Werfel's legacy of letters is no longer complete. What documents are missing? And why? The quest for clues begins in March 1938, when Alma had to leave Vienna in haste. Ida Gebauer, Alma's longtime housekeeper and confidante, took her possessions to a safe place until shortly after the end of the war, when they landed in the archives of the "Municipal Collections of the City of Vienna," where they were cataloged on August 27, 1945.[22] This listing from the Viennese Municipal and State Archives is a singular stroke of luck for the biographer, because it gives him an official document providing an overview of the entire contents of the Mahler-Werfel family's household. Besides countless paintings, drawings, and photos, the couple's complete library, as well as a sealed package with twenty-two diaries written by the lady of the house, are registered. Beyond this the directory lists each of Alma's correspondents, with the appropriate number of documents. Under listing number fifty-five, for example, thirty-two letters from her longtime lover Johannes Hollnsteiner, as well as nineteen pieces of correspondence with the former Austrian federal chancellor Kurt von Schuschnigg, are mentioned. In the legacy stored in Philadelphia, some documents from these persons may be preserved—fewer, however, than the ones named in the list. Finally, some documents from the government minister Hans Pernter are also inventoried, but there is no trace of them in Philadelphia. This can mean only one thing: as the

documents had been returned to Alma after the war, the part that is no longer in her legacy must have been removed or destroyed at a later time. We can only speculate over the reasons for this. In the case of Johannes Hollnsteiner, it was probably because Alma didn't want her intimate relationship with a member of a holy order disclosed to posterity. Something similar may apply to her delicate political relations with Schuschnigg and his minister of education, Pernter.

As the basis for writing down her recollections, Alma used the diaries she had kept for decades, of which, however, only a small fraction of the originals is still preserved. This includes the diary sets (*Tagebuch-Suiten*) numbers four to twenty-five from the years 1898 to 1902, which have been available in a critical edition since 1997. The twenty-two diaries are most probably the ones that were in the safekeeping of the Municipal Collection and form a part of the legacy today. The diaries from the years 1902 to 1905 and 1911 are preserved in copies in Alma's own handwriting from August 1925. By all appearances, the originals of the diaries from all the other years must be regarded as missing.

Among the materials Alma left behind I also discovered a 380-page typescript, which begins in July 1902 and ends in February 1944—thus before Franz Werfel's death. It is obviously a copy of the original diaries from that period. This assumption can be reinforced by further indications: all the entries have been supplied with comparatively precise dates, and the author writes about her contemporaries with a disarming and unsparing candor, so that one doesn't get the impression that this was censored in any way. And, not least, this typescript is marked by the Austrian spelling of German that was in vogue at the turn of the twentieth century. For example, Alma typed the German words *gieng* instead of *ging* (for "went"); *hieng* instead of *hing* ("hung"); or *wol* instead of *wohl* ("well"), so we can see that neither the style nor the orthography had been revised. Throughout the text there are any number of emendations, cross-outs, and comments entered by hand, which because of Alma's characteristic handwriting are unambiguously identifiable. This is why a great deal of evidence supports the fact that a first censoring process occurred once the copy was completed, and the typescript in fact represents a transcription of Alma's diary. This copy must have become necessary somewhere along the line, as Alma—unlike, for instance, Thomas Mann—also preserved her notes on loose sheets of paper or diverse scratch pads. Her handwritten note on the title page of the bundle—"copied from various slips of paper"—makes it clear that the objective of the typescript was to put her papers in a kind of order missing in the originals. She must then have destroyed the originals.

A second typescript in the Mahler-Werfel Collection is preserved under the

title "Der schimmernde Weg" (The glittering path). This 614-page text doubt-lessly represents an adaptation of the diaries. One feature conspicuous right at the outset is the considerably larger volume, coupled with an alteration of style and approach. The form of the diary notations with precise dating was given up in favor of a more essayistic depiction. While Alma dates certain events in her diary with the day, month, and year, in "Der schimmernde Weg" we find only indications of month and year. Frequently even these indications are re-placed by vaguer phrases, such as the aforementioned "at a later time," or even with seasonal descriptions like "autumn." A multipage essay now serves as an introduction, enriched with a retrospective look at her family background and her childhood, something totally missing in her diary. While Alma occasion-ally passes judgment on her family, her men, and a number of contemporaries with injurious openness in her diaries (such as her description of Elias Canetti as a "half-crippled, nihilistic Jew"), these disrespectful verdicts were toned down or occasionally even completely turned around in "Der schimmernde Weg" and later in *Mein Leben*. For example, Alma and Franz Werfel were on a book tour across Germany in November and December of 1932, during which they visited Breslau (now Wrocław in Poland). In a description of this occasion, we find an especially impressive proof of this kind of manipulation. Something Alma was determined to cover up by any manner of means was an encounter with Adolf Hitler, which virtually electrified her. "I waited hours to see his face. I didn't go to Werfel's lecture, but rather sat alone in the dining room and emptied a bottle of champagne by myself." When Hitler finally ap-peared, she admired his "kindly, soft eyes." In "Der schimmernde Weg," and later also in *Mein Leben*, the French luxury beverage is eliminated in favor of a novel by the English writer Thomas Hardy. The fact that Alma claims to have read, of all things, a work by an author whose novels describe the fate of people who struggle vainly against inclination, milieu, and remorseless powers may be a coincidental detail, but it might also be understood as an intentionally placed accent. Finally, Franz Werfel also got a glimpse of Hitler at the last min-ute. Alma: "When everything was over and Hitler climbed with mighty steps up the stairs and then disappeared through the open door, I asked Werfel for his impression. Werfel's exact words were: 'Not all that unappealing.'"[23] This episode from the diary also undergoes a revision; in "Der schimmernde Weg" it says tellingly: "He didn't answer and just raised his eyebrows as he looked pensively into space."[24] And in *Mein Leben* this passage disappears without a trace. All in all, "Der schimmernde Weg" reveals itself to be the revised and commented-upon version of the diaries and represents the template for both

autobiographies. The death of Franz Werfel in August 1945 forms the end of the narrative—further proof that "Der schimmernde Weg" came about after the transcription of the diaries.

I was able to unearth—confusingly enough—a further version in the legacy of Alma's friends Gustave and Gusti Arlt. "Meine vielen Leben" (My many lives) may be identical over long stretches with "Der schimmernde Weg," but it also contains a few passages not to be found either there or in the diary. Finally, a diary fragment from the late forties and early fifties can be found in the property of E. B. Ashton, the ghostwriter of Alma's English autobiography *And the Bridge Is Love*. After that, Alma seems to have discontinued keeping her diary—probably because of ill health. These documents—the diaries, "Der schimmernde Weg," as well as "Meine vielen Leben"—represent the primary sources of the present biography.

Right from her teens, Alma wrote directly from her soul what she had experienced, thought, said, heard, felt, dreamed, and wished. What she wrote for decades was not simply a reporting diary, kept regularly or in chronological order; rather she noted on individual sheets of paper what was happening all around her, with her, and most importantly inside her. What we have here in the most literal sense is a *journal intime*. When we read it today, many decades later, we are dumbfounded at many places by the drastic exhibitionism and not infrequently revolted by the cold contempt for humanity. But before making any moral judgments, we should consider what would be there to read if we ourselves were to put on paper what we really thought and felt, and did it as candidly, unreservedly, and unsparingly as Alma did. We tend to confide things to a diary that we would otherwise never be able to, allowed to, or want to tell any other human being. From the drastically piquant, encoded secret diaries of the baroque Londoner Samuel Pepys all the way to the diaries written in mortal danger by the German Jew Victor Klemperer or the shattering disclosures of an "Anonyma" among members of the Red Army in conquered Berlin—subsequently published texts like these are similar to someone talking to him or herself, in words not intended for the eyes or ears of others. This applies equally to Alma's diaries. People who keep a diary write "personal/confidential" letters to themselves. The tradition goes all the way back to the Roman emperor Marcus Aurelius, when he sat down in the evening in his commander's tent and, by the light of a little oil lamp, put his Stoic *Meditations* on papyrus in Greek. This is work on the self, a formative quest for identity based on the key questions: Who am I? Who do I want to be?

Over the course of time, I discovered more—among them quite sensational

—papers in Austrian, German, and American archives. The unpublished correspondence between Alma and Oskar Kokoschka had been inaccessible to the public until now, and will be evaluated for the first time here. Several documents from the legacies of Walter Gropius, Fritz Wotruba, and Anton Rintelen are also quite volatile. A special treasure trove of sources can be found in a series of interviews the Werfel biographer Peter Stephan Jungk did in the mid-eighties with Anna Mahler, Marta Feuchtwanger, Ernst Krenek, and Gottfried Bermann-Fischer. These conversations, only partially released, were made available to me in full. And last, but far from least, interviews I did with witnesses of the period such as Johannes Trentini, who regularly frequented Alma's home in the twenties and thirties, brought some astonishing new material to the light of day.

Alma Mahler-Werfel's records, along with numerous other unpublished letters and documents, tell the story of a pugnacious and controversial woman, of difficult family conditions, the early death of the beloved father, and three totally failed marriages. Alma's life whisks the reader away to Austria at the turn of the twentieth century, to a time after the First World War, to an atmosphere of bigotry in the so-called Ständestaat ("corporative state"), all the way to the mortally hazardous escape through France, Spain, and Portugal to the United States. Many details of this eighty-five-year life can be seen as both scandalous and grandiose to this day; others touch us and allow us to empathize; still others, like the tragedy of her daughter, Manon Gropius, shock and horrify us. Beyond this, Alma sets the lives of her contemporaries, husbands, and lovers passing in review: from Alban Berg to Carl Zuckmayer, great portions of the social, artistic, and political establishment in Austria and Germany during the first half of the twentieth century are represented. Alma's self-portrait as muse, as "enabler" of important men, is every bit as salient as her delusional political radicalization in the 1930s with hair-raising anti-Semitic narrow-mindedness. Alma Mahler-Werfel's anti-Semitic prejudice was a known fact. The way in which that anti-Semitism so powerfully affected her worldview, so that it was a decisive constant throughout her life, is however first pointed up by the these newly discovered documents. And so—far distant from all clichés—the new, often surprising portrait comes about, revealing a personality full of contradictions, with the extremely ambivalent character of a "Wacky Widow" (*Witwe im Wahn*). It is one of the biographer's tasks not to smooth over contradictions like these, but rather to leave them just as they are.

<div align="right">

OLIVER HILMES
BERLIN, SEPTEMBER 2014

</div>

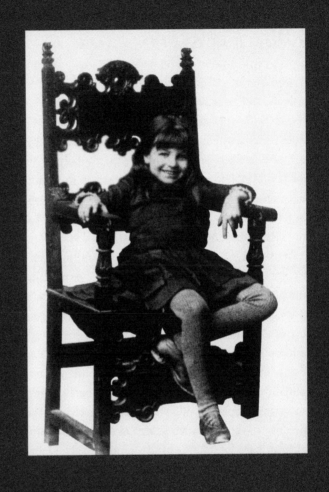

Childhood and Youth

1879–1901

A WORLD IN ORDER?

"The master of the house has his study in a Gothic hall of chivalry with armor, shields, and crusaders' banners on the walls or in a market in a Near Eastern bazaar with Kurdish carpets and Bedouin chests, Circassian hookahs and lacquer boxes from India. Beside the mirror above the fireplace, Japanese masks grimace savagely or make funny faces: Milady's boudoir has a touch of chapel and a hint of harem bedchamber about it. Her dressing table is conceived and decorated as an altar, a 'prie-dieu' attests to the piety of the resident of this boudoir, and a wide divan with orgiastic pillows tossed here and there seems to reassure anyone that it isn't all that bad."[1]

What the physician, journalist, and author Max Nordau denounced in his two-volume work *Entartung* (Degeneracy), published in 1892, comprised an unpardonable misapprehension of good taste—a "degeneracy"—while illustrating the way members of Vienna's *haute bourgeoisie* thought of themselves back in the 1870s. Anyone who was anybody, and who could afford it, had a home outfitted in the style of the times. Plush and pomp were the operative words: exotic draperies hanging on the doors and walls; wallpaper with outlandishly plumed birds on display in lush, overgrown tropical vegetation; massive chandeliers; odd weapons and rare musical instruments on the walls; polar-bear-skin rugs on the floor, along with overstuffed armchairs perched on gigantic carpets. This home decoration style was inseparably connected with one name: Hans Makart. Seldom has one artist left such an indelible impression on the style of an era as did this painter from Salzburg, where he was born in 1840. Emperor Franz Joseph had a very high opinion of Makart's monumental paintings and summoned the artist to Vienna in 1869. Over the coming years Makart's atelier was a popular gathering place for Vienna's upper crust and provided the setting for lavish masquerade parties, at which the master of the house occasionally appeared in the guise of Peter Paul Rubens. But even less-prominent contemporaries were able to take part in Makart's theatrics, since

(*previous page*)

FIGURE I.I Alma Schindler, circa 1890.

the atelier was open to visitors—at an admission charge—from 3 to 5 p.m. daily. Makart was doubtless a talented performer: he marked the expression of an entire era with his personality and his lifestyle. The ladies wore "Makart hats"; "Makart red" was a popular color; and the "Makart bouquet"—a bundle of dried flowers, ostrich feathers, palm fronds, reeds and grasses—was an adornment no middle-class home could do without. For the silver anniversary of Emperor Franz Joseph's wedding to Elisabeth of Bavaria, a lady as popular as she was unhappy, at the end of April 1879, Makart organized an elaborate festive procession in homage to the imperial couple. The festivities began on April 24 with the dedication of the Votive Church, designed by Heinrich Ferstel. Three days later the actual "Makart Parade" took place. Some fourteen thousand persons processed in costumes from the German renaissance, flanked by escutcheon-swinging heralds and standard-bearers and following the route from the grand park called the Prater down Vienna's resplendent new boulevard—the Ringstrasse—all the way to the Augarten Bridge. At the fairgrounds by the outer castle gate, opposite the still unfinished Art History Museum, the imperial couple received the homage of the populace.

One of Hans Makart's close friends was Emil Jakob Schindler. Two years younger, the painter Schindler came from a family of factory owners who had been ensconced in Lower Austria since the late seventeenth century. Initially Schindler was destined for a military career, but he decided in favor of landscape painting and became a student of Albert Zimmermann at the Academy of Fine Arts in Vienna. He found his motifs in nature; Austria's bodies of water and shore scenes exerted a magic spell on him. But also Vienna's mammoth Prater amusement park, and the many ports of call for the steamships up and down the Danube, aroused his passion. Schindler regarded Makart as a role model. Even more than his friend's artistic creativity he admired his *grand bourgeois* lifestyle. While Makart—the "artist prince"—knew no financial problems, the money in the Schindler household was scarcely adequate for the barest essentials. We do not know whether Emil Jakob Schindler was among the countless curious onlookers following the progress of the "Makart Parade," or whether he actually joined the ranks of marchers on that Sunday when his friend directed them by the thousands down the Ringstrasse. Possibly he was taking care of his wife, Anna, who was five months pregnant. The young couple had married only a few weeks earlier—on February 4, 1879—in the Church of the Holy Guardian Angels, the so-called Paulanerkirche. Twenty-one-year-old Anna Sofie Bergen came from a family of Hamburg brewery owners, which had gone bankrupt in 1871, losing their entire fortune.

Only by dint of considerable effort did the Bergens succeed in enabling their musical daughter Anna to study voice at the Vienna Conservatory, concluding her training with the well-known vocal instructor Adele Passy-Cornet. The young singer had concentrated on the comical genre: operettas such as Franz Mögele's *Leonardo und Blandine* and Josef Forster's *Die Wallfahrt der Königin* (The queen's pilgrimage) were her starring vehicles, and she had already played some small initial engagements at the Künstlerhaus and the Ring-Theater by the time she met Emil Jakob Schindler. He, too, was fond of the light classics and made occasional appearances at the Künstlerhaus himself, as he had an agreeable tenor voice.

The marriage began in strained circumstances. Schindler was in debt and shared a small bachelor apartment on Mayerhofgasse with his twenty-nine-year-old colleague Julius Victor Berger. Although this home was actually much too small for three persons, Anna—already three months pregnant—moved in with her husband after the wedding.

Under radiant sunshine and at a pleasant temperature of nineteen degrees Celsius (sixty-six Fahrenheit) on Sunday, August 31, 1879, their daughter Alma Margaretha Maria arrived in this world. Initially her father wasn't sure quite what to do with the infant, as he confided to his diary: "I tell Anna, so as not to hurt her feelings, that I love the child, but I still have no feelings for her. It is possible, even probable, that this will change. There were in fact moments when it was different, and when I think things over precisely I know that my circumstances are accountable for this unnatural lovelessness as well."[2] Schindler suffered from self-doubts and severely reproached himself for his inability to offer his family more comfort. Only a few months after the birth of little Alma he fell gravely ill with diphtheria, from which he did recover, but which also left some slight paralytic symptoms behind. His doctors urgently recommended he take a cure to regain his full health. Because of its excellent medical facilities and its rough North Sea climate, Borkum, the largest East Frisian island, offered the best prerequisites, and Schindler largely recovered there. On his return, Anna Schindler surprised her husband with the news that she was again pregnant. What he didn't know was that during his absence, his wife had started an affair with Julius Victor Berger. Of course Anna Schindler was eager to cover up her dalliance, but Schindler got suspicious, as it wasn't all that hard to figure out that he himself had not been in Vienna throughout the month of conception. Nevertheless he played along with the script and accepted little Margarethe Julie, born on August 16, 1880, as his daughter.

When Emil Jakob Schindler received the Reichel Artist's Prize in February

1881 with the generous endowment of 1,500 gulden, his financial circumstances improved with a single stroke. He could now pay his oppressive debts and move with his family into a larger apartment at the prestigious address of Mariahilferstrasse 37.

Like almost every painter, Emil Jakob Schindler also gave private lessons to selected pupils, not least because of the regular income. In the autumn of 1881 twenty-year-old Carl Moll, the scion of a good family, came to him and quickly became his favorite student. Moll accompanied the Schindlers on several of their vacations to Goisern in the Salzkammergut and went on study trips with his teacher to Lundenburg (today Břeclav in the Czech Republic) and Weissenkirchen. It didn't take long before life in the family would have been hard to imagine without Moll's presence. Emil Jakob Schindler was happy to have a reliable and talented assistant by his side. When he withdrew to work or traveled alone he believed his family to be in good hands with the young Moll. But he would soon be disappointed. Carl Moll not only worshipped his teacher but also his teacher's wife, the twenty-three-year-old Anna. They soon became lovers. They were playing for very high stakes—under no circumstances could the "master" be allowed to suspect what was going on. Publicly they addressed each other in the formal "Sie" form, but in their clandestinely exchanged correspondence Anna and Carl took on a very different tone: "Darling Mollchen," she would coo to him, while he gave the "master's wife" poems and flowers. Anna Schindler even teased Moll by hinting at her previous marital infidelity: "The children are adorable. Yesterday Gretel [Margarethe] even told me she loved Uncle Carl more than Uncle Julius. What more could we possibly want?"[3] It was an atmosphere of dishonesty and suppressed emotions in which Alma grew up. Even if she was still unable to comprehend the full scope of the betrayal, like any sensitive child she could sense the hypocrisy in the air. And possibly the clandestine yet clearly perceptible flow of emotions was the exact reason for which she, who would later style herself over and over again as a "daddy's girl," felt so powerfully attracted to her father.

After Emil Jakob Schindler had acquired some considerable prosperity through his art, he set off in quest of an appropriate residence where the family could spend the summers. In the winter of 1884 he happened upon Castle Plankenberg near Vienna, located halfway between Tulln and Neulengbach. The estate was in the middle of a charming hilly countryside, surrounded by the foothills of the Vienna Woods and expansive vineyards. Schindler was thrilled with the simple three-story palace and its generously proportioned parklike gardens. As far back as the thirteenth century the Diocese of Passau had owned

a farmyard here. In 1622, the bishop of Passau, Archduke Leopold Wilhelm of Austria, gave the property to his chamberlain, Stephan Planckh, who had the castle complex newly constructed. Over the following centuries, Plankenberg was largely used as a hunting lodge and harvest estate. When Schindler rented the estate in late 1884 for three hundred gulden a year, it had already seen its best days. Especially the approximately twelve hundred hectare park (more than four square miles) was sadly neglected and revealed only traces of the stylish property it once had been. "The winter was filled with feverish activity," Carl Moll remembered, "getting the empty building cleaned up and at least making the majority of the twelve rooms habitable."[4] In the spring of 1885, the family was finally able to move into Plankenberg Palace.

This "picturesque el Dorado"[5] was where Alma and Gretel spent large portions of their childhood. The girls played in the park, "set up private rooms for their dolls in the jasmine arbors, we hardly see them during the day, only hear them laughing and singing."[6] For the little Schindler girls, the expansive castle grounds with their mysterious grottos and dungeons were "full of terror, legends and beauty. . . . A ghost walked abroad. . . . The children sometimes trembled in fear of it all night."[7]

Emil Jakob Schindler had an especially close relationship with his older daughter, Alma, possibly because he might have felt that she wasn't cheating on him. For hours on end his big girl would sit in her father's large atelier and watch him as he painted. But he also fostered her musical talent: "My father was profoundly musical! He had a wonderful singing voice, a bright tenor, and sang Schumann lieder with the greatest skill. His conversation was captivating and never commonplace."[8] And he aroused the girls' interest in literature. When Alma and Gretel were first able to read, he took his daughters aside and told them the story of Goethe's *Faust*. "While we were listening spellbound, he said: 'This is the most beautiful book in the world. Read it, remember it.'" This brought about a violent argument between the two parents. Anna Schindler considered it irresponsible to give this book to little girls. As always, Alma remembered, their mother won. "The party of the so-called sensible ones. I was left with something like an idée fixe: I had to get *Faust* back. And my entire youth was like that. Full of attempts to accomplish this or that and without any system."[9] Obviously Emil Jakob Schindler had primarily taken over the musical-artistic part in his children's education, while their mother had the thankless role of the severe governess, who from time to time gave her own daughters private instruction. While father Schindler went off to paint, mother Anna would force her daughters to study. But she was such an inept educator

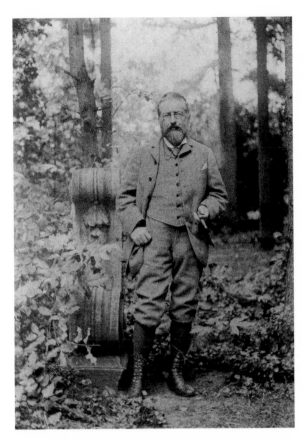

FIGURE 1.2
Alma's father, Emil
Jakob Schindler, in the
park of Plankenberg
Palace: "I had been used
to doing everything to
please him."

"that, for instance, she assigned us the task of learning the entire compound multiplication table by heart in a single day. At the end . . . she had to see a doctor to treat the sore throat she had picked up from yelling at us."[10] Instead of drilling arithmetic with her mother, Alma preferred playing the pianino her father had provided her with. "As I was the only musician in the house," she noted later with a sideswipe at her mother's vocal studies, "I was able to discover my calling myself without getting pushed into it."[11]

Alma was barely eight years old when the family departed on a journey of several months to Dalmatia and Greece. Crown Prince Rudolf, the only son of Emperor Franz Joseph, had commissioned Emil Jakob Schindler to preserve the view of the coastal towns in ink drawings or watercolors. This was part of a large-scale project titled "The Austro-Hungarian Monarchy in Word and Picture." A prepaid commission from a Viennese banker enabled Schindler to take along the family, as well as Carl Moll and a housemaid. In November 1887 they boarded a ship in Trieste, and after a four-day journey reached Ragusa, known

today as Dubrovnik. Little by little the travelers explored the old port city and its surroundings, and visited the island of Lacroma as well as the Breno and Ombla valleys. When the weather got too cold, the Schindlers moved farther southward to Corfu, where they spent the rest of the winter. There Anna organized a temporary household. "She had even carted along petroleum lamps," Alma remembered. "Our landlord was a Greek, and his crudeness knew no bounds. We children were in mortal danger several times, because the Greek children didn't want any foreigners and threw stones at us, which could have hit my sister and me."[12] In March 1888, the family moved back to Ragusa, and in May they returned via Opatija to Austria.

This journey on commission from the archduke made Emil Jakob Schindler famous. He now ranked as one of the most significant painters in the royal/imperial monarchy and was awarded any number of accolades. As early as 1887 he was made an honorary member of the Academy of Fine Arts in Vienna, and the following year he was offered an honorary membership in the Munich Academy. Likewise in 1888 he received the Silver State Medal, in 1891 the Golden State Medal, and the Great Golden Medal in Berlin. In the spring of 1892, the painter made a selection of his works available for the annual exhibition at the Vienna Künstlerhaus. This presentation proved to be Schindler's greatest artistic and financial success. Even Emperor Franz Joseph purchased one of his paintings. At the apex of his fame, however, disaster struck.

In the summer of 1892, the Schindlers decided to take several weeks off for a vacation on the North Sea island of Sylt along with Carl Moll, his brother Rudolf, and Rudolf's family. For Emil Jakob Schindler, this was "the first pleasure trip "—in Alma's words, the first "he could afford after paying his debts."[13] On August 4, they arrived in the town of Westerland and moved into holiday quarters in the Haus Knudsen.[14] They began their vacation in the best of moods; every day the Schindlers walked to the beach or hiked around the dunes. "Unfortunately the master is getting more and more unwell," Carl Moll remembered; "he has no appetite, complains of abdominal pains."[15] The local spa doctor couldn't figure out what was wrong, and so Moll telegraphed the famous surgeon Professor Friedrich von Esmarch in Kiel. When Esmarch's assistant arrived in Westerland, it was already too late. Emil Jakob Schindler died on August 9 from a protracted appendicitis. At the hour of his death Alma and Gretel were sitting alone in a restaurant. Suddenly a man came bursting in, probably Moll's brother, and told the girls to come with him at once. Alma recalled: "I could somehow feel that Papa was dead. There was a storm raging over the dunes, I cried out all along the way. When we got home, Carl Moll

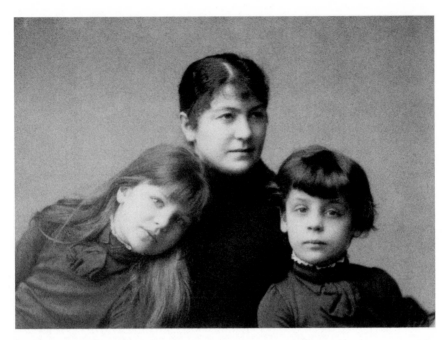

FIGURE 1.3 A world in order? Anna Schindler and her daughters, Alma and Gretel.

came over to us: 'Children, you have no more father.'"[16] Anna Schindler refused to allow her daughters to see their dead father one last time. Despite that, Alma and Gretel sneaked into the room where Schindler lay in an open casket. They stood in front of the corpse for a long time: "He was so beautiful and noble as a Greek, like a magnificent wax image, so that we felt no horror."[17] The news of Schindler's death spread like wildfire; the Viennese papers printed eulogies the very next day. The Sylt Spa newspaper also devoted a tribute to the famous painter. "My mother was beside herself," Alma wrote later; "she shrieked open-mouthed and didn't want to see us. Her uninhibited hysteria bothered me, and I didn't believe her."[18] An autopsy was immediately performed, concluding that Schindler had died of appendicitis.

For Alma, the death of her father was a stroke of fate that would determine the rest of her life. Barely thirteen, with the passing of her beloved father she not only lost the hero of her childhood days, but also any form of orientation. He was her "guide," she wrote, "although nobody besides him might have suspected it. I had been used to doing everything to please him, my entire vanity and quest for honor could only be satisfied with a look from his understanding blue eyes."[19] Emil Jakob Schindler was interred with great tributes at Vienna's

Central Cemetery. For his daughters, this burial was "like a theatrical performance." Alma recalled: "And at the cemetery Mama's weeping and wailing got on my nerves all over again."[20]

THE DYSFUNCTIONAL FAMILY

After Emil Jakob Schindler's death, Plankenberg Castle had to be given up for financial reasons. From then on, the family spent the entire year in the city apartment on Mariahilferstrasse. "And then came boring years," Alma remembered later. "School, development, little infatuations—everything raced past me in a rush of fog with no real happiness or sorrow."[21]

Anna Schindler and Carl Moll had simply continued their love affair inconspicuously following Emil Jakob Schindler's death in August 1892; they finally got married on November 3, 1895. In his memoirs, Moll transfigured his affair of many years' standing. It had been his mission in life, he wrote, "to provide for the master's family."[22] For sixteen-year-old Alma, this wedding was a betrayal of her dead father: this was why Carl Moll had a hard time with her; "He looked like a medieval wood carving of St. Joseph, was an old-style monomaniac and got on the nerves of my circle of friends in the most intrusive manner." Although Moll seriously made every effort to look after his stepdaughter, their relationship continued to be strained "because he had no authority over me."[23]

After the honeymoon trip to Anna Moll's mother in Hamburg, the family moved into a large house on Theresianumgasse in Vienna. In the ensuing years, Moll's atelier became a gathering place for writers, artists, and architects like Max Burckhard, Gustav Klimt, Joseph Maria Olbrich, Josef Hoffmann, Wilhelm List, and Koloman Moser. They had discussions, made music, ate and drank—not infrequently until late in the night. Although Alma kept her distance from her stepfather, she enjoyed the regular visits of the famous men. As if it were a matter of course—and this says a lot about the liberality of the otherwise very strict home—she sat at the table while Moser or Olbrich discussed modern art or contemporary architecture. Especially Max Burckhard, the director of the Burgtheater, Vienna's classical drama theater, had taken Alma to his heart. He sent the girl, who was twenty-five years his junior, theater tickets, discussed with her the plays she had seen, and fostered her interest in classical and modern literature. Once he brought her two huge baskets filled with the basic literature of the classic and modern eras—as foundation stones for her own library. This social contact became even more intensive when Moll and a few others founded the "Vereinigung bildender Künstler Österreichs (Se-

cession) "—the Society of Fine Artists in Austria (Secession), in April 1897. Gustav Klimt was elected president and from then on paid almost daily visits to his colleague Moll, who served as vice president.

At these frequent get-togethers, Klimt became aware of seventeen-year-old Alma and took a liking to the pretty and intelligent girl. Alma, for her part, felt drawn to the famous painter, even though he wasn't exactly what one might call an attractive man. He wore an unkempt beard and wrapped himself in long garments that gave his appearance a somewhat puzzling quality. Beyond this, Klimt spoke a thick Viennese dialect, which had an effect on society ladies that was just as offputting as it was fascinating. This "savage male" cast a spell over Alma.[24] Decades later she even described her dalliance with Klimt as her first great love. Anna and Carl Moll quickly caught on to Alma's enthusiasm for the painter, who was seventeen years older than she was. They looked on with considerable dismay as Klimt paid their daughter compliments and turned her head. Time and again, her parents tried to talk Alma out of this passion. "In the evenings they would pester me like crazy about Klimt and me," Alma wrote in her diary in early July 1898. "I don't know where these people get this from."[25] Her mother even asked her if she was in love with Klimt. Alma found this idea "ludicrous," nothing more. "I love someone so ardently, so devotedly as perhaps no human being has ever been loved before, it is [Richard] Wagner. For me he is the dearest human being on earth—I can swear to that."[26] When, a few months later, after a visit to someone's home, Klimt and Alma "walked to the coach in the night, he said: 'Alma, have you ever thought of visiting me in my atelier . . . all by yourself?' . . . A shudder went through my body, I don't remember what I answered."[27] As a well-brought-up girl from a proper middle-class family, despite all its artistic extravagances, Alma had her doubts about advances of this kind, especially as she had heard from her mother any number of horror stories about Klimt's amorous adventures. He was a notorious womanizer, had a yearlong relationship with his sister-in-law's sister, and, beyond this, slept with several of his models. (At his death in 1918, Klimt was said to have left behind fourteen illegitimate children.) Despite her hesitation—a young woman in her social class doubtless had a reputation to lose—Alma was liberal enough and had great understanding for this "characterless person." "An artist rarely has character"[28] was her summation. Even this early in her life, the eighteen-year-old was convinced that other standards apply to a genius. She stuck to this postulate for the rest of her life.

While her relationship with Gustav Klimt had only been a flirtation until then, that was about to change as the family departed on a several-week tour

of Italy in late March of 1899. They visited Venice, Florence, Naples, Capri, and Pompeii, marveled at Mount Vesuvius, and finally settled for a long period in Rome. Carl Moll had suggested that Klimt travel to Florence to continue the remainder of the journey with the family. He was "too comfort-loving and dependent to travel alone,"[29] Moll remembered. He wanted to give his friend a little treat with this invitation. Klimt gratefully accepted the offer. "Yesterday Klimt arrived," Alma wrote excitedly in her diary on April 25; "need I write anything more."[30] Although the day before, Moll had taken the precaution of urging his stepdaughter not to make eyes at Klimt, the two rapidly got closer together. On the train to Fiesole, Klimt and Alma were alone: "Like a couple, he said, and cuddled up closer to me. On our way back, we sat facing one another, and our knees touched. I couldn't sleep the whole night, that's how excited, how physically excited I was."[31] Klimt wouldn't let up. When he and Alma were in the church of Santa Maria Novella viewing the frescoes in back of the altar, he unexpectedly said to her: "Well, here we are, already behind the altar."[32] In Genoa, where the group traveled two days later, push finally came to shove, as Alma felt at the time. She was standing alone in her room when Klimt suddenly walked in. "Are you alone? Yes. And before I knew it, he took me in his arms and kissed me. It was just 1/10 of a second, because there was a noise next door, and we went downstairs, but still that moment will remain in my memory forever."[33] It was the first kiss in her life. When he kissed her again two days later and said "nothing else is possible but to come together completely," that was too much for Alma: "I began reeling and I had to lean against the banister of the staircase."[34]

What Alma didn't know at this point was that Anna Moll had been secretly reading her daughter's diaries and knew all the details of this little flirtation. Carl Moll, clued in by his wife, was horrified by his friend's behavior. In Venice—their last port of call—he demanded an explanation from Alma. "Carl, I beg you," Alma then appealed to him, "don't say anything to him, I'll talk to him myself."[35] For the young woman, her whole world had fallen apart: "I got to bed, I don't know how. . . . I lay the whole night there with my eyes open and kept thinking about opening the window quietly and stepping into the lagoon."[36] Over the following two days until his departure, Klimt and Alma perforce avoided each other. Carl and Anna Moll watched with Argus eyes to make sure the two of them didn't get too close. Klimt left Venice on May 6, and the Moll family's vacation also came to an end shortly afterward.

"My love is already starting to turn into hate," Alma wrote—back in Vienna—in her diary. "Carl spoke to Kl[imt] yesterday; he cravenly tried to wea-

sel out of it, betrayed me, admitted that he had acted too hastily and revealed himself to be a weakling." Alma was deeply hurt. It wasn't so much the realization that her passion for Gustav Klimt could have no future that bothered her, but rather the way he tried to get out of the whole affair. "He gave up on me without a fight, he betrayed me."[37] By May 15 Klimt was dead as far as she was concerned—in her diary she marked the date with a cross. In her youthful exuberance, Alma certainly didn't understand that she had played only a minor role in Klimt's life. Probably what she had regarded as a raging flame was no more than a flash in the pan for him. But there was another reason for Klimt's hasty retreat. He had no intention of falling out with his friend Moll. In a long letter he promised his colleague he would stay away from Alma in the future. He might have taken a liking to her, "just as we painters like an attractive child," but it had become clear to him in Venice that a man had to accept his responsibilities, "that we can't just dream our way through life, but rather have to live with open eyes." Alma, he was sure, "would have no trouble getting over it. Let us hope for a rapid period of healing."[38] Klimt was correct in this assumption. As early as the evening of May 15, the day that had been so terrible for her, Alma wrote in her diary: "I laughed and had a wonderful time."[39] After nights of dancing, she proudly cataloged the bouquets she had received from her large number of admirers.

Even if Alma soon forgot her Italian ecstasy, her resentment toward her parents remained irreconcilable. "My so-called good upbringing destroyed my first amorous adventure."[40] Despite all her reservations about Carl Moll, her main problem was with her mother. When Alma found out, in mid-March of 1899, that Anna Moll was again pregnant, she suffered a hysterical "crying fit" and was afterward "half unconscious."[41] If Alma regarded the marriage to Carl Moll as treason, she saw the forthcoming offspring as a mockery of her dead father. On August 9, 1899, her half-sister Maria was born—of all days on the seventh anniversary of Emil Jakob Schindler's death. "There is a gray symbolism in all of this"[42] was Alma's prophecy. "I cannot love my mother anymore, for she has given us up for another child. We mean nothing more to her—at the most we are just in the way."[43] Alma felt neglected and like a stranger in her own family, for which she made "the child," as she abstractly called her new sister, responsible: "Since the little one is in the world, we are two families: Carl, Mama and the child[;] Gretl and me.—Carl does all he can to make this situation less painful for us, but even the gods struggle in vain against natural laws. He is only interested in his own child."[44] Although Alma occasionally noted that she hated her mother, she nevertheless still longed for

her recognition and love. In her diaries Alma often wished she could call her mother her best friend. "Yes, all of this is well and good," she wrote, qualifying matters: "a friend, however who threatens to slap your face every 5 minutes, whether in front of others or not, is not the kind of friend you want to tell everything, nor can you tell her everything, because you're afraid of her."[45] Alma was still being slapped by her mother at the age of twenty. "I just get defiant & stubborn,"[46] she noted after one such dressing-down. Nevertheless, she would really "like to be able to talk to her properly about things, but I just haven't got the courage."[47] For all her transfiguration of her dead father, from whom she believed she had inherited all her positive character traits, she secretly ascertained a certain similarity between herself and her mother. "Mama is very domineering, and so am I."[48] The things that left an imprint on young Alma were the unstable emotionality of her mother, her superficiality, her sexual disloyalty, her domineering nature.

UNEXPLOITED OPPORTUNITIES

For a young woman at the end of the nineteenth century, growing up was fraught with problems totally different from the ones girls encounter nowadays. Regular education, a schooling program leading to a diploma of some kind, was virtually unthinkable for girls. The first secondary school for girls in Vienna was started in 1892.[49] The main subjects for the young ladies were fine manners and domestic virtues. Alma was also subject to this "female" dressage. She and her sister Gretel never enjoyed an ongoing education. While Emil Jakob Schindler was still alive, they attended school only during the winter months, which the family largely spent in the Vienna apartment. Otherwise they were taught by "evil home tutors" or just by their mother, "without any system," as Alma remembered years later. "I was nervous and clever up to a certain level—namely that Aryan cleverness with mental gaps." Early on, it became clear to her that she had one deficiency with which her later partners also had a hard struggle: "I can't think anything all the way through."[50] Alma's flightiness also seems to have been grounded in her planless upbringing.

In the Schindler/Moll artists' household, artistic education was more important than regular school attendance. While Alma had begun playing the piano quite early in life, music gained further importance for her after her father's death in the summer of 1892. She now took piano lessons with Adele Radnitzky-Mandlick, practiced several hours a day, and acquired a remarkable repertoire.[51] Her music stand often held works by Franz Schubert or Robert

Schumann, her father's favorite composers, along with piano-vocal scores of operas by Richard Wagner. As Alma was an exceptionally good sight-reader, she soon familiarized herself with the music of the Bayreuth master. Radnitzky-Mandlick also introduced her pupils to chamber music and put on afternoon recitals, at which the young ladies joined forces with other musicians. Alma hated these public performances. Making music for her was a very personal and intimate business. She occasionally took part in her teacher's student concerts, but mostly she invented some excuse to get out of these appearances. Once, when Madame Adele insisted on her participation, she didn't shy away from even drastic measures: "Then off I went to the kitchen and cut a murderously deep wound in my left thumb, splashing blood all over the kitchen."[52]

But she was not about to be satisfied with mere virtuoso performance, pure interpretation. And so the Viennese organist and composer Josef Labor became her first composition teacher in 1895, when she was sixteen years of age. Labor was an elderly gentleman, more of a fatherly friend than a demanding teacher, and hardly in any position to provide much orderly guidance for her talent. Beyond this, he was blind. His instruction was not systematically constructed—now and again they would just converse all morning about general artistic matters, about the painters of the Secession movement to whom the fifty-eight-year-old composer took a distanced approach, or they would talk about Alma's musical god, Richard Wagner. Now and then she would play her teacher dozens of her original compositions, songs and piano pieces, which, of course, he could only judge acoustically. Alma's composing was a kind of self-expression, something intimate, similar to writing in her diary. Her songs are reminiscent of emotionally laden improvisations and are more like dreamy soliloquies than thought-out compositions based on the rules of music theory. Alma might have learned "not all that much" from Josef Labor, as she later wrote in her diary, "but still I found him to be a warmhearted, compassionate friend."[53]

Despite her pronounced musicality, Alma never got past the status of a gifted amateur. "I should like to do a great deed. Like to compose a really great opera, something no woman has ever done before. Yes, that's what I'd like! In a word, I would like to be and become something, and that is impossible—& why? I wouldn't lack the talent, I—only lack the seriousness."[54] The absence of seriousness was not just Alma's personal shortfall. What in her case might look like inadequate discipline from today's point of view is actually traceable to her lack of a role model. Fanny Mendelssohn and Clara Schumann were recognized as composers of distinction, but only long after Alma's youth. And

when Alma judges herself to be a "half-nature," she simply repeats a misogynistic cliché of her time, which we find phrased with particular sententiousness in the writings of Otto Weininger and Karl Kraus. The nineteen-year-old girl believed that women could not be geniuses "because they have too little spiritual profundity and philosophical education."[55] At another place she wished: "Ah—if only I could be a man."[56]

THE PRINCESS AND THE SMART FROG

For over five years, Alma went to see Josef Labor at Rosengasse 4 every Tuesday. She held her teacher in high regard as a fatherly friend, and he enjoyed the young lady's visits. Moreover, she became more and more aware of the limitations of Labor's instruction: "Apart from that, I'm not making any progress in my technique," she realized at the end of January 1900. "I just can't think. I keep making the same mistakes, doing the same stupid things, and I know all too well that he's enjoying me less and less.—I hate myself because I'm so terribly superficial."[57] She realized that if she wanted to overcome her amateurishness, she would need a stricter teacher. In the spring of 1900 the twenty-year-old Alma met Alexander von Zemlinsky. The twenty-nine-year-old composer had been a conductor at the Carltheater since 1899 and ranked as one of the great hopes of the Viennese music scene. When Alma saw him for the first time in a symphony concert—Zemlinsky conducted his own work, *Frühlingsbegräbnis* (Spring interment)—she noted, shocked, in her diary: "A caricature—chinless, short, with protuberant eyes and an overly crazy conducting style."[58] A good two weeks later she made the personal acquaintance of the composer at a soirée and still found him "horribly ugly, has almost no chin—and yet I find him exceptionally pleasing." Alma and Zemlinsky had a long conversation that evening about Richard Wagner, especially *Tristan und Isolde*. When Alma confessed that this work was her favorite opera, Zemlinsky "was so delighted he was totally unrecognizable. He became downright handsome. Now we understood one another. I liked him very much—very much."[59] From then on, Alma had only one desire: "I want to study with Zemlinsky, if only Mama will allow it."[60] Zemlinsky also found this idea appealing and finally promised to take her on among his pupils that winter. Until then, he wanted her to give him some of her compositions so he could get an idea of her knowledge level at the time. Whatever he got then, however, proved a bitter disappointment to him. "In those three songs there are so outrageously many mistakes," he wrote to Alma, "they set my head spinning."[61] Alexander von Zemlinsky was a strict

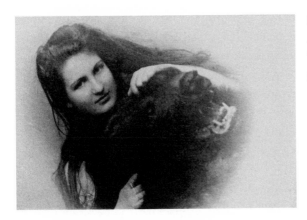

FIGURE 1.4
Alma at nineteen:
"The loveliest girl
in Vienna."

teacher with an incorruptible eye. He criticized his pupil's ideas and made it unmistakably clear to Alma that her superficiality was standing in the way of success as a composer. "Either you compose," he remonstrated, "or you go to parties—one or the other. Choose whatever you prefer—go to parties."[62]

Alma's new teacher provoked "a real storm of outrage"[63] in the Moll household. Mother Anna couldn't calm down and kept repeating that she couldn't understand how Alma could voluntarily have anything to do with someone that ugly. But Alma paid precious little attention to her mother's tirades. She might well have found Zemlinsky ugly "*ad absurdum*" in the spring,[64] but over the course of the summer months of 1900 she altered her verdict: "I don't find him strange—nor is he ugly, for his eyes glow with intelligence—and a person like that is never ugly." For Alma, Zemlinsky was "one of the nicest people I know."[65] Even more, she found him inspiring in a way she had never known before. Josef Labor had to be kept in the dark about all this. So she continued taking lessons from him, knowing all too well that the old gentleman would never understand what she was doing.

If, for Alma, Zemlinsky was initially just "a fine fellow," soon her feelings for him developed further, a lot further. "Today—we sat close together—when he got closer to me, I felt real physical pain . . . from enormous, eager sensuality. My greatest desire, that he might fall completely in love with me, will unfortunately never come to fulfillment, because he knows me too well—my flaws—my limitations—my stupidities."[66] A few weeks later, what had to happen did happen: "I took his head in my hands, and we kissed until my teeth hurt."[67] Alma landed in a roller-coaster of emotions; on the one hand, she couldn't stop thinking about him: "in everything I do, he hovers before me—I feel him."[68] On the other hand, she made a game out of humiliating and

torturing Zemlinsky. Alma kept repeating to him that he was ugly, whereas she could easily have "ten others" in his place.[69] Zemlinsky suffered under Alma's arrogance and vainly asked her not to play games with his feelings. Alma was not all that sure of herself and her contradictory emotions. "And I thought to myself," she wrote in her diary after returning from a wedding, "if I were to stand there before the altar with Z.—how ridiculous that would look. . . . He so ugly—so short, I so lovely—so tall. I could not get a feeling of love in my heart for this individual, as much as I might try. I really want to love him, but I think it is all over for me."[70] She got backing from her friends and her family, who had no understanding for the liaison with Zemlinsky in any case. Max Burckhard virtually implored Alma not to marry Alexander von Zemlinsky, under any circumstances: "Don't defile the good race."[71] And Anna Moll even threatened not to let her daughter's admirer into the house again. Once more, Alma found herself betwixt and between: on the one hand, she confronted her mother with defiance and rebellion, because she wasn't about to allow any new intrusions into her private life; on the other hand she recoiled from the idea of a marriage with Zemlinsky because then she would have to "bring short, degenerate Jew-children into the world."[72] Alma was completely at odds over what to decide. Her pathetic declarations of love followed dubious longings for subjugation: "I thirst for rape!—Whoever it might be."[73] Her erotic daydreams didn't even stop at the doorstep of her considerably older mentor, Max Burckhard. "Some evenings I have noticed with amazement that I can't take my eyes off the round protuberance on the left side of B.'s trousers. My sensuality is boundless. I must marry!"[74]

After almost a year, Alexander von Zemlinsky had put up with enough of Alma's humiliations. "Finally my pride is getting a bit affronted," he wrote to her at the end of May 1901 and told her what "I have so long repressed, but which has so often been straining to get out of my system: "My dear, you keep on stressing, as often as you can, how precious little I am and have, how many things make me unsuitable to belong to you. . . . Have you got so much to give, so infinitely much . . . that everyone else is a beggar by comparison?! Exchanging love for love, that's all I know. You are very beautiful, and I know how highly I regard this beauty. And later? In twenty years???"[75] Alma obviously saw no fault in herself, and she had no idea what Zemlinsky was going on about. "Haven't thought one second about Alex," she wrote almost defiantly in her diary. "If he doesn't want me as I am, with all my faults, he should just forget about it."[76] In a second letter a short time later, Zemlinsky stated his case even more clearly. What he expected from his wife was not, first and foremost,

beauty, but rather love and trust. And further: "I always give more, because I am richer within. Yes, I am—you're smiling? What inner riches do you think you have?! Don't I have so many more? So I am so horribly ugly? All right, I accept that! Now I thank God that I am what I am! And I thank God that there have been so many girls who have penetrated beyond my ugliness to my soul and never said a word to me about it, so that I know I am nevertheless a person of whom it cannot be said that because of this I have no value."[77]

Meanwhile Alma took refuge in eruptive girlish fantasies: "Alex—my Alex. I want to be your consecration vessel. Pour your overflow into me."[78] She made a theatrical production of her relationship with Zemlinsky, all delivered with such a spasm of exuberance, it frequently took on bizarre proportions: "I want to be his bondswoman. Let him take possession of me. He is a sacrament for me."[79] At another place she begged "to be able to suffocate from his kisses."[80] This stage-worthy depiction of emotions distorted her view of the fact that her friendship with Zemlinsky had long since run its course. He was meanwhile wearying of Alma's antics. "I'm fed up," he wrote to her, injured by her superficiality: "Not one warmhearted word, stupid remarks about a yellow bed and a yellow shirt! Delights of cocottes!"[81] Two days later, this was the way he analyzed her behavior: "Your inconsiderate bits of intimate tenderness the last times we were alone came about largely from your longing to find out what tenderness is. That's the feeling I have. . . . As intimately and grandly as you write: 'I want to be a mother to your children!' I get the feeling: if only you really felt that way. But you don't! I'm constantly wondering if I should come for a visit this week. Maybe it would be good if you just don't see me anymore."[82]

HYSTERIA

Alma Schindler's anti-Semitism seems on first glance to be somewhat of a paradox. She who had several Jewish friends, and claimed to be in love with the Jewish composer Alexander von Zemlinsky, occasionally erupted in coarse anti-Semitic invective. Many of her tirades sound artificial; she had obviously assumed an attitude that seemed by general consensus to be regarded as good form and a way of expressing the class awareness of the *haute bourgeoisie* in fin de siècle Vienna. The Austrian capital was presided over at the time by Dr. Karl Lueger, who as mayor headed the municipal government from 1897 until his death in 1910. Honored as "Lord of Vienna," Lueger knew better than anyone else "how to unite all the enemy images of his constituents in a single powerful movement: anti-Semitism." He distilled his central political statement down

to the slogan "Blame it on the Jews."[83] "Handsome Karl," as Lueger was called because of his vanity and his impressive appearance, was a cunning tribune of the people. At his political public appearances, he told the people—preferably in their own dialect—what they wanted to hear, had no trouble placing himself on the lowest intellectual level of his listening audience, and played virtuosically on the keyboard of anti-Semitic resentment. Lueger was a past master of oversimplification: his rabble-rousing speeches were not geared toward mobilizing the mind but rather manipulating the emotions. In private conversations the mayor wasn't all that precise with his aggressively proclaimed Jew hatred. "I will determine who is and who isn't a Jew!" he would retort to anyone who wondered why a Jewish fellow-citizen might enjoy his good favor.[84] In the final analysis, it is immaterial whether Lueger was a committed anti-Semite or simply used anti-Semitism as a means to an end. His policies in any event had ugly consequences: "Jewish" was regarded by countless Viennese as the code word for whatever they didn't like.

Alma was in contact with yet another anti-Semitic trend firmly anchored in German intellectual history at the time: Wagnerism. At the end of the nineteenth century, the composer Richard Wagner ranked, not least because of his inflammatory essay "Das Judentum in der Musik" ("Judaism in Music"), first published in 1850, as the founder of an anti-Semitic religion. After he republished the pamphlet in 1869, Wagner's pathetic effort advanced to a cult book in German-nationalistic circles: Houston Stewart Chamberlain—Wagner's British-born son-in-law—went so far as to declare it "the awakening conscience of the nation."[85] In the following years, Richard Wagner societies shot up out of the ground everywhere. They transported the composer's world of ideas, or what people thought that world was, well into the bourgeoisie. "Yes, the libretto is also so fantastic, such a brilliant piece of German thinking," wrote Alma after a performance of *Siegfried*: "no Jew could ever understand Wagner."[86] At another spot she complained about "the despicable Jew-vermin" in a tourist café she liked to frequent.[87] Statements like these come across as revolting today, but they cannot be regarded as a coherent anti-Semitic worldview. Alma was no "ideological anti-Semite"; she took no interest in the racial theories becoming rapidly popular at the time, and she did not read—as far as we know—any anti-Semitic literature. One might, as often happened, describe remarks like these as the stupid twaddle of an immature and self-important twenty-one-year-old. This explanation does not go far enough, however, because anti-Semitism ran like an unbroken thread throughout her entire life. For Alma, hatred of Jews served as a highly effective power instru-

ment; in the spirit of Karl Lueger, the Jewish origins of an individual offered her the opportunity to play her own "Aryan superiority" card against them. For Alma, the "racial" origin of a person could be his weak point, his Achilles heel. Here something that remains a characteristic attribute throughout Alma's life becomes clear, something that came out distinctly time and again in her diaries—her determination for power, her extremely pronounced need to subjugate other people, especially men, and keep them in an inferior position. "She wanted to be loved," one contemporary witness remembers, "to gain power over her admirers. This had nothing, or almost nothing, to do with physical love. She wanted to be worshipped by each and everyone."[88]

In 1895, Viennese psychoanalysts Sigmund Freud and Josef Breuer described this domineering behavior pattern as a significant component of hysteria. The origins of this disorder concept, however, go back to ancient times. Hippocrates assumed that, particularly in cases of old maids and widows, the uterus (Greek *hystéra*) swelled up, wandered through the body, and brought about every possible disease symptom. In the late Middle Ages, hysterical women were often regarded as witches and believed to have entered into a pact with the devil. All the way into the late eighteenth century the notion persisted that this was a purely organic illness, the root causes of which could be found in the female reproductive organs. It was not until the centuries thereafter that the idea of a nervous disease gradually began to become more widely accepted. Freud was finally the one who classified hysteria as being a part of his newly conceived group of neuroses. That trailblazing work, *Studien über Hysterie* (*Studies in Hysteria*) became the point of departure for any number of scientific research projects.[89] How can a hysterical personality be described? In 1958, the American psychiatrists Paul Chodoff and Henry Lyons provided a definition that has been incorporated into almost all later studies: "It might be said that the hysterical personality is a term applicable to persons who are vain and egocentric, who display labile and excitable but shallow affectivity, whose dramatic, attention seeking histrionic behavior may go to the extremes of lying and even pseudologia phantastica, who are very conscious of sex, sexually provocative yet frigid, and who are dependently demanding in interpersonal situations."[90]

If we apply this approach, then we can see that there are many traits of the hysterical woman even in the young Alma Schindler: the constant vacillation between emotional frigidity and erotic extravagance; an inclination toward coquetry with a concurrent disinclination toward physical closeness; the pronounced tendency toward theatrical and frequently inappropriate posing;

the strong tendency toward superficiality and daydreaming; the toying with thoughts of suicide as well as the total inability to endure criticism. The reasons for this lie in a self-esteem conflict, in a flawed sense of identity. Alma obviously suffered from an acute inferiority complex. She used the tools of imperiousness, jealousy, exaggerated haughtiness, and theatrical antics to cover up her fear that she might be inadequate. This hyperemotionality hampered Alma in the perception of her fears. In his *Allgemeine Psychopathologie* (*General Psychopathology*), first published in 1913, the philosopher and psychologist Karl Jaspers described this defense mechanism: "Instead of the primordial, authentic experience with its natural expression, we have a fabricated, histrionic, forced expression; but not a consciously 'fabricated' one, rather one with the ability (or the actual hysterical talent) to live completely in his or her own theatre, to be right there in the moment, thus with the semblance of genuineness. ... The hysterical personality ultimately has, so to speak, totally lost its core, it now consists only of steadily changing outer shells. One drama just follows another."[91]

At the focal point of Alma's theatrical productions was her demand for attention, love, and homage. After dancing the night away at a ball, she noted: "The men just crowded around like mosquitoes around a lamp. And I felt just like a queen. Was unapproachable and proud, spoke only three cold words to each of them. ... Countless men asked to be introduced to me—it was a genuine triumph."[92] When, however, her magic failed, as several witnesses have confirmed, she would go to bed and weep for days on end. Anna Mahler, Alma and Gustav Mahler's daughter, remembered a telling incident: "In Breitenstein on Semmering there was a postman, every day, in the summer, soaked in sweat, hideous, old; he had once said something impolite to her. Mommy went to bed and sobbed for three days. That's how much it meant to her."[93]

As early as the relationship with Alexander von Zemlinsky, Alma's deep dissatisfaction with herself came to the fore. She humiliated and tortured him in order to boost her own too-weak self-esteem. And this would become a pattern that would characterize many of her romantic relationships. Anna Mahler said, "She had an uncanny knack for enslaving them. And if anyone refused to become a slave, then he was worthless."[94] Alma had a marked preference for Jewish, purportedly weak and unattractive men. Her much-cited erotic attractiveness had nothing to do with genuine sensuality. For her, sexuality was more a kind of kick, a pathetic bit of playacting. That is the home turf of a hysterical woman: to draw a man inescapably to her, promise him everything, drive him crazy, and then make it clear to him that he was Jewish, unattractive, or—as

happened in the case of Gustav Mahler—impotent and hence undeserving of her affections.

Alma, a victim of hysteria? Is it really fair to put another human being—moreover posthumously—in that pigeonhole? What do we gain by marking a person with that "psychiatric label"?

After spending years working my way through tens of thousands of pages by and about Alma Mahler-Werfel, to the point where I finally comprehended the basic pattern of her nature and her life, so that I wanted to put these attributes into words, I found the most coherent explanation not only for her confusing, contradictory, repulsive characteristics, but also for the impressiveness, the strength, and the suffering of this woman in the case histories and theoretical writings of hysteria scholars from Charcot to Freud and all the way to Bräutigam, Mentzos, and Christina von Braun.

Far be it from me to denounce Alma with the generally misogynistic insult "hysterical"; nor do I have the least intention of pathologizing. Alma was not ill; her life is no case history. But when one reads the scientific literature on the hysterical form of neurotic illness, certain parallels to Alma automatically come to mind. In the renowned *Lexicon of Psychiatry*, for example, it says: "Traits of a hysterical personality structure include the narcissistic, egocentrically, status-hungry attitude with histrionic tendencies and an infantile hunger for recognition. Hysterics are not in a position to integrate the sexual element, they remain incapable of having a mature genital sexual relationship and the satisfaction that goes with it. Hysterics are generally very talented at suppressing their conflicts, even to the point where they totally expunge them from their consciousness."

In Philadelphia, when I came upon the original version of Alma's chronicles in the *journal intime* she had kept almost all her life and read what she had recorded very close in time to the experiences she regarded as noteworthy and the way she reflected on those experiences, it immediately became clear: "Suppressing their conflicts, even to the point where she totally expunges them from consciousness" absolutely did not figure in her coping strategy. At very many points in the narrative, one is amazed by the clear view and pitilessness of her own self-appraisals. These attest to her solidly grounded mental health. In the *Lexicon of Psychiatry*, the director of the Heidelberg University Clinic for Psychosomatic Disorders, Professor Walter Bräutigam, goes on to state: "The condition of the hysterical neurosis structure—as psychoanalytically defined—lies in Oedipal fixations with a bonding commitment to the opposite sex parent and unconscious fantasies of sexual seduction. Women define their

own gender role is humiliatingly rejected; phallic traits are frequent. They want to confirm their purported inferiority as women ('penislessness'), or they seek revenge." In Alma's case, however, the "fantasies" of sexual seduction are by no means "unconscious," but rather so crystal clear that she can write: "I thirst for rape!" This fits in with something Bräutigam describes thus in his scientific article: "In many hysterical symptoms . . . besides sexualization, the need for punishment also plays a sizable role."[95] The ego-proximity of her drives accounted for the fact that Alma definitely did not get pathologically derailed or become a mental case. On the contrary, she availed herself of enormous inner resources, which helped her retain vitality, energy, and even attractiveness right into old age.

Alma's hysterical personality disorder is probably traceable to her extremely close attachment to her father. His awareness that his wife was cheating on him caused Emil Jakob Schindler to cling even more closely to his older daughter. This turned Alma into a replacement for her disloyal mother (the scientific term is "spousal substitute"), even though there was certainly no way she could take her mother's place. The compulsion to play this role much too early in her life—Alma was thirteen when her father died—a role she could never assume in real life, possibly triggered a sense of emptiness, insignificance, and inner inadequacy, which Alma attempted to cover up in the form of hysterics.

If we are to believe her diaries, then, Alma was admired by many men, even in her early years, as a "goddess" and a "sovereign." Photos from the time show her as a pretty Viennese girl, but by no means a great beauty. Alma, however, was convinced she was a beauty, and this conviction radiated strongly from her. She wanted to be worshipped, and as she had nothing to give her worshippers, they had to content themselves with the suggestion of her beauty. The thing that made Alma so irresistible was her talent for being a kind of spiritual mirror. She had an incredible knack for identifying fully with her opposite number. Alma caught on quickly to what a man wanted to be and was able to make it believable to him that he was exactly that. Her admirers, who were often appreciably older than she, felt flattered that "the prettiest girl in Vienna" had seen fit to look with favor upon them, of all people. This leaning toward identification, that is to say the skill of instantly making someone else's position her own, is typical of hysterical personalities.

Alma was fully aware of all these traits. Time and again she complained in her diaries about her "half nature," her flightiness and her considerable inability to experience deep and genuine, unfeigned emotions. At one point, she

even caught herself in the act of being a hysteric; "First I turned his head, and then I paid him no further attention: how right he is; I am a totally wicked, superficial, coquettish, domineering, and egotistical female!"[96] The question is only how seriously does she take her own self-condemnation? Perhaps this self-incrimination is reflected only in things she sensed in others.

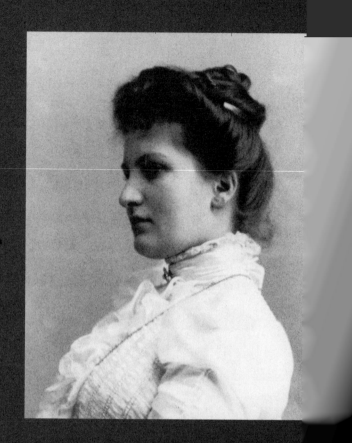

2

Mahler

ENTANGLEMENTS

On November 7, 1901, Alexander von Zemlinsky conducted a concert in the Musikvereinssaal featuring the violin virtuoso Jan Kubelík and the pianist Rudolf Friml. Although Alma hadn't seen him for five days, she did not attend her friend's concert. She had accepted an invitation from Bertha and Emil Zuckerkandl. The Zuckerkandls and their salon were a Viennese institution: she was the daughter of the highly regarded journalist Moritz Szeps and also worked as an influential news analyst in her own right. He held the chair of anatomy at the University of Vienna and was admired by his contemporaries as the most important physician in Austria. Bertha Zuckerkandl's sister Sophie lived in Paris and was married to Paul Clemenceau, a brother of the future French prime minister Georges Clemenceau. Among the regular visitors to their salon were such authors as Arthur Schnitzler, Hugo von Hofmannsthal, Richard Beer-Hofmann, and Hermann Bahr. As Bertha Zuckerkandl had taken it upon herself to spearhead the Secession journalistically, painters and architects like Gustav Klimt, Carl Moll, and Joseph Maria Olbrich also frequented her home. At the table that evening, besides Sophie Clemenceau and the hosts, sat Gustav Klimt, Max Burckhard, Carl Moll, along with his stepdaughter Alma, and — much to everyone's surprise — the director of the Court Opera, Gustav Mahler, accompanied by his sister Justine. Mahler's acceptance of an invitation to this kind of event was a minor sensation. He had the reputation of not deriving any pleasure from such festivities; sparkling conversation and convivial amusement were definitely not to his liking.

After dinner the guests retired for a pleasant chat in one of the other rooms. Alma had initially not taken much notice of Mahler that evening, although he was not unknown to her. In early July 1899, while the Moll family was on summer vacation in the Salzkammergut, Mahler had sent the nineteen-year-old girl, on the prompting of friends, a kind of autograph card, much to her delight.[1] When she coincidentally ran into Mahler a couple of days later near

(previous page)
FIGURE 2.1 Alma Mahler around 1902.

Goisern on a bicycle tour, she found the whole episode extremely uncomfortable. "I hopped on my bike and just rode off."[2] Now, more than two years later, the incident was not mentioned further, and the mood relaxed into an animated discussion in the course of which Alma accused Gustav Mahler of having treated her composition teacher, Alexander von Zemlinsky, discourteously. Zemlinsky had submitted his ballet *Triumph der Zeit* (Triumph of time) to the Court Opera and had not received any response. Mahler countered that he didn't know what to make of the work, and beyond this, he had not understood the composition. To this Alma replied with complete self-assurance in her artistic judgment: "I can explain the book to you, but first you must elucidate 'The Bride of Korea' to me—one of the stupidest ballets ever given."[3] Although Mahler, for his part, conceded that Josef Bayer's *Die Braut von Korea* was a weak piece, he said he was impressed by the resoluteness with which Alma had called him, the considerably older director of the Vienna Court Opera, to order. Mahler was suddenly in the best of moods and invited Sophie Clemenceau and Bertha Zuckerkandl, along with Alma, to the dress rehearsal of Jacques Offenbach's *Les contes d'Hoffmann* at the opera house the following day. Before taking his leave, he even asked Alma if he might see some of her lieder. "I must say, I really liked him very much," she immediately wrote in her diary when she got home, "nevertheless very nervous. He walks around the room like a wild man. The fellow is made up entirely of oxygen. You burn yourself if you get close to him."[4]

The next morning, promptly at eleven, Mahler was waiting for his visitors at the opera. He personally escorted the three ladies through the expansive building, asking them to join him for tea in the director's office. Throughout the tour—perfect gentleman that he was—he carried Alma's coat. He asked Alma how she had slept. "Magnificently!" to which he replied: "I didn't sleep a minute the whole night!"[5] And Max Burckhard, who had joined Mahler on his way home from the evening at the Zuckerkandls, told Alma the following evening about the impression she had made on Mahler. He had allegedly said: "In the beginning, I didn't much care for her. I thought she was a toy doll. Then, however, I began to realize she was also rather clever. My feeling at the beginning was probably because one is not all that used to finding such a pretty girl occupying herself with something serious."[6]

When, a couple of days later, Alma received an anonymous love poem, one stanza of which began with the words "It happened in the night—I couldn't sleep a wink," she could see that the evening at the Zuckerkandls was very likely to lead to serious consequences. Initially, she resisted her budding feel-

ings for Mahler, being, after all, still involved with Alexander von Zemlinsky. "But Mahler's image lives within me. I want to uproot this poison weed."[7]

The following days were an emotional roller-coaster ride: on the heels of ecstatic declarations of love for Zemlinsky followed deep self-doubt. On November 28, events came to a head. "Mahler was here," Alma rejoiced; "I think only of him, only of him," and went on to say, "There is a wall between us—Alex. He doesn't know it, but he still can feel it! I don't know, but I believe I love him (Mahler)! I want to be honest. In recent times I have had no feelings for Alex."[8] Before dinner, Mahler and Alma took a walk near Döbling, during which he flatly declared: "It isn't so easy to marry a man like me. I'm totally free, must be, cannot bind myself materially. My position at the opera can terminate from one day to the next."[9] Alma was doubtless taken aback. The fact that he had decreed a wedding as if from on high, had dictated "his will, his life commands," bothered her. Back home, they both went into Alma's room, where they had their first embrace "without exactly wanting it to happen."[10]

Alma found herself—this was clear to her—facing a difficult, life-changing decision: "If only I knew now—this one or that." It was clearly hard for her to break with Zemlinsky. "I must slowly wean Alex," she noted some three weeks before her engagement to Mahler. "How dreadfully sorry I am."[11] For all this, she wasn't at all sure whether she really loved Mahler. "I have no inkling. Sometimes I think flatly—no." Many things about the Court Opera director bothered her, "his smell, his singing, some things about the way he speaks!"[12] His music—"harsh stuff"[13]—also struck her as strange. What ultimately tipped the scales in favor of her decision to marry Gustav Mahler, of course, remains her intimate secret. In any case, the people around Alma did whatever they could to talk her out of her liaison with Mahler. He was incurably ill, her friends taunted, much too old, and improverished.[14] Carl and Anna Moll also worried: "He is not exactly what I had wished for you," Carl Moll said concernedly. "He is old, in debt, as far as I know, sickly; his position at the opera is shaky. . . . He isn't good-looking. He also composes, but people say there isn't much to it."[15] When these attempts at intimidation proved ineffective, Moll claimed Mahler was a womanizer, alluding to the rumors making the rounds about the opera director's predilection for attractive sopranos, meaning the singers Anna von Mildenburg, Selma Kurz, and Margarete Michalek. These warnings, however, didn't scare Alma off; on the contrary they obviously triggered a deep sense of sympathy in her, which would subsequently prove the keynote in her marriage with Mahler. "He is ill," she wrote compassionately in her diary; "my poor fellow, he weighs 63 kilos [139 pounds]—much too little.

I shall take care of him like a child. I love him with unending emotion." And further: "I am terribly afraid he will get ill on me—I can't say—I see him lying right in his own blood."[16] As Alma based her love on emotion, compassion, and a caring instinct, speaking of her future husband as she might speak maternally about her own child, the tone of the future relationship was clear from the outset.

A scant four weeks after they had met in the Zuckerkandl home, the Court Opera director traveled to Berlin, where he was to conduct a performance of his Fourth Symphony. Every day on his concert tour, he sent Alma love letters we still find moving to this day. "Say hello many, many times to your Mama from me. I've already become so used to looking on her as my own, too, that I will soon make a mistake and call her 'Mama' myself."[17] At another place he asked Alma to tell her mother everything, so that he could immediately present himself to Anna Moll as her son-in-law on his return. Mahler described his travel experiences to Alma in minute detail, allowing her to share intensively in his life, and expected the same enthusiasm from his future wife as well. Alma destroyed her letters to Mahler after his death, yet we can infer from his answers that he was anything but satisfied with her sparse reactions. Time and again, he asked her to write to him more legibly and in greater detail. In doing this, however, he sometimes took the attitude of a strict schoolmaster or an admonishing uncle, which a twenty-two-year-old woman like Alma must have found hard to take. "How lovely it will be," he wrote her, for example, from Dresden, "if we soon go browsing together in your library, putting everything in order."[18] When he said "putting in order," Mahler meant getting rid of those works he considered inappropriate reading for a young wife. In Mahler's view, Alma was a clueless young thing, whom he needed to raise up to his level. This feeling of superiority clearly emerges from a letter Mahler wrote to his sister Justine: "The dear girl is now terribly stirred up and finds herself in a situation—completely unfamiliar for her—in which I had better keep my eyes open for the both of us. She has to gain a lot of maturity, as I can lately see more clearly, before I could take such a momentous step [the wedding] under consideration."[19] His many declarations of love to Alma's address cannot hide the fact that Mahler was also having second thoughts about getting married. In a letter to his sister, he asked her if he had the right to do it: "shackling spring to autumn, forcing it to skip over summer."[20] Mahler wasn't just thinking about the considerable age difference of nineteen years, but also the unequal starting points: on the one side, he, the celebrated conductor, who, emerging from humble circumstances, had laboriously worked his way to the pinnacle

of Europe's most eminent opera house; on the other side, Alma Schindler, just out of her teens, the young woman from a protective family. "And we have developed our entire existence in two weeks,"[21] he wrote to Alma from Berlin at the end of his trip, alluding to the fact that Alma could no longer be unaware of what she would be letting herself in for with this marriage.

For Alma, the weeks in November and December 1901 must have been a nerve-racking time, especially as she had yet to tell Alexander von Zemlinsky about this development. "You know how much I loved you," she finally wrote to him on December 12. "You totally filled my heart. Just as suddenly as this love began, it has also come to an end—it has been suppressed. This awareness has come upon me with renewed strength!"[22] While Alma had initially feared Zemlinsky's reaction, she was now able to heave a sigh of relief because he accepted her confession without reproach. "Today a beautiful, beautiful love was laid to rest," she noted in her diary. "Gustav, you will have to do a great deal to replace it for me."[23] However, her thoughts during these December days were circling around a further problem—her greatest worry was "whether Mahler will encourage me to work, whether he will support my art, whether he will love it as Alex does. For he truly loves it."[24] Doubtless Alma was transfiguring her study with Zemlinsky into a success story, which it wasn't. Despite all his criticism of her music, he had nevertheless taken her and her talent seriously. Thus it was all the more injurious to Alma that Gustav Mahler, to all appearances, took no interest whatsoever in her works. "When our time arrives, and I become his, then I must exert my every effort right now toward securing the place to which I am entitled . . . namely, the artistic one. He thinks absolutely nothing of my art—and a great deal of his own—and I think absolutely nothing of his art and a great deal of my own. That's how it is. Now he talks constantly about the protection of his art. I can't do that. It would have worked with Zemlinsky because I share his feelings for his art—he is a brilliant fellow. But Gustav is so very poor—so horribly poor. If he were to know how poor he is, he would cover his eyes with his hands and feel ashamed."[25] In this diary entry from December 19, 1901, Alma's profound doubts about Mahler's music, which she retained throughout her life, emerge especially powerfully. These lines, as foolish as they sound, make it clear that Alma was under no circumstances about to give up composing without a fight. However, when, the next day, she received a long letter, which her intended wrote her from Dresden, she became abruptly aware that this fight was hopeless. In twenty pages, Mahler discussed with frank openness just exactly how he expected a life together would be. Alma was, he began, too young and immature to possess a genuine

personality yet. She had surrounded herself with false friends—he meant primarily Max Burckhard and Alexander von Zemlinsky—who had given her the deceptive feeling that she was a fully matured personality. Alma and her devotees had "intoxicated one another with phrases . . . and—because you are beautiful, and attractive to men, [they] then, without knowing it, unwittingly pay homage to the loveliness." In short: she had "grown vain because of the things these people think they see in you." Although Mahler was certainly being unfair to the critical Zemlinsky, it is impossible not to recognize the portentousness of the groom's perceptiveness, requiring, as he does, his bride to be a kind of projection surface capable only of reflecting and unable to bring forth anything under her own power.

In the second part of the letter, Mahler addressed himself to the issue of Alma's composing: "How do you envision such a marriage between two composers? Have you any idea how ridiculous and ultimately degrading in our own eyes such a peculiar rivalry would become?" Alma's belief that she could continue taking composition lessons with Zemlinsky even after the wedding was something Mahler found tasteless: "Did you love him [Zemlinsky]? And can you then have the nerve to expect him to play this pathetic role of now giving you further lessons? Do you find it masculine and grand to have him, bearing the traces of his sorrows, sitting opposite you, wordless and obedient, so to speak, simply 'à tes ordres'?! And you claim to have loved him, yet you can still endure that?" Mahler was not just looking for a partner who would be a beautiful, presentable, and quick-witted wife, but even more for a "comrade," a "companion," one who, out of respect for his artistic mission, would subordinate herself to him and relieve him of everyday concerns: "But you must become the person I need if we are to be happy together, my wife and not my colleague—that is for certain! Do you feel this would be an upheaval in your life, and do you think you would have to do without an indispensable high point of existence if you were to give up your music completely to possess mine and be mine as well?" With no consideration of the possible consequences for Alma, before solemnizing the marriage, Mahler made his visions of a partnership clear and asked her to answer him just as honestly: "Tell me pitilessly everything you have to say to me, and be aware—it is better for us to separate now while there is still time than to continue a self-deception. Because, knowing myself as I do, that would ultimately be a catastrophe for us both."[26] Mahler intentionally presented his intended with this difficult choice, so he could be absolutely certain that Alma really suited him. We may be shocked by his calculating self-assertion, considering he basically had nothing

to lose. When Alma Schindler stepped into his life, he had long since already found the "comrade" who would provide him with emotional support. Justine Mahler, the second-oldest of Mahler's three sisters, had already run the bachelor household for her brother in Budapest and Hamburg. She was devoted to him, heart and soul. She "offered him the advantage of female care without the emotional counterclaims a marriage partner might assert."[27]

We have no way of ascertaining how Alma really reacted to this now famous Dresden letter, how she countered Mahler's conditions. In her diaries, the echo of an authentically felt as well as alleged loss of "her" music resounds. Mahler's traditional ideas of a marriage must have struck the young woman as restrictive. "My heart stood still," she noted in her diary. "Give up—give away—my music, the thing I have lived for till now. My first thought was—write him off. I had to cry—because that was when I realized that I love him. . . . I have a feeling as if someone had taken my heart out of my chest with a cold fist."[28] Alma's entries over the following weeks give the impression that her hopes were greater than her misgivings. "Yes, he's right—" she said in her entry as early as the next day. "I must live totally for him, so he will be happy."[29] That was the state of things in December 1901. Later Alma put the legend into the world—and that is what makes it so hard to fathom the truth of her entries—that Mahler had forbidden her from composing. Today we can see from Mahler's Dresden letter just how groundless this claim is. Mahler neither decreed a prohibition, nor did he force her to make a decision, the consequences of which could not have been clear to her. Characteristically, this revelatory letter did not find its way into Alma's edition of Gustav Mahler's letters, published in 1940—the exact wording would have invalidated her self-stylization as a subjugated and impeded composer. At any rate, Alma was still saying decades later that she could yet feel the deep wound Gustav Mahler had inflicted on her in those December days of 1901: "Somehow, however, a wound burned in me, one that has not fully healed to this day."[30]

On Mahler's return to Vienna, Alma had obviously made her choice, and events moved very quickly. On December 23, Gustav Mahler and Alma Schindler became engaged, "officially before Carl and Mama. From then on, only he will fill my heart, only he. I will not give so much as a passing glance at any of these other males anymore."[31] Despite great discretion, the *Neue Freie Presse* found out the news, which then spread like wildfire. While Mahler had first hoped he could keep his private life a secret, the engagement of the Court Opera director now became the talk of the town in Viennese society. The papers in the capital reported in detail on the "young couple" (he was forty-one,

she twenty-two). Alma wrote: "Everywhere the stress is on my beauty, my youth—and my musical talent. In the *Fremdenblatt* it says that I am quick-witted. Oh God, and so many other things!"[32]

Although bourgeois morality strictly frowned on premarital and extra-marital sex, Alma—just like her mother—was no longer a virgin at her wedding. Shortly after becoming engaged, Gustav Mahler and Alma had already slept together for the first time. "He placed his body at my disposal—and I let his hand have its way. His life stood stiff and glorious before me. He brought me over to the sofa, laid me lovingly down and mounted me. There—at the moment I felt him enter me, he lost all his strength. He lay down in exhaustion above my heart—he wept almost in shame."[33] For both of them, for the relatively inexperienced bride, despite her romances, and the well-versed groom, this incident left behind a feeling of shame and embarrassment. "If he would lose that. My poor, poor man! I cannot say how much this whole matter upset me. First the burrowing in my innermost body, then, so close to the goal—and no satisfaction. What I unwittingly experienced today defies all description."[34] A few days later, it says in her diary: "Delight and happiness."[35] More than that: "Delight beyond delight."[36] But their first physical union had left a bad taste behind for both of them.

Another incident in the early phase of their relationship would prove a source of discord between Alma and Gustav Mahler. It had been Mahler's idea to give a dinner party in his apartment on Auenbruggergasse, to introduce his bride and her family to some close friends. Among the invited guests on that January 5, 1902, besides Alma and the Molls, was the philosopher and author Siegfried Lipiner—a friend from Mahler's youth—as well as the singer Anna von Mildenburg, Mahler's former lover. Justine Mahler, who had been in a relationship for some time with Arnold Rosé, the concertmaster of the Court Opera Orchestra, took advantage of the opportunity to introduce him as her fiancé. Although everything had been arranged with the best of intentions, this evening was to foreshadow a lifelong hostile rivalry between Alma and Mahler's close friends. "Never will I forget the bogus ceremonial grandezza of this evening," Alma still remembered even decades later. "Nobody said anything, but evil, hostile eyes took the measure of every move I made." Siegfried Lipiner in particular had extremely grave reservations about Alma. He condescendingly called her "girl," looked her up and down, and probed her general education with such stratagems as asking her all kinds of questions about the Italian painter Guido Reni. Alma had never heard the name before. She defended herself by indicating she was currently reading Plato's *Symposium*,

to which Lipiner only replied with derision, claiming she couldn't possibly understand that book. Anna von Mildenburg, having lost the fight for Mahler's love, and thus already harboring negative feelings toward her young rival, also provoked Alma by asking her what she thought of Mahler's music. Alma's answer was extremely courageous: "I don't know much, but what I do know—I don't like." Mahler is said to have reacted to this bold rejoinder with hearty laughter. Alma's response to this humiliation was mixed with unmistakable undertones of anti-Semitism. "All Jews with doctorates," she noted in her diary that same evening on returning home: "I could find no bridges."[37] Even several years later, she described Siegfried Lipiner as "an evil, hard beast; his eyes much too close together[,] above them an enormous bald cranium. His writing was a bad imitation of Goethe, and he talked with a lisp."[38] Lipiner was so horrified over the meeting with Alma Schindler that he wrote Mahler a long letter in which he depicted his friend's fiancée as uneducated, disrespectful, and affected. Ultimately it was certainly envy that prompted Mahler's friends to be so adamantly opposed to Alma. And of course Mahler, who was so uncompromisingly told to make a choice, took up the cudgels for his fiancée. Later Alma claimed: "Even then, Mahler was so firmly connected to me that all the objections had no effect on him."[39] However, Mahler would hardly have given up his old friendships just because of an evening gone awry and an unpleasant letter. The fact that Mahler was willing to accept such a radical breach with people who had once been close to him can be interpreted as an expression of his great insecurity regarding his decision for Alma. By side-tracking the bearers of misgivings and thus evading further discussion, he might possibly have hoped to get the upper hand over his own doubts.

On the morning of March 9, 1902, Gustav Mahler married Alma Schindler at the Karlskirche in Vienna. As Mahler had been born Jewish, then had himself baptized Catholic in February 1897, and the Catholic Alma had converted to Protestantism in August 1900 (primarily for the sake of her sister Gretel, who shortly afterward married a Protestant, Wilhelm Legler), they had some obstacles in canon law to overcome. The "Dispensa ab impedimento mixtae religionis" had to be obtained from the prince-archbishop's ordinariate. Apart from this, the ninth of March 1902 fell during Lent, when normally no weddings were allowed to take place, which is why permission "for an afternoon wedding during the sanctified period" was also necessary. When all these conditions were met—the couple additionally had to pledge to raise their children as Catholics—nothing further stood in the way of the wedding. The ceremony took place behind closed doors, because Mahler wanted to avoid any social

affairs, and, apart from the newlyweds themselves, it was to be attended only by two witnesses, Carl Moll and Arnold Rosé (Rosé married Mahler's sister Justine the following day), plus the other members of the immediate families.

It is hard to figure out what it was that bound Alma Schindler and Gustav Mahler together. Bruno Walter, back then a new conductor at the Court Opera and a close confidant of Mahler, pointed out the differences in a letter to his parents: "He is 41, and she 22, she is a celebrated beauty used to a glamorous social life, he is so unworldly and fond of solitude, one could harbor any number of misgivings."[40] For all this, it wasn't just the totally different dispositions in temperament or lifestyle that made their life together so complicated. The heaviest burden was that Alma, at least in the beginning years, found herself on the defensive toward her husband. Everyday life was strictly attuned to Mahler's requirements, which demanded that routine and uniformity not be disturbed by an impulsive and life-hungry wife. This was presumably the banal reason that stood in the way of their having a happy future.

EVERYDAY LIFE WITH A GENIUS

Their honeymoon took the Mahlers in March 1902 to St. Petersburg and was—conceivably an unfavorable start for a life together—concurrently a concert tour. On the way there, Gustav Mahler had a severe migraine attack, caused by an overheated train compartment. Alma didn't feel particularly well either; she was already two months pregnant, irritable, and regarded the pregnancy, right from the beginning, as sheer torture. "Today there's a breakfast with the Austrian ambassador," Mahler told his sister. "Thus far Alma has had to cancel everything. Today, though, I hope she might come along."[41] After their return to Vienna, Alma moved into her husband's home on Auenbruggergasse. The generously proportioned apartment with three small and three large rooms, as well as kitchen, bathroom, and a servant's room, was on the fourth floor of an apartment building that the eminent architect Otto Wagner had built in 1891.

Disillusionment set in early for the young wife, who, like so many others in her generation, had entered virtually unprepared into married life and had thus far not been confronted with the duties of running a household, problems with servants, or the whole topic of raising children. If we take into consideration the varied and convivial life Alma enjoyed in her parents' artistic home, it becomes understandable that it was hard for her to adapt herself to a daily routine that was made to measure exclusively for her husband's work

schedule, which had already functioned perfectly well before their marriage. It quickly became clear to her just how much of the vow she had expressed even before the engagement—"I must live entirely for him so he can be happy"— would now be demanded of her. Mahler's daily schedule had not changed very much after the marriage and was minutely planned. He hated any form of time wasting; every moment was to be sensibly filled, and everyone around Mahler was inescapably drawn into the maelstrom of his zealous work ethic. He got up at seven o'clock in the morning, dressed, had breakfast, and then worked at his desk until nine. After that, he left the apartment and went to the opera, where rehearsals, auditions, and administrative duties were waiting for him. When the "Herr Direktor" left the opera for lunch, Carl Hassinger, Mahler's office assistant, would call Alma. That way she knew that her husband would be turning the corner from the Rennweg to Auenbruggergasse in about fifteen minutes. When he arrived downstairs outside the building, Mahler rang the doorbell, and then Alma knew that while he was climbing the stairs to the fourth floor, she would have the time he spent on the steps to bring the steaming soup to the table. And to save him the trouble of fumbling for his keys, she would open the door for him. At the table, nobody was allowed to speak, as Mahler's head was full of ideas and problems. Distraction was unwanted. After the short midday break, during which he and Alma occasionally went for a walk in the nearby Belvedere Garden, Mahler returned to the opera, where he frequently still had to conduct in the evening. When he wasn't on the podium himself, he would watch the performance from his box or work in the office. A sparse supper ended the day.

On vacation as well, Alma's life was largely marked by the obligation of meeting her husband's needs. As Mahler only got around to composing during the summer holidays, he had made it a habit to spend the months without performances in great isolation away from Vienna; first in Steinbach on the Attersee, then later at the Altaussee, until, in June 1901, he moved into his own vacation home in Maiernigg in the Carinthian countryside. The so-called Villa Mahler stood like a fortress directly beside the Wörthersee and was a stately though anything but palatial home. From two large verandas, one open and one closed, as well as from a balcony, there was a breathtaking view of the lake. "As charmingly as it is located," Alma remembered later, "that's how horribly it was furnished," all in keeping with late nineteenth-century taste, which must have struck a dyed-in-the-wool Secessionist like Alma as pure kitsch. "Mahler once caught me standing on a chair tearing down the column gallery from all the shelves."[42]

So he could work undisturbed, Mahler had a little composing cottage built in the woods—consisting of one simple room furnished with a table, an armchair, a sofa, and a piano. In Maiernigg as well, the daily activities all ran in accordance with a punctiliously planned schedule designed to serve his composition work or his physical exercise. While the first half of the day was totally devoted to music, swimming and hiking stood in the foreground in the afternoon. Gustav Mahler was enormously athletic and went about his swimming, rowing, and mountain hiking activities with exactly the same discipline he brought to his composing. Already virtually immobilized by the advanced state of her pregnancy—the fifth month—Alma could scarcely keep up with her husband's brisk tempo: "I had to climb over fences, crawl through hedges. My mother visited us during this period. She was appalled: Mahler had hauled us out to a mountain that was almost impossible to climb."[43]

Their first summer together was thus not very happy. It would be hard to deny that Gustav Mahler displayed a certain egotistical stubbornness in his rigid adherence to the same lifestyle he had practiced as a bachelor. Obviously, with his unwavering concentration on an undisturbed routine, a wife was clearly little more than an ornament, someone who had to subordinate herself to his wishes. We may keep coming back to the fact that Gustav Mahler had given Alma plenty of warning before she entered into her marriage with him, but in this case, there is a huge difference between theoretical knowledge and everyday experience. And so Alma was tortured not only by her uncomfortable pregnancy but also by her increasingly severe self-doubts: "I just don't know what to do. I have such an incredible struggle inside me!" She took a more critical view of her marriage with Mahler. She had given up everything for her husband, and had "sunk to the status of a housekeeper."[44] Nevertheless, Alma was not about to submit without a fight. Disputes between husband and wife came about repeatedly: "I was all alone the whole morning and afternoon—and when Gustav came down, still so full of happiness with his work, I was beside myself, and I burst into tears again. He got serious—my Gustav—horribly serious. And now he doubts my love! And how often have I had my own doubts." Clearly, in that summer of 1902, Alma was suffering from severe mood swings, which she herself couldn't explain. "First I faint with love for him—and the next minute I feel nothing—nothing!" Her state of mind, wavering back and forth between depressive moods and moral self-accusation, stands in sharp contrast to the cliché of the happy and, beyond that, hopeful wife by the side of a fascinating artist. "And always these tears," she sighed in her diary. "I have never cried so much as now, when I have every-

thing a woman can strive for after all."[45] Mahler had also noticed that there was something wrong with his wife. He reacted in his way by composing a song for Alma. As "something strictly confidential for you" was the way he described his musical setting of Friedrich Rückert's poem "Liebst Du um Schönheit" (If you love for beauty). While Alma was very pleased with this gift, it did little to solve the fundamental problems that resulted from her dissatisfaction with herself. "I often feel how little I am and have in comparison to his immeasurable wealth!"[46]

On November 3, 1902, daughter Maria Anna entered the world. Her parents followed the old custom of naming the child after their two mothers— Maria for Gustav Mahler's mother and Anna for Anna Moll. The delivery was pure martyrdom. "The child was, as the doctor said, displaced because of the stresses and strains during the pregnancy." As the terrible and, beyond that, mortally dangerous, torture had finally been survived, and Mahler discovered it had been a breech birth, he allegedly laughed uncontrollably: "That's my child all right; shows the world just the body part it deserves!"[47] The father was thrilled with the little one, and because of her cunning appearance, he gave her the nickname "Putzi" (putzig is the German word for "cute"). Things were quite different with the new mother, who had to struggle with a postpartum depression. Obviously she could not accept her child lovingly. "I still haven't got the right love for her," Alma confessed to her diary at the end of November. "Everything, everything within me belongs to my Gustav. I love him so much that everything is dead beside him."[48] She only reluctantly found her way into the maternal role. "My child doesn't need me," she noted coolly. "I can't just occupy my attentions with her either!" As normal as these emotional deficits may be in the cases of very many women giving birth for the first time (when they express themselves as honestly as Alma Mahler), the fact remains that right up to the early death of her elder daughter in the summer of 1907, Alma was not able to establish a loving relationship with her.

The new family situation was thus unable to contribute to a calming of the minds. Alma felt that her husband was not paying the attention he owed her, and her frustration increased further until the middle of December, when they got into another violent argument. Alma wrote: "Yesterday I told my Gustav it is painful that he takes so little interest in what goes on inside of me, that he has never ever asked me to play one of my pieces for him, and that my musical knowledge only suits him as long as I use it for him." Mahler reacted to these accusations as he so often did: with insensitive and injurious honesty. "Since your flowery dreams haven't come true," he shouted at Alma, "you have only

yourself to blame." Had he not warned her there could be only one composer in the family? "God," Alma bitterly noted, "when everything is so mercilessly taken away from someone."[49] Undoubtedly, after only a few months, their relationship was already stuck in a dead end, which neither husband nor wife was ready to admit. While Mahler totally failed to recognize the full extent of his wife's frustrations, Alma reacted with envy and jealousy. She was envious of Mahler's music, in which she believed he would not allow her to have any part, and she looked with jealousy at their daughter, who was the pride and joy of her father and enjoyed the attention Alma claimed he was not paying to her. And she observed his behavior toward other women with suspicion, a situation that occasionally exploded in ugly scenes: "Gustav let these hussies drink out of his glass," Alma angrily wrote in her diary after an opera rehearsal. The "hussies" she referred to where the sopranos Anna von Mildenburg and Lucie Weidt. "I am so horrified by him that I get frightened when he comes home. Saucy, sweet, cooing, he hopped like a young man around Mildenburg and Weidt. God, if he would only never come back home! And I would not have to live with him anymore!"[50] When Mahler tried to approach her lovingly that same evening, she pushed him away and said: "You disgust me! That was as far as I got. We didn't say a word to each other. The following day a bitter discussion took place in the Stadtpark. He said he felt clearly that I didn't love him. And he was right—since the last event, everything has grown cold inside me." It was clear to Alma—as we can see from her diary entries in January 1903— that her jealousy was nothing other than a pathetic bit of playacting. "It isn't his fault that I often feel unhappy, it's only my fault." And she goes on: "On the outside, I rant, I weep, I rage—and on the inside there is an unbreakable calm, horrifying! . . . Pathetic trait!"[51]

Alma found it especially painful that her husband showed no interest in the convivial get-togethers and festive soirées she loved so much, and even abominated such events as a pure waste of time. While the Court Opera director certainly cultivated his social contacts—for example with his boyhood friend Guido Adler, professor of musicology in Vienna, with the writer Gerhart Hauptmann, with Alfred Roller, stage designer at the Court Opera, or with his composer colleague Hans Pfitzner—nevertheless, according to his wife's characterization, he felt "rarely comfortable anywhere. Then he would spread an atmosphere around himself 'as if a corpse were lying under the table.' I am convinced that the people heave a sigh of relief after we finally leave."[52] Alma found her life by Mahler's side boring. She later claimed he had made her existence joyless, "that is, he tried to: money—frippery! Clothes—frippery!

Beauty—frippery! Travel—frippery! Only the spirit alone!"[53] In her diary, Alma begged: "Oh, if he were just younger! Younger in enjoyment!"[54]

At the beginning of their marriage, Alma stayed mostly in Vienna when Mahler went on a concert tour. She had to sit at home alone, she later claimed, because the young family wouldn't be able to afford a second train ticket. According to her own statements, at the time of their wedding Alma had found a mountain of debt in the amount of 50,000 crowns, which she blamed on Mahler's brothers and sisters. First and foremost Justine, Alma said, had ransacked her brother's finances.[55] Here, Alma was unaware that, after their parents' death, Mahler occasionally had four siblings to support. His debts were balanced out by a sizable income. When Alma met Gustav Mahler, he had an annual salary of 26,000 crowns—in today's money that would be worth around $140,000. In addition there were the fees for appearances as guest conductor, as well as earnings from the sale of his works. In 1903, for instance, Mahler signed a contract with the renowned Leipzig publishing house C. F. Peters, which for the Fifth Symphony alone brought in a fee of 20,000 crowns. That was no paltry sum. Alma received, as we can see on a letter card Mahler wrote in June 1905, a monthly household budget of 1,000 crowns, in other words around $5,000.[56] In her book *Erinnerungen und Briefe* (Memories and letters), she characteristically expunged this communication from her husband. The true amount of the household money would have unmasked Alma's legend about the sparse family finances, and beyond that made clear that she would certainly have been able to accompany her husband on tour. Her domestic obligations would hardly have stood in the way; after all she had two servant girls, as well as an English governess for her daughter. It is more likely that Alma simply had no interest in traveling with her husband. She looked with jealousy at the successes Mahler was enjoying as a conductor and composer. In June 1902, he presented his Third Symphony at a triumphant world première in the Rhenish town of Krefeld. Thereupon, the Allgemeine Deutsche Musikverein (General German Music Society) under its president Richard Strauss invited Mahler to conduct his Second Symphony at the Thirty-Ninth Tonkünstlerfest (Composers' Festival) in Basel. The competition was more than impressive. Composers like Richard Strauss, Max Reger, and Max von Schillings also presented their works. Mahler's appearance on June 15, 1903, in the Basel Cathedral was, however, the indisputable high point of the festival. The Second Symphony and its creator were euphorically celebrated by both press and public. Alma, who had accompanied her husband to Switzerland, did not mention this auspicious occasion in her diary with a single word. On June 15, the very day Mahler enjoyed

one of the greatest successes of his life, we find the following entry: "I played my pieces again, I always feel—THAT, THAT, THAT!" And like a cheap shot at Mahler: "I love MY art! Everything I played today—so familiar! So profoundly familiar."[57] Years later in her book of reminiscences, she mentioned the Basel concert en passant, lauded "the church with its glowing light, the height of the room,"[58] yet still didn't devote a single word to her husband's music.

In September 1903, Alma was pregnant for the second time. Although the pregnancy proceeded without complications, the maternal joy of anticipation was not part of it. "I can't take this anymore," Alma complained at the end of February 1904; "my discontent increases from one hour to the next. . . . It is such a misfortune that I have no more friends." Great care should be taken, however, with entries like this one. As much as Alma in her diaries, or even her published memoirs, kept stressing her great loneliness during her marriage with Gustav Mahler, this may reflect her feelings of solitude, but not the reality of her situation as Mahler's wife. She styled herself as the victim of a workaholic, ascetic genius. "If I could get together with Zemlinsky,"[59] she lamented at the same place. However, exactly at that time—in the spring of 1904—Alma was in regular contact with her former lover. They made music or had stimulating conversations. Occasionally Zemlinsky complained that he could never get Alma on the telephone ("otherwise I would have come to see you long ago"[60]), which hardly fits in with the image of a wife waiting in solitude at home for her husband. Alma had even tried to hire Zemlinsky as a teacher for an appropriate fee. He, however, turned that offer down. He would be glad, he said, "to make music with her" but had "too little time" to "give a lesson for money." Zemlinsky preferred a more nonbinding arrangement that could be discontinued at any time. "So Friday at 5:30, and we won't say another word about it. By the way—in return, now and then you'll give me [a] seat in the opera. Agreed?"[61] Alma didn't conceal her regular meetings with Zemlinsky in any way from her husband, and Mahler gave her a free hand. As so often, however, at some point Alma lost her enthusiasm, and making music with Zemlinsky became boring for her. More than that: a letter written by Zemlinsky in 1906 makes her lack of interest clear: "I often thought to myself how much I also enjoyed talking to you about my works, how much I wanted to show you all the new things I had finished, and yet I always have the impression that all of that didn't interest you that much anymore!"[62] The constant laments about being alone and lonely, not having any more friends, not being allowed to work with Zemlinsky, being suppressed by Mahler—none of this took place in reality. This way Alma turns the spotlight on herself, as she plays the role of the enslaved wife. This drama

first filled her diary, then her published memoirs. Here, Gustav Mahler was cast in the role of the domineering husband.

When, on June 15, 1904, their second daughter, Anna Justina, entered this world—because of her expressive eyes, she was nicknamed "Gucki" (Gawkie) —Alma did not mention the birth in her diary. Instead, in the late summer, she was heavily involved in pining for Gustav Klimt, who, she had heard, was about to get married. According to her entries, these weeks and months were one long emotional torture. "Bruno Walter is here," it says, for example, in early September. "Gustav is playing his Fifth for him. He lets him look right into his soul. I went out of the room. Walter, all these people, all foreign to me! Even the music!"[63] The alienation between husband and wife had hit bottom. "Yesterday we were talking about the old days, and I happened to say that when we first knew each other, I found the way he smelled unappealing. To that he said: 'That is the key to a lot of things—you acted against your nature.' Only I know how right he is! He was a stranger to me, I still find many things about him foreign—and, I believe, [they] always will be."[64] It was at this time, in the spring of 1905, that Mahler began to turn away from Alma, also in the physical sense. "I could be yearning for a man," Alma complained at that point, "for I have NONE! But I am too lazy—even for that!"[65] Later—in June 1920—Alma claimed her husband had a sexual complex; he "was so afraid of the female that it made him psychologically impotent. His way of loving me began to take the form of attacking me more and more at night when I was sleeping." And further: "The more significant a man is, the sicker his sexuality."[66] In Alma's books, there are a number of places in which she depicts Mahler as prudish and inhibited. Here she strays from reality, because, after all, Mahler's erotic relations, which he had with quite a few women prior to his marriage, hardly indicate any fear of the female sex per se. His withdrawal from Alma, in view of her emotional fluctuations and her reproachfully stated dissatisfaction, is not all that hard to understand. While Mahler turned away, Alma let her eyes wander and again fell into flirting. Hans Pfitzner, in particular, had caught her fancy. "I just know one thing," she wrote in her diary after meeting the composer in January 1905, "he begged me to let him come closer, touched me with his hands wherever he could, and finally asked me in an enraptured voice for a photograph. We were alone in the living room. I let it happen—felt that tingle on my skin that I haven't felt in a long time." Alma didn't fundamentally care one way or the other about Pfitzner's advances, nor was she particularly interested in an affair. It was important to her that she had cast her spell on a devotee, and that she was being admired. When Gustav Mahler had seen through

this bit of hanky-panky with Pfitzner, he put more distance between himself and his wife, who of course registered it: "I was not kind to him, he turned around while we were walking and went into the theater. I continued walking through town by myself, it got dark, and I was suffering so much from my own lovelessness that I almost burst out crying. A young man was following me, I noticed it with longing and joy. That evening Gustav was tight-lipped and morose. He said: I always take the side of the other one. And he is right. On the inside we have now become strangers."[67]

It is striking that those diary entries still preserved on the marriage with Gustav Mahler are free of any anti-Semitic sentiments. While Alma had once drawn enormous self-confidence from toying with Alexander von Zemlinsky, tormenting him with his appearance and Jewish ancestry, she seems never to have humiliated Gustav Mahler the same way. He was obviously not about to let his wife's hunger for power subjugate him. And so Alma's anti-Semitism "slept" during her years with him, "because it had been trodden underfoot by Mahler, in whom she had found her master."[68] Alma's dissatisfaction, the pathetic scenes, and her increasingly occurring health problems—all these symptoms of a hysterical personality structure grew. The conflict intensified. Doubtless the marriage was on the skids.

HEAVEN AND HELL

"The calendar of our life is marked in black,"[69] wrote Alma, describing the year 1907, which became an annus horribilis in the lives of the Mahler family. January 1 marked the beginning of a press campaign that would not give Gustav Mahler a moment's peace for months on end. He was accused of numerous counts of dereliction, for example by critic Richard Wallascheck, who complained in the Viennese weekly Die Zeit about big gaps in Mahler's repertoire and the lack of quality in the singers Mahler had engaged. Beyond this, Wallascheck polemicized against Mahler's concert tours, his allegedly too handsomely paid vacation—and anyway, he said, Mahler had become an enemy of the opera; worse yet, Mahler would destroy it.[70] More and more, accusations like these were mixed in with anti-Semitic sentiments. Mahler felt, he told Alma from a concert tour to Frankfurt, "like a hunted animal with the dogs hot on his trail."[71] Direct consequences for the Mahlers' lives, however, didn't come about until the so-called Wiesenthal affair. Bruno Walter and stage designer Alfred Roller had acted behind the back of ballet director Josef Hassreiter—but with Mahler's consent—and tried to cast the mute title role

in a production Daniel Auber's opera *La muette de Portici* (The mute girl of Portici), usually portrayed by a dancer, with the young ballerina Grete Wiesenthal. Hassreiter felt slighted and protested to Mahler's superior, Prince Alfred von Montenuovo, even offering his resignation. While in previous years, when Mahler had made unpopular decisions, the prince had always taken his side, he now began to withdraw his protective hand. Mahler's position was imperiled, and the press attacks continued incessantly. Before the Mahlers set off in mid-March to Rome, where Gustav Mahler was to conduct two concerts, things came to a head at an ominous meeting with Montenuovo. The prince had learned that Mahler intended to prolong his vacation in Italy without official permission and confronted his Court Opera director with this embarrassing act of insubordination, which, perhaps in other circumstances and without the foregoing affairs, might have been regarded as a mere bagatelle. "But the discussion got so heated," Alma recalled, "that both of them agreed to consider Mahler's resignation."[72] After that, there was no turning back for either one of them.

Mahler's decision to leave the Vienna Court Opera is nevertheless not only attributable to the harassments and intrigues of the first half of the year. For a long time, it had become bitterly clear to him that because of many artistic compromises, he had been unable to raise the artistic level of the Vienna Opera—after all, a music theater that gave performances almost every day—to one acceptable by his high standards. Beyond this, his own artistic creativity had become more and more important for him, and he did not want to restrict his composing just to the summer months. The so-called *Salome* affair was finally a further, important reason in the history of his resignation. The fact that Mahler, as Court Opera director, did not succeed in making a place in Vienna for Richard Strauss's opera *Salome*—the work had been rejected by the Theater Censorship Board for religious and moral reasons—had proven a bitter disappointment for him. And when, on April 21, a performance conducted by Mahler was greeted for the first time with whistles of disapproval—the opera presented that evening was Richard Wagner's *Tristan und Isolde*—the determination must have ripened in him to turn his back on the Court Opera once and for all. The decisive factor in Mahler's resignation, however, was a promising offer from the United States.[73]

After long negotiations, the general manager of the Metropolitan Opera in New York, the Austrian-born Heinrich Conried, had managed to engage Mahler for his famous house. This opportunity was not just a stroke of luck for Mahler, but also a necessity for the "Met," which because of the opening

of the Manhattan Opera House under the direction of Oscar Hammerstein in 1906 had to face some pretty stiff competition. The engagement of Gustav Mahler would—Conried believed—boost the attractiveness of his house. On June 21 the contract was negotiated, and Mahler agreed to conduct at the Met from the end of January until the end of April each year for a period of four years. His fee, in comparison to his Vienna salary, was incredibly high: for one season, he received 75,000 crowns—that is to say from 1908 until 1911, a grand total of 300,000 crowns, equivalent to some $1.5 million. Beyond this, Conried covered all travel, hotel, and food costs.[74]

Against this background of glowing prospects for the future, the Mahlers planned to spend a refreshing summer vacation in Maiernigg. Only a few days after their arrival, however, tragedy struck. "We have suffered a terrible blow!" Gustav Mahler wrote to his friend Arnold Berliner on July 4. "My older daughter now has scarlet diphtheria."[75] Their younger daughter Anna had already been stricken with scarlet fever back in May, but over the course of several weeks had fully recovered. Maria, on the other hand, had now become infected with a considerably more dangerous diphtheria, one that can prove fatal even today. She fought ten days for survival. The inflammation in her throat caused a great deal of pain and terrible shortness of breath. Maria got weaker and weaker and began becoming sicker before the eyes of her parents and her physician, Dr. Carl Blumenthal. In the night between July 10 and 11, as a final option, the doctor made another incision in her trachea, while a furious thunderstorm raged outdoors, and the sky turned blood red. Alma was unable to stay in the house anymore: "During the operation, I raced down the shore, screaming out loud, heard by no one." And Gustav Mahler had withdrawn to his room, "internally taking his leave of this beloved child."[76] The surgical intervention brought no improvement: Maria lay in her bed one more day, wide-eyed and with severe breathing difficulties, and died in agonizing pain on the early morning of July 12.

The news of the girl's death spread quickly, primarily through the Viennese press, and countless condolence letters arrived in Maiernigg over the following days. Alma and Gustav Mahler were virtually paralyzed. Anna Moll came rushing over from Vienna to stand by them. But when, on a walk with Alma, she had to look on while the child's coffin was being removed from the house and taken away, she suffered a heart spasm. Alma fainted. Hastily sent for, Dr. Blumenthal "diagnosed a severe cardiac insufficiency and ordered Mother to keep calm and stay lying down,"[77] as Alma later remembered. And Gustav Mahler, without suspecting anything in particular, decided to have himself

FIGURE 2.2 Alma in 1906 with her daughters, Maria and Anna.
"I still haven't got the right love."

examined as well. Blumenthal's verdict was anything but promising: "Well, this heart of yours is nothing to be proud of!" Doubtless Alma later dramatized that statement and thus gave the impression, at that moment, that her husband had heard his own death sentence: "And with that diagnosis the end of Mahler began."[78] Medically, this description is unjustified. Mahler traveled to Vienna on July 17 to have himself examined by the heart specialist Dr. Friedrich Kovacs, who determined a double-sided, compensated heart valve defect. This means the diagnosis was a far cry from a death sentence, because a heart defect is compensated when the organism has learned to counterbalance the defect. Kovacs nevertheless advised his patient to avoid any form of physical exertion, an instruction that had a damaging effect on a bundle of energy like Mahler. Giving up bicycling, swimming, and mountain hiking occasionally turned him into an obsessively self-observing hypochondriac. When Mahler later realized that these medical directives were what was making him ill, he returned to his old habits. For all this—and here many of Mahler's biographers are in agreement—the concurrence for the forty-seven-year-old man of little Maria's death with the heart defect diagnosis represented a turning point of existential dimensions. "It has left him a totally broken man," Bruno Walter wrote in mid-September to his parents. "On the outside, nobody notices anything different about him, but anyone who knows him knows that, on the inside, he is devastated." And Alma? "She seems to be bearing up more easily, with tears and philosophizing. I have no idea whatsoever how anybody could endure something like this."[79]

In 1920—a good thirteen years later—Alma once again concerned herself in her diary with that terrible summer of 1907. With a frankness people can only allow themselves in a diary, she recalls a scene that seems appalling against the background of the approaching but not yet foreseeable death of her daughter. Gustav Mahler and she, Alma, were once driving past their house and had observed Maria as she pressed "her endlessly beautiful dark curly head" against the windowpane. "Gustav lovingly waved up at her. Was it that? I didn't know, but suddenly I did know: this child must cease to be. And right now. Great God! Away with the thought! Away with this cursed thinking. But the child was dead a couple of months later."[80] The suspicion is horrifying: Was Alma really yearning for the death of her own daughter? Was Alma jealous of Maria? Worse yet, was the girl supposed to die because she was her father's pride and joy? Although we recoil at the implication of this thought, it is striking that Alma, when later revising her diary, wrote above the phrase "but suddenly I did know" the little word "wished." Besides this, it says a great deal that the

death of Alma and Gustav Mahler's daughter alienated them even more from one another. According to Alma's entries, Mahler intuitively smelled a rat: "He blamed me, without knowing it, for the death of the child."[81] Maria was buried at Maiernigg, and after Mahler's death her remains were transferred to Vienna, where she found her final resting place beside her father.

The Vienna Court Opera opened the new season on August 18, and so the Mahlers did not have much time to mourn together after the burial of their daughter, as Mahler was still officially on duty and had performances to conduct. On October 15, in a performance of *Fidelio*, he stood on the podium of the Court Opera for the last time. After that, he embarked on a concert tour to St. Petersburg and Helsinki, while Alma went off to take a cure on the Semmering Mountain. On their return in mid-November, only a scant four weeks remained to make travel preparations and take their leave. Mahler had promised Conried he would board a ship at the French port of Cherbourg on December 12. The departure from Vienna's Westbahnhof station became a triumphal event for the Mahlers. Some two hundred people showed up on the station platform before 8:30 on the morning of December 9, among them Arnold Schönberg, Alban Berg, Anton von Webern, Alfred Roller, the Molls, Gustav Klimt, Bruno Walter, and Arnold Rosé. "They were already standing there when we arrived, their hands full of flowers, their eyes full of tears, they came into our coupe and filled it with flowers, the seats, the floor, everything."[82] As the train began moving, Gustav Klimt said what many of them were thinking: "All over."[83]

IN THE NEW WORLD

After a two-day stay in Paris, Alma and Gustav Mahler began their eight-day sea voyage from Cherbourg to New York aboard the *Kaiserin Auguste Viktoria*. Heinrich Conried had booked his new conductor into the Hotel Majestic. The hotel, one of the best addresses in the city, was located directly on Central Park West near the corner of Seventy-Second Street and offered its guests every imaginable comfort. The Mahlers had a spacious suite on the eleventh floor at their disposal, even set up with two adjoining wings. Immediately on arrival, Mahler plunged euphorically into his work, met with Conried and other representatives of the Metropolitan Opera, and held his first rehearsal as early as December 23, while Alma explored the city. The practical street pattern, with numbered avenues and cross streets, made it easy for her to get oriented. In any case, she couldn't ask anybody the way, as she was unable to make herself

understood in English. To the end of her life Alma never acquired a good command of the language.

The initial enthusiasm for New York and life in a totally new environment, however, soon began to ebb and gave way to the monotony of everyday life. The first Christmas without Maria—little Anna had remained with her grandparents, the Molls, in Vienna—must have led to an emotional crisis. "Mahler didn't want to be reminded that it was Christmas, and I was abandoned and alone and wept uninterruptedly all day." An acquaintance of both Mahlers wanted to help by inviting them to his home. But there, too, they couldn't stand it very long: "A few actors and actresses, who came over after supper, frightened us away, because one of them, a depraved female, was called 'Putzi.'"[84] "Putzi" had of course been the nickname of their late daughter Maria. Alma's main problem in the first New York months—as so often in her life—was boredom. She who had, after all, come along just to be with her husband, had no idea what to do with herself and the world, spent whole days in bed and wept a lot—even for days on end, if we are to believe her. She blamed her condition on "heart weakness," which, however, could hardly have been the case with a woman twenty-eight years old. It was much more the feeling of inner emptiness, which must have been so agonizingly noticeable during her first stay in New York. Without her family, she was lonely and must have suffered from homesickness. On top of that, the Mahlers had very few social contacts at the beginning. Not until the end of the season did they make the acquaintance of Dr. Joseph Fraenkel, who was to become a close friend to them both. He had made a name for himself in Vienna as a neurologist and psychiatrist and had come to New York a few years before the Mahlers. Alma and Gustav took a liking to the sharp-witted, humorous, extravagant, and certainly also somewhat odd doctor. "Mahler was more and more taken, and ultimately so utterly captivated by him," Alma remembered, "that Fraenkel could have ordered him to do anything, and he would have done it without a word."[85] The fact that Fraenkel, who had been born in 1867, was to fall madly in love with Alma over the following years was the other side of the coin, which he kept to himself.

After Gustav Mahler had been able to taste his first great success in New York with a performance of Wagner's *Tristan* on January 1, 1908, events at the Met over the course of February and March came fast and furious. Shortly after Mahler's arrival Heinrich Conried had already been forced to give up his position as general manager for health reasons—that was the official explanation. His successor had previously been the director of La Scala in Milan, Giulio Gatti-Casazza, who brought along the conductor Arturo Toscanini.

While Mahler had gotten along splendidly with Conried, the situation then changed radically. Toscanini, like Mahler an ardent admirer of Richard Wagner's operas, did not want to be restricted to the Italian repertoire, but also wanted to leave his mark with Wagner performances. The collision of the two conductors—Mahler and Toscanini—was inevitable. Mahler realized quickly that his link with the Met would not be permanent and began thinking about what alternatives might be available. A new area of activity came within reach when a group of well-to-do New York ladies decided to found an orchestra for their city, one that could compete successfully with the renowned Boston Symphony Orchestra. The woman spearheading this effort, the wealthy Mrs. George R. Sheldon, a banker's wife, was convinced that Gustav Mahler was the one to take over the musical direction. It was planned that, as early as the autumn of 1908, a group made up of the best musicians in New York, with Mahler at their helm, would put on festive concerts in Carnegie Hall. Mahler's first stay in the New World thus ended with this promising prospect. The Mahlers looked forward to their trip home to Vienna and to seeing the family again. "We went away happily from Vienna," Alma wrote Margarete Hauptmann in mid-February 1908, "but I believe—we will be just as glad to return there."[86]

Hardly had they arrived back in Vienna when Alma went off with her mother in the spring of 1908 in quest for a new summer residence. In the wake of the horrible things that had happened the previous year, returning to Maiernigg would be out of the question—the house would be sold. In Alt-Schluderbach near Toblach (today Dobbiaco in northern Italy) in the Sexten Dolomites, they found a large farmhouse, the so-called Trenkerhof. Upstairs, vacation guests would find eleven rooms, two verandas, and two bathrooms at their disposal. This refuge suited their taste and was largely in keeping with Gustav Mahler's requirements: the Trenkerhof guaranteed a minimum of comfort, yet was located in an absolutely quiet corner of the earth. And not least, the enchanting countryside with its green meadows and bright larch and dark spruce forests invited long walks. Not far from their residence, Mahler, following his usual custom, had a small composing cottage set up, where in the following summers his late works—*Das Lied von der Erde*, the Ninth Symphony, and the fragment from the Tenth Symphony—were written. This vacation was decidedly productive for Mahler; his work on *Das Lied von der Erde* (*The Song of the Earth*) made great progress. To Alma's great pleasure, many guests found their way to Toblach. While, for a lover of quiet like Mahler, a bit too much hustle and bustle occasionally dominated the scene, Alma was happy to get together again

with old friends and acquaintances like the banker Paul Hammerschlag and the critic Julius Korngold.

When the Mahlers arrived back in New York on November 21, 1908, for their second season there, it was clear to Gustav that he would soon leave the Metropolitan Opera, not least because—just as he had feared—his collaboration with Arturo Toscanini had gotten off to a very bad start. The tempting plans to build a new orchestra for New York under Mahler's leadership, however, also had to be dropped, for lack of adequate funding. It was now decided to upgrade the already existing and rather insignificant orchestra of the New York Philharmonic Society with new musicians and then offer Mahler the music director's post. Despite the changes and the less attractive conditions, Mahler accepted the offer and mounted the podium of the New York Philharmonic for the first time on March 31. Mahler had taken his leave of the Met with a performance of *The Marriage of Figaro* five days previously.

After the end of the second season in New York, things went on uninterruptedly—in mid-April 1909, the Mahlers arrived in Paris, where preparations began on a performance of the Second Symphony, planned for the following year. In the city on the Seine they spent "days of wonderful peacefulness," as Alma recalled, and met friends such as Sophie and Paul Clemenceau. Carl Moll got the idea of commissioning the famous sculptor Auguste Rodin to make a bust of Mahler. As Mahler at first obviously showed no interest, Sophie Clemenceau claimed with no small measure of cunning that it had been Rodin's express wish to model the famous conductor. "Mahler believed it—with some misgivings—but he agreed to do it, which he would never have done under other circumstances, and the most wonderful sittings began."[87]

In contrast to the previous year, Mahler was now, in the spring and summer of 1909, in a considerably better mood. He looked optimistically to the future, enthusiastically contemplated his new task, and felt generally freer and younger, opening up again to life. Only Alma was in a miserable state. In her book of memoirs she hints darkly: "Back then I was highly nervous, and when I had returned to Vienna . . . a stay in Levico was prescribed for me."[88] The spa near Trento was famous for its hot and sulfurous springs, which promised help for people with skin diseases, nervous disorders, and so-called gynecological problems. Alma was probably recovering there from a miscarriage or an abortion, the particulars of which are impossible to reconstruct. As far back as March, Mahler had written a letter full of allusions from New York to his father-in-law Carl Moll: "Alma is very well—she must have written you already about her condition. She has been liberated from her burden. This time,

however, she is sorry about it herself."[89] According to this—the words "this time" give it away—we can take it for granted that this was not the first time Alma had lost a child. While Alma had all kinds of diversions in New York and Paris, she now experienced her solitude as especially painful and gave herself over to her depressive conditions in Levico. "In deep melancholy, I sat on my balcony for nights on end, looked down tearfully at the jolly, brightly dressed crowd, whose laughter hurt me, yearned madly for something, for love, for life, for a window out of this ice-cold, glacial atmosphere."[90]

Doubtlessly in this summer of 1909 Alma Mahler's alienation from her husband had hit a new low point. When Gustav Mahler came over from To-blach for a get-together in Trento, she was quite horrified by his appearance: "Just before his departure, when he wanted to have himself made particularly good-looking, the hairdresser in Toblach simply cut off all his hair. He was reading the newspaper and didn't notice. He was unrecognizably ugly, like a Bagnonard prisoner without the two prominent sideburns, which gave a bet-ter formation to his incredibly long, haggard face. I couldn't get used to it, nor could I suppress my feeling of alienation, and so he went sorrowfully away two days later."[91] Alma couldn't take this little *malheur* with humor, nor ap-preciate the attention Mahler was showing her—after all, he *had* gone to the hairdresser especially for her—a reaction that bode ill for the future. It is ques-tionable whether Mahler had deeper thoughts about his wife's condition. Her constant need to take cures, her frequent indispositions, the more and more extreme mood swings, and not least her increased indulgence in alcohol were all signs of a genuine crisis. Alma's chronic drinking problem certainly dates to this time. If Mahler had been aware of the seriousness of the situation, it was at least not reflected in his letters. Possibly husband and wife had by this time already put so much inner distance between them that Mahler took no interest in Alma's problems and silently dismissed them as moodiness. Mahler's old friends, however, first and foremost Guido Adler, regarded Alma's behavior as nothing other than blatant egotism. Adler summed up his criticism around the end of 1909 in a letter that has not been preserved; we can, however, as-sume from Mahler's sharp reply, written on New Year's Day 1910, that he stood behind his wife. "You can take my word for it that she has nothing else on her mind apart from my well-being." And he goes on: "When did you notice any wastefulness or egotism in her?" Mahler's assurance that Alma was "a valiant, loyal comrade whose spirit forms an integral part of my creativity" and a "wise, circumspect household administrator"[92] for him nevertheless sounds oddly stilted and almost like a business executive commending a staff

member. Probably Mahler was not all that convinced of what he had written in the letter, because he seems never to have sent it. Alma found the original among his papers after his death.

Back to the year 1909: In mid-October before the Mahlers boarded the ship in Cherbourg for their third trip to New York, they had cleared out the apartment on Auenbruggergasse. It was foreseeable that, in the future as well, they would be spending the summer months in Toblach, and in Vienna they could occupy quarters in the home of the parents-in-law. "I packed all the furniture and books, and all our movable possessions wandered into the warehouse."[93] In New York Mahler plunged zealously into his first season as chief conductor of the newly reconstituted New York Philharmonic Orchestra. Although around half the musicians had been replaced, Mahler was still not satisfied. He wrote to Bruno Walter in mid-December: "My orchestra here is a real American orchestra—talentless and phlegmatic. One stands at the short end of the lever." But he found warm words for the audience: "The audience here is very kind and, relatively speaking, more decent than the one in Vienna. They listen attentively and appreciatively to the music."[94] It is no wonder that he did not see his future in America—obviously after his experiences in New York he only wanted to earn enough money to retire somewhere near Vienna.

THE SUMMER OF 1910

On April 12, 1910, the Mahlers arrived in Paris from Cherbourg. Only five days later, Gustav Mahler was to conduct the long-planned performance of the Second Symphony at the Théâtre du Châtelet, in addition to which there were two concerts in Rome scheduled for the end of April (a third was canceled because of the poor quality of the orchestra). In Vienna, where they arrived on May 3, there would hardly be any respite. The world première of the Eighth Symphony was scheduled for September 12 in Munich. Until then, with the help of many hands, the orchestra and choruses as well as the printing of the chorus parts and the piano-vocal scores all had to be prepared. Throughout May and June, Mahler hurried restlessly back and forth between Vienna, Munich, and Leipzig, and held individual rehearsals and conferences with musicians and soloists. In view of these grueling activities, Alma was at the end of her strength, even though she seemed to have enjoyed her winter in New York: "I was very ill and just couldn't go on—totally exhausted from the constant hounding of such a gigantic motor as Mahler's spirit demands."[95] A doctor recommended that she take a cure for at least six weeks in Tobelbad, where he felt she could

heal body and mind. Back then, the little town in Styria, a few kilometers south of Graz, had become very fashionable, not least because the Wildbad Sanatorium there had introduced the holistic approach of the Dresden naturopathic physician Dr. Heinrich Lahmann. It was the simple things that determined the therapeutic program in Tobelbad: a balanced diet, air, steam, and sunbaths, physical exercise and calisthenics, as well as the health-giving powers of the water. Mahler brought Alma, their barely six-year-old Anna, and the English governess on June 1, 1910, to Tobelbad and then returned to the capital the next day. Although Alma had company, she felt "so lonely and melancholy that the head of the clinic, concerned over my condition, introduced me to some young people, who were to accompany me on my walks."[96]

Even if the events in the summer of 1910 are subjectively distorted or completely omitted in Alma's accounts, we can gain a fairly precise image of what happened in Tobelbad and Toblach from the letters still in existence. First of all, there is the thirty-year-old Alma, unsatisfied in many respects, who, after a nine-year marriage by the side of a genius who lives predominantly for music, suffers from interior and exterior lack of fulfillment. Her relationship with Mahler, despite some occasional bright spots, has descended to a state of more or less indifferent coexistence, and now almost all that remains—in this respect a typical connection for bourgeois married couples at the dawn of the twentieth century—simply serves to put a good face on everything for the outside world. There is virtually no further hint of erotic excitement or sexual satisfaction after, presumably, several miscarriages or abortions, plus Gustav Mahler's disappointed turning away. On photographs from that time, Alma's appearance as a corpulent, rapidly aging matron forms an odd contrast with her husband, who, despite his heart condition and their considerable age difference, still looks younger than she does. And now the wife, disappointed in so many different ways, comes upon the twenty-seven-year-old German architect Walter Gropius, who, after recently completing his studies with the famous Peter Behrens in his hometown of Berlin, has gone freelance and is likewise seeking rehabilitation in Tobelbad.[97] When Alma meets the tall and extremely attractive Gropius on June 4, 1910, she immediately feels charmed by his manly appearance. And he must also have been fascinated by her radiance as a cosmopolitan and experienced lady. A short time later they become lovers.

Gustav Mahler seemed to have had no inkling of all this. From Vienna, Leipzig, and Munich, he untiringly sent letters and telegrams to Tobelbad, so that Alma—as usual—could have a share in his daily life. Full of enthusiasm, he painted a picture of their life together after the coming final season in New

York, about the prospect of being liberated from the base necessity of earning filthy lucre. And for Alma's upcoming birthday he contacted the renowned Viennese architect and designer Josef Hoffmann through his father-in-law, Carl Moll, and commissioned him to create a tiara. As letters from his wife began arriving less and less frequently and even occasionally stopped coming altogether, Mahler got nervous. In a letter from June 21, he asked her flat out: "Are you hiding something from me? Because I always think I can read something between the lines."[98] To all appearances, Alma was not able to calm Mahler, because five days later, he broached the subject again in a telegram: "Why no news I'm very concerned please reply by express."[99] Mahler clearly suspected that something had happened. He wrote to his mother-in-law: "I am so disturbed by the letters from Almschi, which have such a peculiar tone to them. What is going on there?"[100] Worried sick, Mahler traveled on June 30 from Vienna to Tobelbad, where he spent two days with his wife and child. It is not known what happened at this meeting. Apparently Alma was able to mollify her husband and allay his misgivings, as a letter from Mahler to Anna Moll attests: "Just a few words, to tell you I found Almschi much more refreshed and solid, and I am firmly convinced that her cure here is beginning to have a very positive effect on her."[101]

After Mahler's departure—on July 4, 1910, he moved into the Trenkerhof, alone for the time being, to get started there with his longed-for work on the Tenth Symphony, his final composition—Alma continued her clandestine affair with Gropius. When she arrived in Toblach in mid-July, the two lovers were firmly determined to persist in their relationship with great caution—after all, Mahler mustn't be allowed to find out about all of this. Toward this end they had arranged for Gropius to send his letters to general delivery in Toblach, which functioned smoothly for a while—until July 29, 1910. On that Friday, a catastrophe erupted. Mahler was sitting at the piano as usual, checking the mail. Among the letters the postman had delivered to the Trenkerhof that day was one for Alma from Walter Gropius; however, it was addressed to "Herr Direktor Mahler." This letter, which has not been preserved, must have been full of hot declarations of love and intimate allusions. After a couple of lines, Mahler had had enough, as Alma remembered: "He called with a cracked voice: 'What is this?' and handed me the letter."[102] In total consternation, two days later Alma wrote to Gropius: "As this came out quasi by coincidence and not through an open confession on my side—he has lost all faith and trust in me! . . . Bear in mind—the letter in which you openly write about all the secrets of our nights of love—was addressed to: Mr. Gustav Mahler—Toblach—

Tyrol. Did you really want that?"[103] To this day, this incorrect addressing of the letter remains a mystery. Had Gropius intentionally sent the letter to Gustav Mahler, possibly to provoke a decision? Or was it, as Gropius later claimed to the Mahler scholar Henry-Louis de La Grange, just an "oversight"?

Alma was rattled, especially as Mahler had hurled no accusations at her—quite the contrary, it seems that, presumably for the first time in years, he actually listened to her attentively: "What happened now is unutterable! Finally I was allowed to tell him everything: how for years I had longed for his love, and how he, monstrously obsessed with his mission, simply overlooked me."[104] Even harder to take than the sudden discovery of the love affair was the nature of her accusations, which plunged Mahler into deep despair. He was afraid he might lose his wife. And Alma found herself fundamentally in a hopeless situation. On the one hand, in Walter Gropius she had found a man who gave her, besides passionate nights and great infatuation, the attention she had so long had to do without and promised her future happiness together. On the other hand she couldn't bring herself to leave Gustav Mahler. It was pity ("Gustav is like a sick, wonderful child") above all else that bound her to her husband, feeling as she certainly did that her "remaining [with him]—despite everything that has happened—will give him life, and leaving him—death."[105] Alma had not found a clear solution to this dilemma.

As if to make the embarrassing confusion of all parties complete, Walter Gropius came up with the absurd idea of justifying himself to Mahler. Alma later claimed that she did not know about this plan and had just happened to see Gropius standing under a bridge in Toblach, whereupon Mahler agreed to hear him. This, however, is a flat distortion of what really happened. The truth is that Gropius had told Alma he was coming.[106] What had Gropius expected would come of this bizarre meeting? Did he really think he could ask Gustav Mahler for his wife's hand in marriage? According to Alma's recollections, Mahler retired to his room and left the two of them alone: "Mahler walked up and down in the room. There were two candles burning on his desk. He read the Holy Scripture. He said: 'Whatever you do will be rightly done.' 'Make your decision,' but I really had no choice!"[107] When Alma later claimed that in that night she had made her decision in favor of Gustav Mahler—out of a sense of responsibility—and forswore a happy future with Walter Gropius, this was a tactical escape move to extricate herself from the confusion and total disorientation of the situation. Basically what she did was to avoid making a clear decision—or, in other words, she decided in favor of both men and thus, in a practical sense, selected what may have been difficult and nerve-racking,

yet, in view of her unstable emotional household, was still the favorable variation. She gave her despondent and distraught husband the deceptive feeling that he could win her back, and with her lover she let no doubt arise about whom her heart belonged to. The letters Alma wrote on those summer days to Gropius are unambiguous: "You must know that I love you—that you are my only thought both day and night—that I yearn for nothing else for my future than to be and to remain yours." She even urged him to be hardworking and advance his career energetically, "because the more you accomplish, the more you will be mine!!"[108] And on August 11, she said: "regard yourself as my fiancé."[109]

An especially questionable role would be assigned Alma's mother, who traveled to Toblach on August 9. Mahler was very fond of his parents-in-law —after all, they were part of his generation. While he valued Carl Moll as a conversation partner and adviser, he felt a profound affection for his mother-in-law. Mahler clearly trusted "dearest Mama" boundlessly—a mistake, as it would later turn out. Anna Moll, who had probably already been filled in by Alma on the whole situation back in Tobelbad, was, as far as marital infidelity was concerned, an experienced woman. She herself had cheated on Emil Jakob Schindler for years with Carl Moll, and it almost seems she was now giving the equivalent advice to her daughter. In any case, she had no qualms about comforting her son-in-law while at the same time writing heartfelt letters to his rival, combined with the hope he might meanwhile make her child happy. Anna's letter to "Darling Walter"—"You are so close to my heart, I cannot find any other salutation"[110]—leaves no doubt as to her playing both ends against the middle: "One thing is certain: for the time being Alma cannot leave Gustav," she wrote in mid-August, appealing to Gropius's conscience. "That is out of the question! You couldn't possibly be happy after that. So what to do? You must find the power in yourselves and be strong! Both of you are still so very young, you can still wait!" Sometimes the letters took on the tone of secretly delivered communiqués: "We are going to have to handle this letter writing somewhat differently, Gustav always suffers so terribly when a letter from you arrives—he always deals with the mail himself. That is why you must not write directly to me in Toblach either—it is a coincidence that he didn't recognize your handwriting yesterday." It was clear to whom her sympathies belonged: "How much I feel for you and Alma—how much I suffer with you, I cannot say; you just have to feel it."[111] In view of entreaties of this kind— words intended as comfort ("You can still wait!") sound, considering what we know today about the end of this story, somewhat cynically conciliatory—it

appears as though Mahler's own family in that summer of 1910 was just wait-
ing for his end. There is no satisfactory answer to the question of how much
Alma's infidelity and the terrible August days might really have contributed
to his death in May 1911. We can, however, take it for granted that the severe
strep throat Mahler had caught from Anna's governess during that period
struck a man standing under a very heavy, primarily psychological, burden.
Regardless of these medical speculations, Alma's later confession causes us to
stop and think, even now: "Gustav's death, too—I wanted it," she wrote in July
1920 in her diary. "I once loved another man, and he was the wall I couldn't
climb over."[112]

Gustav Mahler was, by and large, clueless and full of hope about his mar-
riage. He promptly showered his wife with pathetic evidence of his love. He
dedicated the Eighth Symphony, the printed edition of which he had been pre-
paring during those weeks of crisis, to Alma. And as if motivated by a guilty
conscience, he suddenly took an interest in some of her youthful compositions
and even suggested some joint rewriting.[113] Still in that same year he had her five
songs printed and given world premières in Vienna and New York. And seem-
ingly minor matters in their everyday lives together underwent a change. Now
the doors were to remain open between their adjoining bedrooms, because he
wanted to hear Alma breathing. He frequently stood like a benevolent spirit
over his wife's bed at night, to watch over her as she slept. And often Mahler
lay on the floor of his composing cottage weeping bitterly, Alma remembered,
when she came to fetch him for lunch.[114] She herself took all this in not without
a sense of inner satisfaction, as she wrote to Gropius in mid-August: "Now, for
the first time, I will really have something from G.—he wants to read difficult
works with me—he's already making music. In short, the man is a different
person—because of these few days of suffering ... wanting to live just for me,
abandoning his 'paper' life (as he calls his strictly regimented existence as a
musician)—even though he has just created an entire symphony—with all
the horrors of this time in it."[115] In these lines it is striking that Alma not only
exonerates herself by downplaying what was definitely the most difficult crisis
in Mahler's life as a "few days of suffering," but also through the underlying
satisfaction she felt watching her husband unsuccessfully begging for her love.
Perhaps Mahler suspected that his struggle didn't stand a chance. The hand-
written score of his Tenth Symphony, which came about in those summer
months, is peppered with any number of marginal notes written as if in a fit
of insanity. In this respect, Alma's dictum about the "horrors of this time" hits
the nail on the head.[116] Comments like: "Have mercy! Oh, God! Oh, God! Why

hast Thou forsaken me! Thy will be done" and also "The Devil is dancing it with me! Madness, take hold of me, the accursed one! Destroy me, make me forget that I exist!" describe his despair, which bordered on madness. Almost every day he wrote Alma little notes begging her for deliverance through her love. "Come, banish the dark spirits, they have me in their clutches, they hurl me to the ground. Stay with me, my staff, come soon today, so that I can rise up again. I lie prostrate, and I wait and ask silently if I can be redeemed, or if I am eternally damned!"[117] At another place he says: "I feel trapped by carnal lust, and eternal slavery is my desire!"[118]

The effusive declarations of love from a man whom she had experienced in the course of their marriage only as an example of discipline and asceticism must have seemed strange to Alma. She even feared, as she confessed to Gropius, that Mahler might develop a mental illness, "because this idolatrous love and adoration—which he is now offering me—can no longer be called normal."[119] Although her fears were certainly exaggerated, it is evident that Mahler was close to a nervous breakdown before the end of August 1910. And after he had caught a severe case of strep throat from the governess, on the night of August 23, he finally suffered "a collapse. From 3:00 a.m. on, Mama and I . . . were by his side almost fearing the worst."[120] Help was urgently needed. We no longer have any way of knowing whether it was the Viennese psychoanalyst Richard Nepalleck, a distant relative of Alma's, or Bruno Walter who advised Mahler to consult Sigmund Freud. In any case, despite his violent angina, he set off on August 25 to the Dutch city of Leiden, to visit Freud, who was vacationing there. Freud himself reported in early 1935 on his afternoon with Gustav Mahler: "He felt his visit was necessary because his wife was rebelling at the time over the turning away of his libido for her. On a most interesting stroll, we went through his life and uncovered his conditions for loving, and most especially his Mary Complex. I was quite impressed with the man's brilliant ability to understand things. No light fell on the symptomatic façade of his obsessive neurosis. It was as if someone were digging a single deep shaft through a perplexing edifice."[121] In her memoirs, Alma stresses another nuance; allegedly Freud had "confronted" Mahler "with the most violent reproach: 'How can anyone in such a situation shackle a young woman to himself?' he asked. Finally he said: 'I know your wife. She loved her father and can only seek out and love that type of man. Your age, which you are so afraid of, is just exactly what makes you attractive to your wife.'"[122] There is, however, no indication that Sigmund Freud and Alma Mahler ever met. It is highly unlikely that Freud ever made the alleged statement that he knew Alma

at least well enough that he was able to comment about her close ties with Emil Jakob Schindler. Beyond this, it is hardly imaginable that Freud ever made "the most violent accusations" to a patient like Mahler, whom he had only analyzed during an approximately four-hour walk through the Dutch provincial capital. However the course of the meeting with Freud may have run, at least their talk seems to have helped Mahler somewhat. "Conversation interesting," he cabled to Alma on August 27. "A straw has turned into a beam."[123]

When he returned from Leiden, Mahler spent a few days in Toblach before departing on September 3 for Munich to conduct the final rehearsals for the world première of the Eighth Symphony. Suddenly he found himself having to pay the price for not allowing the angina to heal completely; Mahler suffered a severe relapse, which knocked him flat. He immediately went to bed, determined not to endanger the concerts under any circumstances, sent for a doctor, and spent several hours taking a sweat cure, which already had helped him in previous cases of feverish infection. Only partially restored to health, he was able to begin rehearsal work on September 5. Friends who met him during this period were horrified at his condition: he looked pale, emaciated, and completely worn out. Alma arrived in Munich on September 6. "Mahler had taken a handsome apartment in the Hotel Continental, all the rooms had been adorned with countless roses."[124] There wasn't much time left for the couple to spend together, which must, however, have been just fine with Alma. While her husband scurried from rehearsal to rehearsal, she secretly made a date with Gropius in his hotel. Once again, Anna Moll served as her daughter's accomplice. Back in August, she had written to Gropius: "Early September a get-together will be possible, but I hardly think any sooner—I will help wherever I can. Just keep your head up—you have a very beautiful goal before you."[125]

The world première of the Eighth Symphony on September 12 and the repeat concert the following day were triumphant successes for Mahler. As the final note of the work faded away, the enthusiastic applause went on and on; it is said to have lasted over a half hour. After the performances in Munich the Mahlers went to Vienna, where they moved in with Carl and Anna Moll. There was only a good four weeks' time before their departure for New York, in which Mahler would need to review the galley proofs of the Eighth Symphony and prepare the new—his last—season. Finally, with the help of his father-in-law, he realized a plan he had been harboring for a long time, to purchase a property outside Vienna, where he could have a kind of retirement home built. They found what they were looking for in Breitenstein near the Semmering:

"Mahler had listened, Moll had chosen it," Anna Mahler remembered. "He said this is the air for him, and they bought the property."[126] Alma did not have a vacation home constructed there until two years after Mahler's death—the so-called Villa Mahler that was her second home until 1938.

While Alma outwardly played the loyal, caring wife by her husband's side, in letters to her lover she painted a picture of their future together: "My Walter, I want a child from you," she rhapsodized on September 19, "and I want to nurture and cherish it—until the day appears when we, without regret, with security and calm—can smile as we sink into one another's arms forever."[127] At the extreme point of her alienation from Mahler, Alma finally made a decision, which could not have been more characteristic: on October 8, 1910, she had her six-year-old daughter converted to the Protestant religion—purportedly because of a Catholic friend said to be horribly despondent because she was unable to get a divorce. Anna Mahler wrote: "The next day, Mommy took me by the hand, and I converted to Protestantism. How clever! That's really nice, isn't it?"[128] Of course little Anna didn't understand that Mama's ominous friend had probably never existed, and even more, that her mother had probably hidden herself behind that unfortunate married woman. Alma's need to spare her daughter her own "fate" was concurrently her admission that she had definitely finished with Mahler. There were other reasons, however, why a divorce from Gustav Mahler was also out of the question for Alma: not only had she no desire to have her marital infidelities come to light in open court, but also, as a divorced woman, she would perforce have lost her status. Apart from the fact that divorced women were marginalized and occasionally treated like lepers in the upper-middle-class circles to which Alma Mahler belonged, the issue was certainly also money. At least since his engagements in America, Mahler was a wealthy man, who could guarantee his wife a secure, comfortable life. Were she now to seek the dissolution of the marriage, she would doubtless lose her inheritance rights to his estate, as well as any pension claims. And for whom would she be relinquishing her famous husband and her upscale comfort? At this time, Walter Gropius was still a largely unknown architect. Alma's already quoted advance—"the more you are and accomplish, the more you will mean to me"—sounds unmistakable against this background. In other words, there was no chance of a divorce. At least officially, Alma would have to stay with her husband.

Shortly before their departure for New York, full of sadness, Alma thought back on the thrilling time in Munich, on the romantic hours she had spent with Walter Gropius. Now—four weeks later—the two lovers would have to

face a long separation. Alma put all her imagination and energy to work trying to come up with some way she might get together with Gropius one more time before the ocean crossing. Two days before Mahler traveled to Berlin to say good-bye to his fans there, Alma left Vienna for Paris, also to meet with friends, as it was officially stated. In actual fact, she had set in motion some downright conspiratorial tactics to organize another tête-à-tête with her lover: "I'll be leaving here on Friday the 14th of October at 11:55 a.m. on the Orient Express. My coupé bed No. 13 is in the IInd car—sleeping car. I have not yet arrived in the city, nor do I know your answer yet. I am writing this hopefully into the blue. I would advise you (if you are coming) to have your sleeping car ticket issued to the name Walter Groh from Berlin—as G. [Gustav] is traveling 2 days later and might perhaps ask to be shown the list."[129] The plan worked.

FAREWELL

On October 25, 1910, the Mahlers arrived in New York aboard the *Kaiser Wilhelm II*. Gustav Mahler immediately immersed himself in his work—after all, by the end of the season, he would have conducted an enormous program, with sixty-five concerts to cope with. Just two days after their arrival, Alma wrote Gropius: "Don't waste your precious youth, which belongs to me.—I got totally dizzy when I looked at this again and felt how eternally happy this and this alone has made me. I love you! So certainly, so legitimately I'd like to say—as if I were your wife—were on a trip—and still—I would wait for you." And finally: "Keep healthy for me.—You know why."[130] Alma's yearning must have been enormous the more heavily the separation weighed on her mind. Postal delivery times of a good fourteen days made the distance between Europe and the New World appear virtually insurmountable. And once again it was Anna Moll who acted as go-between and gave the lovers hope. In mid-November she told her future son-in-law: "The saddest part of all this is that absolutely nobody whatever can do anything at all, not even now,—we must leave things up to time, and I firmly believe that the love you two have for each other will outlast everything."[131] In view of the fact that Gustav Mahler's end was near—he had just over a half year left to live—lines like these, which flirt with the possibility of his demise, come across as horrifying in their cold-bloodedness. In Anna Moll's favor, however, we must bear in mind that at the time Mahler's death was not in the least foreseeable. First, Alma was unwell. "I'm feeling just fine," Mahler wrote on November 21 to his confidant Emil Freund; "I've got a million things to do, and I'm coping very well with all

the work. Alma and Gucki, unfortunately, are struggling with their health."[132] Probably mother and daughter had caught a nasty cold in this extremely frigid winter, from which they, however, recovered by Christmas. To Alma's amazement, her husband insisted on being the one to buy the presents that year. On Christmas Eve, he and little Anna decorated the living room: "After a while the child came and asked for a lace tablecloth for Papa. I was surprised, but I gave her what she had asked for. All of a sudden, the door opened, and father and daughter invited me to follow them arm in arm."[133] In sharp contrast to his usual frugality, he gave Alma gift certificates for an opulent shopping spree, as well as for a solitaire valued at $1,000—luxury articles, which he basically regarded as superfluous. All in all, in the final winter of his life, Gustav Mahler seemed like a changed man. Not only did he shower Alma with evidence of his love; he also looked after his little daughter with greater intensity than before. Mahler and Alma often went for walks in snow-covered Central Park and occasionally even had snowball fights.

On the morning of February 20, 1911, after having conducted a concert the day before at Carnegie Hall featuring works by Weber, Beethoven, Mendelssohn, and Liszt, Gustav Mahler woke up with a sore throat and fever. At first it all looked like a common angina, something that had often afflicted Mahler before. His friend and physician, Joseph Fraenkel, asked him to cancel the concert planned for the following evening, which Mahler, however, vehemently refused to do. He had often conducted with fever, he replied to the doctor, who found himself forced to relent. During the performance Mahler got weaker and weaker, complained of a headache and chills, but kept on conducting. Over the next couple of days his condition improved, and he seemed to have recovered from the attack, until the fever returned with unprecedented severity. Fraenkel, who was uneasy over the course of this illness, arranged for Dr. Emanuel Libman, a specialist in cardiac conditions, to examine his patient. The diagnosis was quickly established: subacute endocarditic lenta—a slowly progressing inflammation of the inner surface of the heart. But not until a blood culture had been made was this confirmed with horrible certainty. Dr. George Baehr, who had done this examination, remembered: "After an incubation period of four to five days had passed, we could recognize a large number of bacteria colonies on the Petri dishes, and all the bouillon containers had a pure culture of those organisms, which can be identified as streptococcus viridans."[134] With that, Gustav Mahler's torturous fate was sealed: the streptococci attack the already damaged heart, and as the heart valves increasingly malfunction, the end of the process is death caused by multiple organ failure. Mahler insisted on

finding out the whole truth, which, however, by all appearances was withheld from him. The doctors rather gave the patient the deceptive impression something could be done to heal his illness. The numerous blood tests and Collargol enemas to which Mahler was subjected were thus nothing but illusory therapy. Penicillin, that wonder drug, might have helped, but it would not be discovered until 1928.

"Gustav is feeling a little better," Alma wrote to Walter Gropius on March 25. "It is a recurring endocarditis—in other words a severe illness and very dangerous for a heart like his." Bearing in mind Mahler's alarming condition, Alma's following encouragements come across as unpardonable tastelessness: "My dear Walter—I implore you, you must also be a completely healthy, strong and physically young man, so that we, when we see each other again, can have endless joy in one another and our love." And as if that weren't enough: "I want you!!! But you?—Do you want me, too? Your bride, Alma."[135] At about the same time, Anna Moll arrived in New York to help her daughter care for her mortally ill husband. Although they had little hope, the doctors urged Mahler to consult European bacteriologists such as the famous André Chantemesse at the Institut Pasteur in Paris. Perhaps this was also just a subterfuge to try and get Mahler back to Europe while he was still able to travel. On April 8, the Mahlers and Anna Moll along with the English governess left New York harbor aboard the Amerika. The crossing must have been difficult for all of them: "On board, he got up almost every day, and we would guide him, which was more like carrying him, up to the sundeck, where the captain had a large space set apart for Mahler, where none of the other passengers would be able to see him."[136] After their arrival in Cherbourg, Mahler was laboriously hoisted through the windows into a railroad coupé. Carl Moll, who had hurried over from Vienna, got on at Brest. In a state of total physical and mental exhaustion, the family moved into the Hotel Élysée in Paris on April 17. There Mahler's sheer invincible will came to the fore one last time. "I woke up in the morning, it was seven o'clock. Mahler was sitting on the balcony. Completely dressed and shaven and ringing for breakfast."[137] The scene was eerie: only shortly before Mahler was in no condition to eat unaided; now he was even ordering himself and his family to make an excursion to the Bois de Boulogne. But a short time later, he collapsed. André Chantemesse had Mahler transferred to a sanatorium, where he examined the famous patient and did a blood culture. The bacteriologist could simply confirm the diagnosis that had been made by his colleague in New York. A serum therapy had no effect; Mahler's condition continued getting worse from one hour to the next. He

FIGURE 2.3 Auguste Rodin's bust of Gustav Mahler
in the foyer of the Vienna State Opera.

begged his father-in-law for poison, because he could no longer endure the headaches.[138] In her helplessness, on May 11, Alma sent for the Viennese internist Franz Chvostek, who certainly couldn't help, but who cheered Mahler up with his jovial manner. In a one-on-one conversation he urged Alma to have her husband brought back to Vienna as quickly as possible while he could still be transported. They hastily packed and managed to catch the night train. The return trip was like that of a moribund king. At each intermediate stop reporters walked up to the train to inquire about Mahler's condition. Medical bulletins were cabled to Vienna and printed by the newspapers there enriched with sentimental anecdotes. The dying became a public event. On the evening of May 12, the Mahler cortège reached the Vienna Westbahnhof, continuing on from there to the Sanatorium Loew. Mahler was still conscious and was happy to see the copious baskets and bouquets of flowers his admirers had left for him at the clinic.

Gustav Mahler must have suffered horribly—the now beginning final phase of the death struggle lasted for six long days. Arnold Berliner came from Berlin and bade farewell to his friend, who kept losing consciousness. On May 14 he was afflicted with a lung infection, and on May 17 he fell into a coma. His eyes expanded to giant size, a sardonic smile played eerily across Mahler's emaciated face, and his fingers trembled on the bedcovers. The last hours were terrible: while a hurricane raged outside, torrential rains poured down, and the world seemed to be coming to an end, the death rattle began. Alma was not allowed to remain with her husband and was sent to an adjoining room. On May 18, 1911, shortly after 11 p.m., all the gasping suddenly fell silent—Gustav Mahler was dead.

3

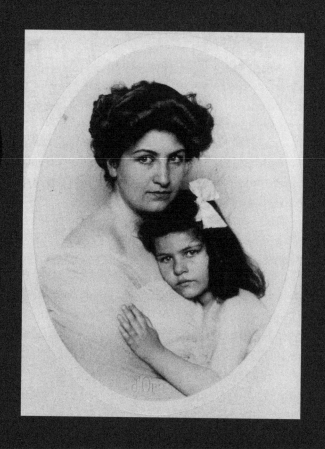

Excesses

1911 – 1915

YOUNG, RICH—AND WIDOWED

When, on the afternoon of May 22, 1911, some five hundred mourners gathered at the small cemetery in Grinzing to pay their last respects to Gustav Mahler, Alma lay sick in bed. "My lungs were afflicted—I was seriously ill," she remembered later; "I wanted to follow him into the grave!"[1] In fact she was not at all well; after all the stresses she had been through, it was no wonder. While just a few months earlier, freedom had been her most ardent desire, now she didn't know what to do with it. She was despondent and disoriented and had to admit that Mahler's death had been a bitter loss for her after all. She initially saw the fact that he had died on Walter Gropius's twenty-eighth birthday, of all days, as a harbinger of destiny and a hopeful sign toward the future. But even though there was actually nothing that could separate the two of them—Alma and Gropius—anymore, they soon discovered some discords they hadn't noticed before now intruding on their relationship. In this connection, Alma speaks vaguely of a long "period of mental and emotional anguish,"[2] which must have been a reference to her guilty conscience over having caused Mahler so much suffering during the last year of his life. The past was catching up with Alma Mahler and Walter Gropius: they were bound together by a secret, which now obviously prevented them from making their relationship official after Alma's mourning period had come to an end. Beyond this, Gropius had been in an oddly indecisive mood since the death of his father in mid-February 1911. He sometimes felt powerless, despondent, if not downright depressive. This was why the situation was tense in August 1911 when Gropius and Alma met again in Vienna for the first time in almost a year. When Alma actually told her lover that she had not only selflessly cared for her mortally ill husband, but had also been so unselfish that she had even accommodated Mahler's alleged need for intimacy on his deathbed—a rumor still making the rounds to this day[3]—Gropius completely lost control. Whatever bedroom gymnastics had taken place, Gropius could not understand it. It was an unbearable thought for

(*previous page*)
FIGURE 3.1 Alma and Anna Mahler, circa 1912.

him that Alma—his "bride"—could again fulfill her so-called matrimonial duties in the final year of her husband's life. Still in his Vienna hotel room, he wrote her a reproachful letter: "I have come to regard my sense of chastity as something so incredibly strong—it stands my hair on end when I think of this horrible business, I hate it for you and me, and I know with all certainty that I have to be true to you for years. Yet this damnation is not the worst thing for men, but rather that the enthusiasm, the belief in myself, has been taken away from me." He felt cheated, used, and, degraded to the status of an eternal lover —a betrayed traitor. "The only consolation I can try to cling to is that I have helped two magnificent human beings like yourselves along in your lives."[4] That already sounded like a letter of farewell. A good four weeks later, this issue still dominated Gropius's thoughts. Since leaving Vienna, he let Alma know, "such a sense of burning shame has arisen in me, one that tells me to avoid you."[5] He summarily canceled a reunion planned for the end of September 1911 in Berlin, and we get the impression that he was intentionally avoiding Alma.

And Alma? "I, however, built my inner independence back up," an entry says cheerily in the diary she had already edited for publication. How she really reacted to Gropius's rejection cannot be reconstructed. "Now I was alone—and without my suspecting it, life lay temptingly before me."[6] After her unhappy and restrictive marriage with Gustav Mahler, she was enjoying—in her own eyes, understandably—her new freedom. And possibly the distance Gropius was showing toward her may have suited her just fine in her new situation: she was only thirty-two, extraordinarily attractive, and the widow's pension from the Court Opera plus her inheritance from Mahler had supplied her with a sizable fortune. When the relationship with Gropius threatened to get too complicated, it was old and new acquaintanceships with men that reawakened Alma's joy for life. She did continue to maintain contact with him, albeit across the distance between Vienna and Berlin, while also delighting in her virtuosity at noncommittal flirtation.

One of the first men to step briefly into Alma's field of vision in the autumn of 1911 was the Austrian composer Franz Schreker. "He didn't play a role in my life," she wrote years later. "I walked a short way by his side and left him at the right time." Perhaps this had something to do with the fact that she couldn't make heads or tails of his music ("too much and often cheap");[7] the one-year-older Schreker was, at least for Alma, nothing more than an entertaining fling. It was pretty much the same story with Joseph Fraenkel, Mahler's erstwhile physician and friend in New York. "After Mahler's death he came to Vienna and wanted to marry me after a suitable mourning period, because he was

very much in love with me. But I didn't want to bind myself to him." Alma left the readers of her autobiography in the dark over the reasons for her lack of interest; in her diary, however, she took an unequivocal stand: "Fraenkel was a hero in America, a great, famous doctor, President of the Neurological Society, etc., etc.—in Europe a poor, sickly, elderly gnome, downright unheroic and only concerned with his severe intestinal illness."[8] Obviously Alma had had enough of sick men; her memories of Gustav Mahler wasting away were too fresh. When she describes Fraenkel as "unheroic" anyway and presents him as a pitiful individual, she shows how much, in this phase of her life, she felt attracted to strong men, to "heroes," with a stroke of genius in their personalities. In October, Paul Kammerer finally stepped into her life.

Kammerer, born in 1880 in Vienna, was, in addition to his activity as a PhD zoologist in a Viennese institution, a great music lover who played the piano outstandingly well and had composed a few lieder, which had been published by the prestigious Simrock Verlag.[9] Kammerer was no stranger to Alma; a few years before, he had visited Gustav Mahler, whom he idolized, and Alma in To-blach, without, however, leaving a very positive impression. On that occasion he had actually offered to work as Mahler's servant, only for the joy of being closer to him. Mahler found this almost canine devotion strange, "so the visit was naturally truncated."[10] Mahler's death had dealt Kammerer a powerful blow: as he confesses to Alma on October 31, 1911: "But in this case I know that the loss is irreplaceable. It is incomprehensible how anyone without some sexual undercurrent, without any family ties, and without so much as an openly declared bond of friendship can love another person as much as I love Mahler. Because this was and is not only admiration, Enthusiasm for the art and the person, this is love!" Now—after Mahler's death—Kammerer transferred his love to the composer's widow. Alma—the biologist maintained—belonged "to the rare breed of brilliant Viennese women"; moreover, he said, he was sure "the factor that elevated Ma[hler] to his exalted position must also be regarded as an accomplishment of his extraordinary wife."[11] Compliments like these were very much to Alma's liking, and Kammerer met her need for homage and adoration in a truly excessive way. After the world première of *Das Lied von der Erde* on November 20, 1911, in Munich, to which Kammerer had accompanied Alma, he suggested on the trip back that she become his assistant. Alma may have known next to nothing about biology—her academic education was, as described, also inadequate in this respect—but, despite this, she accepted the offer. She had arrived at the point at which she wanted to organize her own life, so to speak, from stem to stern. As a well-to-do widow, Alma was not so

much concerned with earning money as with having some meaningful activity, possibly even something like a profession of her own. This new beginning, which also included a move to an apartment of her own, appeared to her as an opportunity to come to terms with the past. Since her return to Vienna, Alma and her daughter Anna had lived with Carl and Anna Moll. It was clear to all parties concerned that this was only a temporary arrangement, especially as Alma's relations with her family fluctuated, as they always had, between distance and closeness. At Pokornygasse 12, not far from the so-called *Eroica* House, where Ludwig van Beethoven worked on his Third Symphony in 1803–1804, Alma and Anna Mahler moved into their own home in early December 1911. About the same time, Alma paid her first visit to Paul Kammerer's biological experiment institute on the Vienna Prater. "Now he has turned over a mnemotechnical experiment with praying mantises for me to work on. He wanted to find out if these animals lose their memories when molting, or if this act is merely a superficial skin reaction. For this purpose, I was supposed to teach them a habit. This attempt failed because it was absolutely impossible to teach these beasts anything. I had to feed them at the bottom of the cage, because they were used to eating a priori in a high position and in the light. The cage was darkened below. There was no way of getting them, for Kammerer's sake, to give up their beautiful custom." Alma had to feed the creatures mealworms, "and that huge crate full of wriggling worms quite horrified me. He saw that, took a handful of worms, and put the creatures in his mouth. He gobbled them down, noisily smacking his lips."[12] It is unclear how intensely Alma pursued her biological studies. Allegedly she regularly went to Kammerer's institute over a period of several months, during which the biologist and his assistant rapidly got closer. According to Alma, the already married Kammerer fell in love with her and threatened several times that he would shoot himself over Gustav Mahler's grave were she not to return his affections. "His passion for me," she wrote years later, "made him the clown of my entire circle."[13] In the eyes of Alma's entourage Kammerer was a ridiculous figure: "When I got up from a chair, he would kneel down and sniff and stroke the spot where I had been sitting. He didn't care at all whether or not there was a stranger in the room. There was also no way to get him to stop these extravagances, of which he had a huge collection."[14] At some point in the course of 1912 Kammerer's antics got too much for Alma, and she discontinued her activity at the institute. The eccentric biologist had clearly been nothing more than an episode for Alma. They did, however, remain friends, not losing contact with each other until after Alma's wedding with Walter Gropius in 1915.

To this day, Kammerer's significance as a biologist is a matter of controversy. For the one camp, he was a genius, for the other a charlatan. With his experiments on midwife toads and salamanders he ventured into one of the greatest puzzles of scientific history: the inheritance of acquired traits. Alma claimed years after Kammerer's death that some irregularities arose in the evaluation of the experiments: "he so ardently hoped for certain results from his research that he was able to sidestep the truth unwittingly."[15] In 1926 Kammerer got into serious trouble when British biologists claimed he had manipulated his examinations. Whether he was really a fraud—a view for which there is considerable evidence—or whether he was the victim of a plot by envious colleagues, remains a subject for conjecture. Financially wiped out, personally disheartened, and scientifically ruined, at the end of September 1926 he shot a bullet into his head.

After Alma had withstood the first six months of the harrowing year of 1911, calm returned to her life and she was able to look confidently into the future. Only her relationship with Walter Gropius had developed into a great disappointment. In December Alma visited him in Berlin, and tension arose between her and his mother. Alma regarded Manon Gropius as stupid and uneducated, and made no attempt to keep her aversion toward the woman a secret from Gropius. This visit seems to have alienated the once passionate lovers even more. Their correspondence may not have broken off even now, but the cooling down of the emotions nonetheless is evident in their letters.

The first Christmas celebration without Gustav Mahler was a time of sadness for Alma and the now seven-year-old Anna. On Christmas Eve, of all times, when Central Europeans exchange their gifts, something happened that ruined the already dark mood: Alma's half sister Gretel was placed in the Purkersdorf Sanatorium on suspicion of having a mental illness. As she had to be permanently tranquilized following her admission, she was transferred two days later to Professor Obersteiner's private mental hospital on Billrothstrasse in Vienna, near the Hohe Warte where Carl and Anna Moll lived. Although the contact between the sisters had grown more and more sporadic over the intervening years—Gretel had married the painter Wilhelm Legler in the summer of 1900 and had moved for a while with her husband and their son, Willi, born in 1902, to Stuttgart—Alma was deeply concerned over her fate. The clinical report (being evaluated for the first time here) is in many different ways a very upsetting document. To begin with, the case history: "In the first year of her life, severe whooping cough. Physically and mentally well developed. A good student in school, was from the outset somewhat stubborn,

FIGURE 3.2

Anna and Alma Mahler:
"She is like another
species to me. Cool—
cunning and Jewish."

forgetful, absentminded, indecisive, taciturn, reticent and shy, but intelligent
and appreciative of art. Became engaged at the age of 17, wanted to take her
life at the time out of a feeling that she could mean nothing to her husband,
as she was unworthy of being loved. Purchased a pistol and sat down in an
abandoned place for the purpose of shooting herself, but wound up not doing
it after all." Gretel suffered from a persecution complex, heard voices cursing
and swearing at her, and felt threatened by her family, who she felt had in-
stigated a plot against her: "She is likewise afraid her husband or stepfather
might beat or do some other horrible thing to her." States of total apathy
followed rages and wild screaming. The doctors at Obersteiner's sanatorium
prescribed strong anesthetics and sleeping drugs such as opium, Veronal, and
Adamol, but they couldn't help the thirty-one-year-old woman. In late Feb-
ruary 1912, Gretel was transferred to the Illenau psychiatric hospital between
Baden-Baden and Offenburg, where she made several attempts to take her life.

She sensed a compulsion, Gretel admitted to the doctors, to kill herself. She frequently broke windows and tried to injure herself with the broken glass. In early August 1912, on a visit to Obersasbach, she jumped out of a second-story window but suffered only minor injuries.

The medical evaluation in the spring of 1913 was not very optimistic: "paranoid form of dementia praecox [chronic premature dementia]. Prognostically, the case would have to be looked upon as unfavorable as to the restoration of mental health. Seeming improvements mostly revealed themselves later to be simulation on the part of the patient, who wished to use it to achieve a certain objective in her illness. There was a great probability that the patient might lapse into a permanent mental infirmity [feeblemindedness] a consequence of repeated states of agitation."[16] Decades of confinement in psychiatric institutions or sanatoriums now began for Gretel; Illenau, Rekawinkel, Baden, and Tulln were the way stations of her suffering until, on March 15, 1940, she was transferred to State Institution in Grossschweidnitz near Dresden. Many patients at this institution had been murdered in the wake of the Nazi euthanasia projects. By all appearances, she had been spared this fate, and she died on December 4, 1942, of natural causes.[17]

It can no longer be stated with certainty whether or not Gretel really suffered from dementia praecox; nevertheless we can assume that the causes of her illness were traceable to her childhood and adolescence. As far back as Illenau, the doctors got suspicious when they looked more closely into the patient's family situation. "Some of her [Gretel's] reticence and fears, by the way, are definitely caused by events in her family both before and at the beginning of her acute attacks."[18] Whatever lay hidden behind this mysterious allusion, something was not right in the Moll-Legler homes. In his unpublished autobiography, Carl Moll mentioned a "natural preference of the firstborn by the mother," going on to say: "The barely one-year-younger sister could not feel this preference because she totally loved her sister herself."[19] Possibly the relationship with her older, beautiful sister was profoundly ambivalent—on the one hand marked by great affection, on the other by an unacknowledged jealousy because of Alma's favored status. Wilhelm Legler took a decidedly critical view of the relationship between his wife and her mother, as he wrote to the director of the mental hospital in Illenau: "There is one more thing I'd like to say; in my mother-in-law's home my wife was always somewhat neglected in favor of her sister Alma. I am not saying this to suggest my parents-in-law had consciously neglected her; my wife surely put herself in that position, and idolized my sister-in-law, who was very pretty and generally

adored, to such a degree, for example, that she would only accept a gift from me if I also gave something to my sister-in-law." Evidently Anna Moll subconsciously gave her younger daughter the feeling that she was not a full member of the family because Gretel might have reminded her of that dalliance with Julius Victor Berger, which had to be covered up under all circumstances. The naturally unspoken accusation of being only a "bastard" caused Gretel to become afflicted with a severe inferiority complex. At the same time, Anna Moll depicted her "real daughter" Alma as someone who—for Gretel—represented an unattainable ideal. It annoyed Wilhelm Legler for years, "that in my view, so much exaggerated love and care was expended on my wife's sister and my brother-in-law Mahler, while I felt that my dependent wife, who was not as healthily egotistical and self-sufficient, had a greater claim on my mother-in-law to devote some attention to her and help her get her household in order."[20]

In her memoirs, Alma did not mention a word of her sister's illness. Nor are we aware of any letters in which she said anything about Gretel. This was no coincidence: when Alma visited her sister on Christmas 1925 at the Bonvicini Sanatorium in Tulln, it suddenly became clear to her that Gretel was not the child of Emil Jakob Schindler and was thus only her half sister. "A haggard, brown head rose from the pillow, and I recognized with absolute certainty the face and head shape of the painter Julius Berger."[21] On her return from Tulln, Alma demanded an explanation from her mother. After long hemming and hawing, Anna Moll admitted having had an affair with Julius Victor Berger while Emil Jakob Schindler was being cured of his diphtheria infection at the seaside spa of Borkum. Once more, the old hatred for Anna Moll was rekindled—as was now clear to Alma—not just because she had cheated on her husband, but also because, after his death, she had repeatedly claimed that his diphtheria had been the cause of Gretel's mental illness. Although this silliness might have been exposed as medical nonsense even back then, Alma had initially believed her mother's fairy tale: "So for years I trembled thinking that I too might go mad, for years I endured hearing my poor father being blamed for Gretl's illness, until I finally broke through the clouds." Alma's realization that Gretel was not the child of Emil Jakob Schindler, and even more, that she herself was the only one to bear the special, healthy heritage of her beloved father within herself, filled Alma with delight. She was "inspired" and "as if newborn,"[22] she noted later in her diary. With that knowledge, Gretel had already died before her time for Alma: her half sister's name never showed up in her diary again.

MASOCHISM

On the evening of April 12, 1912, the twenty-six-year-old painter Oskar Ko-
koschka was a guest in the Moll home. Carl Moll had met the young expres-
sionist the previous year at an exhibition and now wanted to have him do a
painting of his stepdaughter Alma. This portrait commission was more than a
friendly gesture—it was proof of considerable courage. Kokoschka must have
had a confusing, chilling effect on his contemporaries: he ranked as a revo-
lutionary, eccentric, provocateur, and at the same time as a brilliant painter,
whom Vienna's high society simply couldn't figure out.[23] "Oskar Kokoschka is,
as a man and human being, an extremely odd mixture," Alma remembered de-
cades later. "A fine figure of a man, yet the beholder is bothered by something
hopelessly proletarian in his structure. He is tall and slender, but his hands
are red and often swollen. His fingertips are so congested that when he cuts
himself while trimming his nails, the blood comes spurting out in a high arc.
His ears, though small and finely chiseled, stick out from his head. His nose is
somewhat wide and tends to swell up. The mouth is large, and the lower jaw
and chin prominent. The eyes somewhat angled, which gives him the expres-
sion of someone on the prowl. But as such the eyes are beautiful. He holds his
head up really high. He walks very clumsily as if hurling himself forward."[24]
After dinner, Alma and Kokoschka went into an adjoining room, where she
ardently sang "Isolde's Love-Death" for him, accompanying herself on the
piano. "How beautiful she was," Kokoschka remembered, "how seductive be-
hind her mourning veil! She quite enchanted me! And I got the impression that
she also wasn't exactly indifferent toward me."[25] Alma, for her part, claimed
Kokoschka had pressed forward and suddenly locked her in a tempestuous
embrace: "This kind of embrace, however, was new to me . . . I did not return
it in any way, and this very reaction seemed to have quite an effect on him."[26]
Whatever really happened—just three days later she had his first love letter
in her hands: all in all, some four hundred more letters would follow. What
now began was an ecstatic and agonizing *amour fou*, which would ultimately be
attested to by any number of drawings, paintings, and, not least, seven painted
fans. Alma appeared to Kokoschka as strict sovereign and fount of inspiration
all in one, who handed out both praise and criticism. "I know that I am lost,"
Kokoschka wrote on April 15, "if I keep on being so unclear about my present
life, I know that it will cause me to lose my skills, which I should turn toward
a goal outside myself, a goal that is sacred for both you and me." Alma, he
said, was the only woman who could prevent him from "barbarization": "If

you, as an empowering woman, would help me in getting out of this mental bewilderment, the beautiful thing beyond our knowledge that we both worship will bless you and me with happiness."[27] Kokoschka was unpredictable, untamable; in his emotional outbursts he loved Alma passionately and unconditionally, "like a heathen, who prays to his star."[28] At another point, he begged: "I must soon have you as my wife, otherwise my great talent will go to rack and ruin. You must reanimate me in the night like a magic potion."[29] Alma must have felt her great passion in a similar way, although, in retrospect, she describes herself as less tortured. "The three years with him were a hefty love-battle. Never before have I tasted so many spasms, so much hell and so much paradise."[30] Right from the beginning, Alma suffered from Kokoschka's uninhibited jealousy; he could barely endure seeing her maintaining social contact with other people—especially men. "You may not slip away from me, not ever, not for one moment," he wrote to her in early May 1912 at the Dutch beach resort of Scheveningen. "Whether or not you are with me, your eyes must always be directed toward me, wherever you may be."[31] Not infrequently Kokoschka would offend and insult Alma's visitors, or he would appear in front of her from out of nowhere and shield her from anyone else. "He went away late in the evening, but not, for instance, to go home. Instead he walked up and down under my window . . . and toward two [o'clock], sometimes not until four o'clock in the morning he whistled, and that was the sign I had been longing for, that he was finally going away. He left in the comforting awareness that no 'lad,' as he gently put it, had come to see me."[32] If she nevertheless did receive a visit, Kokoschka would make a terrible scene: "Alma, I just happened to come by your house at ten in the morning, and could have wept in fury because you can stand there surrounding yourself with satellites, while I withdraw to the filthy corner again. And if I have to take a knife and scratch every single alien idea inimical to me out of your brain, I would do it, before I find myself sharing the redeeming flame of joy with you—I'd rather starve, and so will you. I will have no other gods before me."[33] Kokoschka's jealousy was boundless, and directed not only at Alma's friends and acquaintances, but especially toward her late husband. Before the world première of Mahler's Ninth Symphony in Vienna on June 26, 1912, a violent altercation broke out between Alma and Kokoschka. "Alma, I can find no peace in you," he wrote her after attending a rehearsal, "as long I know someone else, dead or alive, is a part of you. Why have you invited me to a dance of death, and why do you want me to stand mutely, for hours on end, watching you, while you, a spiritual slave, obey the rhythm of the man who was and must be a stranger to you and me,

FIGURE 3.3
Alma and Oskar
Kokoschka, 1913 drawing
by Oskar Kokoschka.

knowing that every syllable of the work hollows you out, mentally and physically."[34] Kokoschka's jealousy occasionally took on bizarre forms. After a fit of fury, once again triggered by Mahler, or rather the significance he still had in Alma's life, he gathered a group of photographs of the composer, which happened to be on display in the room, and picked up and kissed every single picture. "He said it was white magic, and he wanted to use it to transform his jealous hatred into love."[35]

In early July, Alma and her daughter traveled once again to Scheveningen, much to the irritation of Kokoschka, who only two days after the departure of his adored one was utterly "apathetic"![36] Alma was accompanied by Henriette Amalie (Lilly) Lieser, born in 1875. The two women had known each other for a fairly long time; Gustav Mahler had mentioned a Mrs. Lieser in a letter to Alma written in July 1910.[37] Evidently, however, the women had not become closer friends until after his death. Alma and Lilly had a few things in common: both were well-to-do, liked traveling, and appreciated a cosmopolitan lifestyle. Lilly

was the daughter of an extremely wealthy couple, Albert and Fanny Landau, and had married the entrepreneur Justus Lieser in November 1896. Their two daughters, Helene and Annie, were not much older than Alma's Anna—that also figured in their bond. Occasionally Alma would ask Lilly for financial help —not for herself, but for friends and acquaintances from her artistic circle. This way Lilly supported the composer Arnold Schönberg, for example, for several years, bought him a harmonium, or let him live in her house on Gloriettegasse in the upscale neighborhood of Hietzing.[38] Not until 1915, when Alma noticed that Lilly had lesbian tendencies and was obviously making a play for her, did the friendship cool down. Lilly disappeared just as suddenly from Alma's life as she had previously appeared in it. In the 1920s and '30s, the contact seemed to have broken off completely, even though both of them continued living in Vienna. After Hitler's troops marched into Austria, Lilly Lieser's property was "Aryanized," as these expropriations were called in Nazi parlance, and she had to sell her securities and properties and move into a small apartment. While her daughters succeeded in escaping to England and America, all help came too late for Lilly: on January 11, 1942, she was deported to Riga and died on December 3, 1943, in the Auschwitz concentration camp.[39] Lilly Lieser—this much is clear—was one of the few women who can be described as a close friend of Alma's.

During their stay in Scheveningen in the summer of 1912, Alma met with Joseph Fraenkel, who was still courting her. "I didn't look upon this as disloyalty, because, in my mind, I had already put considerable distance between us. I just wanted to make it clear to myself one last time that it was all over with us."[40] Kokoschka knew nothing of this meeting, although Alma did hint at some nervousness; nevertheless she left him in the dark. There were good reasons for this secretiveness. Fraenkel was a red flag for Kokoschka, whose jealousy took on virtually pathological dimensions. Fraenkel played a role even in the most intimate moments, as Alma recalled in June 1920: "Oskar Kokoschka could only make love to me with the most peculiar game playing. As I refused to hit him during our hours of love, he began conjuring up the most appalling images of murder in his brain, while whispering murkily to himself. I remember that he once evoked Fraenkel in that connection, and I had to take part in a revolting fantasy murder. When he fancied he had been gratified, he said: If that hasn't killed him, at least he'll come away from it with a little heart collapse."[41] Oskar Kokoschka's sexuality expressed itself not only in abnormal imaginary excesses, but also in a tendency toward sadomasochistic practices. He occasionally asked Alma to be strict and merciless with him,

as a quote from the following letter suggests: "I would like it so much for you at least to be dissatisfied with me, but still stay with me and slap me with your lovely, dear little hand!"[42] Clearly, back in his childhood, Kokoschka already felt a certain masochistic pleasure in corporal punishment. "I would often do something mischievous intentionally," he wrote in his memoirs, "after which the teacher would pull me out of my seat, put me over her knee and spank me." And further: "I was probably in love with the teacher!"[43] He occasionally described himself to Alma as a "boy" who needed to be "mistreated" by his strict mistress.[44] Kokoschka's eccentric sexuality was and would have to remain beyond Alma's understanding, because the physical acting out of erotic or sadomasochistic fantasies simply didn't suit her inner disposition. Possibly it was her leaning toward hysterical theatrics that held her back from joint sexual excesses. Humiliation on request was, in any case, uninteresting for Alma.

In the summer of 1912, the relationship between Alma Mahler and Oskar Kokoschka entered its first crisis. This was primarily attributable to Kokoschka's jealousy, which Alma found increasingly harder to put up with. He demanded that she live in total seclusion, give up all her social obligations, and simply be there for him. That would never have worked over the long run for a woman like Alma. And so Alma kept giving him reasons for feeling rejected. Not infrequently she played with his jealousy, tortured him by withdrawing her love or intentionally letting other people get close to her, which he considered a humiliation. In late July 1912, he complained in a letter: "First of all, it never enters your mind that our seeing each other again depends on the completion of my works and the financial freedom this will bring me; you claim it depends on the favor of some friend of yours, telling me to be prepared to step in and fill a gap that might come about when she leaves town—that hurts me terribly."[45]

Just like Gustav Mahler and later Walter Gropius, as well as Franz Werfel, Oskar Kokoschka also had to defend his relationship with Alma to his family and friends. The liaison of the young painter and a widow who was the talk of the town was regarded with enormous skepticism by outsiders. Friends of Kokoschka, such as the architect Adolf Loos, warned him of Alma's allegedly bad influence and foresaw a dreadful ending. Even Kokoschka's mother, Romana, was decisively opposed to this bond! She wrote to a relative: "Nobody would be able to believe how much I hate that person. An old woman like that, who already has an eleven-year family life behind her, attaches herself to such a young boy. . . ."[46] For Romana Kokoschka Alma was simply "Circe," as she disparagingly put it, a disreputable cocotte, who would prove the ruination of her son. A few years later, she even threatened to shoot Alma if she came

anywhere near Oskar again. Once she promenaded "for several hours up and down outside Alma Mahler's house, her hand moving suspiciously inside her coat pocket,"[47] while "Circe" looked anxiously out the window. Without a doubt her hate was deep-seated, and it was reciprocated in kind. Occasionally Alma accused Kokoschka of being "unmanly" (that is, too acquiescent) toward his mother. Kokoschka, who had been close to his family all his life, and supported them financially, reacted with irritation to this reproach: "My relationship with my mother is not unmanly, but rather the suitable one for a woman who can no longer stand the truth because lifelong agitation and worry of every kind have ruined her health."[48] The fact that Alma and Kokoschka's family were at permanent loggerheads made a not-inconsiderable contribution to the breakdown of their relationship.

In the summer of 1912, the situation reached a critical state: Alma suspected she was pregnant again, as we can see in Kokoschka's letter from July 27: "Should you have a precious child from me, then nature in its greatness and goodness is merciful and eradicates all the horrible things, so that it will never tear us apart, for we shall rest on one another and be supported upon one another. You will now draw your health from me, and I have found my peace in you, my lovely one. We will now find the sacred element in the family; you will become a mother."[49] Alma, who wasn't all that sure about her relationship with Kokoschka, found that events were moving much too fast, especially as he was now insisting that she would finally let him marry her. In Mürren, a health resort in the highlands near Bern, to which the couple, along with Anna Moll and Alma's half sister Maria, had gone in early August, Kokoschka secretly began making wedding preparations. Under the pretext of having to apply for new identity documents, he asked his mother to send his baptismal and nationality certificates, along with his certificate of exemption from military service, to Switzerland immediately. While he traveled several times to neighboring Interlaken to get information on the requirements for a wedding, Alma wasn't the least bit enthusiastic about the idea of getting married again: "I was trembling upstairs in the hotel before having to face the possibility he might succeed."[50] Clearly, however, the bureaucratic hurdles were so daunting that Kokoschka postponed his plan.

In mid-September, the two of them set off to Baden-Baden, where Alma had to visit "my sister in the madhouse because I was expected to have a beneficial effect on her mental condition."[51] There it was confirmed what she had been fearing: she was pregnant from Oskar Kokoschka. Alma finally traveled via Munich back to Austria on September 18: "I arrived in Vienna in the eve-

ning—went to the apartment—alone with the child—and in this apartment I suddenly felt: I am not Oskar's wife! Gustav's death mask had arrived during my absence and been placed in my living room—the sight of it almost drove me out of my senses."[52] Around this time, she noted a nightmare in her diary; the imagery of this dream needs little further deciphering: "Narrow ship's stateroom—on the lower bunk, covered with linen, the dying man [Gustav Mahler]—Oskar and I calmly present—death—at the same moment a blissful embrace directly beside the deceased—The doctor comes—Lilly [Lieser]: I hope he doesn't notice anything!!?—the doctor examines and says—go into the next booth—the cramped conditions and the heat here—the corpse will soon start to smell—we wander off—and come back and the bed is empty— all the horror—over, out of commission—within me as well—forever."[53] You don't need an advanced degree in psychoanalytic pathology to realize that Alma was struggling with a guilty conscience. She was suffering under the illusion that Kokoschka's child might have had something to do with the dead Mahler, and this must have been the main reason she did not want to have it. After some painful altercations, Kokoschka agreed to an abortion, which was performed in mid-October. Alma wrote: "In the sanatorium, he took the first blood-stained cotton dressing off of me and brought it home. 'This is my only child and always will be—' Later he perpetually carried around this old, dried-out piece of cotton."[54] Oskar Kokoschka never forgave Alma for having this abortion. Decades later he remembered those dramatic October days in 1912. "That operation in the Vienna Clinic, for which I never wanted to forgive Alma Mahler, is to blame for our relationship coming to an end even before the start of the war. The coming into being of a living creature may not intentionally be impeded because of laxness. It was an intrusion into my development as well—that really is obvious."[55] In 1913, Kokoschka tried to cope with his conflicts of conscience in several terrifying chalk drawings, such as *Alma Mahler with Child and Death* and *Alma Mahler Lies with Kokoschka's Entrails*.

Despite the abortion, which aggravated the crisis between Kokoschka and Alma, Kokoschka's eagerness to get married actually reached an interim high point at the end of 1912. "I'm really looking forward to the beautiful, happy world," he wrote to Alma in December, "when you will be my wife, and will no longer be separated from me."[56] As early as October he had spoken to Carl Moll, "and he gave his permission for our marriage with no particular difficulties."[57] During this period, Kokoschka was working on a double portrait, showing himself and Alma. In this oil painting she is wearing red pajamas, which was a kind of fetish for Kokoschka. "Once got me a pair of fire-engine

red pajamas," she remembers. "I didn't like them because of their flashy color. Oskar Kokoschka immediately took them away, and from then on he always wore them when walking around in his atelier. It was in this garb that he received his shocked visitors, and he spent more time in front of the mirror than he did in front of the easel."[58] The painting unmistakably portrays a man and woman in love: Oskar Kokoschka and Alma hold each other in a close embrace and—as in a marriage engagement—hold hands. Walter Gropius must also have caught on to the meaning of this double portrait when he saw it in the spring of 1913 at the twenty-sixth exhibition of the Berlin Secession.[59] The statement was unambiguous and must have hit him very hard, especially as in her letters Alma had always kept her affair with Kokoschka a secret from him, even though it had been going on for over a year. Why hadn't she told Gropius the truth? Did she perhaps believe that she could simply come back to her ex-lover if she and Kokoschka were to break up? Understandably, however, Gropius had no interest in warming the bench as a substitute. As his feelings for Alma had already distinctly cooled, he now wrote to her less and less frequently until the correspondence finally fizzled out completely over the course of the year 1913.

To all appearances, Kokoschka was neither aware of the full extent of Alma's connection with Gropius, nor did he know that they were still maintaining a correspondence. While Alma and Lilly Lieser were away in Paris for a couple of weeks, Kokoschka's wedding plans were taking on clear contours. "You are to become my wife, and I your only husband," he wrote to her in Paris, philosophizing over "different forms of living together" and describing Alma with no further ado as his "dear bride."[60] And in early July, without Alma's knowledge or agreement, he published the banns in the Döbling parish house. When Alma, by chance, found out about this, she fled with Anna to the western Bohemian health resort of Franzensbad "and stayed there until the date appointed for the wedding had come and gone." In her memoirs Alma later claimed she had promised Oskar "that I would come back and marry him immediately when he had created a masterwork."[61] That was certainly no more than a delaying tactic. Actually Alma didn't know what she wanted herself. She resorted to a bold maneuver. Instead of making a definite decision for or against a marriage with Kokoschka, after a long period of silence she resumed contact with Walter Gropius. At the end of July she wrote him a very revealing letter: "I might get married—Oskar Kokoschka, a kindred spirit of ours, but I shall continue to remain connected with you through all eternity. Write to tell me whether you're alive—and whether this life is worth living."[62] If we

take away the pathos, these lines, insofar as they relate to the announcement of a possibly imminent wedding, do not sound very convincing. It is uncertain how Walter Gropius reacted to this letter or if he answered it at all.

When Kokoschka showed up unannounced in mid-July to see Alma at Franzensbad, his visit culminated in a violent clash. "He didn't find me at home, and when I finally got there, his portrait, which he had turned over to me for 'protection' on my journey, was not hanging on the wall of the hotel room, as he had apodictically commanded. A storm broke out, and he departed, unreconciled."[63] Over the next couple of weeks the tensions increased. In all this, it was not Alma alone who was suffering under her partner's jealousy. Kokoschka also had to put up with her displeasure. "Your letter today pelted me with hailstones of obscenity again, and I am so fond of you, and I don't know why you are so cross with me." We can assume from those letters of Kokoschka's that are still preserved that she used matters of insignificance as an excuse to demean him as a "sissy"[64] or accuse him of being "Jewified."[65] Alma's suspicions even directed themselves toward her barely fourteen-year-old half sister, Maria Moll, who took the occasional drawing lesson from Kokoschka. "I didn't give Maria a lesson today," he assured her, "so that you wouldn't unnecessarily feel offended."[66]

Following her return from Franzensbad, Alma spent just a short time in Vienna, traveling on soon afterward to Tre Croci in the Dolomites. We get the impression that she was intentionally avoiding Kokoschka and escaping from conditions at home. "Finally your first letter," Kokoschka rejoiced on August 21: "I didn't know you were so far away."[67] A short time later, he hesitantly but worriedly followed his lover there. Despite the emotional tensions that had made the springtime so stressful, the late summer weeks in the Italian mountains evidently ran their course in great harmony. In the mornings, they went into the dense forests and watched the young horses as they grazed in a clearing. Oskar captured these outdoor experiences in a number of chalk and charcoal drawings.

DWINDLING INTEREST

The Semmering area is a good two hours by train from Vienna. This romantic mountain landscape with its steep limestone walls, craggy cliffs, broad ridges, and lushly forested valleys was, because of its tranquil and fog-free location, its healthy air and easy accessibility, a popular vacation destination, even in the second half of the nineteenth century. In 1882, the upmarket Südbahnhotel

was constructed, and it rapidly became the preferred holiday domicile for celebrities from government, academe, and the arts. During the summer and autumn of 1913, Alma had a vacation home built on property that Gustav Mahler had purchased outside the small community of Breitenstein back in November 1910. The location was unique: on the crest of the Kreuzberg—a gently curved promontory between the Semmering Pass and the rocky Rax mountain range—it offered an unimpeded view of the two-thousand-meter-high Schneeberg. The vacation house was out of the ordinary: "I told the builder, 'Build me a house around a gigantic fireplace.' He took me literally— and broke the biggest blocks out of our mountains there, shaping them into an oversize fireplace, which with its stone walls extended over the entire length of the room."[68] The construction proportions, along with the low-slung roof covered with larch wood shingles, gave the two-story Villa Mahler the rustic charm of an American farm you would be more likely to see in Texas than in the cool heights of the Austrian Alps. The composer Ernst Krenek, Alma's later son-in-law, remembered: "It was encircled by a huge verandas, which invited the visitor to rest in the shade yet could hardly be used for this purpose. Their principal effect lay in the fact that they made the adjoining rooms dank and dismal."[69] Before Alma moved into her new refuge in December, Oskar painted a four-meter-wide fresco above the fireplace "showing me pointing to the heavens in their spectral radiance, while he, standing in hell, seemed surrounded by death and serpents. The whole thing is based on the idea of flames continuing up from the fireplace. My little Gucki stood next to it and said: 'Hey, can't you think of anything else to paint besides Mommy?'" The first weeks in Breitenstein were "beautifully cloudless," as Alma remembered. "Work was under way in every room, curtains were being sewn on the machine and then hung, etc. My mother was cooking in the kitchen, and in the evenings we sat by the fireplace, read scores, or made music—in short, the time was totally devoted to reconstruction."[70] Oskar Kokoschka claimed in his memoirs that Alma Mahler had again been pregnant during this period.[71] In her own writings, she makes no reference whatsoever to this. Should this really have been the case, then she possibly decided to have another abortion. Probably, however, Kokoschka just put the 1912 pregnancy in the wrong year.

In the spring of 1914—we can trace this in the correspondence—the tensions between Alma and Kokoschka again increased, mostly because his pathological jealousy rose to an unbearable level. Time and again, he hurled severe accusations at her, claiming she was surrounding herself with false friends—"creatures who change when they warmly come creeping up to

you."[72] Alma withdrew more and more from Kokoschka. In early March, she fled with Lilly Lieser to Paris again, while the barely ten-year-old Anna remained—as so often—with her grandparents in Vienna.

There was no way this relationship could have functioned over the long run. Kokoschka was looking for a "maternal inspiration" and expected—despite all the savage debaucheries—care "and loving devotion: and you were surprised that I sought no territory in the world you had made for yourself. You must have a new heart for me. I didn't know that a woman of a certain rank in the world would no longer descend, would make no effort, nor venture a change for my inner rank, because it takes a great effort to come to my level." As Alexander von Zemlinsky and also Gustav Mahler once had done, Kokoschka criticized Alma's superficiality and her inner emptiness—finally her vacillation between the extremes. "Almi, one cannot switch back and forth at will from being foolish one minute and wise the next. Otherwise one loses both possible sources of happiness. And you're becoming a Sphinx, who wants neither to live nor to die, but who murders the man who loves her and who is too moral to withdraw this love or to betray someone for his own well-being." These charges weighed heavily, especially when Kokoschka accused her of being unable to muster "the patience for love."[73] The addressee of those lines reacted just as directly. "Well—now that's all over, too," Alma noted coolly in her diary. "Something I thought would last! I have lost Oskar. I can't find him in myself anymore. He has become an undesired stranger to me." And further: "I WANT to forget him! We haven't benefited one another, but rather made one another mean."[74] And so it was certainly no coincidence that in May 1914, after a long break, Alma resumed letter contact with Walter Gropius. At a time when relations with Kokoschka were becoming burdensome, she assured her former lover that she had become more mature and free and had a great desire to speak with him. "Your image within me is precious and pure—and people who have shared something as strange and beautiful as we have should not lose one another. Come—when you have time, and if it will give you joy—come here to me. It is no resignation that has prompted me to write all this, but rather a brighter, newly enlightened view of things."[75] A few weeks later she wrote once again to tell him she felt lonely and would like to see him again. It is questionable whether Kokoschka suspected what was going on behind his back, whether it was clear to him that Alma, inside herself, had long since given up on him. On the outside, in any case, she continued to maintain the relationship and gave him the deceptive feeling they could have a future together. Clearly thrown off balance, he promised her that he would

FIGURE 3.4 Oskar Kokoschka's *Bride of the Wind*, 1913: "I would come back and marry him immediately when he had created a masterwork."

work on himself and try to change. "But it will take weeks and months until I have changed to the person you need."[76] But as far as Alma was concerned, it was already too late for that. "What am I to make of all this 'become' and all these 'maybes' from this person?" And finally: "Do I still love this person, or do I already hate him?"[77]

At the outbreak of the World War in the first days of August 1914, the last phase of the affair between Oskar Kokoschka and Alma Mahler began. Back in May, Alma had cleared out her Vienna apartment on Pokornygasse and withdrawn to her house in Breitenstein. There, in the seclusion of the Austrian mountains, she was afflicted by an agonizing attack of boredom. "I sometimes imagine," she wrote in her diary, "that I was the one who ignited this whole world conflagration in order to experience some kind of development or enrichment—even if it be only death."[78] Although many of her contemporaries mystically idealized World War I as a catharsis, painful yet necessary to cleanse the earth of things obsolete, Alma's fantasies take on odd forms. Here the war

doesn't seem so much to be the decline of the West but rather serves as a theatrical distraction from personal tedium and spiritual monotony. Although Kokoschka advised her to give Vienna a wide berth and "go to Switzerland with Lieser as long as you can still get out,"[79] Alma headed for the capital of the still existent Royal Imperial Austro-Hungarian Monarchy. As beautiful as the house in Semmering was, Alma missed the big city. In early August 1914 she rented a ten-room apartment on the fourth floor of an elegant building at Elisabethstrasse 22, at the south end of the First District. The pulsating life of this international metropolis was, in a manner of speaking, right outside Alma's front door; the Court Opera, the Pavilion of the Secession, or the upmarket Kärntnerstrasse were all just a stone's throw away. The move back to the hurly-burly heart of the city was concurrently an expression of her alienation from Oskar Kokoschka, who had always insisted that she stay as far away from all this as possible. In her diary, her contemptuous remarks about the painter intensified. "I'd like to settle the score with Oskar. He is of no use in my life anymore. He keeps dragging me back to the libidinous level. I can't do anything with it anymore. And as dear and helpless as this big child is, that's how unstable, even treacherous, he is as a man. I have got to tear him out of my heart! The thorn is deep in my flesh. I know that I am ill because of him—ill for years—and couldn't tear myself away. Now the moment has come. Away with him!"[80] And Kokoschka? In late September 1914, he was still talking about marriage plans in a letter to Alma: "I'm so eagerly looking forward to the time when we always have our little beddies side-by-side. . . . Once I'm living together with you, you can go out and socialize, even in the evenings; just as long as you come home to me, that doesn't bother me anymore."[81]

Like so many others, Alma Mahler was also swept up in the nationalistic frenzy of the first weeks of the war. When German troops threatened Paris at the beginning of September, she zealously took a piano score of Wagner's opera *Die Meistersinger von Nürnberg* and played from it all evening long. "This accursed war must teach us to love our master craftsmen again. It will suffocate this rotten seed."[82] She wrote enthusiastically to Walter Gropius, who had been serving in a regiment of hussars since early August and had already attracted attention for exceptional valor: "I shall come to Berlin when the Germans march into Paris."[83] But things, however, turned out a little differently. With the collapse of the German offensive on the Marne, the western front stagnated into positional and trench warfare for almost four years. The guilty parties were quickly pinpointed: liberal journalists and social democrats, whom Alma equated with "the Jews." On November 12, she wrote an

irate letter to Joseph Fraenkel, who had had the effrontery to defend Jewish accomplishments to her: "What's the point of the Jewish question now? They have received more from Europe than they have given. The spirit of analysis, or social democratic politics, or liberalism, all this 'enlightenment rubbish' was brought into the world by Jews. Today you are another person. But without me you would never have become that person—and that goes for all of you."[84] Alma's letter reveals a tendency that would increase with the end of the relationship with Kokoschka. It not only expresses a kind of diffuse anti-Jewish resentment; her anti-Semitism now acquires a function. She was convinced there was a mission she had to fulfill: liberating the Jews from their Jewishness. She received ideological support from such friends as the highly regarded cultural historian Josef Strzygowski. Alma "quivered with joy," as she wrote in her diary, when the professor confirmed to her she had "made" Gustav Mahler "brighter" and led him away from Judaism: "That was what I had always felt, but I was even happier when I finally heard the word from someone else! I made him brighter. So my presence in his life was a mission accomplished after all?! That alone I always wanted, all my life! To make people brighter."[85] Nevertheless she had to admit to herself that she could not carry out her assignment with Oskar Kokoschka. "He retains the upper hand, resents me for it and doesn't move forward."[86] As fatuous as this kind of remarks may appear, in a very interesting way they reflect Alma's inner world. By "making" Jewish men "brighter," which for the affected individuals came across as humiliations and tortures, she boosted her self-esteem, assigned herself a noble task and thus ascended to a position as "Aryan muse" of internationally significant rank. Not only was Kokoschka not a Jew, but his personality was moreover too strong to get caught in the gears of this mechanism—and so the affair was doomed to failure, as Alma finally discovered. "Oskar Kokoschka is the evil spirit of my life," she noted at the end of October 1914. "He alone seeks my destruction. One cannot cleanse what is soiled—and when he embraced me the first time, everything inside me warned me of his evil eye, but I wanted to make him good—and might have been made evil myself by him. Oh—by this evil fascination! My nerves are shattered—my imagination ruined. What foul fiend sent that one to me?"[87] With this realization, all her inhibitions fell away, she felt herself no longer bound to Kokoschka in any way. Now, whether it was with the wealthy industrialist Carl Reininghaus or the composer Hans Pfitzner, Alma again lapsed into a spasm of noncommittal flirting. While she regarded Reininghaus—"an ancient, shaky codger"[88]—as a pitiable individual, she connected Pfitzner with his "manly music and poetry." Alma describes

a get-together with the composer, quite obviously enjoying her newly won position: "In the evening we sat on the sofa, he took my feet on his lap and stroked them. That was the first evening. The second evening: laid his head over my breast. I stroked his hair—what else was I to do? He wanted to be 'kissed.' I finally did it out of emotion for the poor soul (but only on the forehead)! He wanted more—then I began, in great superiority, to show him the way of pure feeling. Then—this fine poet and musician said literally: 'Well, what shall we do now? Am I going to possess you—or not?' I found him only comical at that moment. For a short while, I still let him speak of 'us,' but this rough-hewn, short, weak bundle of nerves came across to me as pathetic! That's how our artists are. When it comes to living life—they become dilettantes!"[89]

4

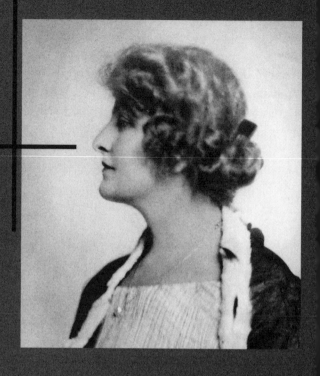

Marriage
at a Distance

1915 – 1917

SELF-DECEPTION

In early December 1914, Oskar Kokoschka was advised of his imminent conscription into the armed forces. "As I was draft eligible," he remembers, "it was clear I would be better off enlisting as a military volunteer before being forced to join up."[1] That was the official version. Anna Mahler told it like it was when she reported that her mother was not completely uninvolved in this decision: "Alma had called Kokoschka a coward for so long that he finally 'volunteered' for military service. . . . Kokoschka had no desire whatsoever to go to war, but she had already had enough of him, he was just too strenuous for her."[2] Kokoschka must have been terribly despondent at this point if he saw the battlefields of World War I as the only way out of his hopeless relationship with Alma. He had wanted "to be under fire for so long," he wrote to her, "until all the evil in me has fallen away."[3] Owing to the intercession of his friend Adolf Loos, Kokoschka was assigned to duty in the Dragoon Regiment No. 15, the most exclusive cavalry unit in the monarchy.[4] To raise the money to pay for his horse, as required by this elite regiment, he actually sold, of all things, *The Bride of the Wind*, the very painting that shows him and Alma in a close embrace, which lends the whole story an ironic undertone.

Despite all their differences, Alma and Kokoschka rang in the New Year together at Breitenstein in the Semmering. Clearly, after an extended abstinence, they slept together again New Year's night—in a letter two days later Kokoschka thanked her for having lured him into her bed "with such unforgettable beauty and such unforgettable dignity."[5] But this convergence, at least from Alma's side, was not genuine, because that very same night she wrote a longing letter to Walter Gropius. "My wish for you is that you may return safely from the battle, your sweet, beautiful nature itself will take care of everything else, then I need wish no more." Possibly Oskar was right there, sleeping in her bed, as she complained of her loneliness. "The time will come when I can bring you out here—here, where you once measured the tract for me with your

(*previous page*)
FIGURE 4.1 Alma Mahler-Gropius, 1915.

steps. I press your hands. Alma."[6] Kokoschka, who was scheduled to begin his military service in Wiener Neustadt on January 3, 1915, had gained new hope from his experiences on New Year's night. Only three days later on the army base, he asked one of his superior officers, a major, for a furlough, but it was not granted. His high spirits did not last very long. When Kokoschka noticed that Alma had not changed and was continuing to flirt with other men, his patience was exhausted. His hatred was largely directed at Alma's friends such as Paul Kammerer, Arnold Berliner, and Josef Strzygowski. "Especially that foolish 'cabinet' frog [a play on words; a 'cabinet' in Austrian German is the smallest room—*Kammer*—in the house: the toilet], but they are all included, whether their names are Wiener, Berliner, or Budapester. As are the reverend clergy, who have been 'modernized' and disabused of the bit of brain power and despotism they had back in the Renaissance. And if you put me in cold storage for a while longer, then I'll just stab one of your Tobbys."[7] Alma defended herself ably in her regrettably no longer preserved letters and evidently even told him that if he was being cheated on, he had it coming.[8] "You've now heaped so much abuse on me every day," he complained at the end of January, "I was almost amazed at your wealth of invective."[9] But she was not only showering him with savage insults; she also wrote affectionate letters to him at the army base. This rapid back-and-forth set him wondering: "Your letters are just as rare as they are dissimilar, so that I don't know what you really want, and what annoyance motivates you to say these things."[10] Kokoschka did not know the reasons for Alma's maneuver; he wasn't aware that she found herself facing a significant decision in the spring of 1915.

Back in mid-February, she had traveled to Berlin accompanied by Lilly Lieser to visit Walter Gropius—"with the shameful intent of getting that bourgeois son of art where I want him." After clarifying the situation—Gropius took her to task for her liaison with Oskar Kokoschka—their old love rapidly flared up once again. "I brought him to the station—but there love took hold of him so powerfully that he spontaneously pulled me up onto the train as it was already moving down the track, and I found myself, whether I wanted to or not, traveling to Hannover with him. Without a nightgown, without the smallest comforts or aids, this way I became, rather forcibly, the prey of this man. I must say, I really didn't mind it at all." A few days later Gropius came back to Berlin: "He suddenly took on the manners of a husband—did everything to ensure that I was expecting, and I tremble even now, that it happened. Then he traveled lighthearted and proud, as if after a mission accomplished, back to the battlefield."[11] The time she spent in the German imperial capital

left Alma's emotional state in total disarray. Gropius's bold action was not the only thing that upset her, but also the realization that her friend Lilly was lesbian and was making a play for her. "My terror of perverse individuals had always been very strong,"[12] she noted back then in her diary. On her return to Vienna she plunged into the social whirl. In her "red music salon," the heart of the apartment on Elisabethstrasse, she received old friends and acquaintances like Richard Specht, Gerhart Hauptmann, and Hans Pfitzner, who again wooed her. She could only smile at his pathetic efforts to get closer to her: "Cats always fall on all four feet—men on three!" Hauptmann and Pfitzner were burning "with fervor for the war," Alma noted approvingly; however, when Olga Schnitzler, Arthur Schnitzler's wife, happened by, her nationalistic euphoria was forgotten. Alma wrote: "She is a loud-mouthed, stupid Jewess."[13]

After the Berlin stay, Alma had written to Walter Gropius: "It stands before me clearly—as my most ardent wish—to become your own, your wife, forever."[14] Yet even if these lines seem to express a firm commitment, Alma was not at all sure of her decision to marry Gropius. Paul Kammerer, in whom she confided, put his finger on her actual problem in a letter:

Today, during my impromptu visit after dinner, you asked me once again if you should marry, and more urgently justified your wish with the necessity to reintroduce your natural-physiological destiny after all into your young life. I did not answer this as I should have. You make your total devotion dependent upon a conviction on your part that the man, exclusively and reliably, in terms of both time and intensity, is your own, that he is neither a "flirt" nor an "imp." But there is still one component missing here, one you found too obvious to list separately: by all means, it is necessary for you to love the man. This condition is, however, if I have understood you correctly, and am not deceived in many things, not fulfilled toward the man to whom you are now contemplating giving yourself as a wife. This is exactly why my advice, after long and thorough consideration, would have to be "no"!

Kammerer's analysis was right on target. After the relationship with Oskar Kokoschka had run its course, it was not so much an inner urge that had Alma believing she had to marry Walter Gropius. It had much more to do with a social, in any case exterior, convention that had her thinking she needed to marry again—today we would call this eleventh-hour panic. Love, despite many a rapturous night, was just not part of the game, and we get the impression Alma had reduced Gropius to his attractive exterior, which was in keeping with her "natural-physiological destiny." One of the curious twists of

this story is that Kammerer, in the same letter, ultimately brought himself into the picture as the most promising candidate and claimed "that the necessary conditions are better met in my person."[15] Alma probably had a good laugh over this, and by the same token she also didn't take the irksome declarations of love from the fifty-six-year-old conductor Siegfried Ochs seriously: "I was appalled by his somewhat viscous avarice."[16]

These different advances, which all reached Alma at the same time, may have flattered her vanity, but they ultimately led only to irritation and depressive rumination. "I don't understand anything at all," she noted in early April. "I must be in pretty bad shape because I feel as if I have lost every chance at happiness forever."[17] And so it is hardly any wonder that her behavior toward Walter Gropius was marked by great indecisiveness. On April 6 she wrote in her diary: "I know exactly what's wrong with me—I love W.G., haven't heard from him for fourteen days and I am sick with longing over it."[18] Only two days later, this passion abruptly changed into a cool distance: "Today I got a blunt, angry letter from W.G. I was deeply agitated—and deeply shocked—but more and more I feel that this person is not what my life is all about. His jealousy of O.K. is boundless! That much Aryan thoughtlessness would at least have to have been coupled with sorcery in my vicinity to be able to endure it; but coupled with philistinism, it is utterly unjustified. O.K. may be thoughtless. But this individual, this little, common individual! On your knees before me if you would be so kind!"[19] And another twenty-four hours later, it even says: "God—give me strength for this and strike him with lightning—that will singe him so badly it will put an end to my shame! Let him, who has afflicted me with so many ugly wounds, be destroyed. I hate his existence! I love ... hate ... love ... hate...."[20] Whatever awful transgression Walter Gropius might have committed, the vacillation between downright childish-stubborn arrogance and rhapsodic eccentricity determined Alma's inner emotional state in the spring of 1915. And so it is also significant that the final separation from Oskar Kokoschka is not traceable back to a decision that matured within Alma's mind, but rather ultimately triggered by an outside occurrence. The already overstressed situation got even worse when the Viennese author Peter Altenberg published his latest work. Alma would hardly have taken any notice of this *Fechsung* (Harvest), a small collection of prose sketches and ironic aphorisms drawn from everyday life in the big city, had Altenberg not also portrayed her "in deep mourning clothes" attending a performance of Gustav Mahler's *Kindertotenlieder* (Songs on the death of children) in the "Grand Golden Hall" of the Vienna Music Society. With the thoughtlessness of a satirist, Altenberg describes the hypocrisy,

the bogus *grandezza* of the scene, and exposes the phony, farcical nature with which Alma presented herself as the mourning widow:

Emotion was feigned. The lady in mourning clothes sat there and concealed her sorrow from the people. — — — The "consecration of the departed" was feigned. Whenever anyone cleared his throat, people said: shhh! Perhaps she was thinking of the shore of the Wörthersee, where her child and her husband had tanned themselves in the sunlight. — — — By her side sat someone who was all too eager to lift the burden from her shoulders. — — — He was, however, quite helpless. He only thought: "How helpless we willing helpers are!" Then he offered her bonbons from Kugler's confectionery, "crème de mocha," — — — "I can't take off the wrapper because of my gloves," she said softly. Then he blushed bright red at the honor of doing her some service. — — — He went about it with such timorous meticulousness that she had to smile. Indeed she smiled. The third Kindertotenlied wept: "Tá da tá, tá da tá, tá da tá da tá da tá. — — —"[21]

Doubtless, Altenberg's sarcasm is directed mainly at Alma and her staged mourning. He even satirized her mannerisms, by ending sentences, as she often did in her letters, with three dashes, stretching the whole thing into infinity. The fact that a mocha bonbon could more strongly hold her attention than the *Kindertotenlieder* was clearly the satirical high point of this anecdote. When she read this, Alma was beside herself and determined to defend herself against this exposure of her person. Paul Kammerer, to whom she turned for advice, suggested she enlist the help of journalist friends to launch a press campaign against Altenberg.[22] But things wouldn't get that far. The Berlin publishing house S. Fischer Verlag declared itself willing to expunge this disrespectful portrait from future editions of the book.

Alma's fury was now unleashed on Oskar Kokoschka. "Altenberg nailed me to the wall in his last book, I just read it. Nothing but lies from A to Z." And further: "Threaten him with a couple of slaps in the face or something else and punish your friend Loos as well."[23] Kokoschka felt he was being unjustly attacked and assured her: "I haven't seen the old Jew [Altenberg] for four or five years now, and I also did not number him among my friends before, we've rather been avoiding each other! So there's no point blaming me if somebody mentions you in his book; the tastelessness of the author alone is more than sufficient to rejoice the heart of a woman like you, who is well known in Viennese concert life, by subjecting her to a verbal thrashing."[24] Since Alma apparently held Kokoschka accountable for everything that went wrong in her

life, this was the straw that broke the camel's back. In that same letter, Oskar informed her that he had—on April 24, 1915—just volunteered for service on the front. Knowingly taking his own death into account, Kokoschka presumably saw this fateful step as the last possibility to assume control of this pathological relationship with Alma Mahler. It remains unclear how Alma reacted to the news; if her further behavior is any indication, she might possibly have regarded herself as liberated from him.

By the middle of the year, Alma had "hit a dead end with the idea of Walter G. I'll find my way out again, even if it's the end of me!" With remarkably clear vision she describes her infatuation with Gropius as a "dead end," as a kind of self-deception: "Today I feel just a bit more liberated once again, although he is certainly kind to me, however he is just tepid, and I am hot—that will never work. Now, at this very moment, I got a letter from him, but it has no effect on me."[25] By describing Gropius as "tepid," while characterizing herself as "hot," she puts her finger on the different temperaments, which would not, however, ultimately cause the breakdown of their relationship. The educated, sophisticated, and certainly also somewhat stiff Prussian from a good family was simply too boring for Alma. Decades later Anna Mahler remembered that her mother had always said that Walter Gropius was "so awfully dull."[26] Intuitively, and not just after speaking to Paul Kammerer, Alma must have known that the alliance with Gropius could not become a happy one. Nevertheless, she pressed for an early wedding. "When you get leave time," she wrote Gropius in June, "I'll go to where you can see me quickest—I'll bring my papers along, and we'll get married . . . without a soul finding out about it."[27] There is actually only one explanation for this incongruous behavior: since breaking up with Kokoschka, Alma had suffered from disorientation, for which she wanted to compensate by marrying the attractive—but, in her eyes, somewhat tedious—architect. "I am so miserable," she lamented, for example, on June 18. "I am completely uprooted. What has happened then? I don't understand anything anymore. I lie in bed and cry, and Gucki is bewildered, she has no idea whatsoever what to make of this. This child is my blessing." Once again her feeling of gaping emptiness was torturously apparent: "What am I left with—a horribly empty chasm!"[28] If we observe Alma's state of mind in those weeks it is not hard to trace a parallel to the final stage of her relationship with Alexander von Zemlinsky. Although this friendship had long since come to an end, Alma always tried to use maudlin playacting and theatrical poses to revive her feelings for him. Even now, fourteen years after her relationship with Zemlinsky had ended, her letters to Gropius are one single gigantic spasm of

exuberance. "I tremble at our ferocity," she wrote to him, her husband, whom she—his wife—she assured him, was constantly thinking of "(never away for a single second)."[29] She occasionally signed her name Maria Gropius: "Kissed, beloved name! The name of my lord and master."[30]

Despite hysterical-ecstatic remarks like this, it was impossible to overlook the fact that this marriage to Gropius was over before it could even begin. We can only speculate on Gropius's reasons for agreeing to the wedding, despite this hopeless point of departure. Quite a few things suggest that he had simply forgotten the twists and turns of the past years and really loved Alma. Perhaps he wanted to bring his life, which had been thrown off-kilter by the war, back onto the bourgeois track, hoping that the great European slaughtering would not last too long, and then he and his wife could found a family. Whatever the reasons, both of them—Alma and Gropius—were fully aware that this would initially have to be a marriage at a distance.

The marriage of Walter Gropius and Alma Mahler took place secretly in Berlin on May 18, 1915. The external circumstances were prosaic. When the couple exchanged vows on that Wednesday at Registry Office III on Paro- chialstrasse, obviously no members of their families were in attendance. The witnesses came, in the most literal sense, off the street: the twenty-eight-year old mason Richard Munske and the twenty-one-year-old army pioneer Erich Subke must have been coincidental passersby.[31] The bridegroom had only been granted a two-day special furlough and had to return to the front immediately afterward, so a romantic honeymoon was out of the question. "Yesterday I got married," Alma matter-of-factly wrote in her diary; "I have landed. From now on, nothing will knock me off my track—my desire is pure and clear, I have no other wish but to make this noble man happy! I am liberated, blissful, calm, excited—more than ever before! May God preserve my love for me!"[32]

When she got back to Vienna, Alma began a married life without a hus- band. Officially she was now Mrs. Alma Gropius, but now and then she also called herself Alma Gropius-Mahler or Mahler-Gropius. Apart from that, her marriage hadn't changed much. She was still alone.

The passionate affair with Oskar Kokoschka would have an even more in- glorious epilogue, in which Alma did not reveal herself in the most favorable light. On August 29, Kokoschka was severely wounded in battle near the small Ukrainian town of Vladimir-Volinsky. His friend Adolf Loos wrote a letter to the author and art critic Herwarth Walden describing the nearly unbelievable story in detail: "OK was shot in the temple during an attack near Luck on the 29th of August after he had been in the field for a month. The shot pierced

his ear canal and went out the back of his neck. His horse also fell. He landed in among four dead horses, crawls out, and a Cossack stabs him in the chest [lung] with his lance. The Russians dress his wound, take him prisoner, and remove him from the scene. At a railroad station, he bribes his guard with 100 rubles to carry him off the train. Now lies in the station under the supervision of the Russians. Two days later the Austrians attack the station. Walls cave in, OK remains safe and sound! The Austrians take the building, and OK can hand over the few remaining Russians as 'his' prisoners."[33]

In Vienna the rumor made the rounds that Kokoschka had not survived this attack. An undertaker even contacted his mother and offered her a bargain price for transporting her purportedly deceased son back to the homeland. Alma also took it for granted her former lover had died. "That didn't stop Alma Mahler," Kokoschka wrote with more than a touch of bitterness in his autobiography, "from going straight to my atelier, for which she had the key, and having sacks full of her letters removed from there. War makes people hard. I found this too cold-blooded and not at all in keeping with her passionate character." Alma also helped herself to designs and drawings he had left behind in his atelier, and is said "to have made gifts of these drawings to young painters, who unfortunately mutilated them by completing them so they would be suitable for sale. Perhaps she wanted to use this to get rid of her pangs of conscience. Balance of a mission gone awry!"[34] Kokoschka sent a message to Alma through Adolf Loos, asking her to visit him just once at his sickbed. Too late. "I knew before that any attempt to turn yesterday into tomorrow would come to naught."[35] Alma had finished with him. During this time she wrote to her husband about Oskar Kokoschka: "None of this, however, bothers me. I don't believe he's as badly wounded as he says he is. I don't believe one thing this man says anymore."[36]

WAR ON TWO FRONTS

"Been married now for over a month," it says in the diary entry on September 26. "This is surely the oddest marriage imaginable. So free and unattached. No one pleases me. I almost prefer females today, because at least they aren't so aggressive. But I am so eager finally to sail into my harbor."[37] What Alma had praised as an advantage just a few weeks after the wedding, namely her independence, was developing over the course of her first year of marriage into a burden. Gropius may have spent the few furloughs from the front to which he was entitled mostly with his wife in Vienna or Breitenstein; nevertheless

the couple suffered under the long separations. "I hate the war!" Alma wrote. "Dear God—let the war be over soon! I can't take it anymore."[38] One more major shortfall soon came to the fore: her bad relations with her mother-in-law right from the beginning. Manon Gropius, the widow of a Prussian privy councilor, and Alma, the glamorous widow of a universally celebrated composer, had nothing to say to each other. Not only did the two women belong to different generations—they represented different worlds. They took—to put it mildly—a skeptical view of each other right from the start. In the spring of 1915, Manon Gropius was still warning her son about Alma; now—a few months later—this conflict escalated. Alma regarded the marriage with this architect, who was still largely unknown at the time, as a social come-down and had the tactlessness to use her letters—which may well have been addressed to him but were directed toward her mother-in-law—to make it clear "that the doors of the whole world, which stand wide open to the name Mahler, slam shut to the totally unknown name of Gropius. Hasn't she ever given one thought to what I have given up for this?" But even that wasn't enough. "Let her simply listen to a symphony, then she certainly will—perhaps understand much more—although I place very little faith in her judgment. I stand above all of this—but because she doesn't—it might perhaps be high time to let her know there are hundreds of thousands of privy councilors walking around—but there was only one Gustav Mahler, and there is only one—Alma."[39] At another point, she complains to Gropius: "I am a bit tired—and your mother is a stranger to me. There is no way to bridge her narrows." And beyond all this, she has "no idea what a human being is."[40] And yet Manon Gropius appeared to exert her every effort for Alma, getting only disparagement in return. "I got this horribly boring letter from your mother again. There is nothing to be done. Her bogus existence is only upsetting to someone—never beneficial."[41] Sometimes Gropius had to put up with harsh instructions about his mother. "First, she must be made aware," Alma arrogantly stressed, "so she will know where I come from, what I am giving up, who I am, and how she must behave toward me." When Manon Gropius evidently complained to her son that Alma had been in Berlin for a Mahler concert and hadn't bothered to get in touch with her, her daughter-in-law replied impersonally: "Tell her, had I come to Berlin for a Mahler concert, she would have found out in plenty of time from the newspapers." The end of the letter could hardly have comforted Gropius: "Please don't be cross—your mother has become an obsession for me—and will remain so, as long as I live."[42] Walter's sister also got caught in Alma's crosshairs: "Your sister's letter is the utterance of a callous Philistine."[43]

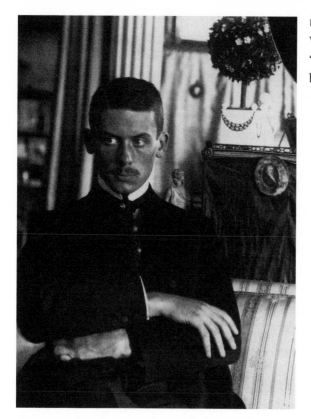

FIGURE 4.2
Walter Gropius:
"My husband must
be first class."

Against the background of the war and its mass slaughter, to which Walter Gropius was exposed on a daily basis, the letters, in which Alma bewailed her alleged social come-down or made fun of her mother-in-law, must have come across as ridiculous. Alma was clearly unable to appreciate the situation of her husband, whose life was on the line every minute of the day. And so Walter Gropius had his hands full during the breaks in the fighting trying to mediate these absurd squabbles. Like Gustav Mahler and Oskar Kokoschka before him, he also had to defend Alma from his family and friends. Time and again he felt called upon to emphasize Alma's better qualities. He still found this easy, especially as not all the letters from Vienna were overloaded with sideswipes. One of the peculiarities of this marriage at a distance was the way bitter laments were followed by ecstatic declarations of love and the exchange of everyday trivia. And so Alma bestowed on her husband erotic fantasies, which in their intimacy reveal a different, sensuous woman, who, after long deprivation, is now in quest of sexual fulfillment. "The first time we see each other again, I shall sink down on the ground before you, remain on my knees, and, kneeling,

beg you to take your sacred appendage in your hands and place it in my mouth, and then I will use all the finesse, all the refinement I have learned with you to give you a raging [illegible]. . . . Then you will go wild, clutch me in your arms and with all tenderness lay me down on the bed, which is as wide as the two of us are long—there are flowers in the room, and candles burn, and you will lay me down and afflict me with hideous tortures, because you always make me wait—until I burst into tears and implore you! Please!!"[44] At another place she asked him: "If this letter tempts you to touch your sweet appendage with your illustrious hand then at least send me the part of it that belongs to me, and I will put it into myself—this way it won't be lost."[45] She emphatically demanded that her husband also write down his sexual fantasies and send them to her, and not without concurrently raising her index finger, seemingly threatening him: "You help me—no, us, when you meet my flaming sensuality halfway, otherwise I don't know what I'll do."[46]

For a long time, Alma kept her marriage with Walter Gropius a secret. "I have been married to the architect Walter Gropius for months," she wrote as late as the beginning of February 1916 to Margarete Hauptmann. "But as this superb human being and artist has been serving on the Vosges front since the beginning of the war, I have been lonely again and living alone since our wartime wedding. That is why I have meanwhile decided to continue being loyal to my dear former name—so I can exist here undisturbed over the winter."[47] The fact that she finally broke her silence a half year later must have had something to do with her certainty that she was pregnant. She even occasionally played with the idea of moving to Berlin—a plan she nevertheless quickly abandoned. As long as Gropius was away at war, Alma wanted to stay in Austria and continue living the life she was used to. She continued to attend concerts and got together with musicians, conductors, scholars, and artists, all of whom deferentially paid their respects to her as the widow Mahler. Now and again, she made new friendships, such as the one with the lawyer and author Albert von Trentini. On a visit to Alma's salon, the thirty-seven-year-old Trentini suddenly fell to his knees before her, "put his head on my lap and wept. He said: 'Since I've known you, I have the same feeling every time. Whenever I look at you, tears come to my eyes.' This person is completely pure—an aura of something nearly sacred surrounds him. I feel very happy in his company."[48] The scion of an old noble family from the Trentino district in Austria had caught the fancy of the thirty-six-year-old Alma, and she even seemed to have fallen somewhat in love with him. When Trentini was drafted in early March, she felt "as if I were liberated," because "during that time Walter paled within me."[49]

At first Alma experienced her pregnancy as a "wonderful time: now I long for the delivery," she noted in mid-June; "it will give me a new lease on life."[50] The war, however, was becoming increasingly perceptible, even in the everyday lives of the civilian population, and for Alma, the advanced pregnancy was certainly combined with complications, especially as she was totally dependent on herself, besides having to meet her social obligations and look after both her daughter Anna and two households, in Vienna and Semmering. And so it hardly comes as a surprise that carrying out her responsibilities— without a husband and in time of war—occasionally placed heavy pressure on Alma. When Walter Gropius once innocently asked her in a letter how the reconstruction work, for which he had done some designs, on the veranda in Breitenstein was getting on, her reaction was exaggerated: "So, that's what an 'architect,' or someone who likes to imagine he is, writes to his pregnant wife—during the war—whose house stands at an elevation of a thousand meters. That truly boggles the mind. . . . As sweet as your letters were—this one has disgusted me so much that I can no longer think of you with respect. I must demand at least this much discretion from you! Otherwise I could have married a German poet in the first place, some idle dreamer with his head in the clouds.—Write and tell me if you want me to set up a day laborer's job for you?—Perhaps fixing up the porter's lodge on top of that???"[51]

As insensitive as Gropius's inquiry might have been, he certainly must have felt that Alma's irate letter was unjust. He had landed in foxholes in the direct line of fire often enough, but each time he had managed to get away with only a couple of superficial wounds. In his letters to his wife he made no mention of the unheroic sides of the war, the blood and dying—he wanted to spare her all that. The two years on the front, however, had left their imprint on Walter Gropius and worn him down—what it meant to be confronted every day with the senseless slaughter of enemy and friend alike remained concealed from Alma. Now and again she would make a scene with him by mail, as she did the time she had gone five days without a letter from him. "If you are cheating on me—then I'll do it, too—mark my word!—and I always find people! It's just that lately I haven't felt like it.—Be sweet to me."[52]

IN THE DOG SCHOOL

When, in September 1916, Alma was about to go into labor, Walter Gropius was given a two-week special furlough to enable him to stand by his wife. After the months of separation, they were both full of happy anticipation. The child,

however, adhered neither to the predicted medical schedule, nor did it respect the limitations of Gropius's furlough plan, as Alma disappointedly noted in her diary: "For fourteen days now I've been waiting for my child. Walter was here, then went away again—sad and terribly lonely, he and I are. I was so longing to put his child in his arms."[53] The parting was difficult for both of them. Gropius returned to his regiment, deeply depressed, while Alma had to wait two more weeks for the delivery. The day finally came on October 5. On that Thursday "a new, sweet girl was born to me. With the most hideous pains—but now that she is here, I am happy. I am in love with this creature!"[54] When the proud father got his first look at his gorgeous daughter, he was enraptured and raved to his mother about her "long, thin, aristocratic fingers and big eyes, which already look knowingly into the world."[55] The Protestant baptism of little Manon Alma Anna Justine Caroline Gropius took place in Vienna on Christmas 1916. Alma's relations with her mother-in-law had briefly improved. As grandmother Manon Gropius was unable to travel from Berlin for the baptism, she sent a gift. "You have no idea how much joy you have given me," Alma thanked her politely and added that she was now sure "that you still do love me a bit."[56] Walter Gropius didn't show up empty-handed either—he gave his wife the painting *Summer Night at the Beach* by the Norwegian expressionist Edvard Munch.

Despite the war and the unreal situation of having to lead their married life at a distance, Alma and Gropius tried to live like a perfectly normal family for at least a few weeks. But appearances were deceiving. Although Alma had announced in a letter written in mid-November to Margarete Hauptmann that she would be moving to Berlin after the end of the war, in her heart of hearts she scarcely believed it herself anymore.[57] In her diary, she gave free rein to her doubts: "He is at war—for a long time—over a year we have been married . . . we don't have one another, and I am afraid we might sometime become strangers to one another. I'll soon be fed up with this living for the future. A temporary arrangement forever!" She had stopped thinking about Oskar Kokoschka, who was recovering from his severe war wounds in a Dresden sanatorium; he "has become a stranger, an ugly shadow for me—nothing in his life interests me anymore." Alma was unsure of her feelings, as she noticed "that my senses tell me nothing—whether or not I can stay loyal to Walter. For I love him, and don't want to lose him."[58] Still, there was no end in sight to the hideous war. With the resumption of the so-called unlimited submarine war in February 1917, the German Reich provoked the entry of the United States into hostilities two months later. That moved the coming of peace even farther away.

Walter Gropius had meanwhile been transferred to the Belgian city of Namur, where he was placed in charge of, among other things, training military dogs at an army communications school. Although this was a perfectly honorable assignment—after all, in World War I, tens of thousands of four-legged troopers served as medical corps dogs, guard dogs, messenger dogs, and cart dogs—Regimental Adjutant Gropius may have been amused to find himself now officially heading a canine academy. Alma, however, was not. "I am still totally unable to reconcile myself with the idea," she wrote him, "of seeing you in a position unworthy of you. It is too repulsive for you—and for me."[59] She was ashamed of her husband: "Dogs are unclean animals. The thought of your looking into their mouths holding them open with your hands—it disgusts me. And besides, I find this a subordinate position. Be a good boy and train your beasts." She concluded this letter with an unmistakable demand: "My husband must be first class."[60] The now thirteen-year-old Anna had no fear of contact in this regard; she wrote to her stepfather: "Mommy told me you have become the head of a war school for dogs. How do you like your job? Mommy is very angry about it."[61] The fact that Walter Gropius had been temporarily taken out of harm's way thanks to his new assignment seemed to be of no interest to Alma. She was far more concerned with her "good name" and was under no circumstances willing to be the wife of a "dog trainer."

The birth of little Manon was, contrary to all hopes, no turning point in the marriage of Alma and Walter Gropius. Not even the little child they shared could in reality bring the two of them closer together. Alma: "I wanted to know once again what it means: to carry—bear—possess the child of a beloved man, but this problem is exhausted. My sporadic infatuation with Walter when he is with me—sometimes turns into an annoyance to me afterward."[62] Statements like these give us the impression that Walter Gropius, first and foremost, had one function in Alma's life, namely conceiving a child with her. Does this mean that the marriage with Gropius was about to fail because the descendant had now arrived, and the stud service had been performed? There were several reasons why the quietus was about to be put on this relationship in the autumn of 1917. In the first place was their different temperaments. It has already been mentioned that Alma found her husband "tepid" and "dull." By contrast, he probably had little understanding of her unpredictable moods and her inclination toward hysterical theatrics. She did not share his passion for architecture anyway, while he, as a musical layman, although interested, could not be an equal partner for her in music. And, not least, the constant quarreling between Alma and her mother-in-law must have been a further

significant and insurmountable obstacle. In the final analysis it was the war that dealt the death blow to this marriage-at-a-distance that had been doomed to failure from the outset. The separation made normal family life impossible; a permanent state of emergency dominated the scene. "The brief healing I had experienced through Walter is now vanishing because of this constant solitude: in fact being separated from him has reached the point where I can almost no longer imagine a life together with him. I am irritated—everything ails me—very sad. I really need some great joy!" And finally: "The 'man' has no further meaning for me. Walter came along too late!"[63]

5

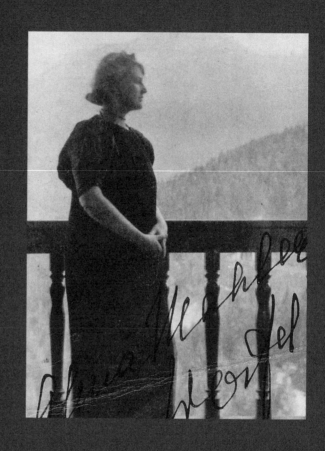

Love-Hate

1917 – 1930

DECISIONS

In the autumn of 1917, the wartime marriage between Alma and Walter Gropius, despite all the lamentations, had ebbed to a level Alma found bearable. Obviously, the thirty-eight-year-old wife had become accustomed to the permanent absence of her four-year-younger husband. In her red salon on Elisabethstrasse, bustling social activity was the order of the day—composers, writers, painters, scholars, conductors, or actors and singers gathered more and more frequently in her home. One might say that she used the time to find her true stature, the way she wanted posterity to remember her: the luxuriant or, as people back then would have put it, "Junoesque" Alma—her eyes in photographs from the time still penetrating and challenging—in the middle of the elite of the intelligentsia, all of them inspired, encouraged, or criticized by her. That was how she liked to regard herself, and it formed the design on which she patterned herself time and again. Shortly before the collapse of the Austro-Hungarian Empire, her life of sophistication began in Vienna, and it remained in place for the following two decades.

"This week was again beautiful and rich," Alma rhapsodized in mid-November 1917 in her diary. For the first time in a long time, she had seen Paul Kammerer again, met up with Josef Strzygowski, and, on November 14, she visited Helene von Nostitz, the wife of the Saxon ambassador in Vienna. When Alma came home that Wednesday evening, her friend the writer Franz Blei and his twenty-seven-year-old colleague Franz Werfel were already waiting for her. Werfel was no stranger to Alma; indeed, two years previously she had set his poem "Der Erkennende" (The perceptive one) to music.[1] They were later joined by other friends and acquaintances, such as Hans and Erika Tietze, as well as the painter Johannes Itten. At first Alma had no idea what to make of the new man in the group. "Werfel spouted some frightful social democratic jargon, but over the course of the evening he became increasingly greater, freer and purer." Nor did she find his outward appearance particularly appealing

(*previous page*)
FIGURE 5.1 Alma Mahler-Werfel.

at the beginning: "Werfel is a bowlegged, fat Jew with thick lips and floating slit eyes! But he wins one over the more he reveals of himself."[2] Decades later, Anna Mahler still remembered Werfel's unattractive appearance, especially his teeth, which, discolored by excessive smoking and coffee drinking, had already turned black. "Handsome he was not. He was short and fat, which was astounding because Mommy actually liked tall, towering people. But some kind of connection was there right from the start—a musical one, in fact. Mommy really played the piano very well, and had been forced to learn to play Verdi instead of just Wagner. Because Werfel had a gorgeous voice—tenor, no heldentenor, thank God, but more of a soft tenor."[3] Over the next weeks, Werfel was an increasingly frequent guest at Elisabethstrasse, not just for the joint music making. They had quickly fallen in love, and Alma again found herself standing between two men, who couldn't imaginably have been greater opposites. On the one side the sedate Walter Gropius, who, not least because of his traumatic wartime experiences, had withdrawn more and more into himself, and on the other side Franz Werfel, who seemed to be downright bubbling over with wit and esprit. Called upon to choose one of the two men, she weighed her options and for a short time even came up with the bizarre idea of coupling her new discovery with Anna, who was only thirteen years old at the time: "But Werfel pleases me. I'd like him to be Gucki's husband. He has one of the finest minds I know—and so endlessly free and sophisticated. A great artist!"[4] Her husband, who in early December had been transferred to the front in Italy, to help his Austrian comrades by using his own experience to instruct them in the deployment of army dogs, now also got a taste of Alma's indecisiveness. Her loathing of Walter's unheroic position took on ludicrous forms. "Since I know that I no longer have to write Head of a Dog School on the address—I can write again. I also didn't marry a man by the name of Kohn. And I ask you—if you have touched some unclean animal anywhere, don't write to me unless you have had a chance to wash yourself thoroughly beforehand.—Because I am so filled with horror of the animals around you."[5] In view of hysterical outbursts like this one, Gropius could not overlook that something was out of kilter with Alma. The increasingly hostile tone in many letters could no longer be explained away by her moodiness. Shortly after Gropius arrived in Vienna for his Christmas furlough on December 15, 1917, the husband and wife got into a series of violent arguments. While Gropius's calm, even-tempered nature, as well as his courteous, albeit somewhat stiff manners had once impressed her, she now found his presence uncomfortable. And when he "opened his mouth to speak, I was ashamed of him!" The totally confused Gropius couldn't figure

out his wife's cool and sometime hostile manner, but, of course, he had no way of knowing that, just a few weeks before, she had fallen in love with another man and now found herself in severe emotional confusion. Every day she longed for her husband's departure. On December 29, the time finally arrived: "I had brought out the last remnant of warmth," Alma remembered, "right to the end, to help me sustain the semblance of an intact relationship." To make his return to the front easier for Gropius, she put her "best smile on my face" while her "heart rejoiced." Because of an unfortunate coincidence, however, he missed the train and had to remain in Vienna for one more day. "When he came back, that gave me the full realization that my love for Walter Gropius had vanished forever. Yes—and more than that—my present feelings were more like a bored loathing."[6]

After Gropius's departure, Alma plunged into the glittering world of social life. She spent New Year's Eve with Anna at the elegant Hotel Bristol, where she rang in the New Year until four in the morning with the Dutch conductor Willem Mengelberg and a large number of other friends. Alma gave a grand reception in honor of Mengelberg on New Year's Day. Besides several representatives of the high aristocracy, the guest list included such luminaries as the composers Franz Schreker, Julius Bittner, and Alban Berg, the banker Paul Hammerschlag, the painter Johannes Itten, the music critic Ludwig Karpath, plus Lilly Lieser and Franz Blei, as well as Franz Werfel. "The evening seems to me to have been a great success," she proudly noted. "My moments of happiness were the ones when I could somehow talk unnoticed with Werfel. I have to hold on tight to my heart, otherwise it will fly away."[7] When Alma and Werfel attended a performance of Mahler's Fourth Symphony in early January, they exchanged rapturous glances. During the intermission she clandestinely took him home. "It happened as it had to happen," she wrote the next day; "he clutched my hand and kissed it, and then our lips found one another, and then he stammered some words without meaning or context, and yet those words were so absolutely true." Alma sensed a "deep spiritual kinship with Werfel," and even spoke of a "divine experience."[8]

The rapturous frenzy came to an abrupt end when Werfel had to resume his duties in the Austrian military press corps. A number of distinguished Austrian writers such as Robert Musil, Stefan Zweig, and Hugo von Hofmannsthal worked in the Kriegspressequartier (war press office), or KPQ, as this unit was known, supporting a war machine (which most of them despised) by supplying the press with articles about perseverance, or inventing sentimental soldier tales. Franz Werfel also had to exert his efforts toward the creation of

war books for children and lyrics for marching songs.[9] In mid-January 1918 he traveled on orders from the press corps to Switzerland, which was completely unscathed by the war. There, oddly enough, he was assigned to give propaganda speeches. Werfel was aware of how to take full advantage of his stay there, by giving over a dozen lectures until mid-March, reading over and over again from his own works. These events, as well as the opening performance of his translation of *The Trojan Women* by Euripides at the Municipal Theater in Zurich rapidly made the young author well known. When, however, he spoke to a gathering of workers in the small town of Davos, denouncing both the bourgeoisie and militarism, he had gone too far. Franz Werfel received orders to discontinue the lecture tour forthwith and return to the KPQ in Vienna.

DOUBLE-CROSS

When Werfel arrived in Vienna at the end of March 1918, Alma was already in her third month of pregnancy. Initially, she wasn't sure who the father of the child was. She hoped that the conception had taken place in that January night after the Mahler concert and not at the end of December when Walter Gropius was spending his Christmas furlough with her. The situation, which was dodgy enough to begin with, would get even more complicated when Gropius, after being severely wounded, had himself transferred to a military infirmary in Vienna, thus moving to the vicinity of his pregnant wife. This forced Alma, who had wanted to keep her perfidy a secret, to lead Gropius to believe the child was his. The pregnancy ran its course uncomplicatedly; in Breitenstein, however, where Alma, Anna, and Manon had moved in the summer, a number of war-related shortages began becoming apparent. Apart from old seed potatoes, polenta, a cheap meat substitute, and various mushrooms, there was nothing to eat. At the end of July, Franz Werfel traveled to the Semmering: "Werfel and I lived our intoxication further and unfortunately paid very little attention to the unborn child inside me. We carried on with total thoughtlessness in our drunken stupor."[10] But their untroubled reverie soon came to an end. Emmy Redlich, the wealthy wife of the sugar manufacturer Fritz Redlich, and her eighteen-year-old daughter had also announced their visit, and so the two lovers were aware of the need for discretion. In the night from the twenty-seventh to the twenty-eighth of July, disaster struck. After Alma and Anna had played almost the entire second part of Mahler's Eighth Symphony on the harmonium in the evening for their burdensome guest, Alma still had to make conversation with Emmy Redlich until late in the night. After they had retired

to bed, Werfel sneaked into his beloved's room. "We made love!" he wrote a few days later in his diary. "I didn't go easy on her. Toward morning, I went back to my room."[11] At dawn, Alma woke up and felt unwell: "I turned on the light with trembling hands and saw that I was standing in a pool of blood."[12] She immediately began frantically ringing the bell. Anna, Emmy, and Maude, Alma's English maid, rushed in and found the bedroom looking like the scene of a horrible massacre. Franz Werfel was woken up by Maude and asked to get a doctor as fast as possible. He suspected what had happened. The passionate lovemaking had caused the pregnant Alma to start hemorrhaging profusely. Still completely dazed, he raced across the rain-soaked fields and meadows to a sanatorium, where he woke the physician on duty out of a sound sleep. As the doctor suffered from tuberculosis, he was only able to walk very slowly. On the way the two men ran into Anna, who was hurrying into town to phone Walter Gropius and tell him what had happened. Werfel joined her while the medical man discovered a self-willed patient in the Villa Mahler. "I took one look at his butcher's hands," Alma noted, "and told him I would not allow him to touch me."[13] Werfel reproached himself severely and wanted to leave Breitenstein that very afternoon. At the station, he looked on unnoticed as Walter Gropius got off a military train accompanied by a prominent professor of gynecology. After considerable discussion back and forth, Alma was transported back to Vienna on July 31. The war made the transfer into a strenuous procedure; the sick woman actually had to cover the final portion of the journey in a hearse. When they arrived at the Sanatorium Loew, the very place where Gustav Mahler had died, the doctors acted fast. The child and mother could only be saved by inducing labor. In the night from August 1 to 2, in excruciating pain, Alma gave birth to a boy. Walter Gropius remained by her side throughout, believing himself to be the father of the child. Franz Werfel was overwhelmed with worries over Alma and the child. When he finally learned of the positive results of the operation, he praised God and wrote a panegyric letter to his lady love: "You holy mother! You are the most magnificent, the strongest, the most mystical, most goddess-like I have ever encountered in all my life. At every moment, in every test of your life, you are perfection."[14] After she had recovered somewhat from the stresses and strains of the delivery, Alma and Franz wrote to each other every day, the letters delivered by messengers. In her longing letters, she addressed him as "my beloved husband" and signed her letters "Alma Maria Werfel." She was meanwhile suffering from the masquerade she was playing with her husband. "The hardest thing for me now is being together with W.,"[15] she let Franz Werfel know. In another place, she wrote: "Poor W. is

suffering terribly. He feels that every word he utters gets on my nerves, doesn't understand why I am so cold and has no idea what to do. But I can't simulate something I don't feel—I just can't. He knows I don't love him anymore, he is racking his brains over how he might change things—I'm at my wit's end."[16] While the cuckolded husband continued feeling his way in the dark, Alma and Werfel exchanged ideas in their letters about what to name their child. They wavered between Gabriel, Daniel, Martin, Matthias, Albrecht, Gerhart, Lukas, and Benvenuto. Alma favored Gerhart: "It is an old wish. Oh, if only I could call him Gerhart Franz."[17] Werfel was not very keen on this idea, and perhaps she also shied away from the association with Gerhart Hauptmann. He suggested taking some time choosing a name.

While Alma was billing and cooing on the telephone with Franz Werfel on August 25, Walter Gropius walked into the room unnoticed, and this abruptly put the quietus on the game of hide-and-seek. He demanded that his wife account for herself, whereupon she confessed everything to him. It came to a series of arguments, which took quite a toll, especially on Franz Werfel. "What's going to happen now?" Werfel wrote. "He'll fight back! He'll do battle for you, he won't let you stay alone in Vienna."[18] His fears were not altogether unjustified. Although Walter Gropius paradoxically harbored amicable feelings toward his rival from then on, he reacted by largely maintaining his calm and self-control. Nevertheless, he wasn't about to give up Alma totally. And Alma had no idea what to decide—she saw herself subjected to severe mood swings, which made her highly insecure. "I committed a deadly sin today," she confessed to her diary in late October. "I gave myself, out of sympathy and without the least sensation, to my husband [Gropius]."[19] Even though her feelings for him had dried up, she still found it hard to call it quits with Walter Gropius. And Franz Werfel had meanwhile lost quite a bit of his fascination for her. Even petty trifles were now bothering her: "He [Werfel] lives in a shrine to shabbiness, the likes of which I have seldom seen." Not only did Alma find his home furnishings cheap and tasteless; she had the feeling "I had walked into the room of an art dealer's mistress." She left Werfel's apartment disappointed and insecure. "Is this going to work? I certainly couldn't live with such a lax individual! I know less than ever what has to happen."[20]

A short time later, the first major dispute between Alma and Franz Werfel came about. On November 3, Austria-Hungary concluded an armistice with the Allies. On November 9, Kaiser Wilhelm II abdicated, and the German Republic was proclaimed. Two days later, the World War came to an end with the signing of the armistice treaty between the Allies and Germany in

the northern French city of Compiègne. And on November 12, one day after the abdication of Kaiser Karl of Austria, the Provisional National Assembly proclaimed the Republic of "German Austria." On that Tuesday, Franz Werfel appeared—thrilled and full of zest for action—at Alma's apartment. He wanted to fight his way through the crowd to the area around the Vienna Parliament, where hundreds of thousands of people had gathered. His friends from the Red Guards, a recently founded organization modeled on the example of Bolshevism, were waiting for him. First he wanted to ask Alma for her blessing: he would not go, he besought her, until she sent him off with a kiss. Alma did him the favor, and he plunged into the fray. When he came back to her later that evening, she was appalled: "His eyes were swimming in red, his face was bloated and covered with dirt, his hands, his clothes—a complete mess."[21] Alma disgustedly turned away from him and sent him away. The visit to Werfel's apartment along with his participation in the revolutionary events of November had led to a disillusionment that would radically change relations between Alma and Franz Werfel. In those days, the future balance of power was established. It would be Alma's task to give the relationship a sense of direction, to determine levels of distance and closeness, and so she assumed the dominant role. Franz Werfel, still incomplete and easy to influence, took the part of the weaker link, and most probably was not unhappy to let her steer his course for him. And so Alma was firmly determined to put an end to Werfel's unsteady coffeehouse existence. At the next opportunity, she decided, he was to withdraw to her home in Breitenstein, where he would live for a long time by himself, so he could write.

SOFTENING OF THE BRAIN

Although Alma's son had been born prematurely, he had made it remarkably well through the dramatic circumstances surrounding his delivery. Suddenly, however, unexpected complications arose. A severe dropsy of the brain, became apparent, one that caused the infant's skull to swell up massively. The doctors were anything but optimistic as they observed the progress of the disease. At the end of January 1919 they advised the parents to allow them to drain the swelling. While this surgical intervention would be very painful for the child, it was the only way to prevent lasting damage. "If only our child would recover," Alma begged four days after the operation, "then all will be well."[22] The agonizing procedure, however, did not lead to the desired success, thus making further punctures necessary. But nothing helped: the little boy's

head grew to monstrous proportions. Although Werfel touchingly cared for Alma, she withdrew from him. She had "the sudden realization that Werfel must disappear from my life," she wrote on February 14, "that he is the source of all my unhappiness."[23] Finally she made the alleged inferiority of his race and his "degenerate" seed accountable for the child's illness, as a contemporary witness recalled.[24] "High time for a turnabout," was Alma's conclusion. "I sent him to work on the Semmering, and there he shall now stay. I have no desire ever to see him again."[25]

The physicians treating the child told Alma her little boy didn't have much longer to live. She hurriedly had the child christened Martin Carl Johannes. Alma was overstressed with taking care of him at home, so she put her son in a hospital. She continued keeping her distance from Franz Werfel. While he may have been allowed to visit her in Vienna in March 1919, Alma got the impression "that Franz is not the right man for my current physical state."[26] As she had done before, she went on wavering between her men: she may have loved Franz Werfel, but at the same time she also had a high regard for Walter Gropius's "excellent character." She was afraid of Werfel, yet concurrently feared "the gray on gray of an existence with Gropius."[27] When, at the end of March, Oskar Kokoschka checked back in, Alma's emotional state went completely off the rails. The painter sent her a message through Baron Victor von Dirsztay, saying that he still loved her as he had before—according to Alma, "worse and more fervently than ever—his every thought and deed were dedicated toward the task of winning me back."[28] Alma was confused: "Since I have again heard from OK, I am once more full of longing for him, I wish that all the obstacles, which were ultimately all of my doing anyway, might be removed so I can live my life to the end with him."[29]

Franz Werfel was baffled by Alma's emotional escapades. He demanded clarity from her and hoped she would decide in his favor. Inwardly, it was clear to Alma that a replay of her connection with Kokoschka couldn't possibly have any future, especially as people were telling stories about him all over Vienna, which considerably alienated Alma. Kokoschka had gone mad, they said, and was now living with a doll. In actual fact, as far back as the summer of 1918, he had ordered a life-size doll from the well-known Munich doll maker Hermine Moos. He had sent the seamstress a number of detail drawings illustrating how he wanted this fetish to look. "Please make it possible to enjoy the feel of those places where the fat and muscle layers suddenly yield to a sinewy skin cover," he instructed her; "what I need is an experience I must embrace!"[30] When, at the end of February 1919, the doll was delivered to Kokoschka in Dresden, he

was greatly disappointed, and tried in vain to recognize his Alma Mahler in this object made of cloth and wood shavings. "The outer shell is a polar bear skin that would be better suited for an imitation fuzzy bear bedside rug, but never for the suppleness and smoothness of a woman's skin,"[31] he remonstrated with Hermine Moos. Understandably the doll was not suitable for meeting Kokoschka's sexual needs. Nonetheless he preserved "the Silent Woman," as this failed copy was now called, for posterity in several pen-and-ink drawings and paintings. He dressed it in expensive costumes and lingerie from the best fashion houses in Paris and had his chambermaid spread the rumor that he had rented a hansom cab, "to ride around with it outdoors on sunny days and took a box at the opera to show it off."[32] The story came to a sudden conclusion when Kokoschka chopped off its head and smashed a bottle of wine over it in a drunken stupor at a garden party. With the murder of the "Silent Woman," he obviously hoped to conquer the Alma inside him. "Early the next morning, as the wild party was almost forgotten, the police rang the doorbell. The officers had a strong suspicion to investigate: somebody had reported seeing a corpse lying in the garden."[33] After Kokoschka had cleared up the misunderstanding, the garbage men removed the remains of the eccentric relationship. It was certainly peculiar stories like this one that quickly put an end to Alma's flirtation with the idea of resuming contact. "It's all nonsense," she wrote in her diary on May 1: "I'm deeply attached to Franz. We have a frighteningly powerful love for each other, and hate each other with a passion. We torture each other too, and yet we are happy."[34]

In the spring of 1919, Alma traveled with her daughter Manon to visit Walter Gropius in Berlin and Weimar, where he had founded the Bauhaus in late April and thus gave a new direction to the architecture, commercial art, and design of the twentieth century. Franz Werfel was terribly worried that Alma might, in this period, decide for Gropius again. During her absence, little Martin died on May 15, 1919, from the effects of his severe illness. Oddly enough, Werfel did not find out about his son's death from Alma, but rather in a letter from Bertha Zuckerkandl. "I can think of nothing other than the child," he informed Alma, "although I have known too long how unalterable this fate was."[35] He begged Alma to come back to Vienna immediately—in vain: she didn't interrupt her trip to Germany, finally returning to Austria in mid-June. Although Alma could never identify herself with her maternal role—as she had already demonstrated in her relationship to her oldest daughter Maria, who had died so early—her complete lack of reaction to the death of her son is difficult to understand, even if we bear in mind that back then disabilities were regarded

differently from the way they are today, and deformities ("freaks") were a far more taboo topic. As far as we are able to know, Alma, in any case, never once mentioned her son after his death, either in her diary or in letters. Nor has any information come down to us about the circumstances under which the child was laid to rest.

After returning to Vienna, Alma did not immediately put any distance between herself and Werfel, as he had initially feared. On the contrary, she now wanted to put an official end to her marriage with Walter Gropius. "What do I care about the elegant gentleman with the brightly colored spats who just happens to be married to me?" And: "I am not a Gropius and so I cannot call myself Gropius either. My name is Mahler for all eternity."[36] In mid-July 1919 she asked her husband, in writing, for a divorce. Gropius agreed two weeks later, without, however, waiving his custody of Manon, which once again plunged Alma into confusion: "What should I do now?"[37] In this situation, she even made her husband the absurd offer of agreeing to spend one half of the year with him and the other half with Werfel, which Gropius understandably considered out of the question. The uncertainty over what would now happen with Manon put Alma in existential distress. "You say: 'Give me our child'! Don't you know what that means to me? Then you might just as well put a loaded revolver next to me!"[38] At the same time, she wished for another child from Franz Werfel. "It's strange," she reflected bewilderedly in mid-September, "that this feeling has not diminished in two years of the most intense physical union, but has only increased."[39] For all of this, she found Werfel's sexuality somewhat scary. She may have experienced quite a bit in her escapades with Oskar Kokoschka; however, the sexual proclivities of her new lover presented her with unfamiliar demands, as she confided to her diary in mid-September: "Franz first admitted his perversities to me and then very skillfully deployed them as phobias. I was so excited I couldn't sleep last night, I kept seeing cripples and him, and intoxicated myself on them. A one-legged person—lying down. He and I. I as a spectator, boundlessly excited, so powerfully that I had to lay a hand on myself. Now I am lying down and envisioning myself in such a situation." When Alma even went so far as to consider "how I could create a situation like that for him to bring joy to both of us,"[40] this puts a significant light on her self-image as a muse.

At this time, Franz Werfel's sexuality was a preeminent topic in Alma's diary—in still another sense. When, in the autumn of 1919, he found himself stuck in a creative crisis, feeling burned-out and powerless, Alma believed she knew the cause of his desolate condition: "He was certainly in a way destroying

himself with maniacal masturbation—until he met me. From the age of 10, this took place up to three times a day. This is why he is also so often tired and worn out, and why his cells are degenerated."[41] Certainly not the only one to pass along this myth from the prudish nineteenth century, Alma feared that he might also be stricken with "softening of the brain" and summarily prohibited him from indulging in any further self-gratification. Franz Werfel—Alma's "man-child"—also took this command very seriously; once, when he had given in to his weakness, he promptly confessed his transgression to her and solemnly swore to try harder. For Alma, whose sexual morality was certainly far more open than that of her contemporaries, it was nevertheless clear: "The more significant a man is, the sicker his sexuality."[42]

BATTLES

In late February 1920, Alma traveled with the three-and-a-half-year-old Manon back to Weimar. They first stayed in a room at the Hotel Zum Elephanten before finally moving into Gropius's new apartment. There, husband and wife went at it hammer and tongs over the custody of Manon. "I have just seen the human beast in its most repugnant form," Alma noted on March 5. "Gropius with an evil, ugly face wants half of—the child! Half of it! I have to turn me over to him completely, because I can't very well share her!"[43] The thought of having to stay in Weimar until the end of March horrified Alma: "How am I to endure this?"[44] The strained situation would ultimately be further exacerbated by political developments, when an attempted armed putsch was launched on March 13 in Berlin. General Walter Freiherr von Lüttwitz and the East Prussian general regional director Wolfgang Kapp took an order from the national government to disband the volunteer corps associations as their cue to put into action a long-planned coup d'état aimed at bringing down the unpopular republic. It took a general strike to put an end to this amateurishly organized rebellion. Armed workers rose up against the right-wing agitators in several German cities, including Weimar, where Alma could observe the hostilities from her hotel room window. She may not have been aware of the precise background leading to this uprising, but her fanatical hatred of the so-called working class alone prompted her to side with Kapp's forces.

Franz Werfel was worried sick about Alma and little Manon, especially when a full week after the end of hostilities he still hadn't received any word from them. "My Life!" he wrote: "It is pure torture for me to know you are there!"[45] Once again he was afraid the situation might end with a reconciliation

between Alma and Gropius. "It will just not do," Werfel complained in a letter, "to continue this interim situation forever. It is demoralizing. What does he want? Are you being totally sincere?"[46] At about the same time he received a telegram from Max Reinhardt inviting him to do a public reading from his new work *Spiegelmensch* (Mirror man) in mid-April in Berlin. This offer from the director of the German Theater alone was a huge success for Werfel. Thrilled, he asked Alma to visit him in Berlin and even hired a nanny for Manon. A short time later, after painful weeks of separation, Franz Werfel stood facing his adored one in Dresden. While he previously had still entertained thoughts of Alma's possible return to Walter Gropius, she declared herself to be his in Berlin. She openly appeared in public with Werfel, went with him to the cafés and restaurants of the national capital, and was always by his side as a matter of course.[47]

"I hired a young Red Cross nurse in Dresden," Alma wrote to Gropius in late March, "and she is wonderfully affectionate with Mutzi." The twenty-five-year-old Agnes Ida Gebauer had won Manon's heart in no time. When Alma discovered the young woman had no family ties, she got the idea of taking her along to Vienna: "I'll get her address—and discuss all the eventualities with her."[48] "Schulli," as everybody called Ida Gebauer, remained in Alma's employ with a few interruptions until 1964.

Once back in Vienna, the next separation from Werfel was already imminent just a few days later. On May 7, Alma and both daughters set off for Amsterdam, where Willem Mengelberg had organized a large-scale Mahler festival to commemorate his own twenty-fifth anniversary as a conductor, and the composer's widow and daughter had been invited as guests of honor. Franz Werfel brought the three of them to the station with a heavy heart, while Walter Gropius stood ready at the German border to receive his daughter. They had agreed that Manon could spend a few weeks with her father in Weimar. The days in the Dutch port city were a great success—not just for Mengelberg and Gustav Mahler's works, but also for Alma, who was being fawned upon all over. Her hotel room resembled a sea of flowers, and large numbers of friends and acquaintances were paying calls. But all the fuss over her late husband went a little too far for Alma. On May 13—the anniversary of Gustav Mahler's death—she wrote in her diary: "I don't miss Mahler, and I wanted to be the grieving widow, at which I completely failed. . . . Apart from that, I am not at all in such complete agreement with his music. It is often strange to me, sometimes even unappealing."[49] On her return trip, Alma picked up her daughter in Weimar. Walter Gropius was shocked, as he confessed to the

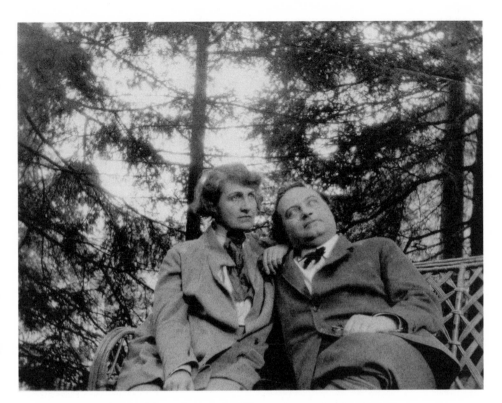

FIGURE 5.2 Alma Mahler and Franz Werfel in Trahütten, Styria, circa 1920.

woman who was still his wife that she had acquired a "horribly dissolute trait." Alma took this tip very seriously and knew immediately what he was talking about: "My imagination, out of love for Franz, is full of the most perverse images of cripples and an addiction to crippling. In the happiest moments I have blended in more and more ugly ideas that excited him. I love him and that is why I will guide him back, not allow myself to be pulled down. Thank you, Walter—thank you!"[50]

After her return home a little more peace and quiet came slowly into Alma's life. She had meanwhile come to an agreement with Gropius over the terms of the divorce settlement. The proceedings were scheduled for early October at District Court III in Berlin. Gropius proved himself to be a true gentleman: he took full guilt upon himself and even allowed Alma to appear as plaintiff against him. To prove this alleged disloyalty on the part of the husband, they staged a farce that would have done credit to any theater: a hotel room with private detectives, Walter Gropius and a prostitute, a couple caught in the act, witness examination, and sworn testimony.[51] In the end, all the actual facts

had been completely turned around. Not Alma but rather Gropius was found guilty of marital infidelity. As the evidence was unmistakably clear, the marriage between Alma Mahler-Gropius and Walter Gropius was ended, without any major complications, on October 11, 1920. And most important for Alma, she was awarded custody of their daughter. The divorce from his wife was clearly like a salvation for Gropius; this was the only way it can be understood why he allowed himself to be cast in the leading role of a pathetic farce. And somebody else was also pleased that the couple had gone their separate ways: "I could weep uninterruptedly,"[52] Franz Werfel wrote from Prague, where he had gone to prepare his family for Alma's first visit. After successfully managing to give a wide berth to Werfel's birthplace time and again, as a newly divorced woman she had no further excuse to avoid going there. As Alma always had problems with the relatives of her husbands and lovers, she initially looked toward this trip with a fair degree of skepticism. Rudolf and Albine Werfel, however, spared no effort to provide a warm and cordial reception for their son's lover. "You left a wealth of enthusiasm behind," Werfel assured Alma after her departure. "My parents love you," he gushed, "they absolutely adore you!" Albine Werfel allegedly even called Alma "the sole true queen or monarch of our time."[53]

AT THE THREE-RING CIRCUS

The new year began with bad news. "Anna has left her husband," Alma wrote on February 21, 1922, in her diary; "she's living in Berlin, and I am completely calm and have no longing whatsoever for her. What a hellish series of ups and downs!"[54] In early November 1920, Anna had married the then twenty-four-year-old conductor Rupert Koller, only to leave her husband a few months later. In retrospect, the failure of this marriage seems virtually preordained: Anna, barely seventeen years old, was basically still a child when she entered this "bond for life." After the wedding, the couple had settled down in Elberfeld in the Ruhr, where Koller was a conductor at the Municipal Opera House. Not very long afterward, however, Anna had already begun to weary of this situation and precipitately separated from her husband. The marriage with Rupert Koller was an escape from the increasingly complicated relationship with her mother. First and foremost, Alma's anti-Semitic sentiments—she was convinced that Anna carried Gustav Mahler's inherited Jewish traits in her person—led to considerable tensions. "She is like another species to me," Alma said, for instance, in her diary in late July 1920. "Cool—cunning and

Jewish."[55] One further difficulty may have lain in Alma's lifestyle. After her father's death, Anna grew up in an atmosphere that—elegantly put—was powerfully sexually charged. As a little girl she was able to observe up close how Alma behaved with her countless admirers or lovers, flirted with them or humiliated them. "Almost still a child Anna seemed to have developed the habit," said Anna's second husband, Ernst Krenek, in his memoirs, "of falling in love with her mother's lovers, of which there were quite a few. Because of these experiences she developed a complex of frustration and hate and seized the first opportunity to escape from the hell of this house."[56] Alma sensed that Anna was drawing away from her. "She despised me," Anna Mahler remembered decades later. "First, I was a girl, and second I didn't fall in love because somebody was well-known or famous or significant, but rather because somebody had pleased me. Appalling! She despised me. I had no success, no money. . . . And I know she loved me."[57]

In the German capital, to which Anna had fled after the breakup of her marriage with Rupert Koller, she plunged head over heels into the hurly-burly of an aspiring metropolis with over four million inhabitants. Anna felt Berlin was the city of the modern era. Officially, she was at the Art Academy in Charlottenburg studying painting, but the young woman—very much like her mother in this respect—spent far more time nurturing her ebullient social life, as was the case in late February 1922 when the music academy put on a masquerade ball in the pre-Lenten carnival season. There she made the acquaintance of the twenty-one-year-old composer Ernst Krenek, who had just concluded a course of study with Franz Schreker. Actually Krenek was not fond of noisy, boisterous parties, but that evening he had let friends talk him into joining in with the jesters and mountebanks. He was immediately delighted with Anna. "She is very musical and extremely intelligent," he wrote a short time later to his parents, "so much so that we enjoyed one another's company immensely."[58] Over the following weeks they spent a great deal of time with each other, and Krenek was firmly determined "to try seriously to win her over."[59]

At first Alma was cautious about her daughter's new partner. "Anna is living with some fellow out there in Berlin. It is the highly gifted cannibal, Ernst Krenek."[60] Nevertheless, she was curious, especially as Krenek, as Anna enthused, was a promising young composer with a great future ahead of him. And so Alma decided to take advantage of her approximately two-week stay in Weimar, which she had planned for her daughter Manon's sake, to make a short side trip to Berlin. When Ernst Krenek found himself face to face with the

famous Alma for the first time, he was so nervous that this otherwise highly self-assured young man seemed inhibited. There was no sign of any spontaneous amicability on either side. "Moreover," Krenek recalled, "I believe she liked me every bit as little as I liked her, and she thought perhaps she might know the reason for her antipathy, as I was potentially one of the fellows who could alienate her daughter from her forever." He had heard a great deal about Alma's legendary beauty, and now stood facing a woman who reminded him of "an extravagantly festooned battleship: she had taken to wearing long, flowing garments, so people couldn't see her legs, which were perhaps a less remarkable part of her anatomy. She had the same style as Wagner's Brünnhilde transposed to the atmosphere of *Die Fledermaus*."[61] The time the loving couple spent with their prominent visitor went whizzing by: "She really had the knack to turn life into a dizzying carousel." Alma invited Anna and Ernst Krenek to the best restaurants in Berlin, where she ordered: "lavish, complicated, and visibly expensive dishes and, first and foremost, rich beverages of all kinds and in sizable quantities." On these occasions Krenek noticed that food and drink were the core elements of her strategy for "making people into helpless subjects of her power." She beguiled and enchanted her guests and was in top form "when the senses and intelligence of her retinue were simultaneously befuddled and bewildered."[62] It is not known what impression Ernst Krenek made on Alma. Obviously it wasn't as bad as Krenek suspected, since Alma invited the young people to spend the summer months with her and Franz Werfel in Breitenstein. In the Villa Mahler, hectic activity was, as so often before, the order of the day, and Alma's many friends and acquaintances made stopovers there. "A fairly colorful individual was an Italian by the name of Balboni," Krenek remembered, "who looked like a gangster and showed up with a huge bevy of women, who, as far as I know, might well have been some kind of harem."[63] This visit was made in connection with Alma's decision to purchase a little palazzo in Venice—her and Werfel's great love. Balboni may possibly have been a real estate agent, but perhaps he might also have been the owner of the property, not far from the Grand Canal, that Alma finally acquired. The "Casa Mahler," as the palazzo was called from then on, was a two-story building, located on one of the handsomest public squares in the city, and it even had a small garden. Until 1935 the family's third home was in Venice.

But Krenek still had frequent opportunities to experience Alma and her peculiarities. In the winter of 1922, on her invitation, he plunged into the exhilarating life in the red salon on Elisabethstrasse. Since Anna, however,

didn't want to live with her mother, the young couple moved in with Krenek's parents. Nevertheless they spent "plenty of time in Alma's three-ring circus, where, as ever, life was always vivacious."[64] Here, Ernst Krenek was able to offer some interesting observations: "Alma was a great gourmande and very gluttonous, but as she knew that the huge amounts of food she gobbled down were likely to ruin her figure, she now and then fell back on the old Roman custom of artificially inducing fits of vomiting and then starting her meal again from the top." However, what annoyed him even more than Alma's eating habits was the sensuous, highly charged atmosphere in the house. "Sex was the main topic of conversation, and most of the time was devoted to noisily analyzing the sexual practices of friend and foe, to which Werfel tried to bring in a serious and intellectual note by discoursing solemnly on world revolution."[65] At first, Krenek understandably took a fairly reserved attitude toward all the sexual activity going on around Alma. When Alma's half sister Maria ("a not unattractive person with a marked business sense and rather crude manners),"[66] however, offered to supply Anna with lovers, "who were prepared to pay large amounts for her services,"[67] that was a step beyond the borderline of the endurable for him. On his return home, he got "so furious about the swamp I had happened into, that I made a terrible scene and smashed a cupboard or something similar."[68]

Anna Mahler and Ernst Krenek got married on January 15, 1924, in Vienna's city hall. Only a few months later, Anna's second marriage was already on the way out. In September 1924 she informed her mother that she was going to leave her husband and move to Rome to study with the painter Giorgio de Chirico. The reasons for the hasty end to the connection initially had to do with the immaturity of the partners. At the later divorce hearing—the marriage was legally dissolved on August 28, 1926—Anna complained about Krenek's highly pronounced sexual urges, while he spoke of his wife's alleged frigidity. This conflict, which inevitably led "by natural necessity to the total alienation of the marriage partners,"[69] as stated in the divorce decree, had deep-seated causes. As much as Anna Mahler, on the one hand, wanted to keep her distance from Alma, on the other hand she was just as deeply marked by her mother's behavior patterns. Ernst Krenek believed that Anna's amours (she married five times) were all aimed at just one goal, namely to escape from "her mother's oppressive sphere of influence. The consequence was that she could never succeed in turning any of these escapades into a lasting lifestyle of her own, a failing that her mother cunningly exploited to keep bringing her back into the old slavery!"[70]

INTRIGUES

In early January 1923, the world première of Franz Werfel's drama *Schweiger* took place at the New German Theater in Prague. While old friends like Franz Kafka didn't think much of the play, the performances in Werfel's hometown as well as the first German performance in Stuttgart a few days later were great audience hits. The press, however, was merciless in its judgment of the piece. Most of the reviewers panned the drama about protagonist Franz Schweiger and described it as embarrassing and trivial.[71] Nervous and insecure, Werfel withdrew to Breitenstein in late January. Meter-high snowdrifts cut off the mountain village from the rest of the world and turned the Villa Mahler into a place of voluntary banishment. Unenthusiastically he sketched out another play, but then soon afterward put it aside. He could not concentrate, for which Alma, who had remained behind in Vienna, was not entirely innocent. She had in fact sent her friend Richard Specht to the Semmering as well, to look at and organize the voluminous correspondence Gustav Mahler had left behind. The musicologist got so horribly on Werfel's nerves that Werfel hastily cut short his stay. "My Alma, don't be shocked," he begged her, "I'll be coming back on Friday." He was worried over how Alma would react to his precipitate return home. "I'm afraid of you," he confessed to her, "and of coming back to Vienna."[72] Evidently his fears were not totally groundless, because at this time Alma seems to have withdrawn from him emotionally. "Werfel dear but uncaring. Sometimes suddenly wild for me—but not tender. That's unfamiliar territory for him. He doesn't know what that is."[73] And a few weeks later, she wrote in her diary: "Oh, I don't love Werfel anymore. It's terrible having this realization "to be married, to reside, live together." Customary rights—yes, constraints from both sides. I am very, very sad."[74]

It comes as no coincidence that Alma, in this condition of dissatisfaction, instigated one of her intrigues in April 1923. In the center of the entanglement stood the Russian painter Wassily Kandinsky and Alma's longtime friend Arnold Schönberg. The two artists had known each other for many years and were friends. Since June 1922, Kandinsky had been living in Weimar, where he taught at the Bauhaus. When the music academy there found itself with a vacancy to fill for a new director, he immediately thought of Schönberg. "I need an immediate answer," Kandinsky asked his friend in Mödling near Vienna on April 15, 1923, "whether you would be agreeable just in principle. If so, then we'll get the ball rolling right away."[75] As Schönberg knew very little about the Bauhaus and Weimar, he asked Alma, not least because of her con-

nection with Gropius, for some advice. What he didn't know, however, was that Alma had an old score to settle with Kandinsky. She now put a rumor in circulation to the effect that Wassily Kandinsky and Walter Gropius were rabid anti-Semites. He—Schönberg—would have to consider seriously whether or not he wanted to work in that atmosphere. That was enough for Schönberg. On April 19 he sent a letter to Weimar canceling his employment application. "The things I have been forced to learn over the past year are not easily forgotten—namely that I am no German, no European, indeed perhaps barely a human being (at least the Europeans prefer the worst of their own race to me), but rather that I am a Jew." In his letter to Kandinsky he went on: "I have heard that even Kandinsky sees only bad things in the actions of the Jews, and sees only the Jewish element in their bad actions, and so I am giving up hope for any understanding. It was a dream. We are two separate kinds of people. Definitively!"[76] Kandinsky was shattered and could not imagine how Schönberg had come upon the idea that he was anti-Semitic. "I don't know," he replied on April 24, "who and why someone might have any interest in shaking what I was solidly convinced is our firm, pure human relationship, and perhaps even definitively destroying it. You write 'definitively!' Whom would this benefit?"[77] Kandinsky kept asking himself who could have started this rumor, and even feared, as his wife Nina remembered, that "Schönberg suffered from paranoia." The initiator of the intrigue was finally unmasked when Kandinsky showed Schönberg's letter to his colleague Gropius. "Gropius turned pale and said spontaneously: 'This is Alma.' He immediately realized that his wife had staged the whole business."[78] When Nina Kandinsky found out about Gropius's reaction, she suddenly remembered an incident from the previous year. Back then she had paid no attention to this occurrence, but now it was possibly an explanation for Alma's behavior. On one of her visits to Weimar, Alma had met the Kandinskys, and back then, they quickly got into a pleasant chat, in which Alma was allegedly trying very hard to please Kandinsky and flirt with him. Asked by Nina Kandinsky when she was planning to visit Weimar the next time, Alma coolly answered that it all depended on her. "At first I had no idea back then what she was trying to tell me. But then the penny dropped. She was interested in Kandinsky!" His pronounced masculine appearance had caught Alma's fancy, and she began using every trick in the book to win the painter over. He, however, turned her down: "Kandinsky loved me too much ever to take any interest in other women, including Alma."[79] In Alma's worldview, men were either admirers or enemies. She regarded anything in between as unworthy of her interest. She wanted to be admired and worshipped, and

when Kandinsky was unready to perform either function, Alma not only lost interest in her opposite number, but also began plotting her revenge. She obviously couldn't have cared less that she was about to destroy a long-standing friendship with her intrigue. Nor did Arnold Schönberg have an inkling of the role he was playing in Alma's obtuse drama. On May 11, 1923, he wrote to her "that you shouldn't tell Kandinsky and Gropius that I found out from you today whose kindred spirits they are. It would be most comfortable for both of them if instead of admitting their guilt, they could simply hurl accusations at you."[80]

FUND-RAISING PROGRAMS

The purchase of the palazzo in Venice, the Casa Mahler, brought Alma to the outer limits of her financial possibilities. Even before the family was able to move into the house in the spring of 1924, a few reconstruction measures became necessary that drove the cost sky-high. And not least, the frequent trips between the three residences in Vienna, Breitenstein, and now also Venice cut a gaping hole in the budget. Alma was certainly aware that she couldn't afford this costly lifestyle when she described her financial situation in late September 1923 as "little money—many needs."[81] Besides this, the inflation in Germany and Austria made planning impossible. The rapid devaluation of the currency over the course of the year seemed unstoppable. While one U.S. dollar cost 47,670 marks on the Berlin stock exchange in May 1923, by October the exchange rate had already skyrocketed to 25,260,000,000 marks.[82] By the end of October, people had to come up with amounts in the billions to pay for a hundredweight of coal briquettes—how was anybody supposed to make it through the winter? Ernst Krenek also wondered "where the money to run this elaborate household was coming from."[83] By the end of the World War, only a small fraction of Gustav Mahler's estate still remained. Back in 1914, the banker Paul Hammerschlag had advised Alma to invest the money in war bonds, as Anna Mahler remembered: "Of course she did it because he was such a famous, great man. Thank God there was a little bit left over."[84] Beyond this, in the 1920s Mahler's symphonies were by no means part of the standard repertoire of European orchestras, which meant the royalty payments were also fairly modest. In her letters to Universal Edition in Vienna, Mahler's principal publisher, Alma kept complaining about the sparse profits, not infrequently lamenting "that I must live in such small, precarious circumstances."[85] Now, this sigh may have been the expression of a business-savvy coquette, because

Alma certainly didn't live in small, let alone precarious, circumstances. The fact of the matter, however, was that the revenues were no longer sufficient to finance her lavish lifestyle. In this situation, Alma designed a fund-raising program centering on the clever marketing of Gustav Mahler and the development of Franz Werfel into a best-selling author.

In the midsummer of 1923 Anna Mahler and Ernst Krenek arrived in Breitenstein from Vienna. Shortly before this they had given up their Berlin place to spend the second half of the year in Austria. As the young people were short on funds, the Villa Mahler initially offered refuge for the summer. It must have been during this period that Alma called Ernst Krenek's attention to a plan that "would ultimately give him little satisfaction and a lot of headaches."[86] It had to do with Gustav Mahler's unpublished Tenth Symphony, which Alma—on advice from Bruno Walter—had thus far kept concealed from the general public. In Walter's opinion the work was too personally colored to be presented before an audience. Now—twelve years after Mahler's death—Alma digressed from the decision she had made. Being a cunning businesswoman, she had come up with the idea, Krenek remembered, "of increasing the list of Mahler's nine symphonies by adding a tenth, because it seemed to be simple arithmetic that ten symphonies on the concert programs would bring in more money than nine."[87] To this day, however, it is still unclear who made Alma aware of the possibility of exploiting Mahler's final work. It could have been the musicologist Richard Specht, who had been busy sorting out Mahler's correspondence in Breitenstein at the beginning of 1923, during which time he might have come across the work and realized that something could be done with it. At any rate, Alma decided that Ernst Krenek should take this fragment and turn it into a complete symphony. He found the project "already repulsive back then," yet felt himself so solidly "chained to the golden cage"[88] that he couldn't say no. The symphony, as Krenek was able to determine, had originally been conceived as a work in five movements. He decided that he could edit the sections titled "Adagio" and "Purgatorio," but would not touch the remaining three. "It would have taken the shameless audacity of an unspeakable barbarian to venture an attempt to orchestrate this passionate scribbling of a dying genius. Alma was profoundly disappointed and disgruntled when I explained this state of things to her. I am glad that I stood my ground and would never have dreamed of being an accomplice in such an outrageous fraud."[89]

While Krenek was getting started with his work in Breitenstein, Franz Werfel was there working under high pressure to complete his first large-scale

novel. As early as the previous year, he had hatched a long-contemplated plan to devote a book to a man he had admired since early childhood, Giuseppe Verdi. As if intoxicated, Werfel spent up to twelve hours a day polishing the life story of his favorite comoposer.[90] Alma supported him in his project and regularly gave him tips, "suggesting that the book must be as good as any of 'these classics,' yet, at the same time be suitable for sale at newsstands in railroad stations."[91] For some time, at least, Alma had been dissatisfied with the income from Werfel's literary works. Unerringly she had realized that there was more money to be earned from a popular novel than from expressionistic poems, novellas, or short stories. Now all they needed was to find a financially strong partner, because Kurt Wolff, Werfel's publisher in Leipzig, couldn't meet Alma's expectations. She ignored the fact that Wolff's personal holdings had also melted away in the wake of the inflation, and thus he was no longer able to pay out any profits. And so it came about very conveniently for her that just now a young man in Vienna was getting ready to found a new publishing house. The twenty-eight-year-old Paul von Zsolnay was the oldest son of an enormously wealthy industrial magnate. The family had earned a great deal of money in the tobacco trade and had a firmly anchored position in the Austrian social establishment. Paul's mother Amanda (known as Andy) was an artistically inclined lady, who associated with a large number of artists and intellectuals.[92] The idea of starting a new publishing house came about coincidentally in the autumn of 1923 at a soirée in the Zsolnay home. Paul von

Zsolnay was initially skeptical because, having studied garden architecture, he was unfamiliar with the publishing business. However, when Alma casually offered him Franz Werfel's Verdi novel, he made the deal. And so Werfel's first novel became the cornerstone of "Paul Zsolnay Verlag." The young publisher was full of zeal and, in particular, always had a sympathetic ear for Alma, as well as for her suggestion of putting an edition of Gustav Mahler's letters on his first publication list. Between Christmas and New Year, Alma and Franz Werfel went out to the Zsolnay family estate to discuss the necessary details. As a brand-new editor, who, by contract, dealt directly with the head of the publishing house, Alma came to enjoy generous special rights. From a calculated retail price of 140,000 crowns, she received 20,000 crowns, in other words a good 14 percent per book. Even if the price were considerably reduced, she would be entitled to the same amount.[93] But this was still not enough: she even talked Zsolnay into putting Mahler's Tenth Symphony on the market in a facsimile edition. Here she was not thinking of just the two movements Krenek had edited, but rather the complete work. For Ernst Krenek this was just too much: "I, however, found it extremely tasteless to publish the facsimile of the last two movements, because the pages were covered over and over with marginal notes, outbursts of a despondent passion, which were directed at Alma, insane expressions of a man who was wrestling with death, and who was almost unaware of what he was writing on. It was embarrassing enough for me to read these cries of a tortured soul, and it horrified me to think that they might be made available to the public, while the object of these confidential monologues by a genius was still alive and thus eager to capitalize on the sensation that had been created out of the vulgar motivation of common avarice."[94] Moral objections like these simply went up in smoke before Alma's business sense: the editions of the letters and the symphony were announced for mid-October 1924.

Despite the gratifying developments of the previous months, Alma was not satisfied with her life. "I don't love him anymore," she lamented in late January 1924, and meant Franz Werfel. "My life is no longer inwardly connected with his. He has shrunk back down to the short, ugly, fat Jew from my first impression."[95] The causes of this disenchantment are unknown. Possibly the diary entry was also just an expression of her emotional imbalance, which may have quickly abated. In any case, when the Verdi novel was released on April 4, 1924, by Zsolnay Verlag, Alma had every reason to be proud of her Werfel. The first printing of twenty thousand copies was sold out in a few months, and it looked like the book would be an impressive success.[96]

While Alma sent Werfel in early July back to Breitenstein, where he was to take advantage of the isolation in the mountains to get started on a new book, she met with any number of musicians, publishers, and journalists in Vienna. The focal point of this activity was a cleverly launched plan. The world première of the two movements of Mahler's Tenth Symphony edited by Krenek was scheduled for October 12 under the direction of Franz Schalk at the State Opera.[97] The sixty-year-old conductor may have been controversial and was regarded as anything but a specialist in Mahler's works, but since Bruno Walter was out of the question because of his negative attitude toward a performance of the Tenth Symphony, and Willem Mengelberg would not be available in time, there was no getting around him. Beyond this, Schalk, as opera director, was the master of the house on the Ringstrasse, and for that reason alone he could not be passed over. Alma had other plans with her friend Mengelberg; she wanted him to conduct the first performances in Amsterdam and New York and to demand "a decent amount in dollars"[98] for her there. Publication of the Tenth Symphony facsimile, and of the Mahler letters, was announced for October 13 and 17 at Zsolnay. Alma had further decided to have a book-let published by the Weinberger Verlag in Vienna containing five of her own songs. While looking through some older papers she had come upon these pieces again. Four of the five songs had been written while Mahler was still alive, and she had set the Werfel poem "Der Erkennende" (The perceptive one) to music in 1915. A booklet with her own compositions, Alma thought, would be a perfect supplement to her concertized fund-raising program. Beyond this, Universal Edition declared its willingness to bring the "Four Songs" already published in May 1915 back on the market in a second printing on October 30, 1924. The limited release of only ninety-six copies, however, made it clear that the publisher didn't expect much in the way of sales. Regardless of this, the positioning of the "Five Songs," as well as the new printing of the "Four Songs" more or less with the aura of the Tenth Symphony drifting above them, and the Mahler letters, would be a cunning advertising ploy.

Even before the book with the Mahler letters came out, Alma was already working on a second publication on her late husband. "Mein Leben mit Gustav Mahler" (My life with Gustav Mahler) was designed to tell the story of a young woman by the side of an egocentric genius. In the summer of 1924 this project was near completion when a dramatic incident occurred. "All of a sudden a horrible pressure in the brain, enormous pains toward the front, I fell back into the armchair and lost consciousness. I soon came to, but the room remained black and took a long time going back to green, and even later than that to its

full colors. Cerebral palsy." Franz Werfel immediately sent for a doctor. When the doctor finally found his way to the Villa Mahler, Alma was already feeling better. After a thoroughgoing examination, the physician diagnosed a dizzy spell. "The doctor strictly prohibited me from doing any work, but in the night I found out the cause of my illness, my writings about Mahler, which over the past few weeks had driven me insane."[99] The occupation with her life by Gustav Mahler's side had clearly taken more out of her than she had envisioned. In her manuscript she berated Gustav Mahler's family and friends. She must have been aware that she was making herself vulnerable with her occasionally one-sided description, and that with only thirteen years elapsed since Mahler's death, there were still numerous contemporary witnesses who might object vehemently to her version. She candidly confessed that it had been "difficult having to be objective, when one is so subjectively involved!"[100] Not altogether unjustifiably, the publishing company feared legal proceedings, were Alma's second book to come out without considerable revisions. Alma, however, was not about to allow the book to be edited. The manuscript first wandered into the poison cabinet; there it remained for sixteen years until she finally released the book to the public.

While Alma had first worried whether the world première of the Tenth Symphony would produce the hoped-for triumph, her concerns proved unfounded. The première on October 12, 1924, was a huge success; press and public alike responded enthusiastically to the unknown Mahler work, and many of the reviewers even demanded that the other movements be completed and performed.[101] Only one voice did not join the jubilating choir. Writing in the *Neues 8-Uhr Blatt* (New 8 o'clock journal) the following morning, Ernst Décsey had a few laughs at the expense of the enterprising widow Mahler and described the concert as one of Alma's self-staging performances: "But Alma Maria's will was done, the will of a fascinating woman, who held sway over the dead Mahler as she had when he was alive."[102] But even Décsey had to admit that Alma had hit her target. She had every reason to be satisfied with the business year as it drew to an end: Franz Werfel's works now topped the list of a financially powerful publishing house, and the Tenth Symphony as well as the letters of her late husband put an impressive amount of money into the family coffers.

ENEMY TERRITORY

The new year brought Alma the fulfillment of a long-harbored wish: on January 15, 1925, she set off with Franz Werfel on a voyage to the Middle East.

"Once again in my life to stand inside the temple of Karnak!" Alma would later write.[103] At first, Werfel was skeptical about this journey. Once he had set himself up on board the steamship *Vienna*, however, his reserve suddenly turned to enthusiasm. Sailing via Brindisi, they arrived at the Egyptian port of Alexandria. They spent the first three weeks in Lower and Upper Egypt, visited Cairo, the ruins of Heliopolis and Memphis, and saw the temples of Luxor and Karnak, as well as the royal tombs of Thebes. A highlight in these weeks was a performance of Giuseppe Verdi's *Aida* at the Italian Opera in Cairo, the site of its world première.[104] On February 10 they took the train to Palestine. The two weeks that followed, however, turned into a war of nerves, which primarily had to do with Alma's anti-Semitic attitude. She was constantly afraid somebody might think she was Jewish. She incessantly griped and stirred up hatred against anything Jewish, so that Franz Werfel, despite his critical stance both to Orthodox Judaism and extreme Zionism, felt himself "forced into the false role of the mediator, a polemicist toward both sides."[105] Because of Alma's attacks, he saw himself being called upon to defend something of which he himself wasn't really convinced. The couple spent most of their time in Jerusalem, interrupted by side trips to Nazareth, Tel Aviv, Haifa, and a series of smaller towns. "Palestine—I can feel an immediate closeness to the old biblical countryside," Alma wrote in her diary when they got back. "But the new Jewry there with all its ambitions was totally alien to my nature."[106] They began their homeward journey at the end of March 1925.

Back in Austria, Franz Werfel withdrew to Breitenstein in early April. There he fell into an artistic crisis and found his previous works awkward, pathetic efforts. Not until the summer of 1925 did he venture to approach a new project. In the dramatic legend *Paulus unter den Juden* (St. Paul among the Jews), he treated the separation of the Christians from Judaism. The author had doubtless been inspired to this consideration by his experiences in Palestine. In early September the drama was already completed in both a first and second version. As Werfel was still not satisfied with the result, he put the work aside for a while.[107] Alma, who had turned forty-six in late August, was planning yet another joint voyage for the following autumn. This time they would be going to India. She knew it would be hard to persuade Werfel to join in this undertaking. The Ullstein Verlag, a publishing company in Berlin, may have been willing to assume all the costs, and beyond that promised a fee of 10,000 reichsmarks (about $39,000), as well as handsome royalties, should Werfel agree to supply the newspaper concern with cultural articles and travel reports.[108] Despite these temptations Werfel refused at the last minute. The impressions he had

acquired in Egypt and Palestine were still too fresh. He, a man of thirty-five, didn't feel he was in a position to begin a new adventure so soon after the first one. Disappointed and angry, Alma reacted to this by withdrawing to Venice.

In December 1925, Franz Werfel set off with Alma for several weeks on a lecture tour through Germany. Some twenty cities were on the itinerary, among them backwaters like Gotha and Mühlhausen in Thuringia.[109] In Berlin the couple attended the enthusiastically received world première of Alban Berg's opera *Wozzeck* under the musical direction of Erich Kleiber on December 14. Alma felt a strong connection to Berg and his wife, Helene, even though both of them, as Alma saw it, came "from somewhat perverted families."[110] When *Wozzeck* was printed, she had helped out her friend with financing, and in gratitude he dedicated the opera to her. Until early February 1926 Alma and Werfel remained in Berlin and enjoyed the social life of the big city in full measure. When Werfel received the renowned Grillparzer Prize from the Academy of Sciences in Vienna, his popularity reached a new pinnacle. This was enhanced by the first Berlin performance of his play *Juárez und Maximilian* in a production directed by Max Reinhardt and premièred on January 29 at the German Theater. It was a huge hit.[111] The playwright Franz Werfel was now the talk of the town. And there was money to be made from his literary artistry. At the end of June 1926, the author and his publisher signed a general agreement, which provided for the highest fees ever paid to a Zsolnay author. In the future Werfel would receive 22 percent of the retail price for paperback editions, with the fee for each printed edition payable in advance of publication. Beyond this, payment would be made on the basis of Swiss francs converted to any currency Werfel might designate.[112] With Alma's help "Franzl"—her "man-child"—was well on the way to becoming creator of standard "Burgtheater fare." The Burgtheater in Vienna was (and still is) regarded as arguably the most prestigious German-language drama repertoire theater in the world. "I'm not so sure," said Anna Mahler; "perhaps it did him absolutely no good to come under Mommy's influence. She doubtless made a novelist out of him. Without her, he probably would have stayed a poet and bohemian his whole life. And he in all probability, as well, he would hardly have given a thought to earning money."[113]

The other side of this success consisted of Werfel's increasing dependence on Alma. She warily observed the way he lived, his attitude toward work, his literary creations—and Werfel drew away from his old friends. While he had once lived in Viennese coffeehouses like the Central or the Herrenhof, discussing everything under the sun well into the night with friends like Ernst Polak,

Alfred Polgar, or Robert Musil, Alma now prohibited him from submerging himself in the all-male groups she hated so much. She sent him to Breitenstein, Venice, or, from 1927, also to the Italian beach resort of Santa Margherita Ligure, where he would find the necessary calm and concentration for work. Not infrequently she had him show her the fruits of his labors—praised, rebuked, and called all the shots for him. Why Werfel allowed himself to be treated like that will have to remain an open question. On the one hand, if we are to believe contemporary witnesses like Anna Mahler, he had very little with which to counter Alma's imperiousness: "His weakness, his eternal giving-in, these really were dark sides of his personality. He had quite consciously subjugated himself to Alma. That did neither of them any good—she even sometimes treated him as if she were really his governess."[114] On the other hand, he allowed himself to be "trained" by his partner "to be the main source"[115] of finance, accustomed to fame and luxury, which he found incredibly attractive. Werfel, the onetime expressionist, who had called for the storming of the Vienna Bankverein back in the November uprising of 1918, probably didn't see any problem in the fact that his Verdi novel had brought him for the first time into the field of pleasant entertainment literature. The reason this change of roles cannot be equated with a true breach is that Werfel, as German literature scholar and cultural philosopher Hans Mayer has tellingly pointed out, hardly ever questioned his identity himself: "And he could be a Marxist, he could be anarchistic or conservative, he could be Catholic—all this was interchangeable, it depended on whatever sparked his enthusiasm at any given time, the inspiration, the emotion."[116]

Werfel's friends, Milan Dubrovic for instance, observed all this with great skepticism: "We, in the coffeehouse, basically condemned the effect Alma Mahler was having on Werfel—we said: that really is a different Werfel, he's become a 'golden boy'! One evening we were sitting together, discussing what those present would describe as the greatest happiness on earth. And then Werfel quite openly answered: 'Success! For me success is largely identical with happiness.' Yes, certainly he had to admit that."[117]

Starting in the summer of 1926, a number of bitter disputes came about between Alma and Franz Werfel. "It is very sad," she noted in mid-July, "but the political divide between me and Werfel is getting boundless. Every conversation, every single one, leads dead certain to that, and our racial difference offers very poor prospects for the future."[118] Ever more frequently she used her anti-Jewish resentments to humiliate Werfel. While he was gaining great recognition with his novels and plays and was numbered among the best

authors in German literature, he had to listen to Alma telling him Jews were not adequate human beings. Anna Mahler recalled: "She said to me in a hotel room, where she was staying at the time: 'Werfel just doesn't know German, no Jew knows German.' She called me 'my bastard.' I found that madly amusing, because I knew I was a crossbreed, but I was anything but that [a bastard]. Her German wasn't all that good either; Werfel's was far better."[119] As she had already done decades before in the case of Alexander von Zemlinsky, Alma made good use of her anti-Semitism to demean her life partner. When, in July 1927, the Vienna Palace of Justice burned down in the wake of bloody clashes between thousands of workers and the government, Alma had no doubt who was responsible for the riots: "The evil seed of Judaism is sprouting." Jewish politicians—"Europe and Asia's worst misfortune"—were, according to Alma's conspiracy theory, provoking the workers. Her conclusion was unambiguous: "The people should put an end to their maneuvering once and for all—before it's too late!"[120] And: "Perhaps the Caesarean section will rescue us, attachment to Germany."[121] Franz Werfel reacted with horror to statements like these. Over and over he tried to talk some sense into her head and explain the real background of the massacre, without success. Alma was profoundly convinced of the alleged guilt of the Jews. The more vehement her tiffs with Werfel, and the more she inwardly distanced herself from him, the more intensely she felt herself drawn back to her old love, Oskar Kokoschka. After Alma had coincidentally seen him in Venice on October 6, she wrote the following passage in her diary: "Ever since I saw O.K. it is like being destroyed. To the point of suicide. Everything else is so utterly meaningless. If somebody leaves such a dear creature, that person deserves being broken on the wheel. It would have been more honorable for me to have died from him rather than to go on living without him."[122] A few days later, however, Alma seemed to have pulled herself together again. "It is stupid," she fretted, "for me still to keep letting myself get thrown out of the saddle."[123]

Alma and Franz Werfel spent the Christmas holidays along with Paul von Zsolnay in Santa Margherita on the Italian Riviera. "Very sad Christmas Eve yesterday," Alma lamented on December 25. "The two Jews, Werfel and Zsolnay, were content! Nobody thought about me. Nobody took any notice of the thirsting Christian woman yearning to bring back her childhood."[124] They celebrated New Year's Eve with Gerhart and Margarete Hauptmann in neighboring Rapallo, where the writer owned a villa. The forty-eight-year-old Alma and the sixty-five-year-old Hauptmann felt a great affection toward each other. "When we parted he gave me a deep kiss on the mouth," she wrote proudly

in her diary. "He said: 'Finally we are alone—' and suddenly his secretary was standing in front of us. Now I embraced her, too, and made a kind of a general joke out of it."[125] These little love games occasionally went too far for Margarete Hauptmann. When her husband, for instance, emotionally announced that in the next life he was going to have a child with Alma, she called him to order with the information that Alma was already spoken for in the next life, too.

The luxurious existence between Vienna, Breitenstein, Venice, and the Ligurian coast couldn't conceal the fact that Alma was unhappy. More and more often she avoided Franz Werfel—as she did in early February 1928 when out of fear of "alienating Werfel"[126] she precipitately ran off to Rome. And as so often before, she felt empty and worthless. "I am longing for some strong sensation,"[127] Alma lamented in early April. While she had previously used anti-Semitism as a cunning power ploy to humiliate people who were close to her, by the end of the 1920s her enmity toward Jews increasingly took on the characteristics—albeit diffuse—of a political conviction. "World fascism . . . that's it. Fascism above the nationalistic parties."[128] Her enthusiasm for the fascistic idea satisfied Alma's wish for the "strong sensation." This almost inevitably brought about an increase in the differences between her and Werfel. Fierce arguments were the result, in the course of which doors slammed, and the two of them not infrequently screamed at each other. "That night I decided not to marry," Alma's diary said on August 3. "The reason for this new alienation is a poem that Werfel is now making, a poem on the death of Lenin." The relationship had doubtless run into a dead end, and Alma found herself in a deep life crisis. "I drink so I can be happy, perfectly happy,"[129] she candidly admitted. "Benediktiner," as she called her favorite high-proof liqueur, Bénédictine, became her constant companion and comforter—she managed to put away up to a full bottle every day. At those moments when she wasn't anesthetized with alcohol, the reasons for her gloom dawned on her. "I have been unhappy for 10 years, and I've just been playing some kind of role. On the outside: the so-called happy lover of a highly regarded author. But I am neither his lover—nor his wife. I am very little in his life and he very little in mine."[130] Alcohol and anti-Semitism joined together in a toxic compound. As she frequently only perceived her surroundings through an alcoholic haze, her hatred of Jews took on insane proportions. "This era will one day be known as 'The vengeance of the Jews,'" she wrote in her diary at the beginning of October. "It is one of the most grandiose theatrical spectacles the way a small scattered handful of people have grappled their way to world control because of blood vengeance and repressed hunger for power, so they can overturn and re-

interpret everything that until then had been regarded as solid and certain."[131] No doubt about it: the connection with Franz Werfel was about to be severed. Alma certainly couldn't imagine in the autumn of 1928 that only a few months later she would marry him anyway.

THE RELUCTANT MARRIAGE

During the first half of 1929, Franz Werfel was working intensively on his novel *Barbara oder die Frömmigkeit* (published in English as *The Pure at Heart*), which he had begun the previous year. Between February and May 1929 he spent almost all his time in Santa Margherita. As in the previous two years, Werfel found the ideal surroundings for writing at the Hotel Imperial Palace on the Via Pagana. The cosmopolitan flair in the Ligurian coastal city, the mild temperatures as well as the luxurious trappings of the hotel, offered every comfort he needed to facilitate his work. In late February Alma paid him a short visit, after spending ten days with Anna in Paris. But she found no rest. Any number of invitations made her so nervous she could "hardly sleep and eat anymore, let alone read." And her upcoming visit from Werfel's parents came at a most inconvenient time for her: "Werfel's parents, proper Jews, certainly mean well, but the problem is me. My soul cannot keep up."[132] Her relations with Rudolf and Albine Werfel may never have been particularly bad, but she never found a genuinely cordial way to approach them, either. Alma felt alien to them, someone who just didn't belong in their lives, which she attributed to the Werfels' being Jewish. A few days later, she found the situation unbearable. Finally, on the fourth of March, Alma traveled alone via Nice to Venice, where she hoped to find peace and a chance to think things over in her beloved Casa Mahler. After ten years in an "open relationship," Franz Werfel was now importuning Alma finally to marry him. She was unsure, especially when a postcard from Oskar Kokoschka in Cairo reminded her of times she had thought were long forgotten. "Why does he keep doing this? It's as if we were bound together by some kind of spiritual umbilical cord." Although she had long since distanced herself from his "somewhat filthy mind," she still felt close to him. It was his decisiveness and resoluteness that fascinated her, while Franz Werfel, "a born high-liver, never takes the consequences of his own teachings." With this, she meant primarily Werfel's political attitude, which he, as Alma believed, "could not possibly understand let alone be able to do anything with because of his birth and social class."[133]

In June, however, Alma suddenly succumbed to all the pressure and agreed

to marry him. Nevertheless, she did impose one condition: before the wedding, Werfel would have to withdraw from the Jewish religious community. He met this requirement on June 27, 1929—even so, he did not have himself baptized a Catholic, as she certainly would have liked to see. One thing has been unknown until recently: without telling Alma, Werfel reconverted to Judaism a few months later—on November 5.[134] We can only speculate on the reasons for his move. Possibly Werfel's clandestine return to Judaism was a kind of silent protest and a sign of inner opposition toward his overpowering wife.

The upcoming wedding had Alma terribly worried. When she went to bed the evening before the marriage, she couldn't get to sleep. "I don't know if I'm doing the right thing," she kept telling herself; after all, she had already been living with Werfel for more than ten years, without a marriage license. "I'm doing this for my worthy neighbor, not for myself. My freedom, which I had continued to maintain despite everything, is now getting a jolt. The love I felt has given way to a very close friendship." Her physical inventory in that July night was not very optimistic: "I am not in very good condition. I'm wearing out right down the line. My eyes refuse to cooperate . . . my hands are slowing their pace over the keyboard—I can't keep my food down, I have trouble standing or walking, at the most I can tolerate drinking. And I often do too much of that. But often it's the only way I can get the chills and shivering in my body under control."[135] In view of Alma's merciless appraisal of her own desolate condition, it doesn't seem all that far-fetched to think she perhaps married Werfel to be better able to endure the calamities of aging, the loneliness and physical deterioration—after all, one month after the marriage, Alma turned fifty.

The marriage of Alma Mahler to Franz Werfel took place on Saturday, July 6, 1929, in the Vienna city hall. In Austria at that time, weddings, as a rule, were conducted either by the Catholic or the Protestant church. Partners not affiliated with any denomination or couples with different religions had the possibility of being married before a government official. These wedding ceremonies were short and fairly unelaborate affairs. The witnesses were Alma's half sister Maria and her husband, Richard Eberstaller, who had just been married themselves—on June 16. When Alma, despite all her misgivings, still said "I do," she might possibly also have been thinking of her twelve-year-old daughter Manon, who had not enjoyed a regular family life before. The irregular shuttling back and forth between Vienna, Breitenstein, and Venice, the frequent changes of private tutors, and, not least, her mother's eccentric lifestyle had left their traces: Manon was a very diffident, somewhat bashful

FIGURE 5.4

Manon and Alma:
"I stripped her naked
for him."

girl. Since December 1927 she had lived in the upscale Educational Institute for
Girls on Vienna's Weihburggasse—a kind of boarding school for daughters
of prominent parents, operated by the well-known educator Adèle Renard-
Stonner. Even so, Alma was constantly taking her daughter out of school to
bring her along on trips. As long as the girl could remember, Franz Werfel
had been part of the family. With the wedding, "Uncle Werfel" would finally
become Manon's stepfather. As honorable as these considerations may have
been, in Alma's eyes, at least, this marriage was anything but a love match.

The marriage with Franz Werfel began—unsurprisingly enough—with
disappointments; time and again, it came to "disgusting scenes," and only a
short time later he was "completely foreign"[136] to Alma. The focal point of
the disputes was once again Werfel's Jewish origin. Although he had initially
abandoned the Jewish religious community for her sake, she refused to let up.
"I couldn't live without Jews, indeed I live constantly with them. But I have
so much resentment toward them that I rise up in defiance—unceasingly."
This conflict was destined to escalate over the following years. "Why did I get

married at my advanced age? Why did I give away my sweet name, my great name, which I have regarded as my own for 30 years now?"[137]

Immediately after the wedding, the Mahler-Werfels withdrew to the vacation house in Breitenstein. The summer on the Semmering would, however, not run its course happily or harmoniously. The diary entries during these months are characterized by an agglomeration of inflammatory tirades aimed at Franz Werfel's friends and colleagues. For example, Alma wrote of Hugo von Hofmannsthal's family: "His three children are untalented, his sons are even downright amoral. The son Franz, who had killed himself because of understandable micromania, couldn't get a job anywhere. He last worked at the age of 26, in the administration office of the Hotel Adlon, but even there he was a total failure." And Alma also found clear words for the relatives of other writers: "Thomas Mann's children, homosexual, lesbian . . . Wedekind's daughter a depraved floozy, Wassermann's children, profligacy and whores!"[138] Shortcomings like these reflect Alma's own troubled state of mind. She suffered because her life, as she perceived it, was just drifting aimlessly. Nervous, extremely irritable, and dissatisfied with herself and the world, Alma left no doubt in her diary that the wedding with Franz Werfel had been a huge mistake. "It is awful," she lamented in late August, "but I feel my most recent marriage as bondage. Much worse than I had imagined it would be. I keep wanting to get out of this net, in which I really willingly felt good for such a long time."[139] Restlessly, as if escaping from each other, Alma and Franz traveled back and forth between Breitenstein and Vienna. They spent the late summer on the Ligurian coast, first in Nervi, later in Santa Margherita. There Werfel completed his novel *Barbara oder die Frömmigkeit*, which was published by Zsolnay Verlag on October 22. The first edition was released with a remarkably sizable printing of fifty thousand copies. Never before had one of his books met with such an expectation of sales. Doubtless Werfel had regained the previous high point of his fame and ranked now among the most read authors in the German language. Five years after Zsolnay Verlag had founded its success with the Verdi novel, Werfel's works were now the top money-earners in the publishing house. If we take just the royalties, then Werfel had earned the most money on the *Barbara* novel—which in terms of today's buying power would amount to over $600,000—as usual, in advance.[140] That, however, exhausted the outer limits of what the publisher could pay. As business manager Felix Costa explained to Alma, this method of payment represented "a huge strain for the company . . . because it is not always easy to make such amounts of money readily available."[141] He had gingerly asked for her understanding should fu-

FIGURE 5.5

Costume party in
Breitenstein: Agnes
Hvizd (Alma's cook),
Franz Werfel, Richard
Eberstaller in drag,
Maria Eberstaller,
and Anna Mahler
dressed as a boy.

ture advance payments not be forthcoming on schedule. Alma, however, was not prepared to make any concessions and hotly demanded her rights.

The friendship with the Zsolnays seems not to have suffered under Alma's uncompromising attitude—quite the contrary. By the end of 1929, the Werfel and Zsolnay families grew even closer together personally. Paul von Zsolnay confessed to Alma on one visit that he could no longer live without Anna, and formally asked for her hand in marriage. What had happened? In the summer, the publisher—up till then a confirmed bachelor—had spent several weeks on vacation at the "Physical-Dietetic High-Altitude Curative Institution," as the Breitenstein spa hotel was somewhat awkwardly called. On this occasion, he saw Anna Mahler again for the first time in quite awhile. While the two of them had known each other since their early youth, they had lost touch. As fate would have it, Zsolnay remembered, "I spent a few weeks together with her on the Semmering. There we had another chance to reestablish our acquaintance, and very rapidly we decided to become a couple."[142] At first, Alma had some misgivings about a dalliance between her daughter and Franz

Werfel's publisher. "Leave this flower where it is, by the side of the road!"[143] was her advice to Anna. Over the course of time, however, the idea of a connection between the two families became more appealing to her. After Rupert Koller and Ernst Krenek, Anna now finally had a husband who—as Alma felt—was on the same social level as she was. If Anna, at the age of twenty-five, was already going to get married for the third time, then it should at least be a useful connection.

The simple wedding took place in secret on December 2, 1929, in Paris. "It was my wife's wish, with which I totally concur," Paul von Zsolnay wrote to an acquaintance in Constantinople, "that the marriage be solemnized as inconspicuously as possible, which in our case wasn't all that easy. That is why we didn't send out our marriage announcements until after the wedding."[144] Anna and Paul von Zsolnay spent their honeymoon in Egypt. When the couple returned to Vienna in mid-January 1930, Alma and Franz Werfel were just setting out on their own—albeit somewhat delayed—wedding trip. Alma had first thought of India, the "land of my longings," as she wrote, looking back. She had already bought the tickets and prepared the journey in detail. Franz Werfel, however, was not very keen on the idea of a seagoing journey of several weeks to India; "it is too far," Alma wrote, "too strenuous, and so I rebooked the tickets for Alexandria—and buried my life's desire."[145] Instead of this, Werfel wanted to return to Palestine, where they had been in 1925, supplemented by stops in Syria and Lebanon. The first stop on their itinerary was Cairo, where the newlyweds stayed at the Continental Savoy hotel. Shortly thereafter they moved on to Palestine. In Egypt, Werfel had picked up a light malaria infection, which may have taken a lot out him, but despite some slight fever attacks, it didn't force him to discontinue the journey. This time Alma and Franz Werfel were both delighted with Palestine. In comparison to their first trip five years before, everything about the place seemed to them "extraordinarily grown, beautified, indeed much more interesting." Both of them felt at home; Alma even went so far as to begin giving in to her "house addiction, and absolutely had to have a house in Jerusalem."[146] From there they went on to Damascus. They found the Syrian capital, however, less inviting; the dilapidated buildings and the run-down cityscape exuded a great sadness. Finally, a travel guide took the visitors to a large carpet-weaving mill. What Alma and Franz Werfel saw there would occupy their thoughts for a long time thereafter. Children, emaciated from starvation, with mask-like faces and protuberant eyes, were forced to work at the large number of looms. When the factory owner, who was present at the occasion, noticed the look of horror on the faces of his guests, he ex-

plained the eerie scene like this: he employed the children for 10 piasters a day in his weaving mill and thus kept them from dying of starvation. They were, he told them, of Armenian origin. Many of their parents had been massacred by the Turks during the World War through pogroms, deportations, and mass executions. This government-backed genocide continued to weigh heavily on Werfel's mind. At further stops along the route, such as Baalbek, Beirut, Acca, and Haifa, he took advantage of every free minute and noted down what he had witnessed in Damascus. He suspected that the fate of the Armenians could give him the material for a new novel. Back in Vienna, he immediately began his preparatory work and visited the Armenian convent of the Mechitarists in Vienna. In the library there he researched a large number of eyewitness accounts, studied maps, and occupied himself with the centuries-old history of the Armenian people. The project slowly began taking shape in his mind. It would, however, take another two years until he could actually begin putting the novel down on paper.

In the summer of 1930, Alma was busy with other problems. The Zsolnays were putting pressure on her to give up the large apartment on Elisabethstrasse in favor of a villa in keeping with their social standing. Alma initially took a negative view of this idea and saw no point in "becoming so fixed on material things."[147] All in all, the contact between Alma and her new relatives had clearly undergone a slight cooling. She suspected that Anna, who gave birth to a daughter on August 5, 1930—named after her grandmother Alma—"is playing a dirty game with me" and stirring up the Zsolnays: "I can palpably feel how disrespect and darkness are growing behind my back."[148] But this still wasn't enough—other members of the family were also giving Alma headaches. "Moll has written a book about my father," she grumbled in late August. "Apart from the fact that I consider it completely tactless that the adulterer is triumphing even 40 years later and stripping poor Schindler naked, praising my mother, his mistress at the time, to the skies, apart from that, the book contains a dedication to his 'daughters,' Alma and Gretl."[149] When Carl Moll still referred to Gretel as Emil Jakob Schindler's daughter a good fifty years after Anna Schindler's ominous fling with Julius Victor Berger, this struck Alma as a belated mockery of her father. The family tie with her stepfather—the "adulterer"—had been a lifelong source of discomfort for her. Johannes Trentini, Albert von Trentini's son, was able to observe relations from up close: "Alma never said anything kind about the Molls, and whenever possible avoided mentioning that she had a family at all. Her father Schindler had status. Her mother was unloved. And Moll . . . she found him very uninteresting . . . she

called him a 'son of a bitch.' Moll must have been a decent human being . . . but . . . just very boring."[150] Alma's feelings for her thirty-one-year-old half sister Maria were also ambivalent. Richard and Maria Eberstaller may have served as witnesses at the Werfels' wedding, but the sisters never entered into close contact. While Alma maintained what can be described as a cordial relationship with her brother-in-law Richard—the forty-three-year-old attorney increasingly advised her in legal matters—she frequently treated Maria condescendingly and patronizingly.

The family relations in Alma's house at the end of 1930—what else could one expect?—were as complicated as they ever had been. In particular, the situation between husband and wife, only seventeen months after their wedding, was totally out of kilter. "Never does Werfel utter one word of thanks for the way I help and help him," she complained in November. Gustav Mahler had been nobler at the end; "Werfel would never have had this recognition, not even if I were to leave him or die!" The conclusion she drew was not very encouraging, and promised anything but a bright future: "Let him take care of his own crap. Why did I get married? Madness!"[151]

6

Radicalization

1931–1938

In mid-January 1931, for the first time in over a year, Franz Werfel moved back to Santa Margherita Ligure to get started on his short novel *Die Geschwister von Neapel* (The siblings of Naples) at the Hotel Imperial Palace. At the same time, Alma began house hunting. The Werfels had decided to take the advice from the Zsolnays and exchange their city apartment for a prestigious villa in the upscale Vienna neighborhood of Hohe Warte. The artists' colony in the north of the city, which had come into existence around the end of the nineteenth century, was also a popular day-trip destination. On Steinfeldgasse, only a short walk from the end of the no. 37 streetcar line, the Viennese star architect, Josef Hoffmann, had built a palatial mansion with over twenty rooms between 1909 and 1911 for Eduard Ast, who owned one of the top construction companies in Austria. As money was no object, only the most precious materials were used, and the entire house was outfitted with products from the Vienna Workshops. When Eduard Ast's firm suffered severe losses in the world economic crisis, he found himself forced, with a heavy heart, to give up his architectural jewel in early 1931. Alma was thrilled with the house and its sand-colored façade. Immediately on entering the building, visitors were struck by the imposing sight of the entrance hall with its yellowish marble paneling running all the way up to the ceiling. A black wooden staircase led to the *bel étage* above, from which they first made their way through a foyer into the spacious grand hall. This in turn bordered on the study, the dining room, as well as the oval-shaped ladies' salon. The architect had even fine-tuned the color harmony among the individual rooms: the dark green walls of the study impressively contrasted with the bright Lasa marble paneling in the grand hall. Finally, the ladies' salon was paneled to the ceiling with gray-green Cipolino marble. A glass double door led into the large dining room, which, with parquet flooring made from different types of wood, pleasantly harmonized with the brown and orange hues of Portovenere marble and the champagne-colored masonry. Moving on

(*previous page*)
FIGURE 6.1 Alma Mahler-Werfel, circa 1930.

from either the hall or the dining room one came to the veranda, which in turn opened onto the garden. The upper floor of the Villa Ast contained the bath and dressing rooms, two children's rooms, a room for the governess, a further living room, as well as a bedroom paneled in palisander.[1]

The generously proportioned rooms and the luxurious interior décor in the villa offered every prerequisite for an assertion of social status on the highest level. As the owner of this art nouveau palace, Alma would be able to call one of the best addresses in Vienna her own. Franz Werfel clearly found these things less important. As he would spend most of the year outside the capital anyway, he didn't want to stand in the way of the fulfillment of Alma's dream. On February 17, 1931, Eduard Ast and Alma Mahler-Werfel signed the deed of sale. The purchase price was largely financed from Werfel's royalties. Rudolf Werfel also subsidized his son with a contribution of 40,000 schillings.[2]

While Franz Werfel continued working in Santa Margherita, Alma was busy organizing the move. On March 29, 1931, she spent her last night in her old apartment. "What will this new house bring me?" she pondered. "I'll need to muster a lot of strength to combat the deaths that happened in that place. So much misery has been bewailed there. Will my cheerfulness be able to dry the walls wet with tears?"[3] The Villa Ast was indeed a house of misfortune. Eduard Ast had lost two of his children there. In 1922 Eduard Jr. succumbed to leukemia, and the following year his daughter Gretel died in childbirth at the age of twenty. Alma knew of these tragedies. In her mind she pictured the shattering scenes, yet didn't want to let them ruin her joy at having the new house. The following day there was no time for morose contemplation: after "an unspeakable amount of work" she had survived the move. "The house received me with warm arms, and I was already sleeping there that evening in my own bed with the feeling I had never slept anywhere else."[4]

Johannes Trentini was frequently among the guests when, in the spring of 1931, Alma gave one party after another at the Hohe Warte: "Almost every day, she had visitors. Alma invariably presided at all these get-togethers in the Mahler-Werfel home. Tall, always in ankle-length dresses, her hair glowing, her jewelry glittering prominently. There were always lots of good things to eat and drink, and Alma knew exactly how to make a beautiful and pleasant evening for her guests."[5] Alma's qualities as a hostess were in high esteem everywhere. Her house was a place where people who might never have met anywhere else got acquainted. Musicians, writers, and actors were as much a part of her guest lists as were government leaders, clergymen, and philosophers. On these occasions Alma was in top form—and the culinary delights played

a significant role, pampering her guests with exceptional, visibly expensive dishes. The excessive partying left its traces: "From Pentecost on, however, I just lay in bed, and I was so exhausted I could hardly talk." Alma begged off further commitments and finally had some peace and quiet—and yet she still missed the daily social whirl: "The house is finished now—but I have no desire to become acquainted with bordeom."[6]

The Werfels spent the summer months of 1931 in Breitenstein, where Franz Werfel worked on the final version of *Die Geschwister von Neapel*, nourishing himself solely on coffee and cigarettes. At the end of September, Alma went off to take a mud cure in Abano Terme for a pain in her arm she had picked up during the move. The little town near Padua with its sulfur and salt springs had been a well-known health spa back in Roman times. She enjoyed the seclusion, checked out the sights in the surrounding area, and did a lot of reading. One book by the Russian author Ilya Ehrenburg aroused her indignation: "A piece of filth by Mr. Ilya Ehrenburg, another Communist because he couldn't succeed at anything else." And she went on: "I can do without the Russians, the whole lot of them, *nota bene*, because the only people one meets with that designation now are Jews disguised as Russians. This sterile, black world." Ehrenburg's example was the proof for Alma: "The Jew strives for clarity, the Aryan for intoxication, see coffee—alcohol. How confused things must look then inside the Jews, and how clear in a Christian brain."[7]

Franz Werfel's *Die Geschwister von Neapel* became a huge hit; the first edition was quickly snapped up by the end of October. He had received his payment, as usual, in advance, a fee equivalent to $300,000.[8] In November Zsolnay Verlag organized a book-reading tour for its author, scheduled to run several weeks and take him all over Germany. It brought Werfel and Alma via Cologne, Münster, and Berlin all the way to Insterburg in East Prussia (today Chernyakhovsk in Russia). The trip began in a saddened mood, brought about by the death of Franz Werfel's close friend Arthur Schnitzler on October 21, 1931, but this changed markedly when they got to Berlin. The cosmopolitan flair of the German capital had quite taken Alma's fancy. The artistically inclined and well-to-do members of the Berlin establishment were not about to miss their chance to invite the best-selling author and his famous wife to any number of receptions. This social whirl, however, came to an abrupt end. Alma noted in her diary: "Phone call from Vienna . . . Anna is ill, then another telegram . . . Anna is physically well, only mentally ill, finally another phone call from Andy Zsolnay. Anna and Paul are divorcing!"[9] Alma understood immediately: this was not just about the well-being of her daughter; business

relations with Zsolnay Verlag were also at stake. Now she was needed in Vienna, so she promptly packed "and was on the train an hour later," while Franz Werfel continued his reading tour alone. Arriving in Vienna, she found out the details of the marital tragedy. Anna had been having an affair for a long time with a writer by the name of René Fülöp-Miller, "that most repulsive of all literati,"[10] Alma groused. Born in 1891, Fülöp-Miller, actually Philipp Jakob Müller, was largely published by small, insignificant publishing houses in Leipzig and Vienna, before signing a general contract with Zsolnay Verlag in July 1931.[11] As Paul von Zsolnay also maintained personal contacts with many of his authors, it is entirely possible that he himself introduced Fülöp-Miller to his wife.

Anna and Fülöp-Miller were so upset by the discovery of their affair that they had attempted to commit joint suicide. Now Alma had to act. She called Fülöp-Miller to account: "I stood naked before this fellow. I fought for a month to liberate Anna from the clutches of this lecher." He now avenged himself "by going to Paul's father, showing him Anna's letters and told the poor old Jew that I was insisting Anna stay with her husband so she could inherit his estate and this was the only reason I was against a marriage with Fülöp-Miller."[12] Adolph von Zsolnay severely remonstrated with Alma. He felt confirmed in his opinion that a woman like Anna, who at the age of twenty-six already had two divorces behind her, was not to be trusted. He smelled a scheme. The old gentleman complained that the only reason Anna had married his son was for his money.

Anna had gone back for a short time to her mother when she noticed she was pregnant. Not knowing whether the child was from Paul or from Fülöp-Miller, she had an abortion. The horrible events of the year 1931—the death of Arthur Schnitzler and Anna's suicide attempt—cast such a pall on the atmosphere that Alma sank into a depression.

In this situation, she rediscovered her old songs. "Why did I allow myself to be diverted so far from my path?"[13] she asked herself with a heavy heart. "She played for me several times," said Johannes Trentini. "I didn't much care for it, but I lied and said I liked it. And, I believe, from an objective point of view, it was quite pretty. But back then, I thought it was kitschy."[14] For Alma, plagued as she was with melancholy, making music was a kind of attempt at self-healing. For a long time, she had been drinking too much, to "drown out" her "suffering soul," as she unashamedly confessed. She hoped music would bring her out of this: "I will now make more music again, and think it is the kind of music that makes me happy, not the eternal Verdi caterwauling, which, with the skill of a brilliant master butcher, takes away the prospect of anything

that is exquisite."[15] The reference to the "eternal Verdi clatter" was a sideswipe at Franz Werfel, who loved Giuseppe Verdi's music above everything else. Alma remained unmoved by the Italian composer's music; she preferred to play pieces by Richard Wagner—or else works she had written herself.

When the former agriculture minister, Engelbert Dollfuss, assumed the office of the Austrian federal chancellor on May 20, 1932, the republic stood at the threshold of a process of radical political change. In the space of two years, Dollfuss, as head of the Christian Socialist Party in Austria, gradually managed to put together an authoritarian regime, the so-called Ständestaat (corporate state). Barely one year after becoming chancellor at an extraordinary meeting of the National Council, Dollfuss succeeded in sidetracking the parliament. Following this inglorious end to democracy in Austria on March 4, 1933, largely overlooked by contemporaries because of developments next door in the German Reich, nothing more stood in the way of expanding the Ständestaat. The principles of the constitution published on May 1, 1934, were Christian, corporate, and authoritarian, and ultimately meant a fundamental turning away from democratic principles. Church and state were not separated in the Ständestaat. All law was derived from God as supreme authority and no longer from the people. The hopes of the regime were geared toward "re-Christianizing society within little Austria, and reestablishing the realm of Christ and kingdom of Christ,"[16] as the Tyrolean prelate Aemilian Schoepfer wrote. The old Catholic dream of replacing "classes" with "estates" (*Stände*) was concealed behind this. At the central point stood the enlightened view of a simply structured, medieval agrarian society, "in which the worker did not rise up and organize against his master,"[17] as Dollfuss proclaimed in a speech. Political Catholicism had no appreciation of modern industrial society and evaluated it as the pathetic creation of demagogues, who, depending on their political hue, called themselves Jews, liberals, Marxists, or social democrats. In the Ständestaat, the Jews in particular ranked as representatives of individualism and liberalism. They were said to be significantly accountable for the destruction of the "old order" and were deemed a threat to Christian values. Although the Jews may have been guaranteed equal rights in the new constitution, this had little effect on the actual situation of the Jewish population. What resulted was a deep discrepancy between the stipulations of the constitution and political reality. A universally tolerated anti-Semitism became even more evident everywhere, a trend the government did nothing to counter. With the so-called May constitution, Engelbert Dollfuss had reached his goal. The "vest pocket dictator," as people mockingly called the chancellor because

he was so short, stood at the top of a clerical-fascistic regime—yet less than three months later, he would become the most prominent victim of a Nazi putsch in Austria.

When Dollfuss took office as the new chancellor in May 1932, the event left no lasting impression on Alma: "Otherwise life just keeps flowing on," she complained in her diary; "hardly anything worth knowing or important for me. One just plays along."[18] On June 3, however, Alma made a watershed decision, which is not hard to understand against the background of changing political conditions: she converted back to the Catholic faith. After leaving the Catholic Church in August 1900, she wanted to give her life new meaning thirty-two years later. "For years I had a feeling of being cast out from the community of the saints. Confession was a difficult obstacle for me to overcome. It had me nervous to the point of fainting. My dear friend the cathedral prelate Müller from St. Stefan's clearly couldn't understand my violent fits of weeping. He knows me differently after all."[19] The religious aspect of her turnabout was, however, insignificant. Alma Mahler-Werfel was not a religious woman, let alone a pious Catholic, nor did her way of life fit in any way into the conservative value system advocated by the Catholic Church in the 1930s. Alma's Catholicism is more to be regarded as an expression of her diffuse political ideology, which would reveal itself with more and more aggressiveness as time went by. As individually motivated as the decision might have been, it also clearly reflected the political trend of the time, which would gain increasing influence on Alma's life in the years to follow.

This year as well, Franz Werfel, Alma, and Manon spent the summer months as usual in Breitenstein. The solitude on the Semmering, which had otherwise served as an inspiration to the writer, now suddenly made him nervous. He was depressed and dissatisfied with himself and his work, because he couldn't come up with a subject for a new novel. Disgruntled, he revised a few older poems, which, however, did nothing to improve his foul mood. Alma remonstrated with him: if he did not write another book, then they would have to rent out the house on the Hohe Warte. Their financial situation was so precarious, because of the purchase of the Villa Ast, that they couldn't afford Werfel's inactivity. Under pressure like this, he "racked his brain"[20] until he thought of his experience in Damascus and was suddenly reminded of the half-starved children in the weaving mill. He wanted to place the story of the Armenians during the World War at the center of a new novel. His writer's block surmounted, Franz Werfel had a subject and a task to perform. Until the middle of November 1932 he worked uninterruptedly on *Die vierzig Tage*

des Musa Dagh (*The Forty Days of Musa Dagh*). Alma was proud of herself: "Once again I am the inspiration for his work—thanks to my cheeky, healthy Aryan nature." Self-assuredly she praised her "healthy" impulses: "A dark Jewish woman would long since have made an abstraction of him. He has that danger inside him."[21]

On July 31, 1932, the National Socialist (Nazi) German Workers' Party, the NSDAP, received 37.8 percent of the votes in the election for the sixth German Reichstag (parliament) and was thus able to more than double its results in comparison to September 1930. This meant that there was no longer any way to prevent the Nazis from participating in the government. During the negotiations, however, insurmountable differences quickly arose between the Nazis and current state chancellor Franz von Papen. And President Paul von Hindenburg was unable to bring himself to transfer power to a State Chancellor Hitler. The aged head of state—Hindenburg was eighty-five at the time—preferred to maintain the line of the presidential cabinet without any parliamentary connection.

Alma attentively followed the political changes in the neighboring country. For her these events were "no struggle between north and south, between Protestantism and Catholicism, but rather quite simply infighting between Jew and Christian." She wrote: "There were bestial Jews occupying the seats of power over almost every country. . . . It now goes without saying that the various nations and countries can no longer tolerate this situation." And further: "But there will be more bloodbaths before the world is finally cleansed. And that is why I am for Hitler. As evil as the medicine may be. The evil it is supposed to drive away is far more evil."[22]

In mid-September Alma and Manon traveled to Velden in the Carinthian countryside. The mild weather, the idyllic location on the western bay of the Wörthersee, as well as the richly forested surroundings made the little town into a popular vacation spot. Here Alma met Anton Rintelen. Born in 1876, Rintelen was a lawyer and university teacher by profession, but after taking an interest in politics following the World War, he had become one of the most influential politicians in Austria. From 1919 until 1926 and from 1928 to 1933 he served as governor of Styria in addition to being the federal education minister in 1926 and 1932–1933. He embodied the extremely ambitious and unscrupulous demagogue. Alma was thrilled with Rintelen's cold-bloodedness, since he personified the kind of power seeker Alma found enormously attractive. Over the following two years, a close personal and political friendship developed between them. Rintelen, however, had more in mind than he revealed to Alma

in Velden: "He was wildly in love with me. He followed me into the bedroom, dragged me out on the balcony and wooed me even more passionately than a young scamp for my love. His idea of love. Immediate surrender! I had a little fun with him, and Mutzi and I laughed halfway through the night at that ungainly lover."[23] The close relationship between Alma and Rintelen met with disapproval in Alma's social circle. "Werfel accused her," Ernst Krenek remembered, "of sucking up to this Rintelen, to which Alma countered: 'Oh, Franzl, don't you know a woman can pray in a lot of different churches!'"[24]

In mid-October 1932, all eyes in Vienna were on Gerhart Hauptmann, who, a few weeks later—on November 15—would celebrate his seventieth birthday. The enthusiastically received première of Hauptmann's latest play, *Vor Sonnenuntergang* (Before sunset), on October 14 at the Deutsches Volkstheater, was the premier social event. The next day, the *Neue Wiener Journal* published the list of the illustrious guests, which, needless to say, included Alma and Franz Werfel. On Saturday, October 15, a special tribute took place: Gerhart Hauptmann was honored for his literary work by the Austrian PEN Club. It was a source of great joy to the recipient that the laudatory speech was given by Franz Werfel. Werfel gave "a profoundly meaningful and very deeply felt speech,"[25] as Alma remembered, and Hauptmann kissed his friend on the brow in gratitude. Alma enjoyed the days with the Hauptmanns. For many years she had felt a deep affection for "this gold-yellow glowing man." Local gossip had it, however, that it was more than just a friendship binding Alma and Hauptmann to each other. The two of them were not wholly innocent here, as Alma's diary entry in the autumn of 1932 attests. "In parting, he kissed me firmly on the mouth, escorted me down the road to the car, where, oblivious to the people standing around, we kissed one another's hands!"[26] Alma admired Gerhart and Margarete Hauptmann; the "Aryan" appearance of the author and his wife obviously impressed her as especially appealing. "How eagerly I look forward to seeing you—O, brightest of all humans!"[27] is one of the disconcerting forms of homage in Alma's correspondence with the Hauptmanns. Their "bright" and "golden" nature was, as Alma felt, a counterpoint to the alleged darkness of the Jews. Her enthusiasm had occasionally taken on some fairly bizarre forms. When Alma was unable to keep a date with her idol, the author received the following lines: "I have just awakened from a disgusting Veronal sleep and am not worthy of appearing before your countenance."[28]

In the late autumn of 1932 Franz Werfel and Alma set off on a reading tour that would take them through several German cities, among them Berlin and Breslau. Disharmony dominated the mood between husband and wife. Alma

was browbeating her husband because of his allegedly lacking lecture skills. She found that he was presenting his texts far too dramatically, and blamed herself, "because I have been soft-soaping him too long, instead of going on a rampage the very first time." For Alma, it was clear that she would have to guide him with a strict hand. As she said in a diary entry, he had simply not earned any leniency. "People are still too obsequious and too frightened of this man. But nobody helps him by not being that way."[29]

The most impressive event during their stay in Berlin was, as Alma confided to her diary, meeting former state chancellor Heinrich Brüning, who had resigned on May 30, 1932, the victim of intrigues. "This seraphic man" explained to Alma the confusing German domestic politics, which had not become any simpler following the Reichstag elections on November 6, 1932. The Nazis may well have emerged from this plebiscite again as the strongest party, but they still had to endure the loss of some 4 percent of their support. For many contemporaries, this was a positive sign; some people even thought they had seen in it the beginning of the end for the NSDAP. The former state chancellor—according to Alma—did not agree: Brüning "told me he was convinced that the Schleicher era would soon be over, and Hitler will have triumphed. He said that a man who could wait that long simply had to win!"[30]

Another encounter at the end of this lecture tour would leave a lasting impression on Alma. As fate would have it, the Werfels stopped in Breslau (now Wrocław in Poland) on December 10, the very same day that Hitler was expected to attend a large-scale political rally there. Alma was electrified by the prospect of actually seeing Hitler personally: "I waited hours to see his face. I didn't go to Werfel's lecture, but rather sat alone in the dining room and emptied a bottle of champagne by myself. Thus well prepared, I then stood with many others and waited for him. A face that has conquered 13,000,000 people must be some face!"[31] Clearly Alma had been following current developments and knew that over thirteen million people had given their votes to Hitler and his party in the Reichstag election on July 31, 1932. Like so many others, she was also fascinated by Hitler: "And I was right, it was such a face! Kindly, soft eyes, a young, frightened face. No Duce. But rather a youngster who will find no age, no wisdom."[32] Initially, she was vexed because there was nothing the least bit regal about Hitler, per se, such as there was with Mussolini. Franz Werfel returned to the hotel after his lecture and also got to see Hitler for a moment. As the object of curiosity disappeared behind a door, Alma asked her husband what he had thought of Hitler. "Not all that unappealing," her Franzl replied.[33]

THE EPITOME OF A PRIEST

In the eventful times shortly before the Nazi takeover of power and the recon-
stitution of the Austrian Republic into an authoritarian Ständestaat, Alma's
festivities became major social events. Visibly proud, she now realized that
the government "almost unanimously" frequented her home on the Hohe
Warte. As early as the winter of 1932, she selected her guests in keeping with
her political radicalization, placing high value, as she noted in her diary, on
"de-Jewifying my contacts (just a little)." "Werfel had almost objected to this.
In the profound misunderstanding with which he defines the two races, he
regarded every Christian as unspiritual and every Jew a priori as spiritual.
And I had to welcome so many jackasses to my home because they were so
intelligent and inspiring, only to find out that they often weren't even edu-
cated jackasses."[34] In her salon, the lady of the house also brought influential
Austrian politicians together with artists and industrialists with whom she
would wheel and deal. Besides Education Minister Anton Rintelen and Jus-
tice Minister Kurt von Schuschnigg, former federal state chancellor Rudolf
Ramek and the head of the War Archives, Edmund Glaise von Horstenau,
also numbered among her new visitors. Mme. Mahler-Werfel enlarged her
salon into a regular contact exchange. The writer Klaus Mann remembered:
"Mme. Alma, who had close relations with Schuschnigg and his crowd, cre-
ated the salon where "la toute Vienne" got together: government, church, di-
plomacy, literature, music, theater—they were all there." It wasn't enough for
Alma simply to play the role of moderator; occasionally she also exercised a
direct influence: "In one corner of the boudoir, people discussed in a whisper
about some appointment to a high government position, while another group
of people were making up their minds whom to cast in a new comedy at the
Burgtheater."[35]

Against the background of current political developments, the appoint-
ment of Adolf Hitler to the position of German state chancellor on January 30,
1933, and the "president's emergency decree for the protection of the people
and the state," which had smoothed the Nazi Party's path toward a totalitarian
regime, Alma, despite her confirmed fondness for the "Führer," hardly took
any notice of political developments. In February 1933, she was completely and
utterly involved in personal matters: at the age of over fifty years, she had fallen
in love. Alma had already met the man in late 1932 at the investiture of Theodor
Innitzer as archbishop of Vienna, which she attended along with Federal Pres-
ident Wilhelm Miklas, State Chancellor Dollfuss and his entire cabinet, and all

FIGURE 6.2
Johannes Hollnsteiner:
"I respect this man to the
point of kneeling down
before him."

manner of local celebrities. Shortly thereafter she invited a few well-known churchmen to a luncheon in her villa. Besides the cathedral organist Karl Josef Walter and the liturgical music commissioner of the diocese of Vienna, Professor Andreas Weissenbäck, the priest and theology professor Johannes Hollnsteiner also found his way to the Hohe Warte that morning. Alma and Hollnsteiner took an immediate liking to each other. By February 5, 1933, he had already visited her three times: "There is a certain confusion within me," Alma wrote. "A little, unimpressive priest can shatter my composure? With what powers? Johannes Hollnsteiner! He was here in my house for the third time—I had a feeling that all the other people around us were just gray silhouettes." The thirty-seven-year-old university professor had well and truly turned her head. "And now I don't know where I am anymore. God in Heaven! The incomprehensibly long night of this winter has yielded to a balmy springtime. It is hardly possible to endure!"[36]

Johannes Hollnsteiner, born in 1895, entered St. Florian's Augustinian Canons' Abbey near Linz at the age of nineteen, and was ordained to the priesthood five years later. He concluded his studies of theology and, following this, a doctorate in history. He continued his academic career at the University of Vienna: in 1925 he received a professorship, in October 1930 he became an associate university professor, and in December 1934 a full professor of canon law. Beyond that, he was a member of the Archiepiscopal Metropolitan and Diocesan Court and from November 1934 its vice president.[37]

In a short time Hollnsteiner had acquired considerable power. He was Cardinal Innitzer's right-hand man and enjoyed good contacts with Rome. Now, only a few months after Innitzer's consecration, many people regarded Hollnsteiner as his successor. But Johannes Hollnsteiner was not only a Catholic priest and theology professor; he also had political ambitions. He had extremely close ties with the later federal state chancellor Kurt von Schuschnigg, acting both as his confessor and his spiritual counselor. The two men had met in the early twenties in Norica, the Catholic students' association in Vienna, from which top political leaders of the Ständestaat would be recruited from 1934 on. These good contacts provided Hollnsteiner with some political influence: he mediated, intrigued, pulled strings, made and terminated careers. Contemporary witnesses such as Johannes Trentini watched Hollnsteiner somewhat warily. Alma asked young "Tita" several times to have Hollnsteiner explain theological or political issues to him. Recalled Trentini: "I never did it, and I preferred to consult someone else." He continued to find the go-getting priest "spooky."[38]

The relationship between the dubious theologian and the aging society lady met all the preconditions for going into history as a piquant love affair. "It was said to be a real affair," Trentini remembers, "and suddenly she felt love again. Werfel didn't care. For a long time he didn't believe it, even denied it, as far as I know. It was her last great passion."[39]

Initially, Franz Werfel would not have noticed the dalliance between Alma and Hollnsteiner, as he spent the first few months of 1933 almost uninterruptedly in Santa Margherita. Hollnsteiner, however, showed up at the Hohe Warte almost every day, remaining there not infrequently into the night.[40] Alma was downright electrified by the idea of having a relationship with a Catholic priest. Anna Mahler remembers a meeting with her mother at which Alma agitatedly told her "that she has fallen in love. And that she gets so excited when she sees the man—she even went to Mass—in his vestments. . . . And then she asked him what that sort of thing feels like. Then he explained to her, yes, that

business with the celibacy, that only applies while one is wearing them. Otherwise it is not at all necessary."[41] As the lovers had good reasons to be afraid somebody might find out about their liaison, Alma rented a little apartment. Anna Mahler even reported that Alma had fed her lover there on caviar and champagne.

"He probably appealed to Alma so much because of his emotions, and certainly not because of his strict Catholic priestly manner," Johannes Trentini surmises. Hollnsteiner differed from the large majority of priests. For that time, he was an enlightened theologian who did not "approach" humanity "with 'sweet little Jesus boy' alone," said Trentini. "Hollnsteiner was no country priest. For many years, everything had been trivialized and sugarcoated, to the point where the homilies were impossible to listen to. Hollnsteiner had a somewhat more intelligent approach."[42] However, the main reason for his appeal to Alma was, according to her, a different one: "I respect this man to the point of kneeling down before him. Everything within me longs for subjugation, but I always had to dominate against my will. This is the first man who has conquered me." So it was a masochistic joy in being demeaned that bound Alma together with Hollnsteiner. His power as a priest exerted an incredible sensual stimulation on her. She was able to watch him celebrate Mass, to watch the way the faithful—herself included—had to kneel down before him to receive the Eucharist, the way he gave them his blessing, and how he pointed the way to them in his sermon. She was intoxicated that Hollnsteiner had weakened because of her and given up the sexual abstinence he was obligated to practice as a Catholic priest. "J.H. is 38 years old, and until now he has never encountered womankind. He wants to be, and only is, a priest. He sees me differently, and I sanctify myself for it. He said: never was I close to a woman. You are the first, and you will be the last." For all this, she was amazed at Hollnsteiner's serenity: "He is so free. . . . Never yet has he uttered the word: sin. He doesn't feel it as that. . . . And I . . . must I be more Catholic than the Pope?"[43]

Although Alma could hardly bring herself to part from her new lover, she traveled to Santa Margherita in late February 1933 where Franz Werfel was finishing his work on his large-scale novel about the Armenians. Alma was racked by nervousness; she kept thinking about Johannes Hollnsteiner instead. After ten days on the Italian Riviera she couldn't stand it anymore and returned to Vienna. Arriving back in the capital, "I had the deepest fellowship with the Catholic leaders. . . . That's where I belong—in the core of my being. This constant existence with Jews has removed me from myself in my own eyes, as much as that was possible. Now I am back home with myself."[44]

OLD AND NEW ALLIANCES

In March 1933, political developments in Germany—the so-called Enabling Act adopted on the twenty-fourth of that month that marked the end of the Weimar Republic and the beginning of the Nazi dictatorship—were about to exert an immediate effect on the day-to-day existence of the Werfels. While intellectuals like Heinrich Mann and Bertolt Brecht left Germany, Franz Werfel made a serious mistake, which doesn't seem to fit in at all with his previous political position, and is consequently puzzling. On the suggestion of Gottfried Benn, the Literary Arts Division at the Prussian Academy of the Arts in Berlin, to which Werfel had belonged since October 1926, sent a circular letter to all its members asking whether they were prepared "in recognition of the altered historical situation" to place themselves at the disposal of the Academy in the future as well. "An affirmative reply to this question excludes public political activity against the government and obligates you to participate loyally in the nationalistic cultural duties constitutionally applicable to the Academy in the context of the altered historical situation."[45] This document, categorized as "contractual," was presented to the members for an "immediate response, exclusively with a yes or no."[46] Any nuances, let alone any discussion, were clearly ruled out. The new administration of the academy wanted a clear distinction between friends and foes and sought a quick arrangement with the Nazi regime. Nine of the twenty-seven-members of the Literary Arts Division, among them Ricarda Huch, Jakob Wassermann, Alfred Döblin, and also Thomas Mann, rejected the demanded loyalty declaration. The majority, however, replied in the affirmative; these included Gottfried Benn, Gerhart Hauptmann, Theodor Däubler, and Franz Werfel. Following a telegraphed request for a form, Werfel declared his loyalty to the new rulers on March 19, 1933. He was amazingly naïve politically. Like so many others, he completely misjudged the Nazis and believed that the brown-shirted nightmare would soon be a thing of the past. When publisher Gottfried Bermann-Fischer, Samuel Fischer's son-in-law, got together with Werfel in April 1933, he was struck by the writer's optimism. Werfel was, he said, even in a happy, easygoing mood, as if the events in the neighboring country had nothing to do with him.[47] And the reason for this may possibly have also been the fear of political censorship of his works, as his new novel *The Forty Days of Musa Dagh* was then scheduled for publication in November. An openly oppositional attitude toward or even an expulsion from the academy might, he feared, lead to a prohibition of his novel, which had taken on an unanticipated immediacy, particularly in light

of the Nazi oppression of politically or racially ostracized minorities. It is, however, entirely possible that Alma urged her husband to make this loyalty commitment, a declaration just as bizarre as it was incomprehensible, because of her own enthusiasm for Hitler and his ideas.

It seems like a macabre joke of history that Werfel's loyalty declaration was basically already obsolete. On May 5, 1933, the president of the Prussian Academy of the Arts, Max von Schillings, signed a form letter, which also reached Werfel by registered mail. It said: "in accordance with the principles established for the new order of the Prussian state cultural institutions," he would "in the future no longer be numbered among the members of the Literary Arts Division."[48] This was a terrible blow for Werfel. Five days later, the Nazi terror reached a new level. As the high point of the "Action against Un-German Spirit" instituted by Propaganda Minister Joseph Goebbels, books by undesirable authors would be burned in a large number of German university towns. In just one action on Berlin's Opernplatz, some twenty thousand books were thrown into the flames. Besides works by Stefan Zweig, Arthur Schnitzler, Sigmund Freud, Karl Marx, and many others, the self-appointed cultural guardians also hurled Werfel's *Spiegelmensch* and *Bocksgesang, Der Abituriententag* and *Die Geschwister von Neapel, Juárez und Maximilian,* and *Paulus unter den Juden* into the conflagration.

In this difficult time for Franz Werfel, it also became clear to him that the relationship between Alma and Johannes Hollnsteiner was not purely a friendship. The priest showed up at the Hohe Warte almost every day in the spring of 1933. Franz reacted with jealousy: "Werfel is now making mistake after mistake," wrote Alma. "Today he didn't want to let me go to church—and that was an injustice. It is some kind of jealousy. I'm not disloyal to him there! Or perhaps I am, in the very place he can never go."[49]

"I'm very worried about Anna again," Alma complained to her diary in late June. Her daughter had a new lover, "and, as always, the wrong choice, a total phony: this time it is a half-crippled, nihilistic Jew, who, once he gets hold of her, can hardly let her go." The individual lurking behind this venomous description, "the sparsely gifted writer Canetti," would be awarded the Nobel Prize for Literature seventeen years after Alma's death. It was tragic, Alma felt, that Anna "always winds up with people inadequately supplied with heart and soul, always purely intellectual destroyers."[50] The twenty-eight-year-old Elias Canetti had fallen in love with Anna and paid regular visits to her atelier, and occasionally at the Hohe Warte as well. In his autobiography, *Das Augenspiel* (The play of the eyes), Canetti described his first meeting with Alma. He saw

"a rather large lady, overflowing on all sides, fitted out with a cloying smile and bright, wide-open, glassy eyes."[51] Elias Canetti was distressed—after all, he had expected the erstwhile most beautiful girl in Vienna, and instead of that he now discovered an "inebriated individual, who looked much older than she was." Under the heading "Trophies," he described the bizarre atmosphere in Alma's villa. The "deliquescent old lady on the sofa" had gathered around her—as if in a mausoleum—the trophies of her life: the full score of Gustav Mahler's Tenth Symphony, with the composer's death cries, displayed in a kind of showcase, as well as a painting by Oskar Kokoschka, which showed her as Lucrezia Borgia. The portrait frightened Canetti, who saw in it "the composer's murderess."[52] The third trophy, her seventeen-year-old daughter Manon, "came skipping into the room a short time later, a light, brown-haired creature, disguised as a young girl."[53] The fourth trophy was Franz Werfel, who was writing in his study. The "impression of the molten dowager"[54] immortalized in the "poison portrait on the wall"[55] wouldn't leave Canetti alone. Long afterward, in memory, he found himself sitting "next to the immortal one and constantly puzzling over her words about 'little Jews like Mahler.'"[56]

From then on, outrageous remarks like these kept coming up more and more frequently, as Alma's diary entries attest. She made Johannes Hollnsteiner's worldview her own, right into the phrasing—and Hollnsteiner regarded Adolf Hitler as "a kind of Luther."[57] "When I look at the tough, invisible activity of a Hollnsteiner, who doesn't care if and when he sleeps, if and when he eats, whose duty is to keep his eyes fixed on God, then I see the INCREDIBLE difference of races and philosophies." And further: "When I look at Hitler— who in fourteen years in the dark—kept working his way up, only to be forced to retreat over and over again, because his time had not yet come, that's how I also see a GENUINE Teutonic zealot, of the kind it would be almost unthinkable to find among the Jews."[58]

Alma's racist views would not remain without consequences. Her Jewish friends not only became increasingly alienated from her—she also felt "separated by insurmountable barriers" from them: "The more I occupy myself with my own existence, the farther away I feel from people of a different breed."[59] Franz Werfel also clearly sensed how much his wife's anti-Semitism was alienating him. "We're tearing one another to shreds," he complained in a letter to Alma, "we're hurting each other, we're forgetting."[60] At that time, in the autumn of 1933, he was working fifteen hours every day in Breitenstein on the final version of *Musa Dagh*. "It is nerve-racking work,"[61] he wrote to Alma. Werfel frequently felt ill and weak, which he attributed to his excessive consumption

of cigarettes. On October 10, the day finally came: "The whole house waited in breathless anticipation until he came down from his atelier. It is a gigantic accomplishment for a Jew to write such a work at a time like this."[62] One event, however, cast a dark shadow on the joy over the successful completion of the novel. On October 18, Albert von Trentini lost his battle with cancer. "We were terribly insulted," Johannes Trentini remembered, "because she didn't go to my father's burial. This was done in accordance with Tyrolean custom back then. He was laid out in the salon, in the open coffin, that's how they did things back then. Then she showed up. But she brought along a bottle of Bénédictine for me, to help me recover. I found that very tasteless."[63]

In the autumn of 1933 Alma's friend Anton Rintelen announced his upcoming visit. The government official, who had resigned his office as education minister in the spring at the urging of Chancellor Dollfuss, was on his way to Rome, where he would assume the post of Austrian ambassador on November 13. Dollfuss, who saw an unwelcome rival in the ambitious Rintelen, was, however, mistaken in thinking he had put him, to some degree, on ice in Rome, as he would play a not insignificant role in conjunction with the later Nazi putsch attempt. Alma organized a farewell party for Rintelen: "On Oct. 22, [19]33, my friend Rintelen left for Rome after we had heartily fêted him." Then, as later, it was clearly a source of fun for her to flirt with Rintelen, "but I used cleverness and skill to make him aware of the fact that he had fallen in love with Mutzi, of whom he had taken no notice before."[64] At another place, she wrote that Rintelen was in fact "head over heels"[65] in love with Manon. Alma saw no problem in her still only seventeen-year-old daughter growing up almost exclusively with older people. Manon, whom Rintelen called "Lizzy," didn't seem to be bothered by this either. She frequently added her signature to Alma's letters to "King Anton," sending him "many respectful wishes."[66] Manon had grown up in an atmosphere in which very little consideration was paid to the delicate feelings of a young girl. The "Aryan" parentage of her daughter revealed itself, as Alma believed, in a special physical attractiveness. This alleged flawlessness—after Manon's death, people spoke in Alma's presence of an "angel"—was constantly emphasized, and also put on display, by Alma. "Our Mutzi is too sweet," she wrote to Walter Gropius only a few months after Manon's birth. "Roller was here yesterday. I stripped her naked for him. She can already do every possible new thing."[67] To the degree that Alma experienced the consequences of aging on her own body, she projected whatever she could no longer radiate—eroticism, and sexual attractiveness—onto her "pure" daughter. It came across as disconcerting but not surprising that older

men, like fifty-seven-year-old Anton Rintelen, courted Manon, confronting her with his direct sexual suggestiveness.

When his wife's escapades got too much for Franz Werfel once again, he escaped in mid-November to Prague. The hope of finding some calm and reflection in the bosom of his own family would not, however, be fulfilled. The city seemed totally changed; many house walls and billboards were besmirched with anti-Semitic slogans. He was frightened. Rudolf Werfel was also worried and feared that the Nazi terror might expand into his homeland. Alma had little understanding for her husband's agitation. In her ideological blindness, she spoke of an "elemental event," meaning Hitler's power grab: "But after months of battling, I finally managed to get him [Werfel] to understand the fault of the Jews. And what they are doing now is again every bit as stupid." And finally: "These fantasizing Jews running around there and wailing in Austria are now destroying the last remainder of respect people still had for them."[68]

In the retrospective view of the year 1933 that Alma preserved in her diary, contemplative tones are a striking feature: the springtime she spent with Hollnsteiner may "have been the happiest time of my life," but even so, she was not satisfied. "My body and my health are very run-down this year, and I have aged considerably."[69] If we look at the photographs of Alma from the 1930s, Elias Canetti's "deliquescent old lady" comes to mind. The overindulgence in alcohol had left clearly visible traces on her.

In early 1934 the domestic political scene in Austria came to a head: after Chancellor Dollfuss had disempowered the parliament in March 1933, relations between the ruling Christian-Social Party and the Social Democratic opposition—Dollfuss had already had the Communist Party of Austria and the Nazi Party prohibited in May and June of 1933—became extremely tense. For quite a while the smoldering odor of rebellion hung in the air. When, on February 12, 1934, a search of the Social Democratic headquarters at the Hotel Schiff in Linz was carried out by the paramilitary "home guard," the Social Democrats and their armed subsidiary organization Republikanischer Schutzbund (Republican Protective Society) fought back. The hostilities in Linz quickly spilled over into Vienna, where workers' homes and municipal buildings stood in the middle of the bloody conflicts. Dollfuss and his justice minister Kurt von Schuschnigg reacted to the rebellion with relentless severity. The government crackdown didn't even shrink from the use of heavy artillery. One stronghold of the proletarian resistance, the Karl-Marx-Hof, was located near the Villa Ast. The otherwise peaceful Hohe Warte suddenly became the scene of pitched battles. "The sharp shooting, we were in the danger zone, got

me all worked up both horribly and almost joyfully."[70] Alma was on the side of Dollfuss and the "home guard." As far as she was concerned, the rebels were nothing but "riffraff," who deserved no better. The Austrian writer Hilde Spiel even reported that a howitzer had been installed in Alma's garden.[71] As Franz Werfel was staying in Santa Margherita, Minister Schuschnigg offered to let Alma and Manon move in with him for the duration of the uprising. She gratefully declined, however, preferring to hold the fort at home. After two days of violent conflict the rebellion failed, largely because the general strike called by the Social Democrats was not implemented. The result was appalling: over three hundred deaths tallied on both sides, and more than seven hundred people wounded. The Austro-fascist government was anything but sparing in its treatment of its opponents. Social Democratic functionaries were arrested by the dozens, among them Vienna's mayor, Karl Seitz, as well as the city councilors. Some of the leaders of the uprising were even summarily executed. The February riots ultimately offered the Dollfuss regime a welcome opportunity to prohibit trade unions and the Social Democratic Party as well as its associations and societies. Engelbert Dollfuss was able to expand his power base successfully in the authoritarian Ständestaat.

After the rebellion had been put down, Alma traveled for three days to Venice. Some small repairs on the Casa Mahler were necessary, and she wanted to supervise the work. Franz Werfel interrupted his stay in Santa Margherita and likewise came to the lagoon city. For the first time in several weeks, the couple spent some time together again. As the telephone connection between Vienna and Italy was down for whole days during the unrest, he had been very worried about Alma and Manon. That is why he was all the happier to find his wife and stepdaughter in such good shape. "Awful days lie behind us," wrote Alma to Anton Rintelen after her return to Vienna. "Lizzy and I embrace you in profound loyalty and friendship,"[72] her letter to "King Anton" concluded. On February 23, 1934, all was still right with the world.

THE DEATH OF AN ANGEL

"I am almost perfectly happy," Alma rejoiced when Anton Rintelen arrived in Venice by plane from Rome on March 28, 1934. She picked her guest up from the airport with Manon; after all they didn't want to lose any time. For Alma, it was still quite clear that her friend was "a great statesman with far-seeing eyes. Only," she added regretfully, "Austria has always shown precious little interest in these qualities."[73] Rintelen did not come to Venice unaccompanied; he

brought along the twenty-eight-year-old up-and-coming critic Erich Cyhlar. The young man promptly fell in love with Manon, yet found "no reciprocation of his affections from her."[74] Nevertheless Miss Gropius must have taken clear notice of her suitor's name, as the coming months would reveal.

Manon and the French governess remained behind in Venice alone when Alma and Franz Werfel traveled to Milan for a few days on April 6, 1934. He had some matters to clarify with the Italian publisher Ricordi. When the couple returned to Venice, Manon was feeling unwell. The symptoms of her illness—headaches and lack of appetite—were diffuse. Her complaints were believed to be signs of a harmless case of flu. When, however, Alma discovered she had lost her crucifix somewhere—it had been a gift from Johannes Hollnsteiner—she was stricken with a great uneasiness: "I don't know why—it was an evil premonition." On April 14, the couple began their homeward journey to Vienna alone; Manon planned to return a few days later. Alma was meanwhile seriously worried: "In her condition, we should have taken her along with us to Vienna. And that's what I wanted too, but she was very strong-willed when she wanted something. The whole day, on our trip, I had a feeling I should have taken her along."[75]

Vienna was in an uproar. The city was preparing for a performance of Gustav Mahler's *Das Lied von der Erde* under the direction of Bruno Walter, at which Alma was expected as guest of honor. On the evening after the concert Minister Kurt von Schuschnigg gave a dinner party at the Grand Hotel. The minister was also present when Alma and Franz Werfel got home later in the evening and received the information that Manon's condition had worsened. Alma immediately reacted and booked flights to Venice for herself and Ida Gebauer for the following morning: "The nurse and I stared out of the plane, because when we looked at one another, we knew that something terrible would be waiting for us!"[76] Franz Werfel, Anna, and Paul von Zsolnay followed them on the afternoon flight. When Alma and Ida arrived at the Casa Mahler, the horrifying diagnosis was already clear: poliomyelitis.

The news of a polio epidemic raging in Venice had been hushed up by the censored Italian press for weeks. The physicians summoned to the scene appraised Manon's condition as very serious: the painful puncturing of the spinal marrow began immediately. Only two days later, a paralysis of the legs occurred, and a short time thereafter, it struck the entire body. Alma wrote to Anton Rintelen: "Lizzy—our Lizzy—is horribly ill! Send us your prayers and good wishes!"[77] Manon was not transportable in this condition; only when her status slowly stabilized could anyone contemplate a journey home. Minister

Schuschnigg even placed Emperor Franz Joseph's former personal train at their disposal to bring the girl to Vienna.

In Vienna, a year of suffering began, marked by the ups and downs of the illness. Manon frequently had severe pains, while on better days, the family gathered fresh hope. "Mutzi is on the road to recovery," Alma wrote Rintelen on their return to Vienna. "Every day her condition gets better, and now we can finally begin with the treatment here."[78] They were confident they would ultimately get a grip on the paralysis symptoms. "I'm feeling much better," Manon comforted her concerned father in a letter; "as you see, I am already writing with ink. I can stand and sit much better, too, and I can move my upper body like a big girl."[79] Through the course of this, her mother canceled all her appointments and travels: "I'll stay here in Vienna with my little one all summer."[80] Manon's return to health continued to make good progress. "I thank you a thousand times for the charming bird book and the magazine on Japan," Mutzi wrote to her "dear little Papa": "Things are also no longer so dull, I'm already eating at the table and receiving visitors. My girlfriend has been with me for four weeks, the one I told you about; isn't that touching?"[81] This girlfriend was Katharine Scherman, the daughter of the American husband-and-wife publishing team Harry and Bernardine Scherman. On the way to Salzburg, the Schermans had left little Kathy with Alma and Franz Werfel. "They took me along on a tour of the city," Katharine Scherman remembered: "We visited museums and the Prater, and a cabaret, where they hired a gigolo to dance with me, this was definitely the usual thing to do in Vienna; and they gave an enchanting party, to introduce some of Manon's friends to me. It was especially delightful for me to stroll through the streets of Vienna with Alma; people were constantly saying hello to her, and she seemed to be the queen of the city."[82]

After Manon's condition had been relatively stabilized in the summer, the healing process stagnated in the winter of 1934. Alma was despondent, Johannes Trentini remembers. "But I am inclined to doubt whether she was now touched because of Manon. I would rather say she was insulted because it was her child who had been stricken."[83] Alma glorified her daughter's suffering. Manon's illness was not just a terrible misfortune for her, but also a proof of the girl's chosenness. She interpreted the fact that, of all people, her only "Aryan" daughter had been so sorely afflicted by fate as proof of her specialness. Elias Canetti would observe this very precisely: "For almost a whole year she was put on display in a wheelchair, handsomely decked out, her face meticulously painted, a precious blanket over her knees, the waxen face enliv-

ened by seeming confidence. She had no real hope. Her voice was unimpaired; it had left the time of innocence behind it, and she put it to good use babbling like a gently flowing brook with her friends, offering visitors a clear contrast to her mother. Now that contrast, which had always seemed incomprehensible, had become even greater."[84]

Manon's illness was celebrated, and the patient was put on exhibition like a monstrance. When the child felt too weak, visitors to the house were allowed to come to the sickbed of the doomed daughter. Manon, who would have liked to become an actress, now found herself playing the starring role in a macabre tragedy. In his autobiography, Canetti expresses his severest reproaches of Alma, "who goes on living as usual, [and] regarded herself as a better person because of her daughter's misfortune. The girl was still in a position to say yes and was summarily engaged to be married. The choice fell on the young secretary of the Fatherland Front, a protégé of the professor of moral theology, who guided the heart of the house's regal leading character."[85]

In this project, Alma trusted in the moral backing and practical assistance of her beloved Johannes Hollnsteiner. Alma's lover, who appears in Canetti's book as a professor of moral theology, immediately had a suitable candidate at hand. The choice fell on the twenty-eight-year-old Erich Cyhlar, the very man who had already courted Manon in Venice back in March. Canetti errs, however, when he describes Cyhlar—albeit without calling him by name—as the "secretary of the Fatherland Front." Since the spring of 1932, Anton Rintelen's protégé had been the personal secretary of Federal Minister Odo Neustädter-Stürmer as well as parliamentary consultant of the federal administration of the paramilitary "Homeland Protection." The bridegroom thus belonged to the establishment of the authoritarian regime, which must have been very much to Alma's taste.

In any case, Erich Cyhlar played along with the tragicomedy, obviously hoping for a career boost: "It made an impression when the young man, sporting a tuxedo, kissed his fiancée's hand. As people in Vienna often say 'I kiss your hand,' it has become a part of the vocabulary in that city, but he actually did it as often as most people just say it. When he straightened up again, with the good feeling that he had been seen performing this ritual, that nothing here happened in vain, that everything and especially a kiss on that hand would be registered in his favor, when he then remained briefly in this charming bow before the paralyzed girl, he stood for both of them, and there were people who then, like her mother, trusted in a miracle and said: she'll get well after all. Her joy in her fiancé will bring about her healing."[86]

FIGURE 6.3

Susi Kertész, Alma,
and Manon around 1932.
"A light, brown-haired
creature, disguised as
a young girl" (Canetti
on Manon).

Alma was more and more convinced that an evil curse was accountable for her daughter's fate: "It's all the fault of this house, this house of misfortune." Here she meant the tragedies that had occurred in the Villa Ast. And now her own daughter was bedridden, mortally ill. Alma wrote: "With every fiber in my being, I long to get out of this house!"[87]

The worry about Manon had clearly taken its toll on Alma. She may have still hoped her daughter would regain her health, but now the paralysis had stricken the entire body, and more and more often the girl suffered attacks of suffocation. On Easter Sunday of 1935 Manon asked for Johannes Hollnsteiner, because she obviously sensed that she was about to die. Hollnsteiner, who was staying in Upper Austria, rushed with a quickly secured automobile to Vienna. There he found a seven-man team of medical consultants intensively looking after the patient. When the physicians left the house at 10 p.m., there was still a slight hope. Alma, one doctor, and two nurses stayed with Manon; Werfel and Hollnsteiner remained on call in the living room. That night, however,

the illness entered the decisive decline. On Easter Monday at 7 a.m., the one doctor who had remained there called his colleagues together. Around 11 a.m., the doctors made it clear to Alma that her daughter's life was nearing the end. Manon Gropius died on April 22, 1935, at 3:45 p.m. from an acute gastrointestinal paralysis, as entered on the death certificate.[88] "Let me die peacefully—I'm not going to regain my health after all—and by playacting, you're just trying to talk me into it out of sympathy." And, directed to Alma: "You'll get over it, the way you get over everything, like everyone gets over everything."[89] Those were Manon's last words.

Walter Gropius was living in London at the time. He may have been informed on the very day of her death by telegram, yet Alma left her ex-husband in the dark on the details for several more days. She was so despondent, she could hardly put one clear thought together, let alone write anything in a letter. It was Johannes Hollnsteiner who was entrusted with the task of informing the father of his daughter's final days:

> Around 11 a.m., the doctors indicated to me that they had run out of options, that I was now requested to fulfill my priestly duty. Mutzi's strength kept ebbing more and more. Calmly, without a fight, she passed over into the other existence at 3:49 in the afternoon. Her eyes free, directed toward the other world, her lips formed into a tender smile, with which all of us, who had been with her so often, were so familiar. . . . It can be a comfort to you that Mutzi was surrounded with flowers and love as she embarked on her final journey. All of Vienna is expressing sympathy. A few hours previously the federal chancellor [Schuschnigg] called me on his return to Vienna after an absence of several days, to be informed of the incomprehensible truth, especially because when he asked on Holy Saturday morning, he was told Mutzi was still doing well.[90]

Walter Gropius had last visited his daughter in June 1934. At that time Manon was already ill, but back then the doctors had told him they could heal her. Perhaps it was the deceptive hope that everything would finally turn out all right that had kept Gropius from making another trip to Vienna. Now he would only be able to take his leave of his child at the graveside. Because of an official stipulation for the avoidance of epidemics, the interment had to take place within just a few days. Gropius, however, was not able to sort out all the necessary passport and visa formalities quickly enough. Hollnsteiner remonstrated severely with him because of that: "When the situation began taking on threatening proportions, you were immediately advised, in the expectation

that you would hurry to the sickbed on the first flight. After all, with a dispatch about the mortal danger of your child no government authority would have given you any trouble on either entering one country or departing from another." This view, however, was naïve. As a German citizen Walter Gropius would never have been able to circumvent all the bureaucratic hurdles and official regulations in Britain and Austria. Besides that he would hardly have managed to find a flight from London to Vienna in the space of a few hours on a public holiday. Hollnsteiner, however, went even further: "The silent yearning of your child for your visit would have been fulfilled by your coming to the burial anyway."[91] Walter Gropius was devastated by Manon's death. Even thirty years later, "when he spoke of the horrible hours of that day," as Gropius's biographer Reginald R. Isaacs reports, he could "not hide the pain that had so overwhelmed him back then."[92]

While Gropius was stuck in London, the Viennese daily papers were reporting on the death of young Manon. "Because of her kindness and charm, she enjoyed the affections of one and all,"[93] it said in the *Neue Free Presse*. The *Neue Wiener Journal* also remembered the deceased celebrity with warm words: "A young human life has been snuffed out. Despite her long, severe illness, which she endured with an exemplary greatness of soul and a joyful nature uncommon for someone so young, Manon Gropius was the sunshine in the house of Mahler-Werfel. Her room, summer and winter a flower garden, attested to the love and admiration this young creature had earned. Beautiful as she was, in soul and body, she has now gone from us."[94]

The interment took place on April 24 and turned into a grand social occasion. On that Wednesday afternoon, Vienna's high society poured into the small Grinzing cemetery. A long motorcade fought its way down the narrow road up to the graveyard. Everybody wanted to be there, everybody wanted to stand as close as possible to the final resting place. But this was not about the deceased, Johannes Trentini recalled: "I would say the whole of Vienna's cultural society was there. Manon had no friends; all of this was in honor of Alma and Werfel. Nobody was there because of Mutzi, but rather they were there to be seen and get their pictures in the paper."[95] Among the curious onlookers was also Elias Canetti, who stood in the line of mourners together with the sculptor Fritz Wotruba and his wife, Marian:

I was sitting in one of the cars, a taxi, with Wotruba and Marian, who was a bundle of nerves and kept snapping at the driver in front of her: "Keep moving! We have to get up front! Can't you drive up there! We're too far be-

hind! We have to get up front! Just keep moving!" Her words kept cracking out like whiplashes, but there were no horses she could beat, just the driver, who got calmer and calmer the more she kept at him. "I can't, Madam, I can't." "But you have to!" Marian yelled, "We have to get up front." She was so nervous she started sobbing: "We mustn't be at the end of the line! The shame! The disgrace!"[96]

According to Canetti, they were finally able to force their way through to the grave, and there he was allegedly able to observe Alma very closely: "I don't remember how we got out of the car; Marian must have pushed us forward through the dense throng of funeral enthusiasts. We finally stood near the open grave after all, and I heard the stirring eulogy from Hollnsteiner, to whom the heart of the grieving mother belonged. As she wept, it occurred to me that her tears had an unusual format. There weren't too many, but she knew how to cry so that they flowed together until they were somewhat larger than life-size, tears the likes of which had never been seen before, like enormous pearls, precious jewelry; you couldn't look at her without being awestruck by so much motherly love."[97]

This stirring scene probably did not happen just this way, however. Canetti could not possibly have seen Alma during the burial at the cemetery, because at the time she was sitting alone in her villa. "I was standing next to Hollnsteiner by the open grave," Erich Rietenauer, then an acolyte at the Grinzing cemetery, remembered; "Alma was nowhere to be seen no matter where we looked."[98] Alma didn't like funerals and had accompanied neither Mahler nor her two children who predeceased Manon on their final journeys. And when, many years later, she was about to be picked up to attend Franz Werfel's funeral, she said gruffly: "I never go to such performances!"[99] She had no desire to break with her tradition. So in his aversion toward Alma, Canetti clearly overshot the mark.

At the open grave, Johannes Hollnsteiner gave the funeral oration that initiated the myth of "an angel's homeward journey": "Like a glorious flower, she blossomed. Pure as an angel she walked through the world. . . . A year of severe suffering brought her to maturity, so that the word of the Bible applies more to her than to any other human being: completed early, she still had a long life. She was mature: and so, in the course of this year of suffering and maturing, the Lord, in whom she believed, whom she loved, who was her support and help, brought her over into his kingdom. She has not died. She has gone home with open eyes. Her eyes without suffering and pain. Her lips framed

in her own special smile, which all of us who could be close to her know so well."[100]

Manon was no longer just an ordinary girl, she was an angel on earth. Johannes Hollnsteiner had given the key phrase that had been gratefully accepted in Alma's circle: "the death of an angel." This stylization had a wide-ranging impact: Bruno Walter wrote in his condolence letter that he believed "this child was too celestial to be able to live on earth."[101] Even twelve years later, Walter expressed similar thoughts in his memoirs: "From Alma's music room, you could look through the glass doors at a beautifully arranged terrace and then beyond that into the garden. I can still see the unearthly apparition before me, which presented itself to us as we once sat there after breakfast: an angelically beautiful girl of about fifteen with a doe by her side, framed in the door—she had her hand on the sweet animal's neck, smiled at us without any shyness and then disappeared again. It was Manon. They called her Mutzi; she is Alma's daughter from her marriage with Gropius."[102] Alban Berg also joined the chorus and dedicated his last composition—the concerto for violin and orchestra—"to the memory of an angel." And Carl Zuckmayer had, according to Alma, fallen so deeply in love with the mortally ill Manon "that he said he would leave his wife and child, and only wanted to live with Mutzi, not giving a damn whether she was paralyzed or not."[103] Finally, the writer Ludwig Karpath published the girl's official obituary in the *Wiener Sonn- und Montags-Zeitung* (Vienna Sunday and Monday paper): "Slender as a young pine tree, dazzlingly beautiful, highly talented, modest in demeanor, kind and good-natured in her close relationship with her significant mother and her mother's husband Franz Werfel, Manon was the most beatifying joy of everyone who knew her. A wonderful creature in the chastity and purity of her emotions, Manon walked like an angel among us, worshipped by the friends of the family, nurtured and protected like a young sapling, to keep her from all harm. Manon, known simply as Mutzi, had something majestic before which everyone was happy to bow."[104] Alma regarded her late daughter as a "saint." "Yes, it's brutal," Johannes Trentini explains: "That has to do with the fact that everyone in her circle thought she was a virgin. The expression 'saint' was often used in that context. She had been trained for it . . . to be angelic . . . by Alma and the people around her: the angel in the Mahler house, an artificial product of the people around her, yet someone who had nothing angelic about her. I believe that the purity of this child really came about because she was probably frightened away from human contact by her mother." As the sexually supercharged atmosphere in Alma's house had led to a certain frigidity in her daughter Anna,

Manon, similarly, first displayed no interest whatever in men. "She sent all of them away," said Trentini, "and that was certainly not common in that society in those days. And that's why everyone called her a 'saint.'"[105]

The sorrowing mother developed an idée fixe that she been assigned a mission by her late daughter. "She was closest to my heart. Closer than all the people I had ever loved. Because I love her idea even more, the idea of Mutzi, and nothing else in this world. . . . How awful this God is—if He exists, how despicable. Destroys my posterity in the purest form! For she was my better self, somewhat blended with a very good essence from the other side."[106] Alma projected her racist arrogance on the "Aryan angel," Manon. The relationship to her only still living child, Anna, then became even more complicated. Even years later, Alma left no doubt in the mind of writer Claire Goll that she had only had one "proper child": "'My only daughter,' she said with a sigh that lifted her ample breast. But Alma, I cried, don't you have two others as well? Yes, but those two are both half-breeds."[107]

POWER AND INFLUENCE

The relations the Werfels maintained with the political ruling class in Austria were, following the introduction of the Ständestaat, no longer merely social in nature. The contacts with some of the representatives of the regime—Anton Rintelen has already been mentioned in this context—can certainly be described as friendships, which, however, would not always accord them advantages. Shortly after the Republic of Austria was transformed into a dictatorship on May 1, 1934, the country was again shaken by another bloody putsch attempt. Midday on July 25, 1934, rebels dressed in uniforms of the federal army and the police attacked the Austrian Radio building and the Federal Chancery in Vienna. As the rebels stormed the central offices of the government, Dollfuss tried to get away and was shot in the back. Denied medical aid, he died the same evening from his injuries. It was quickly revealed that Austrian Nazis had been behind this conspiracy. The person slated to succeed the murdered chancellor was none other than Anton Rintelen, who already happened to be in Vienna since July 23 and presumably had been conspiring with the Austrian Nazis for some time. The coup, however, was so ineptly prepared that Rintelen couldn't possibly have brought it off. When Italian troops marched up to the Brenner Pass, the mutiny collapsed. Rintelen, who had made himself available at the Hotel Imperial, was taken into custody, where he tried to commit suicide. In early March 1935 he was put on trial, which triggered some headlines

the consequences of which would prove uncomfortable for Alma. The once so powerful "King Anton" now stood a broken man before the court, accused of high treason. Alma had no doubt that "he was in cahoots with them," as was, in her view, "everyone else in Austria—but I am just as convinced that he had absolutely nothing to do with the murder of Dollfuss." The evening before the putsch, Rintelen had put his friend in a precarious situation "by pleading with me last night to drink a glass of beer with him and his friends in [a tavern called] the Griechenbeisl." Did Alma know anything about the planned action? "I was later summoned to the regional criminal court, but my testimony was so innocuous, and so absolutely in conformity with the tapped phone calls I had made with Rintelen, that, thank God, they said they could do without my testifying in the main trial."[108] Anton Rintelen was threatened with a death sentence. Justice Minister Egon Berger-Waldenegg, however, instructed the chief prosecutor to conduct the trial in such a way that the defendant would get away with a life sentence. On March 14, 1935, the sentence was passed.

In the summer of 1934, the previous justice and education minister, Kurt von Schuschnigg, assumed leadership of the government and continued the reactionary-authoritarian course of Chancellor Dollfuss. Franz Werfel welcomed the new federal chancellor with effusive praise—a political statement that seems paradoxical against the background of Werfel's biography. Schuschnigg's personality, as Werfel wrote in the *Wiener Sonn- und Montags-Zeitung* on August 6, combined "three of the noblest human values: profound religiosity, incorruptible intellectuality, [and] high-level artistic talent and erudition." For him, it was a "stroke of fortune" that Austria "on the brink of the abyss has found this distinguished and firm hand of leadership!"[109] Subsequently a friendship developed between the writer and the chancellor, who often came to visit him late in the evening, where for relaxation he would get Werfel to read him some sonnets by Goethe. Occasionally, it is claimed, Franz Werfel would also rewrite speeches for Schuschnigg. Franz Werfel's stance toward the Ständestaat and the leader of this totalitarian regime provoked a good bit of objection. For Willi Schlamm, the founder and editor in chief of the Prague-based *Europäische Hefte* (European periodicals), Werfel was "the classic case of a saturated individual," as he wrote with a rapier wit in September 1934: "The accredited author—a miracle of technology: toss an advance payment in the top, and culture promptly comes flowing out down below—is once again the Punchinello, the jester at the court of power." And further: "In the old days the clown-poet who was tolerated at court occasionally avenged himself against

the government with genuine art; such a soul purifier for Schuschnigg, such a lyrical enema, will never be anything more than a Zsolnay author."[110]

One year later, in the summer of 1935, following Manon's funeral, the Werfels and Anna Mahler traveled to Italy. In Viareggio the family got together with Schuschnigg. Benito Mussolini placed a state limousine at his Austrian colleague's disposal so they could go on little excursions in the surrounding countryside. Schuschnigg enjoyed the days, especially the time he spent together with Anna Mahler, "because he was wildly in love with Anna."[111] Despite all discretion, the chancellor's affair with Gustav Mahler's daughter could not be kept completely secret. "Anna owned a thick stack of love letters from Schuschnigg," Elias Canetti remembered, "which she could under no circumstances leave lying around at home, because her best friends were ultra-left-wingers. Socialism was Anna's true belief, but Schuschnigg oppressed the Austrian left wing with all severity, even tried to stamp them out." And he went on: "The consequences would have been inconceivable were Schuschnigg's letters to fall into the hands of Anna's left-wing friends! She would have been branded a traitor! Hadn't Schuschnigg, in his onetime function as justice minister, been responsible for the execution of socialist fighters?" Alma is said to have been all for this adventure: "But as much as she [Anna] may have hated her mother, in the final analysis she wound up doing what Alma told her to do."[112] When Schuschnigg's wife Herma was killed in a car accident on July 13, 1935, the chancellor—according to Canetti—regarded this stroke of fate as punishment for his flirtation with Anna Mahler and put an end to the affair. In his obituary for the deceased wife, Franz Werfel lauded the dictator as a "pure" and "extraordinary man": "The Austrian humanity, which he, the spiritual, sensitive, imperturbable man embodies on such a high level, this humanity, which has not succumbed to any of the embittered contemporary phrases, must be preserved and enforced for the redemption of Europe."[113] Werfel's eulogy was surely an expression of gratitude; after all, during Manon's illness, Schuschnigg had stood by the family with words and deeds. For the *Arbeiterzeitung* in the Moravian city of Brno, this homage was regarded, in the writer's opinion, more as a "literary cheap shot": "People are starving in dungeons, while the Werfels are eating their fill out of the trough and then licking their hands. The embodiment of human filth!"[114]

Since Alma and Franz Werfel could no longer be happy in the city where Manon's tragedy had begun, they decided to sell the Casa Mahler. On July 31, 1935, Alma, Anna, and Ida Gebauer traveled to Venice: "In a single day, we had packed everything and emptied the house. But how painful it was for us."[115] In

Breitenstein, where Alma retired after she returned from Italy, her memories of Manon also caught up with her. "I don't care anymore about my life or anyone else's. What's the point of it all? If death keeps grinning in one's face with its inexorable illogic?"[116] She let nobody come near her. Mostly Alma just lay in bed and stared at the ceiling. When Werfel tried to comfort her, she sent him away.

On her return to Vienna, Alma found out from Carl Moll that a monument was to be erected in May 1936 to commemorate the twenty-fifth anniversary of Gustav Mahler's death. Alma was initially skeptical because this plan had already been under discussion for a few years and never come to fruition. As far back as 1926, a monument committee had been formed, and they had been able to acquire the services of the highly regarded sculptor Anton Hanak. The funding was secured with generous donations from the United States and Great Britain. After Hanak's death in January 1934, Alma gave up the project. When it was then announced that Fritz Wotruba had been commissioned to create the monument, she got curious. The twenty-eight-year-old sculptor not only ranked as a major up-and-coming talent, whose Mahler plans were soon the talk of the town; he was also an attractive young man, and beyond this, he had briefly been Anna Mahler's teacher. Alma had already met Wotruba several times in Viennese artistic circles and was thrilled with his masculine charisma. She now made a cardinal error and tried to seduce the sculptor. "She came to him in his atelier with some enormous mortadella sausages under one arm," wrote Elias Canetti, describing a typical scene, "and then after she left in disappointment, she told her daughter: 'He is unsuitable for Mahler. He's nothing more than a simple peasant.'"[117] Evidently Alma—still hysterical in this regard, even at her advanced age—had gone on only perceiving men either as admirers or enemies. And when Wotruba—beyond this, a married man—failed to return Alma's advances, she enlisted Johannes Hollnsteiner's assistance to plot her revenge.

The intrigue wasn't long in coming. While the Werfels were away on a trip to New York at the end of 1935, Hollnsteiner made his way to Vienna's city hall. There, his old friend Richard Schmitz had been lord mayor since April 1934 and was known to be an unshakably strict Catholic. Hollnsteiner cunningly mentioned in passing that Wotruba's designs were indecent, since the sculptor had planned to place two semi-clad ladies on the monument. His calculation paid off. "Schmitz turned down the Wotruba project!" Hollnsteiner wrote to his lady friend on December 24, 1935. "You have been proven right once again! He told me that when he saw the photos, he had said only one word: 'Lesbos.' And he isn't all that wrong either! He was very nice and emphatically stressed

that he was entirely in favor of the erection of a Mahler monument, but he didn't want setting up a couple of lesbian females and calling it a monument. He also had basically nothing against Wotruba. But he had seen very little from him apart from naked women, which most certainly didn't have much to do with Mahler."[118]

Barely a year later, however, Alma would get paid back for her intrigue against Wotruba. The sculptor wanted the fee for his work and sued the monument committee for payment of his honorarium in the amount of 17,500 schillings.[119] He found himself, however, facing off with a formidable adversary: Johannes Hollnsteiner obviously pulled out all the stops with the aid of his influential friends to keep the intrigue under wraps. On April 9, 1937, the case was dismissed by the Vienna Regional Civil Court, a decision that remained unaltered despite an appeal hearing a short time later.[120] For Wotruba, his failure to get a positive court judgment was further proof he had been the victim of a conspiracy. "Under the pressure of political conditions at the time and the machinations of my opponent, Prof. Hollensteiner [sic], this legal matter was completely hushed up by the press, and I was left without any compensation. The court fees, however, had to be paid by the other side."[121]

Franz Werfel found his wife's machinations totally incomprehensible. Mostly he just shook his head when he found out about Alma's monkeyshines, but occasionally some fairly acrimonious quarrels ensued. "My marriage has long since ceased to be a marriage," Alma complained in February 1936. "I live in deep sorrow beside Werfel, whose passion for monologues has become boundless."[122]

Back from America, Alma and Franz Werfel were drawn to Switzerland in the spring of 1936. In Zurich they met Johannes Hollnsteiner, who was there to give a lecture on April 5 on Christianity and Germanic culture. Sitting in the audience at the Theater was even Thomas Mann, who wanted finally to meet the influential Viennese theologian personally. For some time Hollnsteiner had been trying to persuade Chancellor Schuschnigg to offer Austrian citizenship to the eminent writer, who was being threatened with the loss of his German citizenship.[123] When Thomas Mann found out that the Werfels would also be coming to Zurich sometime later, he invited all three—Alma, Franz Werfel, and Hollnsteiner—to his home for tea. They talked a lot about political developments, Thomas Mann noted, "about Hitler, Vienna and Schuschnigg, to whom a card was sent."[124] A few days later the guests moved on to Locarno, where Hollnsteiner celebrated Mass on April 22 to commemorate the anniversary of Manon's death. In her diary, Alma invokes the presence of her daughter:

"I feel her every moment. She is all around me."[125] While Alma traveled back to Vienna, Franz Werfel took up residence in Bad Ischl, where he began work on his next novel, *Jeremias, Höret die Stimme* (*Jeremiah: Hearken unto the Voice*).

In the Austrian capital, meanwhile, preparations were under way to commemorate the twenty-fifth anniversary of Gustav Mahler's death. While Mahler's music had largely disappeared from the repertoire in Germany, the memory of him in Austria was held aloft in majestic celebrations. Bruno Walter and the Vienna Philharmonic, as well as the Vienna Symphony, had put together an extensive program: between April 26 and May 24, 1936, Mahler's Second Symphony, the monumental Eighth Symphony, the *Lieder eines fahrenden Gesellen* (*Songs of a Wayfarer*), as well as *Das Lied von der Erde* (*The Song of the Earth*), were performed. These events "stood under the honorary patronage of His Excellency, Federal Chancellor, Dr. Kurt von Schuschnigg," as it said on the handbills. On May 18, 1936, the anniversary of Mahler's death, Alma and Franz Werfel gave a festive afternoon and evening reception "in honor of Bruno Walter," with numerous prominent representatives of "'the Viennese Upper Crust' in attendance."[126] The next day, the *Neue Wiener Journal* published extracts from the guest list: besides a goodly number of professors, aristocrats, privy councilors, and other members of the social establishment, the ambassadors of the Netherlands, Sweden, Belgium, Poland, Hungary, and France also showed up. With her invitations to the diplomatic corps, Alma had done Chancellor Schuschnigg a great favor. It was hoped the diplomats would report back to their homelands, if everything went according to plan, that the Ständestaat honored the prominent Jew Gustav Mahler, and that another prominent Jew— Bruno Walter—was in close contact with the government and the chancellor. In short: Austria, in contrast to Nazi Germany, was a tolerant, cosmopolitan, and liberal country.

On the other hand, the commemoration organized parallel to this by the Vienna State Opera—Mahler's former base of operations—was, by contrast, boycotted by Alma. There she still had an open grievance to resolve with its director, Felix Weingartner. On the morning of June 14—a few hours before the beginning of the event—Alma sent a brusque telegram to Weingartner, canceling her participation and Anna's without giving any reasons. Franz Werfel also sent his regrets, apologizing for his absence in a telegram from Bad Ischl. This move to discredit Weingartner came at the end of an intrigue that had gone on for several months. The bone of contention was Weingartner's memoirs, in which he had made disparaging remarks about Gustav Mahler— his predecessor at the Court Opera. Alma was unforgiving. When Weingartner

assumed the post of opera director a second time in 1935, she found a way to settle the score with him. Once again, it was Johannes Hollnsteiner who engineered her intrigue.

"Dear Mr. Federal Chancellor," Hollnsteiner wrote to Schuschnigg, "May I direct your attention to an incident that certainly calls for your immediate intervention, because if it were to go any further, it might definitely harm Austria's good reputation. In the State Opera, the bust of Gustav Mahler, a work by Rodin, has been removed from its previous position and placed in the most unfavorable spot imaginable. At the time, the bust had been turned over to the State Opera by Mrs. Mahler under the condition that it would be displayed in a worthy location." As if this were not enough, Hollnsteiner uttered a threat to be taken seriously:

> Mrs. Mahler, who has been informed by many sources, always with considerable indignation over this repositioning, is firmly determined to demand the return of the bust, unless it is immediately restored to its previous situation. It certainly goes without saying that this cannot remain concealed from the general public, with subsequent comment in both the domestic and most especially the foreign press. I have never made any secret, not even in the Mahler-Werfel home, that I regard a healthy anti-Semitism to be a necessary attribute. This action on the part of Mr. Weingartner is, however, simply ridiculous and nothing else. It seems utterly undesirable to me that this matter somehow be publicized under the title of anti-Semitism on the part of the Austrian government. I shall content myself with simply reporting this state of affairs to you.

Last but not least, Hollnsteiner concluded his intervention by saying it was "certainly necessary to make the Opera Director aware of the previously general feeling of purity in the institution he had mistreated. Please forgive me, dear Mr. Federal Chancellor, these straightforward words!"[127]

Hollnsteiner's letter was a cunning move, for it hit Schuschnigg in a sensitive spot. Of course he was aware that Austrian domestic politics had been attentively followed by other countries since the introduction of the authoritarian regime. That was why Schuschnigg couldn't allow himself any scandals about a Mahler bust, and he certainly didn't need any allegations of anti-Semitism on the part of the opera director. If Weingartner were to leave his post, as Hollnsteiner seemed to be implying, then Austria would also be helped. A few hints about the reputedly immoral life of the conductor, "who had married one Jewish woman after another,"[128] rounded off this denunciation.

Felix Weingartner did not find out about the charges being leveled at him until June 1936. "I personally did not have the slightest thing to do with this entire matter," he assured Alma in a letter. "These were orders from the Federal Theater Administration, which were presumably enacted before I took over the director's position."[129] Weingartner's new defense, however, came about too late. Totally clueless, he didn't register the fact that this had nothing to do with the bust, but rather that the whole business was only a pretext for getting rid of him. Weingartner's days at the Vienna State Opera were numbered. On August 24, 1936, in Salzburg, Education Minister Hans Pernter demanded the conductor's resignation. Seven days later he left his post, for health reasons, according to the official version.

A new problem arose when Alma found out Bruno Walter had written a short Mahler monograph. This news sent her into a wild panic, fearing that she might be unfavorably portrayed in the book. Even before it was shipped to the bookshops, Alma got hold of the manuscript. When she read it, she found it not only "highly unsympathetic," but worse than that, it seemed to confirm her most horrible fears. "And I—am simply not there. This wound to my ego ruined my night. I shall zealously take up the cudgels in my own defense. Perhaps it was wrong of me after all not to have published the letters . . . keeping me so far in the background like that! This will have those pigs believing I might have something to conceal. It was right to make facsimiles of these sketches to 'X' [the Tenth Symphony]. There is no way these old opponents of mine can get around this: 'to live for you,—to die for you—Almschi!'" Alma had always kept her distance from Bruno Walter. During Mahler's lifetime she looked warily at this close friendship between Mahler and Walter. Now, many years later—and this is characteristic of her ideological blindness—she ascribed her difficult relationship with Walter to his being Jewish. "They" "still hate the unsullied, beautiful Christian in me. For the Jews cannot forgive us our brighter nature. And even if they dye their hair blond 10 times, they still remain a dark, savage, eastern people. Black-souled and devoid of compassion. It isn't enough for Mr. Walter and cohorts to have poisoned my youth—they want to get at me in my old age as well."[130]

APOCALYPTIC MOOD

As was the case with virtually all the educated and politically interested circles in Europe, the Spanish Civil War, which would plunge that country into over three years of horror, also split the Viennese intelligentsia into two camps. At

the Werfel home, the split went right through the family. While Franz Werfel took the side of the democratic government, Alma supported the adherents of General Franco. Heated disputes broke out more and more frequently. The tone got rougher, they yelled at each other, and it became clear how irreconcilable the couple's political positions were. For Anna Mahler, Werfel was just "the poor soul," "the weakling," who was unable to counter Alma's arguments. Alma got progressively stronger-willed, Werfel constantly weaker. In these arguments Alma's inability to indulge in a meaningful exchange of opinions came clearly to the fore. Her constant repetitions of absurd claims drove her husband into a white-hot fury as Anna recalled: "Werfel tried a new argument every time—it was so stupid of him to try to convince her! Until he ran out of patience after hours of bitter, noisy disagreements, sprang to his feet, and walked out of the house. He kept on seething with rage while Alma, cool as a cucumber, promptly turned her attention to completely different matters, paying no attention whatsoever to the foregoing squabble. Then he came back, distraught rather than refreshed, and they, howling and screaming, would start all over again. Alma was fresh and in the best of moods and received Werfel in her capacity as the winner."[131]

Anna had already had to go through this in her early youth. From this she had learned the lesson, as she willingly confessed, "never to get into an argument with Mommy. She scared the living daylights out of me."[132] Anna also sympathized with the Republicans during the Spanish Civil War, which further exacerbated the already strained relationship with her mother. "The leader of my adversaries is always Anna," Alma lamented. "It is so painful for me a 150% Jewess had been born from my womb."[133] She wrote these lines in the Czech health resort of Marienbad (today Mariánské Lázně). In mid-September she had traveled to the city at the foot of the Kaiserwald to take a cure: "It is anything but jolly to have yourself inspected from top to toe, naked." She kept on escaping into her memories of Manon. In the diary, the idealization of the girl increased gradually to the proportions of a transfiguration: "She was much too beautiful," said the entry on September 24, "too pure to play the part of a creature on earth."[134]

On March 19, 1937, Franz Werfel, on the initiative of Federal Chancellor Schuschnigg, received the Austrian Cross of Merit for Art and Scholarship, First Class. This award made clear what had long been well known: Werfel was the darling of the regime. His example marks the ambivalent dividing line between Jewish artists and the authoritarian government. Despite the unambiguous anti-Semitic alignment of the Ständestaat, many Jews had a significant

share in Austrian cultural life. Even some portions of the Jewish bourgeoisie regarded Dollfuss and Schuschnigg as guarantors of a national independence in the Alpine republic and supported their governments.

Werfel's success did not change the way Alma was now increasingly drawing away from him. "No, I can't write anymore," her diary said in early April 1937. "No! I am so horribly alone. Tenderly loved from all sides and most profoundly abandoned."[135] The Spanish Civil War had split the husband and wife apart. Werfel hardly ever showed up in the house they shared. He preferred to do his work in hotel rooms outside Vienna, while his wife's views, through the influence of Hollnsteiner, became more and more radical; and alcohol may also have been a contributory factor. In this phase of her life, Alma Mahler-Werfel was most certainly trapped in a deep crisis. She mourned for Manon, was well over fifty years old, overweight, and could not come to terms with the consequences of aging. Werfel "really wanted to leave her," Anna Mahler remembered. "But he didn't have the strength to do it: every time he kept coming back to her."[136]

More than ever, Alma felt that the villa on the Hohe Warte was a house of misfortune. "I have decided," she noted in mid-June, "to rent out the house where Mutzi died."[137] Franz Werfel welcomed this decision, having never felt really comfortable in this pompous palace anyway. Now the job was to pack up all the household items, thousands of books and musical scores, countless pictures and precious objects of every kind. Before the Werfels left the Villa Ast, they gave a huge farewell party in the garden on June 12, 1937. Almost all of Vienna's high society was present. The *Neue Wiener Journal* reported: "The hosts, supported by their daughter Anna Mahler, did the honors in the most charming way as they received their guests."[138] Besides several representatives of the high aristocracy, and the private and public sectors, such eminent artists as Ida Roland, Bruno Walter, Carl Zuckmayer, Egon Wellesz, Alexander von Zemlinsky, Ödön von Horváth, Siegfried Trebitsch, Arnold Rosé, Karl Schönherr, and Franz Theodor Csokor showed up. The gala affair began at eight in the evening and lasted until two the following afternoon. A little band played melancholy Viennese folk tunes, and for many of the guests, something like an apocalyptic mood hung in the air. Since the agreement of July 11, 1936, between Hitler and Schuschnigg, in which Germany guaranteed to recognize the sovereignty of Austria in return for amnesty for the Austrian members of the Nazi Party, attentive contemporaries were worried over the future of the small country. The festive party was a great success. At the end of it, an inebriated Franz Werfel fell into the garden pond, and Carl Zuckmayer spent the night in the doghouse.[139]

In Vienna, the Mahler-Werfels now had no place to live. They wanted to set up their primary residence for the time being in Breitenstein. The furniture and books were put in storage, and in Vienna, a reasonably priced hotel would have to suffice. On July 1, the couple checked into the Carlton Hotel on the Wiedner Hauptstrasse.[140] But only a week later, Werfel moved back out and went to Marienbad, while Alma left the apartment five days later and moved on to Breitenstein. They had nothing more to say to each other. The more caustic the differences between husband and wife became, the more intensely Alma again felt herself attracted to Oskar Kokoschka. She frequently even dreamed about her erstwhile lover. "Why did I leave that man? He was the strangest, most beautiful one in my life."[141] Over the weeks that followed, Alma exchanged a few letters with Oskar, in which, however, she again lost all her joy in fictitious flirtation. "Now that I again had a kind of choice," she noted self-assuredly, "I have decided totally in favor of Werfel."[142]

Alma couldn't abide Vienna anymore. Abruptly, in late October 1937, she traveled with her daughter Anna clandestinely to Berlin for three days—a possibly perilous undertaking, since Nazi ideology regarded Anna as a "half Jew." In the German national capital, the two visitors strolled down the streets and looked at the houses all adorned with swastika flags. The militarization of German society made a great impression on Alma. "A whole nation there was under arms," she admiringly wrote later in her diary, while in other countries everyone just "boozed, gobbled, fucked, and slept."[143]

Back from Berlin, Alma was plagued with fears for the future. She was not afraid of the Nazis—quite the contrary, she could even acquire a taste for a life under the swastika. Anna Mahler was able to report that her mother occasionally wore a swastika insignia underneath her coat collar, even though Alma was demonstrably not a member of the Nazi Party.[144] Alma, however, was more confused than ever as to her feelings for Franz Werfel. In this situation, she sought out the services of a palmist on November 26. She was delighted with the skills of this palm reader; after all, he had discerned, as she was pleased to hear, an impressive artistic talent in her palm lines, "right beside great religiosity in which nobody is ever willing to believe."[145] After that, the fortune-teller predicted her future: Alma would leave Vienna at the age of fifty-nine and move with her husband to another country. There she would live with him in tranquil friendship. Leave her native city of Vienna, become a refugee, give up her family and her valuable possessions? No, Alma wouldn't even dream of leaving Austria. By no stretch of the imagination could she believe that the palmist might ultimately be proven right.

The Involuntary
Escape

1938–1940

DEPARTURE FROM VIENNA

"Oh, it was a ghastly Christmas: I was so deeply distraught—this festival of joy throughout the world—that could only happen so perfectly for me through Mutzi's incredible ability to love—I cannot celebrate it anymore without her. She is around me always and forever but on days like this, I suffocate with pain. Werfel and Anna said one day is just like the next.... What do they know...? What did the cells of their grandparents feel on this day? Vengeance and retribution against the Goyim, who had abrogated their alleged rights, ... What else can happen to me? What else can make me happy—without my child, who has taken my soul along with her."[1]

Actually, Franz Werfel and Alma wanted to spend the holiday season—as they had the year before—in Milan. However, as he was suffering from a severe case of bronchitis, they initially remained in Vienna. When he felt better, they started out toward the south on December 29. After a stop in Milan, where the Werfels stayed in the Grand Hotel, in the rooms where Giuseppe Verdi had lived decades before, they continued on to Naples and from there to Capri. Franz Werfel was instantly very much taken with the island. The balanced climate and the perpetually green vegetation inspired him, and, for the first time in a long time, he wrote a few more poems. But this idyllic calm was abruptly shattered. "The bomb exploded, and Werfel came hurtling into my room with the newspapers: Schuschnigg had gone to Berchtesgaden."[2] At Hitler's "Eagle's Nest" on the Obersalzberg on February 12, 1938, negotiations had begun between the German dictator and the Austrian federal chancellor. Schuschnigg could no longer fend off Hitler's threats, and in the hope of retaining Austrian autonomy vis-à-vis the German Reich, he unconditionally agreed to grant amnesty to all the imprisoned members of the Austrian Nazi Party and to appoint their fellow Nazi Arthur Seyss-Inquart to the post of interior minister.

(*previous page*)
FIGURE 7.1 Alma and Franz Werfel: "We're tearing one another to shreds, we're hurting each other, we're forgetting" (Franz Werfel in a letter to Alma).

This political development took Alma and Franz Werfel completely by surprise. At first Alma wanted to head straight back to Vienna to get a personal impression of the situation on-site, but then decided rather to spend another couple of weeks or so with her husband in Naples. Both of them were torn in both directions, undecided and full of fear over what the future might bring. On February 28, Alma left for Vienna. It was clear to her, as she retrospectively wrote, "that Werfel could not possibly come along to Vienna. He was in danger!"[3] After an arduous rail journey, she finally reached her hometown, where she spent the next two days incognito. Neither Johannes Hollnsteiner nor the Molls knew anything about her arrival—only Ida Gebauer had been informed. Alma observed the events with bafflement. In the space of just a few weeks, Austria had completely changed; the "Heil Hitler!" greeting, which in Germany had already replaced such straightforward salutations as "Guten Morgen," was no longer banned, and the swastika flag was no longer regarded as subversive. Shortly after her return, in wise foresight, Alma closed all her bank accounts. She and Ida Gebauer sewed the cash, countless schilling notes, into a money belt, which Ida smuggled across the border to Zurich. Alma also toyed with the thought of selling her valuable artworks. She was thinking primarily of Edvard Munch's famous painting *Summer Night at the Beach*, which Walter Gropius had given her at Manon's birth. The sale of this artwork, which had hung on loan at the Austrian Gallery since August 1937, would—so Alma hoped—fetch a sizable sum. Alma asked Carl Moll to reestablish contact with the museum—the gallery was very much interested, but could unfortunately not raise enough money to meet Alma's demand for 10,000 schillings (some $51,000). Nevertheless, a few years later, on April 16, 1940, Moll sold the painting to the Austrian Gallery—for 7,000 reichsmarks (about $38,000)—so that he could use the proceeds to have some urgently necessary repairs made on the roof of Alma's Breitenstein house.

On March 9, 1938, in Innsbruck, Schuschnigg announced a referendum on the sovereignty of Austria. The government's slogan, published on hundreds of thousands of handbills, was "For a free and German, independent and Social-Christian and united Austria—for bread and peace in the land!" This conglomeration of national goals "sounded frightened and unfree," Alma recalled. "Nobody picked up those flyers, only the wind played compassionately with them."[4] The pressure exerted on the Schuschnigg government prompted widespread declarations of solidarity. Anna Mahler and her friends—the architect Heinrich Riss, the industrialist Kurt Lichtenstern, and the writers Anton Kuh and Leo Perutz—also supported the chancellor despite

their rather left-leaning political positions. "She hung around with a bunch of Communistic churls and her lover at the time, Riess [Riss], a dreary lump of flesh,"[5] as Alma wrote. There was no help in sight for Austria in the face of the threatening incursion of German troops—Berlin had issued an ultimatum demanding that the plebiscite be canceled. In a radio address on March 11 at 7:15 p.m., Schuschnigg announced his resignation. Two days later, the "annexation" of Austria into the German Reich was sealed by Hitler and Arthur Seyss-Inquart, Schuschnigg's successor. On Heldenplatz in Vienna, a jubilant crowd welcomed the "reunification" of the two countries.

Suddenly Alma remembered the palmist's prophecies. Something that would have been unthinkable for her only a few months ago had now become reality. It was clear to her that she would first have to leave Austria to get to Franz Werfel, who had taken ill in Naples. On March 12, Alma said farewell to her mother, "knowing I would never see her again. I left her convinced I would only be away for eight days."[6] She spent the following night with Anna and Johannes Hollnsteiner in her hotel room. The whole night was devoted to discussion, talking about old times and the uncertain future. The next morning Alma and Anna left Vienna and traveled toward the Czech border. Via Prague, Budapest, Agram (today Zagreb, Croatia), and Trieste, mother and daughter finally reached Milan, where they saw Franz Werfel again. But their stay there would not last long—the Lombardian capital "did not please us this time "— and so they were happy to accept an invitation from Werfel's younger sister, Marianne Rieser, to join her in the Swiss city of Rüschlikon. Their days there, however, were steeped in gloom. "It was the only sad time of our emigration. Was it their fault or ours?—I don't know!"[7] Tensions arose repeatedly between Alma and her sister-in-law, especially because Alma gave free rein to her unshakable anti-Semitism, which the other lady had no desire to listen to within her own four walls.

After taking care of the cumbersome passport and visa formalities, the Werfels traveled via Paris to Amsterdam, where Willem Mengelberg had invited them to a small Mahler commemoration. Alma enjoyed the time in the Netherlands. Some of Gustav Mahler's fame cast a bit of reflected glory on her, which distinctly boosted her self-esteem. On May 9, the journey continued on to London: "There I was afflicted with a veritable nervous breakdown!"[8] While Franz Werfel immediately felt just fine in London, Alma got no satisfaction from living in England. Time and again he tried to persuade his wife to transfer the center of their lives to London, especially as Anna Mahler had also decided to settle there, but he made no headway with her. "Here in London not one

German book . . . no piano . . . no German-speaking people, an unrelentingly cold city "—that was how Alma summed things up. Whatever it would take, she wanted to go back to France. On June 1, 1938, Alma and Franz Werfel arrived in Paris and moved back into their "little, cheap sleazy hotel."[9]

"It is exasperating," Alma wrote in her diary shortly after their arrival. "After a 20-year marriage, we are speaking two languages. Neither one of us understands the other. The racial divide is insurmountable." Alma accused her husband of being concerned only with his family. This "fussing over his family," as she called Werfel's worries, got on her nerves. She had not resigned herself to being an emigrant, especially as she had no intention whatsoever of declaring any kind of solidarity with the European Jews. "Politically, however, I reserve the right to think and say what I want. That the worthy Jews today have nothing but vengeance and retribution on their minds, that they calmly, even approvingly, just stood by and watched all the many years of Communist atrocities—today the whole world takes umbrage at them for that."[10] When Alma attended a performance of Wagner's *Tristan und Isolde* under Wilhelm Furtwängler's direction at the Paris Opera on June 23, she felt something like "homeland." "I shall never allow myself to be torn out of this culture! Where are the others then . . . the better ones . . . ?"[11]

In the course of these weeks, news of Johannes Hollnsteiner's fate penetrated from Vienna through to Alma and Franz Werfel. Even before the so-called annexation, the go-getter priest ranked with many Nazis as an influential string-puller and a secret head ideologue of the Schuschnigg regime. That meant that after the German incursion he was in danger. Alma had had good reason to advise her lover as far back as early March to burn all of his possibly incriminating documents as quickly as possible. Nevertheless, Hollnsteiner did not regard himself as imperiled, which would turn out to be a serious mistake, since the Gestapo, as they later accused him, had found letters of intervention from him in virtually every Viennese ministry. On Sunday, March 30, 1938, he was picked up at his Augustinian Monastery of St. Florian by two Gestapo officers. During the eight weeks of his confinement he was left largely in the dark as to the reasons for his arrest. In the night from May 23 to 24, 1938, Johannes Hollnsteiner was transferred without prosecution or trial to the concentration camp in Dachau. There followed an eleven-month imprisonment, during which the clergyman, unused as he was to physical exertion, had to work in a gravel pit, in road construction, and as a stove fitter. When an SS guard discovered that Hollnsteiner was a scholar, he hit him in the face: "You son of a bitch, I'll show you who's the teacher here!"[12] For the Gestapo, Johannes Hollnsteiner was an

"enthusiastic Schuschnigg supporter" and "opponent of the National Socialist state" and as such was "to be rejected as a politicizing clergyman."[13]

The Werfels were horrified by what had happened to Hollnsteiner. While they had managed to flee into the initially safe territory of France, their friend was forced to endure torturously strenuous exertions. Bruno Walter, who had also emigrated, and had been informed by Alma of Hollnsteiner's arrest, thought with "painful compassion"[14] of the prominent theologian. But nobody could help him.

SANARY-SUR-MER

In mid-June 1938, Franz Werfel moved from Paris to the nearby suburb of Saint-Germain-en-Laye. He took a spacious room in the most beautiful hotel in town, the Pavillon Henri IV, so he could start working again after several months of agonizing unproductivity. The castle park and the adjoining woodlands invited him to take extended walks. Having felt ill and weak for a long time, he hoped to find the necessary rest and rehabilitation in the solitude of Saint-Germain. Alma remained another couple of days in Paris before heading to southern France. She had decided, not least because of her husband's debilitated health, that the Côte d'Azur would become their new home. She finally selected the little fishing village of Sanary-sur-Mer. The dreamy spot of earth near Marseille was a center of German emigration: Thomas and Heinrich Mann, Lion Feuchtwanger, Bertolt Brecht, Ludwig Marcuse, Ernst Bloch, and others stopped there from time to time until 1940. With the help of a friend— Anne-Marie Meier-Graefe—who had been living for some time in the South of France, Alma found appropriate accommodations high above the local bay, at Le Moulin Gris (the gray mill), an old Saracen tower. On the second floor of the building was a round room that would be an ideal study for Franz Werfel. One could look through the twelve large windows at the open sea—a breathtaking view. On July 1—while Alma and Anne-Marie Meier-Graefe were still discussing the organizational details of the move—she received a call from Paris: Franz Werfel was severely ill. Alma had to go to him immediately. In Saint-Germain she found her husband in a miserable state, having suffered a mild heart attack. "I feel sicker than ever before," Werfel wrote in his diary that day. "It's as if my head were full of water. It is threatening to burst open because of the intense pressure."[15] Alma immediately had her husband brought to Paris. It took a long time for his condition to improve. After a good four weeks, the Werfels finally settled in their new domicile in Sanary.

"What else can happen?" Alma asked herself on her fifty-ninth birthday. "I keep saying to myself . . . I love him, I love him, but whom? But what?"[16] Alma was deeply depressed. She might have followed her husband into exile, but her relationship with him was less clear to her than ever before. "God in heaven!" she noted on the following day, "no one can go on living so hopelessly. I'm at my wit's end."[17] Alma blamed her husband for the fact that she had been forced to turn her back on her native city for his sake: "I yearn so often for home! For Vienna."[18]

The emigration would not bind the Werfels more closely together, as one might have expected. Alma's anti-Semitic outbursts just deepened the divisions between husband and wife, a situation that did not remain concealed from other people. The writer Lion Feuchtwanger and his wife, Marta, often got together with the Werfels in Sanary. Although frequent and acrimonious political discussions took place between the two authors—Werfel resented Feuchtwanger's flirtation with the Soviet Union—the two couples still managed to establish a kind of friendship. "I was alone in Sanary," Marta Feuchtwanger remembered, "Lion had to go to Paris for some kind of meeting, and then Mrs. Werfel invited me over, she was really very hospitable, she went to a great deal of trouble, hired a girl especially to serve us, so she wouldn't have to go in the kitchen, and we had some excellent trout. A really excellent meal." Then the evening took an unexpected turn. "So we then started to eat the trout when all of a sudden the two of them begin arguing, over something really unimportant, and then she said: 'Don't forget, I'm not a Jew! I am not a Jew!' He had apparently said something that didn't suit her at all."[19]

We can get a particularly good idea of how far apart the Werfels were politically from their reactions to the so-called Munich Agreement of September 29, 1938. While Franz Werfel roundly condemned the division of Czechoslovakia, Alma saw in it "a great event," which the world had awaited "with bated breath." For her Hitler was "a genius at the head of a great nation." She may have been "inseparably bound to the fate of the others "—as she put it—but she had not lost what she believed to be her "just, objective view. I shall now have to wander with a nation alien to me all the way to the other end of the world—and nevertheless this is the only way I have of coping with the situation (despite the fact that I have lost my homeland, my intellectual and material properties, and will never see the people I love, my mother, again) [by] observing this heroic individual [Hitler] with the greatest admiration as he strides triumphantly above humanity."[20] She was living in French exile "with a Jewish-Communistic mob," she wrote in her diary, "and I do not belong among them."[21]

During this period, Alma even considered a separation from Franz Werfel. "As the Reich Ministry of Propaganda communicated in Berlin by telex, Mrs. Mahler-Werfel (widow of the late composer, Gustav Mahler) wishes to be able to live undisturbed in her Vienna home. Mrs. Mahler herself is an Aryan. This is why I request immediate information on whether any public office might make problems concerning the stay of Mrs. Mahler-Werfel in Vienna."[22] The matter was urgent, as the signatory of the letter, Dr. Wolfram from the Reich Propaganda Ministry in Vienna, stressed on October 5, 1938. The answer from the competent regional personnel commission, however, took two months in coming: "The aforementioned individual was married in both marriages to Jews. She is currently in the process of suing her present husband for divorce. Her attitude toward the present state and party can be described as loyal, and she enjoys the highest reputation with her former employees. In a political sense nothing negative is known."[23]

A divorce suit, however, was never officially submitted. Nevertheless it was no secret to the people in Vienna that the marriage had for a long time continued to exist only on paper. Alma's brother-in-law, Richard Eberstaller, could also report that she "had already had the intention of divorcing Werfel back in 1937; the marriage of the two named individuals was unhappy."[24] Despite all the disappointments and frustrations of her life together with Franz Werfel, Alma finally decided in favor of her husband after all. It was quite clear, as the lamentations in her diary attest, that she was all too aware of the consequences of aging and that she was not likely to find a new partner that easily anymore now that she was pushing sixty. Beyond that, despite the fact that any number of bitter disputes had arisen over the past years, Werfel accepted Alma's repeated humiliation almost without a fight. He had grown accustomed to her hysterical character; she knew what she had to lose if she left him. In this context, a continuation of the relationship with Johannes Hollnsteiner would never have been an alternative for Alma, who had become accustomed to the security of marriage. It was, fundamentally, her fear of the unpredictability of a new partnership, or even solitude, that bonded Alma with Franz Werfel and led her into exile against her will.

ALMA, BRUCKNER, AND THE FÜHRER

After the Second World War, Alma tended to depict her relations with her half sister Maria and her husband Richard Eberstaller as very bad. She claimed there had been no further contact between the families after 1938. The opposite

is correct. While the Werfels were preparing their emigration to France, and also later during their American exile, Alma was in constant contact with her brother-in-law. The main issue in their correspondence was Anton Bruckner's Third Symphony. Gustav Mahler had made a piano reduction of this work for Bruckner, who was his teacher. In return, the older composer expressed his thanks more than generously: he presented Mahler with the manuscripts of the first three movements as a present. After Hitler's troops marched into Vienna, the Nazis showed a marked interest in Bruckner manuscripts held in private hands. The "Führer" was very fond of Bruckner and regarded the publication of "original versions" of his symphonies "cleansed" of the influence of others, to be a culture-political goal. The collection of the precious manuscripts was coordinated by Joseph Goebbels's Propaganda Ministry. On March 31, 1938—a few days after the annexation of Austria—the Berlin ministry received a list with the names of the owners of Bruckner manuscripts. Besides the widow of the conductor Franz Schalk and the bishop of Linz, Johannes M. Gföllner, Alma Mahler-Werfel was named. Dr. Friedrich Werner, the author of the list, was mainly active as an attorney at law in Vienna and also served as the acting head of the International Bruckner Society, as well as the musicological publishing house commissioned with publishing this edition of the symphonies. His opposite number was Dr. Heinz Drewes, the head of the music division in the Propaganda Ministry. The acquisition of the scores enjoyed top priority, "because we fear," as Werner wrote to Drewes, "what might happen to this valuable treasure."[25] This fear was, in the case of the Third Symphony, entirely justified, because Alma, with the help of Ida Gebauer, had long since had her husband's valuable property smuggled to France. When Dr. Werner asked Richard Eberstaller about the score, Alma's brother-in-law could only report the loss. Werner was irked by this news and pressed for the reacquisition of the Third Symphony. Eberstaller said he was prepared to mediate in the matter. Should he succeed in getting the score back, so he hoped, then this coup would be favorably registered in Berlin, because the ambitious attorney felt that he still had a long way to go before reaching the goal of his career. On October 21 Werner reported to Berlin that Eberstaller had meanwhile spoken with his sister-in-law. Mrs. Mahler-Werfel offered the government two options: "either they could purchase the manuscripts for a price of approximately 15,000 reichsmarks [about $67,000] or they could buy Mrs. Mahler-Werfel's house or villa at a value of some 160,000 reichsmarks." It is unclear how Alma planned to carry out this deal. Friedrich Werner also wondered about this odd suggestion. "In my humble opinion, only the first offer could even be consid-

ered."[26] At the Propaganda Ministry, Alma's first offer moved up the chain of command until Eberstaller finally told his sister-in-law a half year later to deliver the Bruckner manuscript to the German Embassy in Paris. The diplomats there would, he promised her, pay the amount Alma had requested; meanwhile, she was asking for 1,500 British pounds sterling[27]—now worth some $96,000—in cash. But when Alma appeared in the embassy on May 3, 1939, with the Third Symphony under her arm, she found herself confronted with the fact that none of the officials present knew anything about such an agreement. Under these circumstances she was absolutely unwilling to turn over her treasure to the Germans. The reason the sale fell through was banal: the Propaganda Ministry had neglected to inform their colleagues in Paris on time about Alma's appearance; the appropriate instructions did not arrive at the embassy until May 4. Eberstaller finally managed to talk Alma into making another visit to the German diplomatic post. Now nothing stood in the way of the sale. A few weeks later, however, Berlin inquired impatiently if Alma had meanwhile put in an appearance at the embassy. On June 6, Paris informed them that Mrs. Mahler-Werfel had not been seen there again. What the parties concerned didn't know was that as early as mid-May, Alma and Franz Werfel had returned to Sanary, "to the billions of mosquitoes and horseflies."[28]

The story, however, came to an end in America. In mid-December of 1940, Friedrich Werner advised the Goebbels ministry that Alma was still prepared to sell the manuscript. Mrs. Mahler-Werfel, he said, could be reached by telegraph at a New York hotel and expected to have the sum transferred to her in British pounds or U.S. dollars. Dr. Drewes was amazed at the owner's audacity. "Everything is all right," his marginal note said, "but where are we supposed to get hold of those currencies?"[29] A few weeks later the estimate from the budget division was submitted: the amount demanded by Mrs. Mahler-Werfel was still so high that "it would have to be transferred from the gold reserves of the Reichsbank." In the situation at the time, as the competent official stressed, a measure of this kind would not be justified; "after all, in the case of Mrs. Mahler-Werfel, we are dealing with a more or less non-Aryan emigrant, for whom we have little cause to forward amounts like this in foreign cash."[30] For reasons of currency policy, as they were officially called, the purchase of the score was declined. Alma's deal with the Führer had, once and for all, failed to come about: she had gone over the line. It is questionable whether Franz Werfel found out anything about his wife's activities. He certainly would have regarded it as cynical that Alma wished to do business with the same regime that was threatening the very lives of himself and his family.

In the autumn of 1938, Anna Moll's health rapidly deteriorated. A severe case of bronchitis and acute heart problems forced her to remain in bed. "I telephoned her," Alma wrote on November 28 in her diary; "I was told she was still breathing."[31] The following morning the old lady died of a pulmonary edema.[32] Carl Moll could barely cope with his wife's death. He had to be restrained several times, Alma wrote, "because he wants to kill himself. Why don't they just let him do it? He's absolutely right."[33]

In this difficult period, Alma traveled from Sanary-sur-Mer to London. After the loss of her mother, she had a need to see her daughter Anna. "It was wet and cold, and we almost froze to death."[34] In the city on the Thames, she also ran into her former son-in-law Paul von Zsolnay, who had managed to get out of Vienna at the last minute and emigrate to England. "He was totally nazified," she noted in her diary: "Zsolnay remained pro-Nazi for a long time afterward, this offspring of a Jew."[35]

Franz Werfel was drawn to Switzerland. In his sister Marianne's house, a reunion with his parents as well as his sister Hanna took place. They spent their days in constant anxiety, for which the uncertainty of the political situation following the Munich Agreement was accountable. Rudolf Werfel in particular urged emigration to America as soon as possible. His son Franz, on the other hand, did not agree. Although he had applied for a U.S. visa for Alma and himself, the two of them didn't want to emigrate until no other option was left. Life on the Côte d'Azur was, meanwhile, very much to his liking, and his health was also on the upswing there.

On their return to France after their stays in London and Switzerland, Alma and Franz Werfel decided to go to Paris for the winter months, because spending a winter in Sanary seemed too lonely for them. Over the following weeks, he worked in Saint-Germain on his novel trilogy *Cella oder die Überwinder* (Cella or the conquerors), and Alma pursued her social interests. She even regularly held a little salon in her suite at the Hotel Royal Madeleine. Her regular visitors included the writers Guido Zernatto and Fritz von Unruh, the former French ambassador in Vienna Count Bertrand Clauzel, the director Erwin Piscator, the composer Franz Lehár, and Bruno Walter. When the last guests had departed and Alma remained behind alone with her thoughts, her depressive mood would instantly reemerge. "Why sleep, why wake," she lamented: "Whether we booze, gorge ourselves, screw, or force ourselves to create ascetic work values, nothing makes any difference. . . . I have become totally desolate and don't

even want to die anymore."[36] The laments are also an expression of sexual frustration. Alma's erotic relationship with Werfel had "long since become a turbid matrimonial creek. Why get up in the morning, why do our hair, for whom do we get dressed?" Franz Werfel, she said, was "totally washed out—yes, gone senile—and very hopeless."[37]

The Werfels spent the summer—interrupted by a visit from Anna Mahler—in deceptive tranquillity on the French Riviera. On commission from the Allert de Lange publishing house in Amsterdam, Alma revised her thus far unpublished memories of Gustav Mahler, which she had largely completed back in mid-1924. "I wrote this book many years ago," Alma stated at the beginning of the foreword, "for the sole reason that nobody knew Gustav Mahler as well as I did."[38] The *Memories and Letters* (*Erinnerungen und Briefe*), which didn't come out until 1940, were, however, not well received. In particular, the fact that, at the end of the book, Alma had Mahler's frenzied marginal notes to the Tenth Symphony printed, degrading them to a love letter, went too far for many readers. "Read some of G. Mahler's (embarrassing) letters to his wife,"[39] Thomas Mann wrote in his diary. Here he was referring to those letters that Mahler had sent Alma after her affair with Walter Gropius had leaked out. As Alma had refrained from making any comment or providing any context, it was of course impossible for Thomas Mann to take the reason for these letters into account while pronouncing his severe judgment. Alma, as author, didn't take veracity all that seriously. Of the 162 Mahler letters published in 1940, only 37 were word-for-word reproductions of the originals; 125 documents were truncated or distorted, and in three cases Alma had combined two letters into one.[40] The sections she expunged often contained Mahler's complaints about his young wife. His frequent requests for Alma to write more clearly, as he was unable to decipher her almost illegible hieroglyphs, were removed, as were his repeatedly expressed complaints about her problematic character and her permanent dissatisfaction.

After the start of World War II on September 1, 1939, German-speaking emigrants in France were regarded as undesirable aliens and potential spies. "*La douce France* has suddenly become a severe France,"[41] Franz Werfel noted in his diary. Arbitrary house searches and interrogations became an integral part of everyday life from then on. While the refugees had felt safe here only a few weeks before, they now found themselves subjected to the mistrust of the bureaucracy. Franz Werfel suffered from "being treated like . . . a number, indeed an inferior and dangerous number."[42] On September 6, the Werfels received a visit from five scowling police officers, who once again checked the couple's

travel documents. The next day, Franz Werfel was even approached by a criminal investigator right on the street. The policeman wanted to know what he was writing and for whom. Novels and poems, Franz answered, whereupon the guardian of law and order acerbically replied that he was writing especially for the proletariat. It was an atmosphere in which Germans, Czechs, and Austrians were under suspicion as a matter of course. Anyone who spoke German was regarded either as a Nazi or a Communist.[43]

Even before the outbreak of the war, Franz Werfel's parents and his sister Hanna, with her husband, had decided to leave Switzerland and move on to Vichy. This would prove to be a disastrous mistake. In the central French town Rudolf Werfel suffered a stroke. Franz Werfel received a telegram calling him to his critically ill father's side. He now had to move heaven and earth to get himself a travel visa. Every day the Werfels commuted by streetcar between Sanary and the competent government office in Toulon. When the papers arrived in late October, Alma and Franz Werfel could finally start on the arduous journey. After a six-hour interruption in Lyon, their travel papers were rechecked, and the two of them arrived in Vichy. Alma experienced the city as "unutterably bleak, no light, we stumbled around in the dark and have to walk long distances."[44] The sight of his stricken father profoundly shook Franz Werfel. Rudolf Werfel was bedridden and, as a result of the stroke, could no longer speak clearly. With the feeling he might never see his father again (Rudolf Werfel died on July 31, 1941), Franz set off for Sanary a couple of days later. On the Côte d'Azur life initially went on as it had before. "One can't do anything else but wait," Alma complained. "Our life here in the tower, completely isolated, might just possibly be called beautiful, if this existence had not been forced on us."[45]

ODYSSEY

After the German Wehrmacht invaded smaller western European nations such as Denmark, Norway, Belgium, the Netherlands, and Luxembourg, it was clear to the Werfels that it was only a question of time until Hitler's forces also marched into France. They hurriedly traveled to Vichy one last time to visit Rudolf Werfel. Back in Sanary, they hastily packed up their household goods and left their tower home on June 2, 1940. They spent the next sixteen days in Marseille because their U.S. visa applications had expired. Their efforts to acquire new travel documents, however, proved fruitless. Paris was occupied by the Wehrmacht on June 14, and when, on June 18, they heard the rumor

that the Germans were already outside Avignon, they decided to go for a quick escape. Alma wrote: "We got hold of a car that would bring us to Bordeaux for eight thousand francs."[46] From there they planned to force their way through to Spain. The trip turned into an odyssey: the route was supposed to take them via Perpignan; however, the taxi driver inadvertently headed toward Avignon, where the Germans were suspected to be. The man at the wheel finally completely lost his bearings and even began driving in circles, so that Alma and Franz actually arrived twice at the small town of Narbonne, where they had to pause because of approaching nightfall. As no hotel was willing to accept German-speaking refugees, they spent the night in a former hospital. Alma was appalled by the primitive hygienic conditions; the stand-up toilets prevalent in southern France especially disgusted her: "I hope the Germans will install proper toilets for these peoples."[47] The next morning the aimless journey continued, but suddenly came to a halt in Carcassonne, where roadblocks prevented them from moving any farther. Only by dint of considerable effort was Werfel able to acquire two tickets on the last train to Bordeaux. Over thirteen hours behind schedule, the couple finally arrived at the port city in southwestern France. The situation there was complete chaos. Just the night before, the German Luftwaffe had massively bombarded the city. And to make matters worse, all their luggage had disappeared. The loss of the precious Mahler and Bruckner scores was a devastating blow for the Werfels—after all, they had planned to use them to finance their new beginning in America. After failing to find a hotel room, and being forced to take refuge in an erstwhile brothel, they decided to move on to Biarritz the following morning. At the little seaside resort near the Spanish border, they just happened to meet Viktor and Bettina von Kahler, acquaintances from Prague, who were likewise on the run. Every day, Werfel and Viktor von Kahler would go from Biarritz to Bayonne to apply at various consulates for visas. Unsuccessfully. Alma had meanwhile received a promising hint: in Saint-Jean-de-Luz, people said, a Portuguese consul was generously issuing visas. When they arrived there, their hopes were again dashed. A few days previously the diplomat had gone insane and thrown all the passports and visas into the sea. The thought of landing in the "jaws of the enemy"[48] was more than Franz Werfel could bear, and he suffered a nervous breakdown. Viktor von Kahler finally managed to find a taxi, which brought the couples via Orthez and Pau to Lourdes, where they arrived on June 27, 1940.

The small pilgrimage site on the northern edge of the Pyrenees had been made famous by the story of the miller's daughter, Bernadette Soubirous, to whom the Virgin Mary is said to have appeared several times in a grotto in the

FIGURE 7.2

Escaping: passport picture, France 1938. "No one can go on living so hopelessly."

year 1858. After some initial ecclesiastical hesitation, the visions were finally officially confirmed in 1862. The sleepy little backwater then quickly developed into a popular pilgrimage site. The Werfels took a simple room in the Hotel Vatican. After the experiences of the past weeks it had become clear to them that they would only be able to get out of France with a valid visa. They would also have to go back to Marseille, as this was the only place where they would stand a chance of getting their hands on the papers that would rescue them. Nobody could have predicted that they would have to spend over five weeks in Lourdes waiting for the so-called *sauf conduite*—the safe-conduct papers for their trip to Marseille. More or less to pass the time, Alma began taking an interest in the story of Bernadette and regularly attended services at the massive Rosary Church. Franz Werfel was also fascinated with the mystery. During one of his final visits to the grotto of Lourdes, the writer pledged an oath: if he and his wife could manage to escape to America, he would write the story of Bernadette Soubirous.

When the necessary papers finally arrived on August 3, 1940, they could finally get started on their return trip to Marseille. Six weeks after the Werfels had first hurriedly left Marseille, they returned to the starting point of their odyssey, There the couple took rooms in the luxurious Hotel Louvre & Paix.

Thanks to the personal intervention of the American secretary of state, Cordell Hull, they were issued safe-conduct documents for Spain and Portugal, as well as visitors' visas for the United States.[49] These documents, however, were virtually worthless, as the French authorities refused to issue them exit visas; they invoked Article 19 of the armistice treaty with Hitler's victorious Reich signed at Compiègne on June 22, in which the French government pledged to turn over German refugees on request. At the end of August the respected art historian Louis Gillet even came to Marseille to help Franz Werfel. He had once been an influential man, Alma recalled, "but now his power is exhausted."[50] He could do nothing for them. At least Alma—in a development that could only be compared to a miracle—got back the luggage she had lost en route, including the suitcase with the valuable Mahler and Bruckner scores. The manager of the Hotel Vatican in Lourdes had personally intervened and used his connections to get her property back.

During those August days, Heinrich Mann, his wife, Nelly, and his nephew Golo arrived in Marseille from Nice. Nelly was—according to Alma—"dead drunk" and in a desolate condition: "she was horribly agitated, suddenly raced out to the balcony and tried to throw herself off. Werfel and Golo held on to her," as she "mercilessly started clobbering them." Alma could not figure out what bound the famous author Heinrich Mann to "this washerwoman." Heinrich was a puzzle to her altogether: "Now and then Mann says something clever, which amazes everybody, because he makes the impression of somebody totally lost."[51] Yet Alma's further destiny on this adventurous escape would result in close ties with the Manns.

When the thirty-two-year-old American journalist Varian Fry suddenly showed up in Marseille, the situation of the refugees abruptly changed. Fry was a staff member of the "Emergency Rescue Committee" that had been founded in New York only a few weeks previously for the purpose of trying to enable individuals, primarily intellectuals, to escape from France. The primary mission of the organization was the acquisition of American visas and the coordination of private aid organizations. The young Quaker was doubtless the right man for the job: Varian Fry spoke both German and French fluently, and because of his journalistic activity he had a thorough knowledge of the political situation. And not least, he was an extremely clever tactician: he established close contacts to the often corrupt consular officials and the Marseille Mafia, secured forged passports and transit visas, and beyond this, he was full of idealism and zeal. Only a short time after his arrival at the Côte d'Azur he visited the Werfels at the Louvre & Paix. Fry was surprised that the

couple was registered under the name of Gustav Mahler. Moreover, the hotel personnel acted very mysteriously and took their time allowing him to visit them in their room. While Franz Werfel seemed anxious and nervous, Alma greeted her guest with chocolates and a bottle of Bénédictine. Over dinner that evening at the Basso, an expensive restaurant at the old harbor, they discussed various escape options. After that he visited the Werfels on a daily basis. As the political situation might abruptly change, none of the numerous ways they discussed for leaving France could be regarded as permanent. Fry finally made the following suggestion: Heinrich, Nelly, and Golo Mann, Marta and Lion Feuchtwanger (the author had been liberated from an internment camp near Nîmes and then brought to Marseille), as well as the Werfels, should try to cross the Spanish border near Cerbère. There were good chances, Fry explained, to do this even without an exit visa. Alma and Franz Werfel were immediately in agreement. The departure was set for September 12. Anne-Marie Meier-Graefe came from Saint-Cyr, helped Alma pack, and accompanied her friends to the station the next morning at 5:30. Lion and Marta Feuchtwanger were no longer in the group. An escape by the author, who had been stripped of his German nationality, seemed too perilous, especially as a rumor had been making the rounds to the effect that the Spanish customs officials were not letting any more stateless persons over the border. The Feuchtwangers would find another way to get to their American exile.

When the Werfels arrived on the station platform with twelve suitcases, Varian Fry and his assistant Dick Ball were flabbergasted. Traveling via Narbonne and Perpignan, the group reached Cerbère in the late evening, where their escape came to an end for the time being. "But when we came into the hall," said Fry, "we saw all the travelers forced to line up in front of the border patrol office, where they had to show the officers their papers. This put us in a panic because I was the only one who had an exit visa, and thus had the right to travel."[52] While Fry tried to calm the Manns and the Werfels, Dick Ball approached a French border official, who explained to him that he was not allowed to let anyone through without an exit visa, and then summarily confiscated all their passports. And so the refugees had to spend a worrisome night in an abandoned hotel near the station. Early the next morning Ball tried his luck again; "I didn't like this guy's tone at all," Ball reported to his colleague. "He somehow seemed to know something. He said we'd better take them [the Werfels] away, as long as this was still possible, at best today."[53] It was a tricky situation, because the only alternative to taking the train would be to cross the border over the mountains by foot. The two Americans doubted, not en-

tirely without justification, that the almost seventy-year-old Heinrich Mann and the overweight Franz Werfel were up to the exertions this might involve. But there was no other option. After briefly discussing the virtually hopeless situation, Golo and Heinrich Mann, along with Alma, decided to start climbing the mountain that very day. Franz Werfel suddenly interjected that it was Friday the thirteenth. He started to quiver and stammered something about this being an unlucky day, and they would be better off waiting until tomorrow. Alma interrupted her husband: "That's nonsense, Franz,"[54] after which he fell into a stony silence. "I have a feeling," wrote Carl Zuckmayer to a friend in October 1940, after he had found out the details of this adventurous escape, "that without her, Franz would simply have stayed lying there, and that would have been the end of him."[55] Once they had made up their minds to cross the border, Varian Fry took over their luggage, which he, as an American citizen, would have no trouble bringing over the border by train. Before that, he supplied his charges with a dozen packs of cigarettes, with which they could bribe the border guards. Under the blazing sun, Dick Ball accompanied the group to the mountaintop. The climb was arduous, especially for Heinrich Mann and Franz Werfel. "The goats ahead of us kept plunging down, the shale stones glared, they were slippery as glass, and we had to pass close by steep chasms."[56] Several times Nelly had to support her husband, who despite considerable effort could barely cope with the physical exertions. Nelly's "stockings hung in tatters from her bleeding calves,"[57] Alma remembered. Franz Werfel suffered the most from his fear that they might be picked up along the way by the dreaded *gardes mobiles*. Alma, on the other hand, seemed to be handling the stress fairly well. The whole time, she carried the remaining cash, her jewelry, as well as the Mahler and Bruckner scores, with her in her hand luggage. At the peak of the seven-hundred-meter-high mountain, Dick Ball turned back. As Alma and Franz Werfel had a considerable head start, they decided to continue marching on without Heinrich and Nelly Mann. It made more sense, they believed, to cross the border in pairs. They laboriously crept down the mountain, finally reaching the border station. After Alma had slipped the border patrol a few packs of cigarettes, the guard got more and more friendly and gave them a sign to follow him. "And where did this moron take us? Back to the French border station." When the Werfels saw the dreaded *gardes mobiles*, Alma blurted out: "Jesus, now they've got us!" Would all their struggles be doomed to failure? The commander of the border station "was suddenly very kind and gave them a cordial hand signal to let us pass through."[58] The soldiers even showed them the right way to go. The Werfels got back together with Golo,

Heinrich, and Nelly Mann shortly before the Spanish border, which they could now effortlessly pass through. Once they had finished their strenuous descent into Portbou, the refugees had to show the officials their travel documents one more time. "After a torturous wait, each of us finally got our papers back with the necessary stamps."[59]

At the railroad station in the little town, they met Varian Fry, who had been nervously awaiting the arrival of his charges. After a short night in a simple hotel, the journey continued the following morning toward Barcelona. In a state of complete mental and physical exhaustion, the group reached the Catalonian port city three hours later. For the first time in months they could finally heave a sigh of relief and recover from the stresses and strains behind them before setting out on a fifteen-hour train ride to Madrid. There, Varian Fry had been able to organize plane tickets to Lisbon. When the aircraft landed on September 18, 1940, in Lisbon, they had almost made it. In Estoril, an upscale suburb of the Portuguese capital, the Werfels checked into the Grand Hotel d'Italia. Alma signed the registration form as Mrs. "Werfel-Mahler," as if to demonstrate to the whole world that nothing could ever separate her and her husband. They spent the following two weeks in "a heavenly calm in a heavenly country."[60] On October 4, the Manns and the Werfels left Europe aboard the Greek steamship *Nea Hellas*, bound for the United States. The ship was badly overcrowded, and the crossing accordingly unpleasant. Despite the terrible food, which Alma mentioned in her diary, the joy of having made it out of the hellhole of Europe prevailed. Only Heinrich Mann never left his cabin. "He was mad at the whole world," Alma claims in her diary. "When his nephew came to visit him, he was lying on his bed busily drawing pictures of women with big bosoms, and sometimes only the latter by themselves."[61]

In Safety —
and Unhappy

1940–1945

"New York is again a grand sight and a colossal experience,"[1] Alma noted in her diary on her arrival at New York harbor. On October 13, 1940, exactly one month after the harrowing trek across the Pyrenees, their escape was finally over. "Alma was the first one to appear on the gangway," Carl Zuckmayer, who had emigrated to the United States the previous year, remembered, "as sprightly as ever with a white traveling veil wafting in the breeze and radiant with anti-Semitism. Alma had arranged with the captain that they would be allowed to disembark earlier. One of the first things she said after she had barely set foot on land was whispered in my ear: 'Don't come to my hotel room tomorrow afternoon any later than six, there will be a couple of important people there, very valuable contacts, but don't tell all the Jews.' It wasn't the least bit different from the Grand Hotel or the Hohe Warte. She is superb. Unpredictable."[2] Dr. Frank Kingdon, a member of the board of the Emergency Rescue Committee, welcomed the rescued individuals on the pier. Thomas and Katia Mann had also shown up to pick up their family. And a number of reporters and journalists were eager to get the details of their adventurous escape.

In the two and a half months that followed, Franz Werfel and Alma stayed in a suite at the St. Moritz Hotel. Old friends and acquaintances, such as the Zuckmayers and the Feuchtwangers, Alfred Döblin, and Otto von Habsburg, came to visit them. Franz Werfel's joy over the successful rescue was, however, beclouded by his profound worries over his parents. Albine and Rudolf Werfel had left Vichy in the summer and moved to Bergerac, a small town some ninety kilometers to the east of Bordeaux. They thus found themselves in as great a danger as they had been before. Immediately after their arrival in New York, Werfel and his sisters—Marianne Rieser, who meanwhile also lived in New York, and Hanna and her family, who had been able to make it out to London—tried to get their parents out of France, an undertaking that would only partially succeed.[3]

(previous page)
FIGURE 8.1 Alma Mahler-Werfel in Los Angeles, circa 1941: "She is superb. Unpredictable" (Zuckmayer).

IN "GERMAN CALIFORNIA"

In the early 1940s, Los Angeles had developed into a new homeland for German immigrants: the writers Thomas and Heinrich Mann, Bertolt Brecht and Alfred Döblin, the composers Arnold Schönberg and Erich Wolfgang Korngold, the theater director Max Reinhardt, to name but a few, settled at one time or another after their escape from Europe in "German California." It was this feeling of not wanting to be alone that motivated the Werfels to resettle on the West Coast of the United States. The mild climate and the verdant vegetation especially attracted Franz Werfel. The antique dealer Adolf Loewi and his wife (Alma knew the couple from Venice) offered to look for a suitable house for them, and one was quickly found in the upscale district called "the Outpost," high above the city in the middle of the Hollywood Hills. This elegant neighborhood was marked by a labyrinth of small angular and winding roadways. Underneath the mountain was the Hollywood Bowl, an enormous open-air arena, where concert, opera, and operetta performances were regularly given. When the wind was favorable, Alma and Franz could hear the performances from their back porch. The Werfels' house on Los Tilos Road was comparatively small. As in many American homes, the front door opened right onto the living room, where Alma's grand piano stood. A small corridor led to the kitchen and dining room. Werfel's study, as well as the bedrooms—the couple also slept in separate rooms in America—were located in the basement. Doubtless in terms of space, the house was fairly modest and not comparable to the country house in Breitenstein or the mansion on the Hohe Warte. Even so, conditions were satisfactory. Adolf Loewi even managed to recruit a butler to make life a bit easier for the Werfels.

August Hess was "a slim, slight middle-aged man of medium height, with grayish blond curly hair and the watery eyes of a happy alcoholic."[4] Hess, born in 1904, was German by birth and came from the area near Heidelberg. He had opted for a career in entertainment and had been engaged as an operetta tenor at a provincial theater. After his ensemble went bankrupt on an American tour, he stayed on in the United States and made ends meet by working as a butler. Alma was thrilled with the new household employee. She enjoyed having a German in the house who hadn't been forced to flee the country because of the Nazis, and who didn't hate Hitler and the Germans. "He radiated the aura of a purely Aryan man she had missed for so long."[5] In the midst of all the Jewish immigrants Alma ran into every day, August Hess—as she must have felt—was a welcome "Aryan counterpoint." The new servant was particularly

FIGURE 8.2
August Hess—butler,
chauffeur, gardener,
Alma's drinking partner,
and Werfel's valet: "He
radiated the aura of a
purely Aryan man she
had missed for so long"
(Albrecht Joseph).

devoted to Franz Werfel. He may not have understood much of what he was writing about, but he venerated him all the more for that. "Handsome August," as he was called because of his attractive appearance, was butler, chauffeur, gardener, Alma's drinking partner, and Werfel's personal valet all rolled into one, and their life in America would have been unthinkable without him. August Hess transported his employers all over town in his own Oldsmobile; visits with Otto Klemperer or Max Reinhardt, invitations to tea or cocktails or to a dinner party followed one another in rapid succession. The Werfels had totally settled into their second exile: "We live here from one blue, blossoming day to another and praise God."[6]

"Werfel has started to work," Alma recorded in her diary in early 1941. "Thank God! It is such a miracle he can concentrate once again."[7] And a few

days later, she wrote: "It is the Song of Bernadette. It is Lourdes, the great experience we had there."[8] Franz Werfel had remembered the pledge he made in the grotto at the French pilgrimage site. The subject had taken hold of him. With great intensity he devoted hour after hour every day to the story of the miller's daughter, Bernadette Soubirous. Dr. Georg Moenius, a German priest, who, like the Werfels, had escaped via France to the United States, backed Franz Werfel up with his theological knowledge. Only four months later, in May 1941, the first draft of "Bernadette" was completed. As always, Werfel now began to revise his text. While previously he had always written his revisions in further drafts himself, he now hired a secretary for this job. Albrecht Joseph was barely forty years old when he went to work for Franz Werfel. He had been born in Frankfurt, where he worked in the early twenties as a theatrical director. Later he moved on to motion pictures and wrote a couple of successful screenplays. After the Nazi power grab, his career was cut short; as a Jew he had to leave Germany, and he made his way via Austria, Italy, England, and France before he finally arrived in the United States.

As a rule, Franz Werfel had his secretary come to work in the morning. Then Albrecht Joseph would drive his rickety old Packard coupe up into the Hollywood Hills. Occasionally he would stop outside the front door and stay there for a moment without ringing the doorbell, so he could listen to Alma play the piano, often practicing works by Johann Sebastian Bach. "She could play Bach magnificently with a great deal of emotion and power, and I was really sorry when she finally stopped and I had to ring the bell." He enjoyed these moments, which were a privilege, because "she refused to play for anyone else but Werfel."[9] Werfel and his secretary then retired to work in the cellar studio, where Werfel dictated for several hours from the black school notebooks in which he always wrote his novels and poems. Besides Werfel's close connection with Friedrich Torberg (about which more will be told later on) and such other German immigrants as Thomas Mann and Bruno Walter, it is largely the unpublished memoirs of Albrecht Joseph that give us a relatively precise insight into the Werfels' everyday life in Los Angeles.

"Don't act like a Jew," Alma would call out to Albrecht Joseph after the day's work had been completed, "sit down and drink a sip of schnapps!"[10] By afternoon, the lady of the house had already knocked back the greater part of her daily bottle of Bénédictine. "Benediktiner was too sweet for me," Albrecht Joseph remembered: "I took a glass of whiskey. I didn't want any more than just one glass. Then she said: 'I can't drink with you anymore because you're a Jew.'"[11] Although Joseph pointed out some well-known Jewish alcoholics in

an attempt to counter this prejudice, Alma stuck to her guns. She was convinced that Jews were also inferior to "Aryans" when it came to drinking. Although statements like these bordered on the incomprehensible, Alma still managed to make quite an impression on her listeners with them. Franz Werfel continued to suffer under Alma's anti-Semitism, which was just as extreme and unbelievable in America as it had been back in Europe before their immigration. Joseph noted: "The quarrel was about the news, which was, as usual, pretty bad. Alma took the position that it could not be otherwise since the Allies—America was not in the war yet—were weaklings and degenerate, and the Germans, including Hitler, supermen. Werfel did not let this nonsense pass but Alma would not yield. The pointless argument went on for about ten minutes, then Werfel clapped me on the shoulder and said: 'Let's go downstairs and work.' In the middle of the narrow winding staircase, the chicken ladder, he stopped, turned around to me and said, with a tinge of real sorrow, 'What is one to do with a woman like that?' He shook his head: 'We mustn't forget that she is an old woman.'"[12]

"I have finally found some real friends here!" Alma's call resounded toward Albrecht Joseph as he arrived one morning for work. Visibly excited, she told him about Gustave Otto Arlt and his wife, Gusti, whom she had met a couple of days previously at a gathering in Arnold Schönberg's home. Gustave Arlt was the son of German immigrants and worked at the University of California as a literature scholar. A close friendship rapidly developed between Alma and the Arlts. Attentive observers, however, were unable to share her excitement over these new friends. For Albrecht Joseph, they were intrusive busybodies, and beyond that, politically highly suspicious. Gustave Arlt had the reputation of being a staunch anticommunist with a sympathetic attitude toward the Nazi regime. In Arlt's presence, Alma could gripe freely about the Jews and the Marxists, as Joseph remembers: "They became unavoidable fixtures in the Werfel house from then on, and they stimulated in Alma an insane hatred of anything Russian or democratic which at times made her sound like a McCarthyite." Alma left no doubt in anyone's mind "that one part of their attraction for her was that they were pure Germans."[13] If we are to believe Albrecht Joseph, Franz Werfel kept his distance from the couple—in particular, he found Gusti Arlt extremely hard to take. "His wife was the worst caricature of a German housewife imaginable, swollen with repressed venom, absurdly ugly, fat and exhaling an aura of superiority and pride that was almost admirable since it was based on absolutely nothing."[14] Noticing how important this contact was to his wife, Werfel withdrew in an effort to grin and bear it. August

Hess, on the other hand, said straight out what other people—possibly also Werfel—only thought. "He suspected their friendship with the Werfels of the basest opportunistic motives, and he told them so to their face."[15]

One episode connected with the Arlts tells us a great deal about the marital differences between the Werfels at the beginning of their American exile. When Franz Werfel received the information that his father had died on July 31, 1941, in Marseille, the Arlts just happened to be guests at the house on Los Tilos Road. The death of his father was a source of great pain to the son. He reproached himself severely for having been unable to spare his parents the fate of emigrants in France. Albrecht Joseph still precisely remembers the atmosphere: "It seems to me almost unbelievable that two strangers [the Arlts] could obtrude themselves on such a day, with the pretense of wishing to soothe Werfel's grief and suggest to spend that day with him and Alma, taking them for a sightseeing tour and having dinner together. I never talked to Werfel about this, but I am convinced that, stunned as he probably was by the sad event, he submitted to this expedition rather than have an argument with Alma, who was all for it."[16] Alma called the shots with a shocking heartlessness, which, however, is not much of a surprise—think of the problematic visits in Switzerland and France—because she continued to regard her husband's family as strangers.

Alma evidently thought of her husband's loss of his beloved father as a minor detail, well worth ignoring. But Franz Werfel's worries were also directed toward his seventy-year-old mother. When he finally discovered she was on her way to Portugal and would be arriving in the United States at the end of September 1941, it was a great load off his mind. In New York, where the Werfels went in the early autumn of 1941 to pick up Albine Werfel, they set themselves up for a long stay. Alma opened a little salon in her hotel suite, where she received political figures, members of the high aristocracy from the toppled Austro-Hungarian Empire, as well as artists like the Russian painter Marc Chagall. "Then as now, I am in heaven here and only here. . . . I go to the theater and listen to music whenever possible. The broadcast of the Mahler 1st [Symphony] is a great pleasure to me, and especially because the Pseudo-Mahler-Pope, [Bruno] Walter, didn't do it."[17]

AMONG THE IMMIGRANTS

One of the Werfels' closest friends in America was the considerably younger writer Friedrich Torberg. Franz Werfel had been casually acquainted with his colleague back in Vienna; in California, a close friendship developed between

them. In a very short time, Torberg began feeling almost at home in the little domicile on Los Tilos Road. For Franz Werfel, the close bond with Friedrich Torberg at least partially replaced the sorely missed Vienna, the coffeehouse atmosphere, and the Austrian cultural world in general. Torberg admired Alma and saw in her a stern noble patroness, through whom "he felt protected from collapsing and going completely to rack and ruin." Alma praised him, chided him, and, according to Torberg, told him things "that nobody else but you can say to me."[18] The correspondence between Alma and Friedrich Torberg is reminiscent in many ways of her correspondence with Alexander von Zemlinsky, Gustav Mahler, and Oskar Kokoschka. In his letters, Torberg got annoyed again and again over Alma's inability to participate in a dialogue, while she occasionally oppressed him with little fits of jealousy and her egocentricity. When Torberg told Franz Werfel in a letter that he and his New York friends often spoke of him, Torberg received the following irate rebuke from Alma: "I was mad at you when you wrote to Franzl that you all talk a lot about him! Am I just a dog? I must be a stranger to you, you evil Jews, you! . . . And when you are among yourselves, you just drop me under the table!"[19] Torberg had a hard time figuring out all that egotism: "Somehow you have yet to liberate yourself from the illusion that a Jew definitely has to suffer because he is a Jew, and that he absolutely has to wish he were something else (at best a Catholic)." It was an error, Torberg assured his friend, "to suggest that suffering and yearning Jews like these, when they finally get together in their catacombs, and are for once 'among themselves,' heave a great sigh of relief and, as first item on the agenda of their conspiracy, they drop you under the table."[20] Torberg clearly didn't comprehend that the mixture of self-involvement and the fun of insulting put Alma in a position to discipline him, whose relationship with his own Jewishness was not as uncomplicated as he claimed. Alma's calculation paid off: Torberg obediently assured her in his next letter how frequently he and his friends spoke of Alma and how very much they all loved Alma. And as if that weren't enough, he regarded his "dearest lady friend," as he called Alma, as a great role model. When the Werfels were again traveling, Torberg wrote them longing letters and could hardly wait for his friends to return.

"We'll be back in mid-January," Alma reassured her young friend. "Perhaps only to pack and then go off again," she added, "perhaps to stay."[21] When the couple returned to their own four walls after a scant four months in New York, they then remained on the West Coast for a while. For the first time since their arrival in California, Alma complained about American culture. "The atmosphere out here is empty and monotonous," she wrote in her diary. "And

this atmosphere is made by people. And they have been here only 200 years, and their only accomplishment was: the destruction of the little bit of Indian culture."

She missed Europe, especially Italy and Austria. Alma sadly recalled the years in Venice and Santa Margherita Ligure. "Italy is the homeland of us all"[22] was her conclusion.

"Had coffee, bathed, left."[23] Thomas Mann began the first of April 1942 with a meticulous grooming session. After breakfast there was still time for him to do some writing before meeting the American art collector Robert Woods Bliss for lunch. For that evening the Nobel laureate for literature had another invitation on his schedule. At 7 p.m. he and his wife, Katia, drove to the Werfels in Hollywood. Alma had invited Mr. and Mrs. Mann, the Arlts, as well as the composer Erich Wolfgang Korngold and his wife to dinner. Golo Mann joined them, along with Heinrich and Nelly Mann somewhat later. With so many prominent contemporaries in her house, Alma was in her element. She graciously served the most exquisite dishes, which prompted even the fussy Thomas Mann to accord the rating "catering satisfactory."[24] August Hess had his hands full, as Alma kept on serving up fresh champagne and black coffee. It might happen here, as Albrecht Joseph remembered, that the lady of the house, after countless Benediktiners, would raise her glass high in the air and yell: "Come on, August! Get a glass for yourself and clink with us. We're all one happy family!"[25] August Hess hated displays of this kind. While Heinrich Mann was suffering from a dental fistula and couldn't enjoy the evening, his wife Nelly enjoyed herself all the more. "Desolate performance by the wife,"[26] noted Thomas Mann over his sister-in-law's conduct. Heinrich Mann continued to be a puzzle for Alma. She observed in him "the diminution and decline of the lower jawline," which gave her "the impression of total idiocy." For Alma this was clearly a "premonition of death."[27]

The Song of Bernadette became Franz Werfel's greatest success and soon ranked as one of the top-rated best sellers in the history of publishing in the United States. When it was released to America's bookshops on May 11, 1942, with a sizable first edition of two hundred thousand copies, its author was already a household name nationwide. By late July the novel had reached an edition of four hundred thousand copies.[28] The Bernadette hysteria acquired even greater momentum with the sale of the motion picture rights to Twentieth Century–Fox Studios. The story of the French miller's daughter moved people to tears. On the request of his American publisher, Ben Huebsch, Franz Werfel and Alma traveled in mid-June of 1942 for eight days to New York—the center

FIGURE 8.3
Alma and Franz Werfel
on the set in Hollywood
with Don Ameche and
Claudette Colbert.

of the enthusiasm. Werfel received countless interview requests, several conversations with the author were broadcast over the radio nationwide, and all the major daily newspapers published reports and reviews. And, last but not least, New York's high society wanted to take a closer look at the phenomenon Werfel: he and Alma were passed along from one party to the next.

In New York, Franz Werfel met his mother and sister again; their time together, however, must have been difficult, as we can see from Alma's disrespectful description of her mother-in-law in her diary: "His mother is a poor lamb, bleating straight to the right, then straight to the left with no opinion of her own. Her face is unusually ugly, it's all crinkly. She looks pathetically at the world through small eye-slits. The teeth force their way out of a small puckered mouth, which has a hard time smiling or laughing. All right, she is old, but still she has been like that as long as I've known her!" Nor did Alma find one kind word for her sister-in-law Marianne Rieser. "And now his sister, who struts around proud as a peacock, regards herself as a genius, which she certainly isn't, envies everybody who she thinks has it easier than she does. It is a constant cackle, croaking, and cawing the likes of which I have never seen anywhere before."[29]

When the Werfels returned to Los Angeles in early July 1942, the social whirl of their New York days carried on without interruption. On Saturday, July 11, Bruno Walter invited the Werfels and the Korngolds to dinner along with Thomas and Katia Mann. A little later, their daughter Erika Mann, who for some time had been having an affair with the sixty-six-year-old Walter, appeared. The dissimilar lovers were very careful—indeed had to be, because, officially, the conductor was happily married. While Walter played some selections from Johann Sebastian Bach's *St. Matthew Passion* on the piano, Alma and

Erika Mann got drunk. Thomas Mann watched this booze-up disconcertedly: "Erika regrettably overdid it with alcohol (with Mrs. Mahler). She can't handle it, especially not under the influence of the climate, the wearying effects of which everybody is complaining about."[30]

The countless social events Alma and Franz Werfel attended together could not hide the fact that all was not well between husband and wife. Unattractive scenes erupted on a regular basis, during which Alma left no doubt that if it wasn't for him, she would never have left her homeland. The Jews are now going through another test, yet another punishment. . . . The younger ones have taken refuge in America, and the older ones have remained behind, thinking they would be able to end their lives in their own familiar environment. But Hitler reshuffled the cards. . . . And now the younger ones have to do everything, making monstrous financial sacrifices to bring the older ones over here, despite the fact that they are far away in their minds." Alma thought she could observe "how the young ones fear the coming of their elders. When I look at Werfel's mother, the way she paws the air with her hands, yells and is generally obsessed with herself, then I can imagine how all the others are suffering."[31] Franz Werfel, who was still reproaching himself for not having rescued his ailing father, regarded Alma's attitude as appallingly cynical. At a social occasion a short time afterward, tensions began escalating rapidly, which Albrecht Joseph witnessed: "When someone said that nothing could ever make the world forget the horrors which the Nazis had committed, Alma, as was to be expected, took issue and said that one must never generalize, and that the Nazis, after all, had done a great many praiseworthy things. Someone replied that merely to think of the concentration camps was sufficient to make one sick for days. Alma: 'Those horror stories are fabrications put out by the refugees.'" The mood hit the zero point. After a moment of absolute silence, Franz Werfel sprang to his feet and was seized with a terrible spasm of rage. "He was beside himself," Joseph recalled, "had completely lost control and was dangerously close to a fit of apoplexy." The instigator of this excess reacted as she always did in such cases—with ignorance: "She probably felt that Werfel, being childish, had childishly misbehaved."[32]

Franz Werfel fled from Alma's anti-Semitic outbursts to idyllic Santa Barbara—some eighty miles north of Los Angeles, where, in hope of finding peace and quiet for his work, he moved into a bungalow at the luxury Biltmore Hotel. Obviously it was these time-out periods—in Europe at Santa Margherita, in Venice and on the Semmering, in America at Santa Barbara—that enabled the Werfels, geographically separated, to find their way back to each

other despite sizable differences, and thus maintain a stable relationship for over twenty-five years. And they also retained the tried and true, traditional separation of roles in America: while Werfel was writing the final version of his new play, *Jacobowsky und der Oberst* (*Jacobowsky and the Colonel*), in the late summer of 1942, Alma was preparing to move house yet again. The couple had decided to leave the Hollywood Hills and buy a place in the high-profile villa neighborhood of Beverly Hills, where, not far from Santa Monica Boulevard, there was a handsome bungalow for sale, with an expansive lawn. "There was such a scramble to buy the place, people were overbidding one another," Alma recalled; "finally we outbid the others and got it."[33] The house at 610 North Bedford Drive had been built for the Australian actress May Robson and embodied the standards of the *haute bourgeoisie*. "It was one of those typical upper-middle-class ticky-tacky houses, cute from the outside, dark inside and furnished in atrocious taste," Albrecht Joseph wrote.[34] Friends and acquaintances of the Werfels dotted the new neighborhood: Friedrich Torberg lived not far away on Sunset Boulevard, and the actor Ernst Deutsch and his wife, Anuschka, also lived nearby. They often met up with the Korngolds, the Schönbergs, or Lion and Marta Feuchtwanger. Alma especially enjoyed getting together with Erich Maria Remarque, whom she had met at a party on August 12. "I found a great friend and drinking buddy in Remarque," Alma told Carl Zuckmayer shortly thereafter. "He is quite a fellow and a great relief after the Manns, Ludwigs, and Feuchtwänglers. (That's what they called the gnome in France) etc. etc.!"[35] The forty-four-year-old Remarque was tall and had a masculine, rakish aura. Whenever he and Alma got together, there was always plenty of alcohol flowing. And yet their first evening was anything but smooth going, as Remarque hinted in his diary: "Werfel and his wife. The wife a wild, blond wench, violent, boozing. Has already put Mahler under the earth. She was with Gropius and Kokoschka, who seem to have escaped from her clutches. Werfel won't. We hit the bottle. She whistled to Werfel as if he were a dog, and was proud of the fact that he actually came. That got me mad, and, swimming in vodka, I gave her a piece of my mind."[36] Obviously Alma couldn't stay mad at Remarque, especially when after that nocturnal boozing session he wrote her a charming letter. "How do people, dearest lady, reemerge from a stormy vodka-rum downpour night—(dreams in their hair, Bromo-Seltzer in their stomachs, chaos ebbing away behind them)—either as friends for life or enemies for all eternity—who knows that?" Remarque gave her a bottle of Russian vodka, ensconced in a huge bouquet of flowers. That was how he showed Alma his respect, the kind that "wolves have before lionesses."[37]

At the first party in the new house on October 11, 1942, once again almost the entire "neighborhood" showed up. Thomas and Katia Mann, Ben Huebsch, Erich Maria Remarque, as well as the Arlts, were on the guest list that Sunday, and Alma could once again put her talents as a hostess to the test. "A lavish meal, sparkling California burgundy. Benediktiner with the coffee,"[38] Thomas Mann wrote in his diary. Alma was in a celebratory mood, not just because of her successful home purchase: "Annerl [Anna] is married, she's expecting a child and this time with love and hope."[39] Alma's fourth son-in-law was the Russian conductor Anatol Grigorievich Fistoulari. Born in Kiev (today the capital of the independent Ukraine) in 1907, Fistoulari had settled in England in 1940 and worked primarily as a guest conductor. Alma was at first delighted for her daughter; yet, hedging her bets, she stated in her diary, "Hope she won't soon find him boring, as she did in all her previous involvements."[40] Not until several years later, when Alma found out Fistoulari was of Jewish origin, would she change her attitude and move to a position in opposition to him.

Alma and Franz Werfel rang out 1942 and rang in 1943 in New York, especially because he wanted to see his mother again, since she felt herself a stranger in that big city. Apart from regular visits from her daughter Marianne, Albine Werfel lived in solitude in a large apartment building. Alma opened her salon at the St. Moritz Hotel and met with old friends and acquaintances. In the first week of January, however, she caught a bad case of the flu, which had her bedridden for the better part of a month, making her unable to enjoy the rest of their stay to the fullest. "Since yesterday, I can only get up for an hour a day," she wrote on February 9 to Friedrich Torberg: "I'm not allowed to go out, I've missed everything.—Concerts! Everything! I'm very down!"[41] It took a long time for her strength to return. "Heard a lot of Mozart in the opera," Alma reassured her friend fourteen days later: "Otherwise I am just getting started again—running after music."[42]

THE WEAK HEART

After almost three years in America, the Werfels began feeling increasingly at their ease in their California exile. As early as her sixty-fourth birthday on August 31, 1943, Alma stressed her satisfaction: "It is a paradise," she noted in her diary. "Werfel was wonderful to me on this day, and I will remember that."[43] A good two weeks later, two days after Franz Werfel's fifty-third birthday, this situation would change completely. Friedrich Torberg just happened to be there as a guest in the house on Bedford Drive when Werfel, visibly content,

lit "a coal-black, heavy Havana cigar." Alma reminded her husband of his doc-tor's reservations: "At my request he threw it away, but immediately lit another, albeit somewhat lighter cigar. Then later a few more cigars. It was late, and I went to my room. But only a half hour later he followed me with a totally changed expression, and I could barely carry him into his room."[44] In the night before September 13, Franz Werfel suffered a severe heart attack. Dr. Erich Wolff, a heart specialist who had fled from Germany, subsequently ordered a strict smoking ban and described to his patient in no uncertain terms the con-sequences of too much smoking on his health. Werfel just laughed. As long as he could remember, he had smoked one cigarette after another. With the best will in the world, he could not imagine ever getting rid of this addiction. Alma, however, took the diagnosis seriously and conscientiously monitored his adherence to the doctor's orders. In this worrisome time, the friendship intensified between the Werfels and Friedrich Torberg, who often spent the entire night at the sick man's bedside. When the nicotine withdrawal got too much for him, and Alma wasn't around, Werfel would ask his friend to light a cigarette for himself and then blow the smoke in his face.

Despite the good care, Franz Werfel's health remained precarious. Suffoca-tion attacks, intense perspiration, shortness of breath, and high fever were ev-eryday occurrences, all day and all night. "Franzl is still not out of the woods," it said in Alma's diary in early October. "He is very weak, his heart needs a great deal of support, he breathes heavily, he is attached to the oxygen tank for several hours each day."[45] In the early morning of October 21, Franz Werfel suffered another coronary infarction. When the doctor finally arrived at the end of a long wait, Werfel had already calmed back down, but, as Alma wrote, "the anxiety has remained!"[46] When physicians determined a swelling of the intestinal tract, they wanted to x-ray the patient to ascertain the cause. During the examination Werfel collapsed. The doctors ordered strict bed rest. "Now everything is destroyed," Alma wrote, "and so I live only for the restoration of his weak powers and hope . . . hope."[47] His condition very slowly improved: her husband might be "still very weak," Alma wrote to Lion and Marta Feucht-wanger in early December, yet she added that a visit to them would soon be possible, hoping "that Werfel might soon be far enough recovered to venture the long trip."[48] Her plans were regrettably too hasty. On December 14, Franz had another severe heart attack and was dangerously suffocating: "He was more in the other world than in this one, but magnificent, as always."[49]

Because of his bad condition, Franz Werfel, to his great regret, was unable to take part in the first public screening of the Bernadette movie. The enthusiasm

for his Lourdes epic continued at a high level; more than a million copies of the book had already been sold, and the film première on December 21 was a further high point. On that evening, Alma and Franz Werfel sent all their friends and acquaintances to the Carthay Circle Theater in Hollywood while they enjoyed the spectacle in peace and quiet over the radio.

Although Werfel was very weak and could not tolerate any excitement, Alma invited Gustave and Gusti Arlt to a New Year's Eve dinner. While she was sitting in the living room with her guests, Werfel lay in bed. Through the open door, he could participate a little in the conversation. On New Year's Day, Alma received a telegram from Anna, sending her good wishes for 1944 and expressing the hope they would see one another again. She had now become a mother for the second time. When thinking about her daughter and her little grandchildren, Alma had to cry, and reflecting on the old song "In einem kühlen Grunde" (In a cool valley), she was plunged into a great fit of melancholy. "I felt as if she would never run across any of us ever again,"[50] she later wrote. Her last meeting with Anna was already five years in the past. Alma regularly sent money and food parcels to give her daughter in London a helping hand. Anna Mahler complained in one letter: "Say, do they really have vitamins in America that can cure your hair? At this rate I'll have to wear a wig soon—and I feel so shabby and old in general. Unfortunately you didn't pass your eternal youth along to me."[51] Alma took remarks like that to heart; she herself felt worn out, especially because of her constant worries about Franz Werfel. "I don't know," she reflected in her diary, "how much longer I will be able to endure this life under a roof of anxiety. This overexertion is costing me my last little remnant of youth." She described Werfel as "horribly irascible, nervous, unpredictable. He can't see how miserable I am."[52]

The first half of 1944 was taken up with Franz Werfel's slow recovery. By early July his condition had stabilized to such a degree that he could go on retreat to Santa Barbara. He wanted to continue work as soon as possible on a project he had already begun in May 1943. Back then, he had needed only a few days to write five chapters of a "travel novel" with the working title "A Short Visit in the Distant Future." In *Stern der Ungeborenen* (Star of the unborn), as the book was later called, he transferred a large number of autobiographical experiences to the year 101943 and created a bizarre science fiction story. As Werfel still needed medical care, Alma hired a personal physician for her husband. Bernard Spinak, born in 1884 in Warsaw, called only "Schwammerl" (Mushroom) by everybody and highly regarded by his patients, seemed like a relic from times long past. Until Werfel's death, "Schwammerl" was his constant

companion. With energy people thought he had lost, Werfel worked for several hours a day with short rest periods, little strolls, and telephone conversations with Alma. Occasionally he also visited the "Old Mission," a Franciscan monastery, where his friend Father Cyrill Fischer lived (he will come up for further mention a bit later in the narrative). Werfel mostly spent the weekends in Beverly Hills with Alma.

In the spring of 1944, Friedrich Torberg, who was always short of money in Hollywood, received an offer from the renowned *Time* magazine to switch his base of operations to New York. The call to the East Coast, and especially the prospect of working with such eminent journalists as Willi Schlamm and Alfred Polgar, seemed like a sign from the heavens for Torberg, who had always felt lonely and out of place in California, despite his close friendship with the Werfels. As a farewell gift, Torberg gave Alma a photo of Oskar Kokoschka, which she then contemplated for a long time: "The look of a genius in his eye has given way to that of a cunning calculator, which also proves what a Russophile total ass-kisser he is," Alma wrote. As if she somehow had to justify herself, she finally stated: "In a word, I am not sorry that I left him, even though I still occasionally sighed for him later. He is, after all, the 'son of a serving maid'—and his working-class manners were always strange to me."[53] With Friedrich Torberg's move to New York, his friendship with the Werfels continued in the form of an exchange of letters, which give us a good insight into the everyday lives of the couple on the West Coast, as primarily Alma reveals herself with extraordinary candor in her correspondence with Torberg. "In general Werfel is feeling quite well," Alma reassures her concerned friend: "Only yesterday he had an accelerated pulse again, and he often clears his throat—which is why I sent for the doctor that evening."[54] Apart from some minor health hurdles, Franz Werfel was outstandingly productive in the summer of 1944. Every day he wrote four to five pages of his "travel novel," which he sent to Albrecht Joseph for typing. Later, Alma's birthday—she had turned sixty-five—was celebrated at a big party on August 31: "In the night, at 12 o'clock, the Arlts came by with a bookcase, and Franzl was waiting with them for me in the living room with incredible gifts, it was all lit up with candles, it was breathtakingly beautiful!"[55]

Over the following months, the Werfels commuted between Los Angeles and Santa Barbara. Largely because of their fear for Franz's health, the two suffered under the periodic separations. The severe illness had spawned a great closeness between husband and wife, one that would have been unthinkable in the preceding years, even at the beginning of their American exile. The mo-

ment Alma could assume the role of the caring "mother-in-chief," the marital disputes lost much of their significance. Despite his weak heart, "his sexuality is now blossoming again," Alma confided to her diary, "and because I worry about him, especially about the terrible pains he has been getting after the joy of love for years, I try to distract him, which in turn gets on his nerves. . . . For the past two days, he keeps on saying: 'I'll go to the whorehouse to get myself titillated!' His eyes dwell on the sight of anything female with unquenchable lust." Alma's claim that Werfel had always been like that, and her conclusion, "that's why he's so wasted today,"[56] sound like a reproach. Not his excessive smoking, not the many years of neglecting his own body—according to Alma—were accountable for his weak heart, but rather Werfel's compulsive nature.

CAESURAS

In the spring of 1945, Europe looked like a rubble heap. Millions of people had fallen victim to the war, while anxious nights of bombardment, and years under a totalitarian regime, spreading terror into daily life, lay behind the survivors. Not everyone regarded the end of the war as a liberation; some of Alma's family felt the collapse of the "Thousand-Year Reich" as a personal downfall. The Eberstallers, as long-standing members of the Nazi Party (Richard Eberstaller had joined the party on January 31, 1931, his wife, Maria, Alma's half-sister, on March 12, 1933), were so ineluctably bound to the Nazi ideology that a life after Hitler seemed meaningless. Shortly before the Red Army marched into Vienna, Eberstaller wrote a will for himself and his wife, which he deposited at the competent regional court in Döbling on April 11, 1945. The following night Richard and Maria Eberstaller, as well as Alma's stepfather Carl Moll, took poison. When, the next morning, Karl and Rosa Sieber—the Eberstallers' subtenants—walked into the kitchen the two families shared, they found a copy of the will on the table along with a little cash, as well as a letter.

Sieber hastily scanned the letter, read something about death, burial, and attendant inconveniences, for which Eberstaller apologized. "When we went into the E's bedroom that morning," wrote Karl Sieber, "Professor Moll was dead, Mrs. E. still breathing, Dr. E's throat was rattling."[57] Rosa Sieber said later that she and her husband had tried to resuscitate Richard Eberstaller, so "that he might have gone on living for a couple of hours."[58] But, since there were no doctors to be found in the aftermath of the hostilities, Eberstaller died an agonizing death. It is unclear when Alma found out about the suicide of her

family and how she reacted to it. Still, in mid-June of 1945, she wrote to an American military chaplain stationed in Austria, asking for information about her relatives. "You would be doing us a great favor if you could find out how my stepsister and my brother-in-law . . . are doing, and what condition my house in Vienna XIX Steinfeldgasse 2 and my house in Breitenstein on the Semmering are in."[59]

Soon after the end of the war, in the early summer of 1945, Johannes Hollnsteiner tried to reestablish contact with the Werfels. It was the first personal message Hollnsteiner had sent to his old friends since his arrest in 1938. The explanation for his long silence was understandable: "As my friendship with you, et al., had been used as a reproach against me, I really didn't dare write to you without running the risk of putting myself once again into even greater danger."[60] Alma, however, had already received the information back in the summer of 1941 that after his release from the concentration camp in Dachau, Johannes Hollnsteiner had resigned from the priesthood and joined the Nazi Party. Alma's informant, the wife of the writer Siegfried Trebitsch, claimed that the theologian had even married. Although the contact had broken off, Alma could initially not believe that her former lover could have changed so much. "This lady thought she could break my heart . . . but guess what. After five minutes of astonishment and excitement I discovered the whole business, including Mr. Hollnsteiner, meant less to me than anything else in this world."[61] Mrs. Trebitsch, however, had played a little fast and loose with the truth. After his return from Dachau, Hollnsteiner had indeed parted company with his fellow friars. Before 1938, in the Ständestaat, the priest had lived the life of a bon vivant. Under the change of conditions, continuing this would have been out of the question; after the "annexation," Catholicism no longer played any kind of role in political life. But Hollnsteiner did not feel he had been called to a life in a monastery or as a parish priest. When Hollnsteiner's home monastery, the Augustinian Brothers of St. Florian near Linz, was closed down in 1941, and the Upper Danube Regional District offered him a job as a librarian, he took advantage of the opportunity and submitted his resignation from the order on May 5, 1941. He did not, however, join the Nazi Party. At that time Hollnsteiner was already living together with his future wife, Almut Schöningh, whom he then married in a civil ceremony on September 7.[62] "While he once had an influence on me," Alma wrote in her diary in 1941, "this is now washed away forever because of his terrible betrayal of everything he once regarded sacred." With the marriage and his pandering to the Nazis, Hollnsteiner had clearly lost his attractiveness; he was only interesting to Alma

as a priest: "Never again desirable, eradicated from both my life and death and from Mutzi's."[63]

In his 1945 letter, Hollnsteiner justified his actions, explained the reasons for his resignation from the order, and reported on the experiences of the previous years. He had even written down his recollections of his time beneath the swastika: "If you are interested, let me know, I'll try to send you a manuscript."[64] Alma, however, was not interested in Hollnsteiner's memoirs, which have remained unpublished to this day, nor did she like the familiar tone that "Holli"—that was how the letter was signed—used in an attempt to retain the closeness they had shared before 1938. Evidently the injury he had inflicted on her by leaving the priesthood and getting married was too deep. And so Hollnsteiner had to wait more than a year before an answer from California reached him.

"Dear Dr. Hollnsteiner," Alma wrote on June 30, 1946, "I have now recovered from the one shock—namely your defection from the church—and also Franz Werfel, who believed you, has asked me—finally—to forgive you! I would have done that long ago had the dreadful misfortune of Franz Werfel's death not meanwhile occurred! . . . Take good care of yourself—as an average citizen!"[65] When Hollnsteiner tried to explain himself again the following year, Alma reacted as if she didn't know what he was talking about: the formal "Sie" with which she addressed him had meanwhile switched back to the more familiar "Du." "Thank you very much for your letter," she wrote on July 3, 1947. "It explains nothing to me, and I do not understand it! You have not fulfilled your high mission—and the whole world is talking about this and nothing else. . . . Live happily in the knowledge that you have done the right thing for yourself. That is all I can say to you—and all your former friends think as I do!"[66]

This harsh reaction was in fact no exception. Nora, Princess of Starhemberg, the wife of the onetime head of the home guard Ernst Rüdiger von Starhemberg, had already written to Alma in dismay from her Argentine exile in November 1941: "It seems too grotesque to me that Hollnsteiner, of all people, if still in control of his senses, could sink so deeply into insanity! Why? Certainly he has gone through a great deal and had to endure many wretched experiences—but we have all had to face that, each one in his own way has also suffered—but suffering strengthens our belief in God, and ultimately purifies us to achieve goodness and greatness—and not the opposite! Especially in the case of a priest, I can and will not believe that he could so totally have let himself go." The princess even suspected a plot, "a hypnotic, evil influence as a consequence of which he [Hollnsteiner] had acted against his own will."

And she went on: "Do you know that doctors were treating him? He did have a heart condition, right?—Who knows what was done to him?"[67]

Johannes Hollnsteiner's former friends from the Ständestaat era remained unappeased and from then on avoided their onetime role-model priest. And Alma? With all the verve with which, in 1947, she had expressed her dismay over Hollnsteiner's "lapse," eight years later she would resume their contact. At age seventy-five, however, it was Alma who invoked the old times. "I ask you to let me know," she wrote him in February 1955, "if and how you are living—if you are content . . . ?!—etc. and if you sometimes remember me?!"[68] These lines were first sent to Ida Gebauer in Vienna, who brought the letter to Hollnsteiner in Linz a few weeks later. Hollnsteiner was thrilled. Alma's letter evoked in him long-past experiences. In his reply, dated May 23, 1955, he said: "But I have always thought of you with love and gratitude, recalling all the unforgettable, beautiful years in Vienna, when you brought me out of my isolation, expanded my horizon and bestowed unforgettable experiences on me. Thanks to you and your guidance I became a new person."[69] When Hollnsteiner won an essay contest sponsored by the UN in mid-1955 and was thus invited to come to New York, Alma rejoiced: "I cannot begin to tell you how happy I am to be seeing you again."[70] And three weeks later she again affirmed: "I am so eternally happy to be seeing you again—after so many years of the hardest trials!"[71] In late September 1955, in New York City, Alma and Johannes Hollnsteiner again stood face to face. Seventeen years had passed since they had taken leave of each other in March 1938. Further details of the 1955 meeting are not known. It seems to have ended in a frank discussion in which Alma forgave her friend. In any case, over the coming years any number of cordial letters and postcards were exchanged between Linz and New York.

DEATH AND TRANSFIGURATION

On August 17, 1945, Alma received a phone call from Franz Werfel in Santa Barbara, giving her the happy news that he had completed his utopian novel *Stern der Ungeborenen.* He planned to return to Beverly Hills as soon as possible. Although Alma begged her husband not to travel until the temperature cooled down in the evening, he set off right in the midday heat. When he got home, the first thing Alma noticed was his extreme exhaustion. Straining with every step, he trudged the short distance from the car to the house. As Dr. Spinak had been given a couple of days off, Alma called Dr. Wolff, who gave Werfel an injection of heart medicine and prescribed a morphine shot for that evening.

During the night, from Saturday to Sunday, Werfel suffered another severe heart attack. Doctors were called, and when they arrived, after a thorough-going consultation, they ordered three days of bed rest. Over the following week, he began feeling better, sitting in bed, and even worked on a new edition of his favorite poems.

On August 25, seven days after the heart attack, Werfel was feeling well again, so well in fact that nobody could talk him out of going out to dinner with Bruno and Lotte Walter at Romanoff's restaurant. The Walters arrived a bit too early that evening. While the Werfels were still getting dressed, Bruno Walter played a few bars from Smetana's opera *Prodaná nevěsta* (*The Bartered Bride*) on Alma's Steinway grand piano. When he heard the music he had been familiar with from his childhood, Franz immediately came out of his room, began singing along with the arias, and put one foot in front of the other as if dancing. It developed into a jolly, carefree evening. The following morning, Werfel woke up full of confidence. In the best of moods, husband and wife chatted about the possible stages of their upcoming European trip. Vienna, London, and Rome were right at the top of their wish list, and a little side trip to Prague was also under consideration. After lunch, Werfel lay down for a nap, while Alma waited for the Arlts to arrive for coffee. Shortly before the guests appeared, she took one last look to see how her husband was doing. He had risen from the bed and was back sitting at his desk, with the planned poetry book in front of him. When Alma came back to his office a couple of hours later, shortly before 6 p.m., she made a horrible discovery: on this August 26, 1945, two weeks before his fifty-fifth birthday, Franz Werfel had succumbed to a last heart attack. He had slid from his office chair onto the floor, where Alma found him. She yelled for help, as if her own life were at stake. August Hess showed up immediately and helped her get him back on his bed. They took turns trying to revive him with heart massages and the oxygen inhaler. Noth-ing helped—Franz Werfel's heart had stopped beating. A doctor was called, but when he arrived all he could do was to pronounce him dead and have the body removed from the house. Alma was given a strong tranquilizer and lay down on Franz Werfel's sickbed. Professor Arlt and his wife Gusti stayed over-night with Alma, "installing themselves on sofas in the living room, keeping a close watch on everything."[72]

The news of Franz Werfel's death spread like wildfire—including at the Pacific Palisades, where Thomas Mann was just having his dinner. Lotte Walter informed the writer. The next morning Thomas and Katia Mann, the Arlts, Bruno and Lotte Walter, and the Viennese operetta star Fritzi Massary, along

with a few others, paid condolence calls on Alma. "Painful and hard,"[73] Mann noted later in his diary.

The funeral took place on the afternoon of August 29 at Pierce Brothers Funeral Home in Beverly Hills. As a large number of mourners were expected—in fact a total of 114 persons registered in the condolence book, among them the Manns, the Schönbergs, Otto Klemperer, and Igor Stravinsky, to name just a few of the celebrities present—the ceremony had to be precisely planned. Alma asked Albrecht Joseph to help her organize the obsequies. Bruno Walter and the soprano Lotte Lehmann had agreed to provide the musical accompaniment. All in all, the event promised to be a worthy remembrance of the deceased. However, when Albrecht Joseph came in the car to call for Alma, she refused to attend the funeral. "I'm not going," she answered brusquely. She was sitting, as Joseph relates, clearly unmoved, and working at Franz Werfel's desk. When Albrecht Joseph insisted, she replied without any further justification: "I never go to those things."[74]

The funeral service degenerated into a farce. In the overcrowded chapel, everyone was waiting for the ceremony to begin. However, it kept getting later. Neither the sorrowing widow nor Monsignor Georg Moenius, who was supposed to conduct the ceremony, had shown up. An organist played contemplative music and was at some point replaced by Bruno Walter, who played a couple of short piano works by Franz Schubert, compositions of which Franz Werfel had been particularly fond. When Walter completed his performance, a torturous silence followed. Alma and Father Moenius were nowhere to be seen. Then Walter played the Schubert pieces once more, but again nothing happened. When Moenius finally showed up alone, over an hour late, the funeral began. The mourners, of course, had no way of knowing that the priest had been with Alma right to the last minute, waiting while she edited the clergyman's homily. With no regard for the lateness of the hour, she made changes, crossed out whole passages, and composed some excessive additions of her own.

"His speech was an amazing performance," Albrecht Joseph remembered. Moenius began with the statement that, at the moment, Franz Werfel and Karl Kraus were cordially shaking hands somewhere up in heaven. A few listeners regarded this opening as a descent into tastelessness; after all, Werfel and Kraus had been arch-enemies. The middle part of the eulogy was also a problem when Moenius inserted into his overview of Werfel's literary work a discussion of its religious aspects. The end of the sermon left behind an irritation that aroused considerable speculation. As Albrecht Joseph recalls it:

"'The Church,' he said, 'recognizes three baptism rites: the baptism by water, the baptism in emergency, which can be performed by any believing Catholic when there is no time to call a priest, and finally the baptism by desire which means that someone who in his last moments on this earth earnestly desires to be received into the Church can become a Christian by the mere force of this desire although no visible or audible rites are performed.'"[75]

Joseph, whose report we can certainly believe, was not the only one who was confused by these comments. What did a peroration about the different kinds of baptism have to do with the funeral for Franz Werfel? Can one conclude from this that Franz Werfel had not departed from this world as a Jew? We have no way of finding out the whole truth. Werfel's death, the events of his final moments, remain unknowable, even if a great deal of evidence supports Albrecht Joseph's suspicion. A few days after this bizarre funeral, Joseph had demanded an explanation from Monsignor Moenius, asking him if Werfel's possible baptism by desire was the reason Alma took so long rewriting his eulogy. The clergyman's reply was very telling. "He avoided a direct confirmation, but did not deny my assumption that she had insisted on this point."[76]

Despite constantly circulating rumors about a conversion of Franz Werfel to the Catholic Church, the assertion of his baptism by desire in anticipation of death could be viewed as downright monstrous. After all, there are written documents in which he clearly stated his firm commitment to Judaism. In a letter to the archbishop of New Orleans, Francis J. Rummel, written in 1942, Werfel may have expressed his warm feelings for the Catholic faith and the church, which he described as "the purest power and emotion sent to the earth by God to combat the evil of materialism and atheism"; as the Jews, however, were struggling to survive a period of gruesome oppression, he was reluctant "in this hour to slink away from the ranks of the oppressed." And further: as long as there are anti-Semitic Christians, Werfel wrote, "a converted Jew must feel uncomfortable with the idea of presenting himself in a bad light."[77] That was unambiguous and so fundamental that Rummel refrained from answering it.

Despite this clear statement, there were three persons in Franz Werfel's life who had an interest in his baptism. First and foremost was Father Cyrill Fischer, whom Werfel frequently visited in his monastery in Santa Barbara. Fischer had corresponded with Alma over a long period on this topic. "I now consider it my conscientious duty and no less my obligation as a friend," the priest cautioned in a letter written in 1943, "also to call attention to your responsibility for your husband's fate." A few lines later it was made clear what lay concealed behind this pious instruction: "I am firmly convinced that the partial cause of

some of his present 'agitations' can be traced to this spiritual confusion, in the quest for the bright, free exit into the Catholic Church." It was an expression of a perfidious demagogy to imply that Werfel's not being baptized was a partial cause of his severe heart disease (trivialized here to "agitations"). The demand addressed to Alma was in any case unambiguous: "Perhaps here you should be the angel who shows him the way to the Christ child. St. Bernadette will guide you in this task, and the Blessed Virgin, the mother of the Savior of the world, will send you her thousandfold blessing." And so that Alma would know what to do if push came to shove, Father Cyrill explained to her the necessary steps to take. "In case of emergency, should his condition suddenly become further aggravated, you could baptize him yourself, saying the words: 'Franz, I baptize thee in the name of the Father and the Son and the Holy Spirit,' and while you say these words lightly pouring (not just sprinkling!) a bit of holy water, or even normal water over him in the form of a Cross. August might do this as well. . . . I don't think this would be any cause for agitation but rather a source of happiness and relief for Franz and yourself."[78] Alma was appreciative for these hints and felt so close to the Franciscan friar that in her reply, she offered him the more familiar "Du" as their future form of address. Fischer was, as we can see in his many letters to Alma, obsessed with the idea of converting Franz Werfel to the Catholic Church. Afflicted with the advanced stages of cancer himself, the priest knew that he didn't have long to live. Perhaps it was the desire to do one more very special thing in the time remaining to him that drove his action.

The second of the trio was Monsignor Georg Moenius, whom Franz Werfel frequently consulted on theological matters during the writing of The Song of Bernadette. He also harbored the ambition of converting Jewish immigrants to Catholicism. "When Werfel died," Marta Feuchtwanger remembered, "he immediately showed up at our place the next day and wanted Lion to become a Catholic. The king is dead, long live the king!"[79]

And finally, Alma was the last driving force. Not just because of her deep-seated anti-Semitic resentments, Franz Werfel's being a Jew was a constant problem for her, one that didn't get any less bothersome over the course of the years. That was why she considered her husband's unmistakable commitment to Judaism in his letter to Bishop Rummel a huge mistake. Alma feared (not altogether unjustifiably) that Werfel's rejection of baptism might affect the success of his books in bigoted America.

What happened on August 26, 1945, on Bedford Drive has, then as now, prompted a great deal of speculation. If we project the scene before our mind's

FIGURE 8.4

The conversion: Alma Mahler-Werfel with Father Georg Moenius: "I could have given him an emergency baptism when I found him— yet I would never have dared to do it."

eye, it does not appear so absurd to suggest that Alma might have seriously considered the possibility of an imposed baptism by desire. Thanks to Father Cyrill's instruction, she knew what to do, and she would have been able to take advantage of the opportunity. In fact quite a few things speak for this surmise. After Werfel's death the German language scholar Adolf D. Klarmann had conducted several conversations with persons close to Werfel, among others his mother, Albine Werfel, his sisters Hanna and Marianne, Friedrich Torberg, and also with Alma. In late October 1945, he found out something new from her, which he promptly preserved in his notes. "After his death, F.W. received a baptism by desire."[80] At the same time, Alma also exacted Klarmann's promise that he would under no circumstances reveal this secret to anyone else. The new initiate scrupulously kept this solemn promise for the rest of his life. He even underscored the word "secret" twice in his notes.

Alma's stance on this issue vis-à-vis other people or the public in general was always accompanied by attempts at self-justification, although she herself claimed the opposite to be the case.

When the writer Manfred George mentioned in passing in an article he wrote for the German-Jewish weekly paper *Der Aufbau* about half a year after Franz Werfel's death that a priest had spoken at the grave, Alma felt prompted to issue a rebuttal. In a letter to the editor, she stressed that the priest had spoken "as a friend of the family and not as a priest." And: "He had offered to do this voluntarily. No rabbi had come up with that idea—I would have been so grateful to him."[81] When Moenius read these lines, he was irked and wrote immediately to Alma: "Not a word about how much I appreciate the high honor bestowed on me, but nobody knows better than you do how I came to

this honor. I most certainly did not volunteer my services, I never would have dared to. I am also quite baffled that you no longer remember how, in your house, directly opposite you, I already corrected that kind of remark."[82] Although Manfred George had merely mentioned Moenius's presence without attaching any further surmises, Alma felt she had been caught with her hand in the cookie jar, and she tried to divert his suspicion from herself to Georg Moenius, which must have been why she spread the rumor that the peculiar eulogy for Franz Werfel had been Moenius's idea. Without a doubt, Alma was playing with fire. From then on, the ghosts she and the priest had evoked in the funeral oration would continue to haunt them.

Friedrich Torberg, with whom Alma otherwise enjoyed a great openness, eventually got to hear the official version. When, even ten years after Franz Werfel's death, the rumors that he had been baptized had still not abated, Torberg asked Alma finally to answer "the old, still unclarified question."[83] Alma had sensed her friend's suspicion, and yet her answer was still fundamentally evasive. "I could have given him an emergency baptism when I found him—yet I would never have dared to do it."[84] Despite all his warm feelings toward the Catholic church, Franz Werfel had remained steadfast over the years in his rejection of his wife's anti-Semitic tirades and, even in hard times, had continued to declare himself loyal to his Jewish religion. With his baptism *in extremis*, Alma might have emerged from the fray with a monstrous and dubious triumph. However, what really happened on Bedford Drive on the evening of August 26, 1945, cannot be clarified with any certitude to this day.

9

Last Refrain

1945–1964

LA GRANDE VEUVE

For Alma, Franz Werfel's death was not only the loss of someone she had been together with for over twenty-five years; it also subjected her to yet another fundamental change in the circumstances of her life. She may always have been the one who looked after the social contacts in the household they shared—with her lavish festivities back in Europe or her exorbitant dinner parties in America. Now, so it seems, the actual focal point of these events was no longer present. From now on, life would grow quieter around Alma, who would spend the rest of her days—the following nineteen years—for the first time without a man by her side. Viewing her in the light of her increasing isolation, speaking a foreign language in a strange country, we can best understand her attempts to cast herself constantly, as Thomas Mann so astutely described her, in the role of the *"grande veuve"*[1] of two great men and then use this status to acquire recognition, let alone affection.

In the autumn of 1945, she felt so forsaken in her house in Beverly Hills that she preferred to spend most of the winter in New York. On October 4, she arrived in the city on the Hudson, where she initially checked into the St. Moritz, moving on a little later to an apartment hotel called the Alrae, on Sixty-Fourth Street, where she reserved a suite until late February 1946. In New York she found her hoped-for distraction: she got together almost every day with Friedrich Torberg and his new girlfriend, Marietta Bellak, whom he married at the end of 1945—incidentally with Alma functioning as matron of honor. Marietta Torberg remembered one supper with Alma: "Everyone got a lobster. I ate mine, she cut hers into little pieces because she never ate anything, she only drank. And she drank lots of champagne, following it up with great quantities of Benediktiner, and I was sitting on the floor after supper, at her feet, and she tousled my hair, and then she said: 'Viehchi' [little animal]—that was what she always called people she liked—'Viehchi, you're not Jewish, are you?' And I said, 'Listen, Alma, yes, I am, one hundred percent, on both sides—father

and mother.' She was really a dyed-in-the-wool anti-Semite. And when she liked somebody, she refused to believe it. And she was plastered, too, and she wanted to force me into saying that I had been born Roman Catholic. I just couldn't do her that favor.'"[2]

Besides the Torbergs, Alma again saw old acquaintances like Erich Maria Remarque and Marlene Dietrich, Alfred Polgar and Carl Zuckmayer, with whom she partied the night away as she had done so often before. And she attended concerts with the New York Philharmonic, or went to the opera. "I have many people around me," Alma wrote to Lion and Marta Feuchtwanger in mid-November, "but coming home in the evening and the irreversibility of being alone are dreadful."[3]

After almost half a year on the East Coast, Alma finally went back to Los Angeles at the end of February 1946. In her house, so full of memories of Franz Werfel, she felt increasingly uneasy. And the presence of August Hess had become burdensome. He had a choleric temper, and frequently gave free rein to his irascibility. While Franz Werfel was still alive, Alma had been better able to cope with his peculiarities; now, however, she was afraid of his temper tantrums. Gustave and Gusti Arlt, who still had an old score to settle with Hess, advised her to fire him. And when Alma was planning a stay in San Francisco in late August 1946, wanting to spend the first anniversary of Franz Werfel's death there, Professor Arlt was assigned the task of giving Hess his notice, so that he wouldn't be there on her return. When she arrived back in Beverly Hills in early September, however, August Hess was still there. Having failed to resume her authority, Alma decided to keep him on. Albrecht Joseph suspected that Hess must have known too much about Alma's financial situation.[4] And not least, he had been a witness to things that had happened on Bedford Drive in the hours after Franz Werfel's death. To many people, the relationship between Alma and her butler seemed totally bizarre. People were constantly whispering to one another that they were having an affair—an absurd claim, because Hess had never tried to cover up the fact that, as a homosexual, he had a distinct preference for men.[5] Nevertheless, Alma must have nurtured the ambition to lure yet another unattainable man with her charms. In her diary, she wrote a characteristic sentence: "Homosexuals torture people without knowing it or wanting to do it. They let somebody lick on a little piece of sugar and then, cool as a cucumber, they stick it in their trouser pocket."[6]

At the end of 1946, Alma was planning a trip to Vienna to put her property situation there in order. Because of an ongoing delay in the issuance of the necessary entry permit—Alma had become an American citizen on June 14 and

was thus regarded as a foreigner in Austria—she first spent a couple of weeks at the end of September in New York. She implored Marietta and Friedrich Torberg not to tell Franz Werfel's family that she was coming to town. "It has unfortunately become clear, "said Alma, "that he had been right to leave his parents' home when he was a youngster. I do not wish to talk to them! What's the point?!"[7] And she wrote to Oskar Kokoschka: "Werfel's family, to which he could never get close, is now avenging itself on me—or trying to avenge itself—on me, whom he idolized for so many years."[8] Since Franz Werfel's death, the old dispute had come out in the open between Albine Werfel and Franz's sister Hanna on the one side and Alma on the other. The putative reason for this was Werfel's will, in which Alma was named as sole heiress. His mother and sister felt that they, as members of his immediate family, had been passed over, and they contested the will their son and brother had left behind. In actual fact, the will was ambiguously drafted and raised a number of complicated legal issues. First of all, it had to be clarified if the provisions applied only to the proceeds from the American rights to Werfel's works, as Albine Werfel argued. Were this the case, then the Werfels demanded the proceeds from the European rights. Alma engaged a New York attorney named Rudolf Monter, who had served as a business and legal adviser to Franz Werfel right from the beginning of his American exile, with whom she entrusted the job of representing her interests. Monter was determined to prevent the confrontation between Werfel's mother and his widow from coming to trial under any circumstances. Albine Werfel, however, reacted negatively to Monter's letters. She made it clear "that my son—unlike his widow—had never believed in a victory for Hitler." And finally: "Franz Werfel's mother refuses to allow you, Herr Doktor, to lecture her on her son's intentions."[9] The disputes came to a sudden end when it became known that Zsolnay Verlag had independently turned over all the rights to Alma. That left Werfel's relatives empty-handed. No wonder, then, that this kept family relations poisoned for years to come. Alma wrote: "How fortunate for Franz Werfel not to know that he comes from a family of gangsters."[10]

WARS ON FALSE PRETENSES

When, in September 1947, Alma finally received an entrance visa for Austria, nothing further stood in the way of her long-planned visit to Vienna. Her itinerary would take her via London, where she wanted to get together with her daughter Anna and her family. After more than eight years of separation,

she initially anticipated this reunion with Anna skeptically. "I haven't seen her since 1939," Alma had written to Oskar Kokoschka back in February, "and this has not made my heart grow any fonder."[11] Alma was horrified with Anna's appearance; she looked much older than her forty-three years. She was thin and pale. Nevertheless, the reunion ran its course cordially, and they made a date for the Fistoularis to visit Los Angeles in early 1948. When Alma arrived in Vienna the following day, there was a film crew from the Austrian newsreel company waiting for her on the tarmac. The reporters asked her to get out of the plane several times. Over and over again, she climbed the gangway and played the role of herself arriving. She enjoyed all the media hype—she had never had a reception like this before. On September 17, she moved into a small room at the Hotel Kranz and became acquainted with the less-than-majestic conditions in war-ravaged Vienna. "There . . . I slept every night with rats; the hotel was bomb-damaged, and these vermin blithely came and went through the large holes between my room and the outdoors."[12] The days in the Austrian capital were filled with court dates, and stresses and strains with bureaucracy. The prime focus of her legal issues concerned a number of valuable paintings from her property, in particular the painting *Summer Night at the Beach* by the Norwegian expressionist Edvard Munch, which Carl Moll had sold to the Austrian Gallery in April 1940. Ever since the end of the war, Alma had repeatedly claimed that her stepfather had not been authorized to dispose of her property, which was why the precious artwork had to be returned to her. But the legal situation was not quite as simple as Alma thought it was. Alma would have to prove that Carl Moll had traded without her agreement back then. Toward this end, she parlayed the tall tale about the evil and greedy relatives who were out to cheat and rob her: "My mother's husband [was] a Nazi—he was an adviser to the party. Mr. Eberstaller, still a Pan-German, who, of course, immediately became a Nazi leader; my stepsister a rabid Nazi—the whole family insane—only my mother kept her distance, as long as she lived, and had the good fortune to die in time."[13] Carl Moll and the Eberstallers were unquestionably Nazis. But Alma had turned the truth upside-down: she concealed the fact that she had been in friendly contact with her family for all those years, and that she had tried, with Richard Eberstaller's help, to sell the score of Bruckner's Third Symphony to the Nazis. At first, she had skillfully fit right into the ideologically overloaded atmosphere of the postwar era. However, when Alma was unable to present any solid evidence for her version, the authorities began to smell a rat. The competent Senior Restitution Commission at the Regional High Court of Vienna consequently interrogated several persons who had been

habitués of the Mahler-Werfel home before 1938. Here, Willi Legler—Grethe Schindler's son—confirmed the harmonious family relations between Alma and her relatives.[14] Even her long-standing confidante, Ida Gebauer, clearly unwittingly, stressed the friendly interchange among the family members.[15] And according to the testimony from Paul von Zsolnay, who doubtless knew the family very well, Alma was "very fond of her half-sister, Maria Eberstaller, despite various little jealousies, and used her husband, Dr. Eberstaller, as a legal adviser."[16] A further witness got right to the point: Mrs. Mahler-Werfel "could not have acquired any better advocates than Prof. Moll and the Eberstallers."[17] One particularly weighty consideration was the fact that without the proceeds from the sale, it would have been impossible to finance the urgently needed repairs to Alma's Breitenstein house, which totally eliminated the contention that Carl Moll's actions might have been prompted by a desire for personal enrichment. And not least, as far back as early March 1938, Alma had commissioned her stepfather to sell the Munch painting to the Austrian Gallery. This made the counter-evidence overwhelming. Alma, in any case, felt herself so totally in the right that any further proceedings seemed superfluous to her. With the help of friends and acquaintances from the Ständestaat era, she pulled out all the stops in her effort to influence the Austrian justice system. And so Alma visited some movers and shakers of that era like Richard Schmitz, in hopes that the once influential erstwhile mayor of Vienna might be able to help her. Schmitz, however, after several years of confinement in a variety of concentration camps, had become an old, broken man, without any official status or influence. He could do nothing for her. Exasperated, Alma left her hometown on September 23, 1947—empty-handed. She flew via Prague, Frankfurt, and Brussels to London, from where she continued on to New York. She would never see Vienna again.

Her fruitless attempts to get back *Summer Night at the Beach* were the main reason that Alma, despite her great homesickness—which she was less and less willing to admit as the years went by—never set foot on Austrian soil again after 1947, remaining in America more or less against her will. Right up to the 1960s she tried over and over again to get the painting back—each time unsuccessfully. And because she was too proud simply to accept these constant refusals from the Austrian authorities, she assumed the role of a dethroned queen and chose to remain in exile. Obviously she found it impossible to regard the attitude of the courts as anything other than a personal insult. In the years that followed, Alma intensified her attitude to that of a hysterical-irrational opponent to official Austria—as evidenced in mid-April

FIGURE 9.2

The last visit to Vienna: Alma Mahler-Werfel and her loyal Ida Gebauer at Alma's arrival in Austria, September 1947.

of 1948, when she staged a charade targeted to embarrass the Vienna State Opera.

The backstory is quickly recounted. Carl Moll had had a casting made from the bronze bust of Gustav Mahler sculpted by Auguste Rodin in early 1909. This copy had survived the war undamaged, unlike the copy Alma had given to the Vienna State Opera in May 1931. As Alma saw it, Rodin's artwork should be restored to its accustomed place in the foyer of the opera house, which was why, in a generous gesture, she presented the bust from Moll's estate to her first husband's former base of operations. Alma even claimed she wanted to travel to Vienna to turn over the precious gift personally at a solemn ceremony. At her request, the Vienna Philharmonic invited Bruno Walter to provide a musical accompaniment to the festive event with a performance of Mahler's Second Symphony. As close to the event as April 14, Alma confirmed her participation to the conductor. Shortly thereafter, however, she must have changed her mind. On April 18—just two days before his departure for Europe—Bruno Walter found out coincidentally from a friend that Alma had canceled her visit to Vienna. At first, Walter thought this new development was just a bad joke; when it later turned out that she really didn't want to make the trip after all, he reacted with bewilderment. The next day he wrote her a letter: "If you don't keep your word now, that still doesn't release me from the obligation to keep mine. I cannot leave either Vienna or the Vienna State Opera in the lurch at this point in time." For Walter, it was a foregone conclusion that the bust would have to be turned over in any case, "otherwise my trip, the ceremony, and all

the hard work done by the people in Vienna will have lost their meaning." And finally: "Then no one will be able to protect you from the consequences of such a scandalous act, and you will have done great damage to yourself, the Vienna Opera, and Austria."[18] When Bruno Walter finally found out the reasons for Alma's cancellation, he could scarcely believe his ears. A mutual acquaintance told Alma that Walter had been bragging that he would be dedicating "the new opera" in Vienna. This was obviously a misunderstanding, because, after all, in the spring of 1948 the reopening of the State Opera was still far in the future. Alma, however, was insulted, because she had not been mentioned in connection with it. Instead of talking to Bruno Walter about this rumor, she simply canceled her trip. "I had hoped," the conductor wrote her when he found out, "that after receiving my last letter from New York, you might have found a word of regret for believing me capable of . . . such ignoble motives and actions, as well as a word of apology for not telling me, of all people, about your decision not to go to Vienna. What a pity you couldn't bring yourself to admit you had committed an injustice!"[19] Alma reacted to this response by simply repeating her accusations. She acted as if she had never received Walter's rectification. On his return from Vienna, Bruno Walter was sick and tired of these disputes. He had "absolutely no desire," he informed Alma, to perpetuate these disagreeable exchanges with her. Even so, he felt it was urgent to write her again: "because I must avoid your regarding my silence as agreement with your last letter, which is full of misstatements." Nor did he have any understanding for her fabricated hurt feelings: "But if these things cause you to suffer to the point of tears, it just shows that you have a fondness for suffering, and not that any of this is my fault." With the statement that "none of your accusations are justified, none of your grievances traceable to any error on my part,"[20] he put the quietus on this dispute.

A few years later—in July 1954—Bruno Walter again aroused Alma's wrath. The Vienna Philharmonic wanted to establish an international Gustav Mahler Society with Walter as its chairman; Alma's support was also requested, as she was "indispensable for the establishment and success of this society," as Hermann Obermeyer, chairman of the orchestra, assured her in a letter. "Can you, most honored lady, aid us in this undertaking? We know of no one else to whom we can turn."[21] Alma, however informed the orchestra of her refusal in late October 1954. "I must tell you in all openness that I, at least at the present time, have no interest in the society you are founding." Obermeyer had not reckoned with this response. "You will understand this," said Alma's purported justification, "if you consider the way the Austrian state and the Vienna

Philharmonic behaved, and continue to behave toward Mahler's works and especially toward myself."[22]

Much of Alma's martyrdom pose is hard to credit; the issue was hardly her late husband and his work, the Philharmonic, or the Mahler Society. Alma was still fighting a war on false pretenses for the return of the Munch painting. Bruno Walter found it unbearable that she would sally forth into the fray against her old homeland on the back of Gustav Mahler. In late May 1956 he wrote her a stern letter: "I can and will not go into the details of the matter that upsets me so much anymore. The fact is that you are putting up resistance to my efforts on behalf of the Mahler Society and through it toward the promotion of Gustav Mahler's works for reasons that I, with the best will in the world, cannot fathom." Since Alma could not admit her real motivations, she suddenly countered this with the statement that she did not feel herself sufficiently appreciated by the new organization. Bruno Walter stuck to his guns: "What do you mean, you aren't a full member? After all, you were offered an honorary membership, which is more than an official membership. If this is the real reason for your rejection, then I suggest the following to you: the society will appoint you its first honorary president, myself its second, and it will give me the greatest satisfaction to step aside in your favor. It is so important for me to keep on doing as much as I possibly can for Mahler's works before making my final exit from the scene, and I urgently beg you again not to make these efforts any harder for me."[23] Thereupon, Alma withdrew, pouting. "It grieves me terribly," she wrote to the conductor, "that you are so annoyed with me. It goes without saying that I want no position whatever in the Mahler Society." And further: "You have devoted your whole life to doing everything humanly possible for Gustav—you belong in the first position."[24]

Alma's persistent attempts to get her former property back from the Austrian state are not, however, solely prompted by an aging woman's craving for recognition after finding herself spending less and less time in the limelight. They also have a banal side. Three years after Franz Werfel's death Alma was plagued by financial worries. "As all the books are out of print," she lamented to Torberg, then "you can imagine the rest!" There was not that much more money to be earned with Werfel's works. *Stern der Ungeborenen* turned out to be a financial flop, and large print runs of books like *The Song of Bernadette* were now things of the past. So Alma was left with no other alternative but to sell some of her valuable handwritten documents. "Otherwise I have decided to put manuscripts up for sale, as I have no further income."[25] Besides Bruckner's Third Symphony, there were manuscripts by Alban Berg (the particell, or draft

score, of the opera *Wozzeck*); Gustav Mahler (the Ninth Symphony, *Das Lied von der Erde*, three songs from the cycle *Des Knaben Wunderhorn*, a few pages from the Tenth Symphony); and Franz Werfel (the Verdi biography and *Die Geschwister von Neapel*), which Alma offered the renowned Zurich auction gallery L'Art Ancien. Felix Rosenthal, the head of L'Art Ancien, had a catalog expressly printed for this purpose containing information on the valuable manuscripts.[26] The publication listed the minimum bids. The highest minimums were for Bruckner's Third Symphony and Mahler's *Das Lied von der Erde* at 35,000 Swiss francs each, followed by Berg's *Wozzeck* particell (SF 12,000) and the Ninth Symphony by Gustav Mahler (SF 10,000). The Franz Werfel manuscripts were priced at SF 6,000 each, in the middle range. All in all, the manuscripts Alma was offering for sale had a minimum value of 117,500 Swiss francs, the equivalent of some U.S. $425,000 in today's purchasing power. Despite exhaustive research, it could not be determined if all the manuscripts were actually auctioned off, and what the final sum was.

In March and April 1948, Alma received a visit lasting more than a month from her daughter Anna. After their brief reunion the previous year in London, the two women had a lot to tell each other. In her daughter's honor, Alma gave a dinner party on March 22, to which she invited Thomas and Katia Mann, the Arlts, as well as Father Georg Moenius. There was "plenty of champagne and Benediktiner," as Thomas Mann recalled.[27] Although she enjoyed the time with Anna, Alma didn't feel quite right about it. She let Friedrich Torberg know: "My daughter's visit left me immeasurably strained. She is clever and warm, but I am now totally accustomed to great solitude, and this change of pace cost me a lot of nervous energy!"[28] Alma felt, she confessed to her friend, strangely empty and burned out. "You've got to get away. No matter where, just get away"[29] was the reply from Torberg—who thought he recognized the constant memory of Franz Werfel's death and Los Angeles as the cause of Alma's melancholy. Anna had also noticed that Alma was unhappy. "Couldn't you live with us?"[30] she wrote to her from London after her return. Anna's friendly invitation, however, was not an option for Alma—a life in London was unimaginable for her, especially as she absolutely could not stand her son-in-law Anatol Fistoulari. When she spoke of the conductor, Albrecht Joseph remembers, she would shrug her shoulders and say: "What can one expect? Miscegenation."[31] Alma made no secret of her hostility toward Fistoulari, not even to Anna, whom she wrote with injurious frankness that she had married a loser who was unworthy of being a member of the Mahler family. Anna feared these letters, as she later told her mother: "Every time I see your handwriting

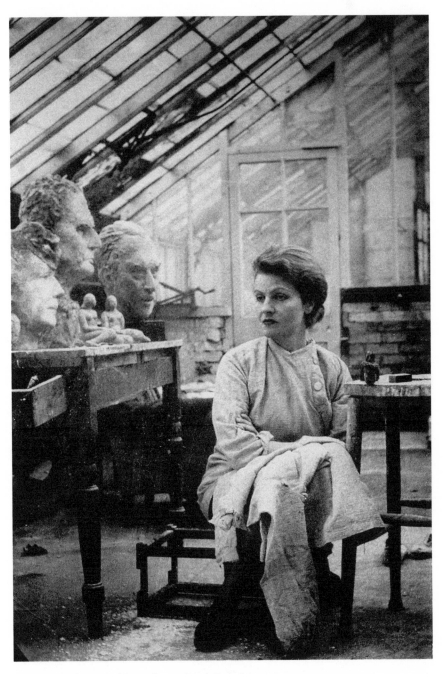

FIGURE 9.3 Anna Mahler in her atelier in London.

I feel a sharp blow in the pit of my stomach—in fear that your letter will be repugnant, and then I heave a sigh of relief when I find myself unscathed after reading it."[32]

Alma's life in California held less and less variety for her to glean from the daily monotony. Occasionally she got together with Thomas and Katia Mann, the Feuchtwangers or Bruno and Lotte Walter; apart from that, "people just keep on vegetating."[33] When Eugene Ormandy, music director of the Philadelphia Orchestra, announced a performance of Gustav Mahler's Eighth Symphony at the Hollywood Bowl in late July 1948, Alma moved back into the social spotlight for a short time. As she was Mahler's widow, she was invited to attend not just the concert, but all the rehearsals as well. Alma visibly enjoyed the attention, and showed up accompanied by the Manns and the Walters and clad in an evening gown for the general rehearsal. While Thomas Mann was checking out the orchestra ("the lad in the red jacket playing the first cello, quite fascinating"),[34] Alma had to rise from her seat at the beginning of the rehearsal and bow to acknowledge the applause from the people present. And in the intermission, she and Bruno Walter were given a special welcome as guests of honor. Speaking to the eighteen thousand spectators Dr. Karl Wecker, the general manager of the Hollywood Bowl Association, even made reference to Alma's own compositions—certainly the crowning glory of the evening for her. "Speaking of me, he said that I was not only the wife of two geniuses, but I myself have also written a great deal—in other words, that I am an artist."[35] While Alma, in view of tributes like this, was able to transform herself into a true "grande dame," even in this role she is still the classic hysterical woman she was from turn-of-the-century Vienna right into the 1950s, equally capable of dispensing with noblesse because of some trivial matter. We can clearly see the proximity of noblesse and insulted pettiness, even at an advanced age, in her reaction to a minor oversight on the part of industrialist Arthur Atwater Kent, who in the summer of 1948 gave a grand party in honor of Eugene Ormandy. Atwater Kent had made a name for himself and earned many millions as a manufacturer of expensive radios. After the sale of his company, he retired to Los Angeles, where he particularly enjoyed surrounding himself with stars and starlets from the film industry. It went without saying for this art-loving bon vivant that Mahler's widow had to be invited to his party, especially as he was casually acquainted with Alma. By dint of an unfortunate lapse, however, he addressed the invitation to "Mrs. Alma Wefel"—obviously a typographical error. This is the kind of minor oversight most of us would just ignore, but not Alma. "I regret that I know no one of that name," she ironically informed him:

FIGURE 9.4 "Cold duck. Alma amusing" (Thomas Mann about a get-together with Alma). Alma Mahler-Werfel with Thomas and Katia Mann along with Eugene Ormandy and his wife at the performance of Gustav Mahler's Eighth Symphony in the Hollywood Bowl, late 1958.

"The invitation certainly cannot be intended for me, as I am sure that after the pleasant evening we spent together at my home a few weeks ago, you must know my name." As if this weren't enough: "Under the circumstances I would be masquerading under a false name if I handed this card to your doorman, and I regretfully feel this would be improper."[36] And so just one missing letter could make it impossible for Alma to maintain a moderate attitude. If she herself occasionally didn't do things precisely by the letter, as we will see in her treatment of her early correspondence with Franz Werfel, well, that is another matter entirely.

In the spring of 1949, Alma received a parcel from Ida Gebauer in Vienna containing the letters Franz Werfel had written to her in all the years before 1938. Alma was delighted to get this treasure trove she had already given up for lost. Over and over again, she read the letters and basked in memories of better years spent together. Page by page, she typed all the documents up. "Today it is already 100 letters," she wrote to Friedrich Torberg on June 23, "but this is just the beginning! You will be enraptured when you read them!"[37] Obviously Alma, motivated by preparing the typescript, was toying at this time with the

idea of publishing Franz Werfel's letters to her. Although she assured Torberg that "not one word, not one comma will I change,"[38] we nevertheless cannot be certain she kept her word. Many of Werfel's letters contain highly articulate, effusively phrased avowals with a kind of naïve, child-like quality, in which, time after time, the author pledges Alma his love. Were she to publish these very personal documents—even years after Franz Werfel's death—she could slake her hunger for homage and recognition. In the summer of 1949, she authored a foreword for the edition of letters, one that gives us a clear view of her innermost feelings. In this text, assuming the role of the objective observer, so to speak, she reports on her relationship with Franz Werfel from their first meeting until the writer's death. In this story Alma appears as a "lovely blond woman,"[39] while Franz Werfel, right to the end, is portrayed as "the wooing youngster."[40] "Whether in Vienna or Italy, whether on the run in France or in the hard-won peace and quiet of California, wherever, whenever, his first and last thought, his concern, his desire was always devoted to the woman without whom, in the most literal sense of the word, he could not live."[41] Not a word about the many crises in this relationship, the agonizing disagreements in the 1930s. Her time with Franz Werfel was turned into a singular success story for him—and Alma's collection of letters is ultimately nothing more than a hymn of praise to herself. This was well recognized by Friedrich Torberg, whom Alma had asked to prepare Werfel's letters for publication: "Thereupon, he wrote her very diplomatically," Marietta Torberg remembered, "that he wasn't going to do it. In reality, he threw a fit bemoaning the fact that a man like Werfel could demean himself to such a degree to write such mawkish, syrupy letters."[42]

In this context we should also mention an autobiographical novel written by Alma titled "Zwischen zwei Kriegen" (Between two wars), which was unknown until recently. In her handwriting on the cover page of the typescript, the author had inserted the Greek words *Allos Makar*, which refer to a poem by the same name, which Oskar Kokoschka had written in 1914. *Allos Makar* is an anagrammatic rearrangement of the two first names "Alma" and "Oskar"; spelled with Greek letters, the anagram means something like "different is happy."[43] Kokoschka's poem, which deals with his difficult relations with Alma, as a motto for an autobiographical novel? Both the title and the plot, at first glance, suggest that the story takes place between the First and Second World Wars. At the center of the novel are the highly gifted Jewish composer Victor Fischler and the piano student Eva Hochstädter, behind whom none other than Gustav Mahler and Alma are concealed. Even small details, such

as Mahler's way of dressing and his heart condition, are projected onto Victor Fischler. The other characters also have their counterparts in Alma's life: members of Mahler's family, who are described as impoverished and disagreeable, are just as present as Alma's bourgeois family and various individual characters like Walter Gropius and Johannes Hollnsteiner, who appears as a "spiritual counselor." Because the story has been transposed to the 1920s and '30s, and Victor and Eva emigrate to America, we can clearly discern many of the attributes of Franz Werfel in the figure of Victor Fischler. The novel takes up an issue central to Alma's being, one that afflicted her over the course of many years and figured significantly in her relationships, especially with Jewish men. Her anti-Semitic feelings and her conviction that she had a higher mission are woven here into the plot of a dime novel: the author describes Eva as her "blond self" and speaks of Victor's "demonic sorcery"[44]—references to Mahler's Jewishness and Alma's "Aryan" origins. Central is the idea of the "salvation" of the Jew, which is made clear in one of the key scenes between Victor and Eva. "He knelt down and kissed her naked body, and they were a unity, and nothing could part them. He stammered: 'You have illuminated me; if anything becomes of me, it will be you who helped me distance myself from dark Judaism. . . . I have you to thank for my liberation and readiness to soar, your bright blue soul has given it to me . . . I could never have accomplished this on my own.'"[45] Not until the "salvation" comes—the author tells us—is the contradiction between Jews and Aryans, between "spiritualization" and "love," resolved. "Eva: 'Something separates us. I strive with every fiber of my heart toward true life. You toward total spiritualization. . . . What I see as salvation is something you cannot comprehend, and what you see as salvation is madness for me.' 'My motto is: I love, therefore I am. Yours is: I think, therefore I am.'"[46]

As to the processes leading to this diffuse redemption, the author leaves the readers completely in the dark. At the end of the novel Eva and Victor have fled from Hitler to the United States, and we find something like a "Christian conclusion": "She no longer loved him because he was 'different,' she loved him because he was strong and had suffered oppression. He loved her more than ever for her bright nature, her loyalty and her identification. . . . And they suddenly knew that there was no Judaism—no Aryanism—no separation—there was only one Christianity at the highest level. The incarnation of mankind—in and of itself—all matter is the same—the human being is but a narrow strip of passion."[47] Franz Werfel's letters, and Alma's novel, are still unpublished to this day. The reasons Alma ultimately never pressed for the publication of this material remain unknown.

Among the ever-dwindling circle of German immigrants in California with whom Alma regularly got together was the Mann family. Even though contact had grown less active since Franz Werfel's death, they all still continued to maintain a friendly relationship. Thomas Mann evidently had a high opinion of Alma as an entertaining conversationalist. "Cold Duck. Alma amusing,"[48] it says in one of his diary entries about an evening they had spent together. But in late 1947, that relationship would deteriorate.

From May 1943 until January 1947, Thomas Mann had been working on his novel *Doktor Faustus*, in which the principal character was the "German composer" Adrian Leverkühn. Here, the author strove to provide as vividly picturesque a description as possible of the mathematical rigor in Leverkühn's compositions, doubtless clearly taking the twelve-tone music developed by Arnold Schönberg as his inspiration. The Wagner-lover Mann had been familiarized with Schönberg's concept primarily by an intensive exchange with another German immigrant in California, the philosopher Theodor W. Adorno.[49] Mann was fascinated by Schönberg's ideas. Alma was informed of the content of the novel through a number of private readings, and as a musician, she knew for certain that Adrian Leverkühn was a practitioner of Schönberg's compositional theory. Only Arnold Schönberg himself seems to have known nothing about it. The Manns and the Schönbergs may have seen one another from time to time, but nobody talked about *Doktor Faustus*, nor had Schönberg been present at one of the author's private readings. On January 15, 1948, Mann sent the composer a copy of the novel with the dedication: "To Arnold Schönberg, the real one, with respectful greetings . . ."[50] Because of an eye condition, however, Schönberg was unable to read the book and thus could not pass a judgment of his own on Mann's literary version of his compositional technique. And this is where Alma's dubious role begins: she informed her old friend Schönberg about Mann's new work—evidently, as it would later turn out, in drastic terms, to the point where Schönberg, as inventor of the twelve-tone method, feared he would be ignored and forgotten. So, after not exactly being uninvolved in triggering Schönberg's annoyance, she put on her Janus face and attempted to mediate between the two artists. "Phone call with Alma Mahler about Schönberg," Thomas Mann noted in his diary on February 21, 1948. "Wants it stated in the book that the twelve-tone technique is his intellectual property. How to go about it?"[51] When Mann failed to check back with her, Alma called him again three days later. "Schönberg insisting

through Alma Mahler," he wrote.[52] As a consequence of the "intervention," Mann finally volunteered the idea to have a explanatory postscript printed in which it was noted that the "twelve-tone technique" was Arnold Schönberg's intellectual property. On October 13, Mann sent a copy of the newly released English translation of *Doktor Faustus*—including the explanatory postscript—to Schönberg, who thanked him cordially for it a short time later.[53] With that, the actual cause of the disagreement was expunged.

The dispute, however, went on, and, worse than that, now the conflicts were carried out in public. On November 13, 1948, Schönberg wrote a letter to the editor of the renowned *Saturday Review of Literature* in which he complained bitterly about Thomas Mann and accused him of identifying him as Leverkühn. Suddenly he felt the personal dedication—"the real one"—was an insult. Beyond that, all at once he also no longer liked the explanatory postscript for which he had previously thanked Mann in writing. Now it was only "a few lines which he hid at the end of the book on a page and in a place where no one would ever see it."[54] One possible reason for Schönberg's contradictory behavior could be his concern about his posthumous reputation. Perhaps there was a little envy in play as well: while Thomas Mann seemed to be living on the sunny side of life in America, Schönberg lived in very modest circumstances.

Thomas Mann found out about Schönberg's accusations on December 9, 1948, when the publisher of the *Saturday Review* sent him a copy of the letter to the editor. There the author could read Schönberg's view of things: "Thereafter, Mrs. Alma Mahler-Werfel told me that she had read the book and was very upset about his using my 'theory' without naming me as author. . . . When Mrs. Mahler-Werfel discovered the misuse of my property, she told Mann that this was my theory, whereupon Mann said: 'Oh, does one notice that? Then perhaps Mr. Schönberg will be angry!' . . . It was very difficult for Mrs. Mahler-Werfel to convince him that he must do something to correct this wrong."[55] With that, Alma's double-cross was unmasked: she was the one who had provoked Schönberg's anger toward the novel. "Alma Mahler-Werfel as intermediary,"[56] Thomas Mann noted tersely in his diary, thus putting his finger on something the European immigrant community in Los Angeles already knew. "She enjoyed gossip," Albrecht Joseph remembered, "and talked without any inhibition about intimate personal relations—not her own but those of her guest or of third persons. It was livelier than her very general, vague comments on literature and art, and much more enjoyable than her political dissertations, which, under the influence of Dr. and Mrs. Arlt, became increasingly stupid and fanatical."[57] As early as the afternoon of December 9,

Thomas Mann drafted a reply, which his daughter, Erika Mann, transcribed and brought for translation to Gustave Arlt, "who is appalled by Sch.'s saddening testimony—and by Mrs. Mahler."[58] Both texts appeared in the January 1, 1949, edition of the *Saturday Review of Literature*. While Schönberg's letter to the editor attests both to his indecisiveness and obvious ignorance of *Doktor Faustus*, Mann strove for objectivity. He staunchly defended himself against the charge of identifying Schönberg as Leverkühn. He also denounced the "gossip of meddling scandal-mongers,"[59] by which he doubtlessly meant Alma. In the first months of 1949, the relationship between Alma and the Manns cooled down considerably. In all of Thomas Mann's diary entries until the end of August, she is mentioned in passing only once.

Alma reacted to this alienation with a radical change of position. While she had initially taken Schönberg's side, horrified by the seeming abuse of the twelve-tone technique in *Doktor Faustus*, she now switched over to Mann's side in the spring of 1949. And once again she functioned as a source of information. When Alma was allegedly asked by Schönberg's wife, Gertrud, to break off contact with Thomas Mann, she immediately phoned Pacific Palisades and informed the writer.[60] Surely, this message was hardly designed to ease tensions. Alma, meanwhile, doubtlessly felt caught in the act. It was obviously uncomfortable for her that Thomas Mann had seen through the intrigue. Meanwhile she severely reproached her friend Schönberg for bringing her name into play; the information about Mann's latest novel had been confidential, and now he had involved her in an extremely awkward situation. Schönberg, in turn, felt unjustifiably criticized and had no intention whatsoever of accepting Alma's accusation. In a smooth move, he reproached her—"How often you have done this to me "—and reminded her of some smaller affairs into which Alma had dragged him. "I hope you will bear this in mind in your future considerations."[61] The dispute over *Doktor Faustus* would come to a sudden end in January 1950—this time without Alma's interference. Arnold Schönberg, weary of the struggle, offered his adversary, with no further ado, to put the argument behind them.

A FINAL HOMAGE

Plans were under way to celebrate Alma's seventieth birthday in grand style. The festivities required a vast array of preparations, and eager workers were busy the whole day getting the house and garden in top shape. In the dining room, an enormous buffet was set up offering an elegant selection of delica-

cies. When the numerous guests arrived, the entire place radiated a festive glow. August Hess, along with a phalanx of catering waiters, served champagne, Bénédictine, or black coffee. At midnight, a specially hired brass band played. In their search for an appropriate gift, Gustave and Gusti Arlt came up with something special, and in the spring of 1949, friends and acquaintances of the honoree were each told to take a sheet of paper, which they were to adorn any way they wanted, and then send it back to the Arlts. Bound in leather, this gift from her friends came together as a singular document. Alma was overjoyed with this very personal gift. But not until she leafed through the book the next day in peace and quiet did she become aware of just how unique this souvenir was. Among the seventy-seven well-wishers were the writers Franz Theodor Csokor, Lion Feuchtwanger, Heinrich and Thomas Mann, Fritz Unruh and Carl Zuckmayer, the composers Benjamin Britten, Ernst Krenek, Darius Milhaud, Igor Stravinsky, and Ernst Toch, as well as the conductors Erich Kleiber, Eugene Ormandy, Fritz Stiedry, Leopold Stokowski, and Bruno Walter. The former Austrian chancellor Kurt von Schuschnigg sent greetings from St. Louis, where the jurist had served as a professor since 1948. Franz Werfel's boyhood friend Willy Haas authored a hymn of praise, which was right to Alma's taste: "I never will believe the tall tale claiming you are seventy, precisely seventy years old. You are either a hundred and thirty: to judge by your life experience, your keen mind, and your unfailing helpfulness. Or else you are now, let's say, thirty-five, to judge by your charm. But you are timeless. As evidenced by your wisdom, your dignity, and your human authority, which nobody can resist. And you are 'blessed' amongst women, for you have beautified the lives of two great men and raised them on high—ah, what am I saying!? Two? Everyone who has had the honor of loving and honoring you, also including your old, loyal friend, Willy Haas."[62] The conductor Fritz Stiedry even composed a miniature opera, titled "Der gerettete Alkibiades" (Alcibiades rescued) for Alma. Thomas Mann stressed that he had always been her friend, "an admirer, if you will, who found refreshment in every get-together with you—the joyful stimulation that exudes from your personality, a humane nature in female form, a great woman. All of these things are you. This I attest with joy and gratitude, and the fact that you are additionally the widow of two wonderful men and great contemporaries, elevates the reverence with which I offer you my cordial felicitations on your special day."[63] Mann—whose annoyance with Alma had abated—clearly didn't bear grudges in this case. According to Albrecht Joseph, "some of his left-wing friends expressed their astonishment at his continuing to see Alma, who represented the

sort of German that had, in the war years, become taboo for Mann. He was reported to have been seriously puzzled for a few moments and thought the problem over, then to have smiled and said: 'She gives me partridges to eat, and I like them.'"[64] Walter Gropius wrote from Cambridge: "Past and present join together! Heartfelt thoughts!"[65] And Oskar Kokoschka also checked in: "My dearest Alma, you will understand that I join you in celebrating the 31st of August, 1949, in my own special way. What the two of us know of one another is an event in time, singular, and yet repeatedly occurring to remain constantly in the present. In keeping with the realization that divine, eternal existence touches on future development, the span of time that we spent with each other rises for me like a myth, distinctly above the events from the historical time in which world wars, disasters of all kinds shattered society from the ground up. You and I have survived this, our continued lives shall be the proof of the continuum! Thus Oskar Kokoschka greets you, Alma, on this 31st of August '49."[66]

Only one person was missing—at the party and in the birthday book—Arnold Schönberg. Because Alma had ultimately intervened in the dispute over *Doktor Faustus* on the side of Thomas Mann, her relationship with Schönberg was put to a hard test. On the evening of her grand celebration, Alma took Thomas Mann aside and assured him she had completely broken off relations with Schönberg.[67] However, this alleged breach had nothing to do with reality; it was staged only to demonstrate her loyalty to Mann. Alma's "reconciliation with him [Schönberg]" actually took place as early as just two weeks later. The laconic comment "with blessing"[68] made it clear that Thomas Mann certainly couldn't have believed the "total breach" in the first place. While the overzealous Gustave Arlt had expunged Schönberg from the list of contributors to the birthday book, Schönberg himself had not been inactive and actually composed a "birthday canon," which he dedicated to "Alma Mahler-Werfel on her 70th birthday." The short work was based on the text: "The center of gravity in your own solar system circled by glowing satellites, this is how your life appears to the admirer." In an accompanying letter, however, Schönberg explained why he did not join the throng of well-wishers, making an unambiguous reference to the events of the past months: "Dearest Alma, it does me no good to move about in other people's solar systems. That is why even today you will not find me among the celebrities congratulating you. So let me, as a solitary outsider, wish you all the best, health and a long life."[69]

After the grand celebration, Alma's life grew quieter. Now and again she would visit the Manns, or else they drove to Beverly Hills. "Nonsense. Ate

and drank too much," noted Thomas Mann in his diary after a dinner party at Alma's house. "Clatter of Mahler music on a badly maintained piano."[70] At another point, it says: "Alma quite amusing and truthful over the discomfort of life and the corresponding undesirability of repeating it. She left early. I was quite exhausted."[71] Alma was now an old lady. The legendary drinking bouts with Carl Zuckmayer and Erich Maria Remarque were things of the past, while it was pointless even to think about nocturnal excesses. She had already long been afflicted with health problems; high blood pressure and heart trouble especially bothered her. She had written a letter the year before to Friedrich Torberg complaining about the consequences of aging: "Now and then I get little warning shots—to which I pay no attention—mainly I don't consult a doctor. I consider that the healthiest tactic."[72]

NEW YORK, NEW YORK

In the summer of 1949, Alma again received a visit from her daughter Anna, who had separated from Anatol Fistoulari shortly before. After the failure of the marriage, she was toying with the idea of changing her life completely and leaving London. When Anna found out that she would be able to teach sculpture at UCLA, she took advantage of the opportunity and moved to California in November 1950.[73] After years of separation, mother and daughter found their way to each other again—both seemed to find their physical closeness comforting. In Beverly Glen, a neighborhood near the university, Alma bought a small house for her daughter and granddaughter Marina (Anna's first daughter, Alma, had grown up in Paul von Zsolnay's home). Shortly after her move, Anna met Albrecht Joseph, who had likewise just put a failed relationship—with the German pianist Lella Simon—behind him. Almost as if it was meant to be, Anna and Albrecht Joseph formed a friendship, which would shortly turn into a loving relationship that would last for thirty-eight years. In 1970 Albrecht Joseph became Anna Mahler's fifth and last husband. Alma had strong misgivings about this connection. In no uncertain words she warned Anna of Albrecht Joseph: as Joseph put it, "Not only was I a Jew, I was also uncreative."[74] Once again, Alma was obviously motivated by her anti-Semitic resentments—the creativity issue was an idée fixe, and Alma had made up her mind that a man like Albrecht Joseph, who had been Werfel's secretary and then worked as a film editor, could not be a creative person. That settled the matter, as far as she was concerned. Even years later, in a communication with her friend Gusti Arlt, Alma left no doubt what she thought about her

daughter's relationship: "Now, thank God, she isn't thinking about marriage—but a 'relationship' is repulsive enough to me!"[75]

After the initial euphoria, Alma's closeness to her daughter in Los Angeles became increasingly difficult. "When I came to America," Anna Mahler remembered, "and Werfel was dead, I was positively gobsmacked at how horrible she could be."[76] Except for some short visits, mother and daughter had spent the previous thirty years apart from each other, not sharing everyday life. To Anna, this newfound physical proximity to her mother became a burden. Alma felt lonely, frequently got bored, and expected her daughter to keep her company. When Anna declined—for whatever reasons—Alma's jealousy came to the fore. "Mommy was a very jealous person," Anna Mahler remembered. "Needless to say, she did everything she could to ostracize other people's friends, even mine. She wanted to keep people strictly to herself—that was all right."[77] Evidently Alma was simply unable to fathom that her forty-six-year-old daughter was leading her own life. And her uncontrollable jealousy of Anna's friends was even directed at her little granddaughter Marina, in whom she saw nothing more than a disturbing factor in her relationship with Anna. "The child," as she abstractly called her granddaughter, had Anna in a firm grip. "Oh, Gusti," Alma pleaded to her friend Gusti Arlt, "Couldn't you exert some influence on her, so she won't let the little brat tyrannize her all the time!?"[78] It is clear that this infantile jealousy toward a child, who, after all, was barely eight years old, did precious little to normalize relations between mother and daughter.

This conflict may possibly have contributed to Alma's decision to follow through on her long-standing plan to move to New York. Back in late 1945, she had bought a house on Seventy-Third Street, only two blocks from Central Park. The narrow building was a typical Upper East Side brownstone. On each of the four floors were two apartments, all consisting of a room, a kitchenette, and a bathroom. When, after some maneuvering, she finally managed to reserve two stories for herself, she finally moved to the East Coast in 1951, initially planning to keep the house in Beverly Hills. It must have been primarily the memories of her time there together with Franz Werfel that initially prevented her from putting her time in Los Angeles behind her once and for all. Alma looked forward to the new beginning, and the physical layout of Manhattan reminded her of Europe. Distances here were short, many places were easily accessible on foot, and it was just a short cab ride to the Metropolitan Opera and also to the Philharmonic concerts at Carnegie Hall. While Alma set herself up on the third floor; the top floor of the house, on the fourth story, was reserved

FIGURE 9.5 Alma's living room in New York: between the bookcases—paintings and drawings by Oskar Kokoschka.

for August Hess or for use as guest quarters. Alma's refuge consisted of two apartments facing one another—one side serving as a living room, the other as a bedroom, separated only by the stairwell landing. The living room was lined from floor to ceiling with bookshelves, which gave the impression that the walls consisted solely of books. Between the bookcases hung the six fans on which Oskar Kokoschka had painted for his beloved between 1912 and 1915, as well as his oil painting *Alma Mahler*, from 1912. Because there was insufficient space on the walls, two drawings by Kokoschka, showing horses near Tre Croci, had to be mounted on a door. Further paintings and photographs stood between the books and on a *secrétaire* and a sideboard. A table with four leather armchairs formed the central point of the room. Alma's second apartment, on the other hand, was dedicated to music. One eye-catcher was doubtless the black Blüthner grand piano, on which a large portrait photo of Gustav Mahler had been placed. On the walls hung some paintings by Emil Jakob Schindler, which Alma had recovered from her property in Vienna after 1945. And next to the desk stood a safe containing some valuable original manuscripts. Although her new domicile was in no way comparable to the Vienna apartment on Elisabethstrasse, let alone the luxurious villa on the Hohe Warte, Alma

seemed totally content. Her standards were certainly no longer what they had been in the twenties and thirties. When the French composer Darius Milhaud visited Alma in her New York apartment, he thought he was in a museum. This concentrated collection of history prompted him to remark laconically that it was "nice to chat with somebody who had known Mozart personally."[79]

In the autumn of 1952, Alma embarked on an extended European tour with her friend Gusti Arlt. While Gusti wanted to spend some time with her relatives in Germany, Alma planned her visits for Paris and Rome. A stay in Vienna was not contemplated, even though Friedrich Torberg, who had returned to Vienna in the spring of 1951, had asked Alma several times to visit Austria. But her lingering bitterness with the dispute over the Munch painting and the behavior of the Austrian courts sat too deep. In Paris, Alma took a room for the last two months of 1952 at the Hotel Royal Madeleine, the same place that had been the first stop on her exile fourteen years before. As she strolled along the same street from the church of Sainte-Marie-Madeleine down the boulevard Malesherbes, then turning right into the rue Pasquier, she got the feeling that time had stood still. In January 1953 Alma traveled on to Rome, where she also spent almost eight weeks, then joined Gusti Arlt to board the ship for their homeward journey. The Atlantic crossing was a pleasant one, in good weather; the two friends sat together on the sundeck, chatting or reading. And—as so often—Alma made an interesting new acquaintance. She was sitting alone in the fresh air when suddenly there was a tall man standing in front of her, who introduced himself as Thornton Wilder. Alma realized immediately that this was the famous American writer, whose early work *The Bridge of San Luis Rey* she had read several years before. The time spent with the fifty-three-year-old Wilder, who was an amusing and charming conversationalist, shortened the voyage for her, so that she forgot time, and when the ship landed in port, they parted company as friends.

A year later, Alma was again making travel plans. Initially wavering between Rome and Gran Canaria, she finally decided to go back to Italy after all, in early September 1954. She flew to Rome for a few weeks, where she got together with Friedrich and Marietta Torberg. During her stay, however, Alma complained of exhaustion and heart trouble. Nevertheless, she summed up her journey positively: "Since I have been feeling almost well again it has been very beautiful indeed, but I wasn't able to look at much of anything. Since I know all these places anyway, that doesn't bother me."[80]

THE DOUBLE BIOGRAPHY

In the final decade of her life, Alma devoted herself primarily to one project: recounting her unquestionably dramatic life. She may have already begun her preparatory work back in late 1944, but it languished because of constant interruptions. Even so, by the end of February 1945 she had already finished some two hundred pages, and in mid-1947, the first version ("Der schimmernde Weg"—The glittering path) was complete. She had been motivated to start recording her recollections after she learned that Bruno Walter was also working on his memoirs. Alma, who had always looked with suspicion on the close friendship between Bruno Walter and Gustav Mahler, feared that Walter would present a distorted image of her in his book. As it turned out, her misgivings were unfounded. Walter went out of his way to present a fair portrayal and sent questionnaires to friends and acquaintances whose help he wanted on matters of detail. "Among other things," Alma tattled to Friedrich Torberg in a letter, "he asked . . . where he had celebrated his sixtieth birthday!? Well— he really ought to know that! Such a significant gentleman. Of course I know it—big deal!"[81] The clearly discernible hostile undertones would, however, grow weaker over the coming years. When Walter decided to change his base of operations from New York to Los Angeles after the death of his wife, Else, Alma initially reluctantly anticipated this move. "Well—if our relationship hadn't been so badly impaired," she wrote to Torberg, "I really could have liked him."[82] The contact with her old rival, however, would prove unproblematic, and friendly connection came about when the conductor purchased a property at 608 North Bedford Drive in July 1945 and he and his daughter Lotte became Alma's next-door neighbors. And, to her relief, Alma was even given an opportunity to read Walter's memoirs prior to publication. After reading the manuscript, she finally had to take back her misgivings and reservations about Bruno Walter. "The beginning was a bit too sugary and lower middle class for me. But later on, this sweetness and light develops into real quality."[83] All kinds of anecdotes were in circulation about Walter's legendary mild-mannered nature, his gentle and benevolent character. One particularly charming story was being spread around by his secretary at the time, Hilde Kahn: While he was dictating a letter, it might happen that Bruno Walter struggled to hold back the tears, so very overwhelmed he was over his own words. Thomas Mann also read the conductor's memoirs. "Well then," was his lapidary judgment, "some touching stuff."[84]

In her own memoirs, however, Alma let anything but good nature determine the tone. In her conception of the text, she referred back to the diary she had kept since her early youth, albeit with long interruptions and with varying intensity. If the first, still unrevised version of her memoirs occasionally hit her readers like a roundhouse punch, this is certainly attributable to the unfiltered diary entries. While Paul von Zsolnay—surely one of the first people to get to read the manuscript in the summer of 1947—may have diplomatically rated the memoirs as a "natural event" and spoken of an "uninhibited confessional work," at the same time he also made it unmistakably clear to Alma that portions of the text would have to be rewritten primarily because of the "frequent references to racial issues as an essential element of the book."[85] Obviously, Zsolnay's cautious objections alerted Alma to the fact that she would not be able to publish her memoirs without editing, and that she was not up to doing the job on her own.

What then followed was that a not inconsiderable number of editors went to work on revising Alma's manuscript, and all of them—except for one—failed at the attempt in a variety of ways. The first was Austrian author Paul Frischauer, born in 1898, who certainly had all the requisite savvy to carry out this tricky job gently, discreetly, and with plenty of sensitivity. "Great Men's Wife" or "Wife of the Great" were still the working titles of the book back in 1947. Only a few months after it had begun, the collaboration came to an ignominious conclusion. In a synopsis, Frischauer had taken particular exception to the quantity of anti-Semitic excesses on the part of the author. When Alma failed to respond to his letters, he sent her a telegram in late November 1947, revealing his amazement "at having received no reply to my letters."[86] With that comment, Frischauer had overstepped the mark. Alma demanded by telegram that he turn over to August Hess all the manuscripts and books he had received from her. For the bit of work he had already done, Frischauer would receive $800. Clearly Frischauer had committed a faux pas by failing to bear in mind in his critique that Alma expected nothing less than admiration from her readers. "Whatever provoked you to take such an unfriendly attitude toward me," Frischauer wrote to his former employer in mid-December 1947, "it is a mystery to me (perhaps it's a mystery to you, too). I ask you, however, not to take the somewhat sharp judgment I made in my critical notes on your manuscript personally. They are the essence of what might be held against you if your manuscripts were to remain as they are. I want to direct your attention toward possible objections to them: it's just a friendly warning of what might be said against you, a warning that is well meant even if it is sharply articu-

lated."[87] Alma, however, was incapable of taking a critical look at herself as proposed in this letter—her craving for recognition in her later years, so it seems, would only sanction an attitude of worshipful awe. And so the memoir project came to a grinding halt.

Not until the second half of the 1950s did Alma's project slowly get moving again. She had found another ghostwriter in the person of E. B. Ashton, who was a talented writer and much-sought-after translator, and beyond that he enjoyed excellent contacts with both American and British publishers. He was doubtless the right man to edit Alma's manuscript and arrange the publication. Ashton was the pen name of Ernst Basch, born in 1907. In his hometown of Munich he had initially studied law, but in 1933 he had to discontinue his studies shortly before completing his doctorate. Basch had attacked a Munich Nazi bigwig in a newspaper article, then left Germany after the Nazi takeover and emigrated to the United States. After the Second World War he was largely active as a translator, producing English versions of works by such authors as Karl Jaspers, Gottfried Benn, and Theodor W. Adorno. The contact between Alma and Ashton came about through his wife Hertha Pauli, who had met Alma on their escape from Europe. On August 1, 1956, Alma and Ashton signed a book contract with the Hutchinson Publishing Corporation for the English edition of Alma's memoirs.

First of all, the new ghostwriter acquired an overview of Alma's life. After reading the diaries and the memoir manuscript, it was clear to Ashton that, first and foremost, there would need to be strict censorship of quite a few passages. Alma's anti-Semitic cheap shots and the abundant attacks on persons still living could not be published under any circumstances. Alma agreed. "I must urge you both," she wrote to Hertha Pauli, "to leave out any statement that might be unpleasant for the persons involved, as I have often asked you to do! . . . Here I mean my mother, my daughter and Zsolnay. I don't want any lawsuits for defamation of character!"[88] Ashton's worries that the text would be little more than a total distortion unless extensive revisions were made are undeniable here: "Alma's memoirs, in their present state, are certainly no monument. Because of the disunity, they have something more like the quality of an involuntary caricature—and this way they cannot and will not leave any pleasant memories behind. . . . I'd like to mention that the effect of Alma's quite brilliant sentences and perceptions often fall by the wayside because the arrangement and placement are wrong." He suggested that Alma make use of a questionnaire from which her answers could be taken as the basis of a new arrangement of the content and presentation of the material. "I have a clear

FIGURE 9.6 Welcoming the New Year of 1956 at Alma's home in New York: Anna Mahler (*l.*), Susi Kertész (*third from l.*), Alma (*center*), and Ida Gebauer (*second from r.*).

view of how the book ought to be arranged and rearranged. But I cannot do this without Alma's agreement and her total cooperation—with mind and heart!"[89] That was how he outlined what would ultimately prove to be a large-scale, time-consuming project, which also demanded a full commitment from Alma. But this exchange of ideas between the author and her ghostwriter was not meant to be. Alma may have answered one or two of his questions occasionally; however, Ashton quickly noticed that her information was frequently unreliable. She confused one year with another, mixed up the people in her narrative, and wrought havoc with the truth, if the truth was not to her liking. E. B. Ashton was thus forced to depend largely on himself in his rewriting of the memoirs. Beyond this, Alma said she had been "seriously ill for a whole year," as she wrote Walter Gropius on August 20, 1958, "and unfortunately haven't been able to pay as much attention to the book as I should have."[90] The years of excessive alcohol consumption had left their traces: Alma suffered from cardiac insufficiency and had had several light strokes, which, however, because she had long refused to have herself medically examined, were diagnosed too late. "Since Franz Werfel left me," she wrote to Lion Feuchtwanger

on June 5, 1958, "I've been just dragging myself along, until I got a coronary thrombosis from all the excitement about a year ago—to say nothing of the consequences."[91]

When Alma's memoirs reached the bookshops under the title *And the Bridge Is Love* in the spring of 1958, the reactions were varied. Paul von Zsolnay wrote to her with diplomatic benevolence in late September 1958: "The English edition may be different in many ways from the manuscript you made available to me back then, but the impression it left on me after reading it is uninterruptedly strong and lasting."[92] For others, reading the book was a source of irritation. One member of this group was Walter Gropius. A radically shortened description of the relationship between Alma and Gropius, covering a scant two pages, gives the reader the impression that the events in Tobelbad were nothing more to Alma than a fly-by-night flirtation. She did not devote a single word to their passionate love letters, nor did she mention that she needed only a short time to decide in her own mind in favor of Gropius. A bare fifty years later, he felt he had been depicted in a totally false light. Walter Gropius was not just incensed over her lack of sensitivity—he was also disappointed and deeply hurt. Disgusted, he wrote his ex-wife a farewell letter on August 17, 1958: "The love story you connect with my name in your book was not ours. The memory of Mutzi should have kept you from stripping our experience of its essential content, and its literary exposure has now caused the blossoms of remembrance to die within me as well. The rest is silence."[93]

Holding Walter Gropius's letter in her hands, it dawned on Alma what she had done. She immediately tried to appease him. Naturally she described the depiction as a regrettable mistake and put the blame on Ashton and the publishing company. "I, however, was concerned about you, and I instructed the adapter to have the publisher send you everything concerning you, so that you can censor it. Not until I received your latest letter did I realize that this had not occurred!"[94] It was all too obvious that this explanation was nothing more than a lame excuse. Alma tried to justify herself once again in April 1960: "I beg your forgiveness! I am more guiltless than you believe me to be!" As usual, Alma evaded responsibility by evoking the memories of Manon. "Your child and mine completely understood me—it was too much, it wasn't allowed. I shall seek her in the hereafter—now I am completely alone! You are a great man, and I have always known that too! Don't forget me—just as I have never forgotten you, not even when you least expected it!"[95] Alma's attempt at appeasement fell on deaf ears. The relationship between her and Gropius remained shattered. As late as 1968 Walter Gropius intimated in an interview

with journalist Thilo Koch that Alma's "Apologia pro vita sua" "was quite obviously not a pleasant topic for him."[96]

Initially, a German translation had been planned for Alma's memoirs. A collaboration on that or other projects with E. B. Ashton was now, however, out of the question. Moreover, while she believed a further adaptation of the project into German would be a great success, the reactions of her closest circle of friends seemed cautious and negative. The job of coauthoring the German edition went to Willy Haas. The author and literary critic had been a close friend of Franz Werfel, whom he had met during their student days in Prague. From 1925 to 1933, he was the editor of the prestigious magazine *Die literarische Welt* (The literary world), and after his return from emigration, he worked, among other jobs, as an editor and columnist on the Hamburg daily paper *Die Welt*. His literary qualifications were undisputed, and through his close ties with Franz Werfel he also held Alma in high regard: in short, Willy Haas took over this assignment "with great pleasure."[97] E. B. Ashton, however, who had originally been slated to do the translation, was not about to take his rejection lightly. Through his attorney he threatened Alma with a lawsuit if sentences from the English version were taken over into the German edition. In May 1959 she wrote to Willy Haas, "I asked 'Mr.' Ashton to deal gently with the important people I number among my friends—but he pulled out all the positive points and developed everything with a negative touch! Please don't read it. He said if one sentence from his book were to show up in your version, he would sue me!"[98] And on May 15, she even added: "This Ashton business has really made me ill!"[99]

Willy Haas, by contrast, worked to Alma's satisfaction, and unlike Paul Frischauer and E. B. Ashton he enjoyed her support. Haas sent finished sections of the book regularly to New York or referred questions on still unclarified matters to Alma. For him as well, the focus of his work was a careful smoothing out of the rough spots in the original text. This, more than ever, was also in keeping with Alma's wishes; after all, she didn't want to face any further rejections because of her memoirs, like the ones Ashton's version had generated. As she emphatically begged Haas in early January 1959, "We must go easy on still living persons and famous individuals who play leading roles in this history, such as Gropius, O.K., etc. Gropius is very shy and does not want our relationship to be shown in a harsh light. Handle it in keeping with your feelings." And finally an additional urgent appeal: "Please eliminate all references to the Jewish question."[100]

Only a short time after the release of *Mein Leben* (My life) by the eminent

German publishing company S. Fischer Verlag in 1960, speculation had clearly sprung up as to the extent of the revision, largely nourished by the foreword by Willy Haas: "Even so, with the release certain considerations had to be taken," he hinted. "She had made several foresighted judgments, but also some mistaken and dangerous ones. Here we had to make a preliminary selection."[101] These allusions, however, were inadequate to cover up what observant contemporaries had long suspected, namely that *Mein Leben* was, in large part, a cleaned-up version that had precious little to do with reality. Alma's "remarks on racial issues," as Paul von Zsolnay chivalrously described her anti-Semitism, had completely disappeared. Private matters dominate *Mein Leben*, and Alma appears as the always seductive, sensuous muse, serving the cause of art to the point of self-abandonment, idolized by all her men. "The German version was considered so hot," Albrecht Joseph remembered, "that it was sold under the counter, like pornography."[102] Worse yet, the mere name "Alma" became a synonym for a double entendre that set listeners giggling. Suddenly *Mein Leben* assumed a place in the pantheon of "tell-all" books alongside the spicy recollections of Josephine Mutzenbacher, the main character of a novel titled *The Life Story of a Viennese Whore, as Told by Herself*, its authorship attributed to Felix Salten, the same author who gave us *Bambi* a few years later. It tells the story of a professional tart in Alma's hometown, and was also considered under-the-counter pornography when it was published. Our authoress was anything but pleased with this perception of her book. She assured her former son-in-law Ernst Krenek: "I really only wanted to stress the philosophical aspects in the book, not the personal ones." When Krenek told this anecdote to Theodor W. Adorno, Adorno sardonically retorted: "Well, I rather prefer the pornographic aspect myself."[103]

A LATE LOVE

Throughout Alma's life, largely characterized by her diverse connections with men, her relationship with Oskar Kokoschka was a frequently overlooked constant. Their separation in 1915 may have been the consequence of a passionate love-hate relationship, which proved no longer endurable for both of them; nevertheless, a final break-up had never taken place. Now and then they would write to each other, and reflections regularly show up in Alma's diaries, as previously cited, about Oskar Kokoschka and his significance in her life. After Franz Werfel's death, the letters that passed between them—as one can clearly see with a glance at Kokoschka's unpublished correspondence—

would intensify and undergo a remarkable late blossoming. "I will never figure out—never comprehend," she wrote him in the spring of 1946, "how we could ever have separated! Since we were made for each other!"[104] Alma increasingly escaped into her memories of the years together with Kokoschka. Beautiful moments—as well as somewhat depressing ones—reawakened this way to new life. "It is frightful," she lamented in late September 1946, "that our child never came into the world back then. We are not the only ones who may weep over this—so may the world . . . ! He should have been a genius. COMING FROM THE TWO OF US—It's all over—you live a life that is alien to me—as mine is to you—and so I am a poor soul!"[105] At another point, she assured Kokoschka that he is "the very essence of a great and beautiful man in my life! I live in your room with the fans . . . and my portrait (which I rescued for myself from Vienna) surrounded by your art—only there do I live!"[106] Although Alma kept assuring Kokoschka that she wanted to see him again, she avoided any encounter. When, in 1946, he invited her to join him in London, she declined, she said, because of her daughter. "I don't want to come to London because Anna and family are exploiting me, and I have no interest in that."[107] Alma also let other occasions come and go, as she did in 1954 in Rome, where a get-together might have taken place. Kokoschka wouldn't let up and invited her the following year to visit him and his wife, Olda, in Villeneuve. Once again, Alma begged off: "Unfortunately we are separated by over 3,000 miles and some other things."[108] Her jealousy of Olda Kokoschka, reduced here to "some other things," was one more barrier, which—as Alma must have felt—made a reunion impossible. The main reason, however, may presumably have been something else altogether. Alma refused to meet Kokoschka because she didn't want him to see her as an old woman. She was aware that she could no longer qualify for the role of the seductress, the Circe, the femme fatale—in other words the woman she had been when Kokoschka met her. But Oskar Kokoschka was also living in his memories of Alma. "Do you still love me, too? Show it to me with a clear sign, with the touch that wakes me up."[109] Occasionally he would ask her to write him an erotic letter: "Because I'm flying back to prudish England, where people totally forget that they have a body, inside which, inside a second body, will flail about with blood lust like a female bull that seizes upon a man and will not let go until he is expended. From where else then could this have come upon me if not from the one, who was the first of all at the outset to offer herself to me so that I could be taught everything—happiness, misery, pain, delight, fury, and then perishing in wild frenzy. You were my teacher, my instructress, and I have subjected many people to the same thing in loyal

succession, and in the right meaning it emerges from my innermost depths, where you sit with open thighs and press the wine from the grape."[110]

At another point he promised her: "If I ever find the time, then I'll make you a life-size wooden figure of myself, and you should take me to bed with you every night. The figure should also have a member in the position you made it for me, so you can remember me better and through practice also acquire a lust for the real thing again. We will get together again some time. Live for it, my unfaithful love, who urges it out of my life into oblivion."[111] When Alma and Kokoschka were exchanging letters like this, she had already reached the eighth and he the seventh decade of their lives, and their last meeting had taken place over twenty years before (they had coincidentally seen each other in October 1927 in Venice without exchanging a word). The fact that they couldn't forget each other even after decades of separation, and were still sending erotic letters back and forth even in old age, was an expression of their bizarre love affair—an *amour fou*.

FINALE

On August 31, 1959, Alma Mahler-Werfel turned eighty. Countless congratulatory telegrams arrived from all over the world, and friends and acquaintances wished her a very happy milestone birthday. While her seventieth birthday had still been grandly commemorated, the celebrations ten years later assumed a more modest tone. Her physical afflictions—results of a weak heart as well as several light to medium strokes—were now becoming more distinctly noticeable, beyond which she was almost deaf. Anna came from Los Angeles to New York to mark her mother's grand occasion with her. All in all, Alma made a frail and frighteningly confused impression—for example, she asked her daughter who had won the Second World War. Now it could no longer be denied that Alma needed regular care. But who was to look after her, especially since August Hess had announced that he wanted to leave New York? Hess had been in Alma's employ for over fifteen years, was in his late fifties himself, and wanted to retire to Los Angeles. He had never been able to derive any satisfaction from New York. The hectic activity in the metropolis remained uncongenial to him. Beyond that, as she grew older, Alma was less and less inclined to put up with his irascible temper. When talking to friends she jokingly referred to him as "my murderer,"[112] because she was allegedly convinced that one day he would put her in her coffin. When August Hess left her, Albrecht Joseph tells us, he was a wealthy man. In Los Angeles he bought a couple of apartment buildings,

which he profitably rented out. Back then people would whisper to one another that he could never have earned that much money from his butler's job. Alma was well known for not paying her employees well. Quite possibly, as the gossip mill contended, he might have exacted a pretty penny from her for his silence. After all, he would have been able to report some embarrassing details about Werfel's alleged baptism by desire, or the sexual appetites of the aging Alma. Hess, however, was not destined to enjoy his retirement for very long—he died October 4, 1960, in Los Angeles.

Alma now had to look for another caregiver. With a veritable deluge of telegrams and letters to contend with, she wrote to her former housekeeper, Ida Gebauer, who was living in Vienna after dissolving an unhappy marriage, and told her to move to her house in New York. "Whenever Mommy needed her, she came," Anna Mahler remembered. "She was a regular serf. In these last years in New York, she lived with Alma in her apartment and never slept—an old woman with a strong character."[113] The over sixty-year-old Ida devotedly looked after Alma and often stayed awake with her until the small hours of the morning, for in the final years of her life Alma began suffering severe bouts of insomnia. Then the two women would talk about the old days in Vienna, Breitenstein, and Venice, about Manon and Franz Werfel, about Alma's happy childhood years in Plankenberg, and about her beloved father, Emil Jakob Schindler. Alma was more and more pronouncedly anchored in the past.

Alma left her apartment less and less often. Sometimes she would patronize one of the restaurants she regularly frequented, where she would consume a small meal along with a few glasses of champagne. Now and again she would also attend a concert or go to the Metropolitan Opera. "Yesterday I was in the general rehearsal of the Mahler 2nd under Bernstein," she wrote in the early sixties to Gusti Arlt. "For a change this is really a brilliant conductor. . . . because he is also a very interesting composer."[114] Leonard Bernstein, who was very enthusiastic about Mahler's work and wielded some influence on its reception, never missed an opportunity to invite Mahler's widow to his concerts with the New York Philharmonic.

One of the last visitors Alma received was a U.S. correspondent for the ARD, the West German public radio and television network, a reporter by the name of Thilo Koch, who contacted her in 1963. He had become aware of Alma on reading *Mein Leben*. He went off in search of Mrs. Mahler-Werfel, finally found her, and received an invitation to join her for coffee. Thilo Koch's description of this afternoon hour is a sad testimony to the solitude of an old woman. One last time, Alma struck a pose and played a scene that was just

FIGURE 9.7 Mother and daughter in the early sixties in New York: "Had I known you the way I know you now, I wouldn't have treated you so badly."

as impressive as it was bizarre. "Once I had found the right door," the visitor remembers, "a middle-aged woman opened it. This couldn't be Alma. This woman seemed to be mute, but she nodded her head knowingly when I told her my name. She opened a door, and I thought I had walked into a dream. The room was totally darkened even though it was a bright, sunshiny afternoon. A few lamps were placed in such a way that only the person in the middle of the room was clearly visible, though not all that clearly. This person was seated on an armchair behind a table on which her heavily bejeweled hands reposed. As I approached the table to say hello, I found myself shrouded in a cloud of heavy, sweet perfume. Glowing eyes looked expectantly over at me." Koch was still not sure what to make of this situation: the reception from the "mute woman," obviously Ida Gebauer, as well as Alma's self-staging, had thrown him off-balance. During the conversation he was struck by the way Alma never addressed herself to his questions. She may have nodded understandingly and looked attentively over at the gentleman opposite her, but she talked right past him. Suddenly Thilo Koch realized why she wasn't answering his questions. She was quite deaf. As his discomfort increased, Alma spread out her story

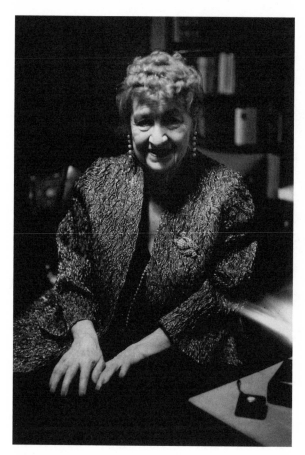

FIGURE 9.8
Alma Mahler-Werfel
in 1963: "somebody who
had known Mozart"
(Darius Milhaud).

before him, told him of Gustav Mahler and Franz Werfel, and presented her treasures—musical scores, books, pictures. Koch: "I would gladly have listened, but her sentences often just broke off. Then her hands and eyes would search the table for some specific point—and found none. I felt as if there were a lump in my throat that kept getting bigger." Slowly Koch realized that he had become a spectator at an exemplary drama: "She had meticulously staged all of this. Perhaps working for days on the lighting and her makeup. She might possibly have not been visited by anybody for weeks? Or months? Or even years?"

Koch was disappointed and felt sympathy for Alma. This almost deaf creature, rattling off her monologues—this woman he had found in her little Manhattan apartment didn't fit the image he had made of her. This macabre scene, however, was played by both of them right to the end. Thilo Koch forced himself "to kiss her cold, elderly hand,"[115] made a courteous bow, and the "mute woman" showed him back out into the bright, sunshiny day.

As of early 1964, the intervals between Anna's visits to her mother in New York started growing shorter. More and more often Alma would say: "If Mahler were to walk in the door now, I would go out with him!"[116] Doubtless, at the end of her life she regarded herself increasingly as Mrs. Mahler and spun herself increasingly into her imaginary world. She now spoke very seldom of Franz Werfel. In her final days the two women came closer together, closer perhaps than ever before. Anna remembered a remark Alma had made, which tells us a great deal about their precarious mother-daughter relationship: "Had I known you the way I know you now, I wouldn't have treated you so badly." Anna, who had experienced her mother virtually all her life only in gestures of rejection, was profoundly shaken by this late acknowledgment. "That shocked me so horribly because I didn't know she was treating me badly, and that she knew she was doing it. She kept saying: 'I always know everybody immediately,' and she had known me for a good long time. That is horrifying, don't you think? I thought it was simply the way she was. Just being my tiger-mommy, but no, she did it on purpose, and that was a shock."[117] Many contemporaries were astounded when, at the end, Alma began taking an interest in Anna, of all people, for whom she had barely shown any positive feelings for decades. Obviously Anna didn't totally trust this change of heart, as she confided to Gusti Arlt in a letter: "Yes, that's right. The more senile Mommy gets, the more she admires me. I can't claim that it means much of anything to me now. Yes, it would have thirty years ago!"[118]

When it was determined that Alma had a form of diabetes, she categorically rejected the diagnosis. Diabetes, Alma contended, was a Jewish disease, which was why she couldn't possibly have it. And so she went right on drinking a bottle of Bénédictine every day, despite all her physicians' concerns.

The end of her long and varied life was lonely. Some friends had already died; others, like Friedrich Torberg, had moved back to Europe; while still others had dropped her in disappointment. Gustav Mahler had been dead for fifty-three years, and Franz Werfel had left her nineteen years ago. Death did not come unexpectedly. Alma was convinced she had met Crown Prince Rudolf of Austria on a mountaintop. And the heir to the imperial throne also wanted to have a child with her. (Alma was not quite ten years old when the crown prince committed suicide in Mayerling.) When Anna tried to embrace her mortally ill mother one last time, "she pushed me away and threw me on the ground. She didn't want any help from anybody."[119] Alma Mahler-Werfel died on December 11, 1964.

EPILOGUE

"Mommy has just died."[1] In only a few words, Anna Mahler informed Alma's closest friends and acquaintances—among them Gustave and Gusti Arlt, and Adolf and Isolde Klarmann—of her mother's death. Friedrich Torberg in Vienna also received the news on the very day of her death. Even though his contacts with Alma had become less and less frequent over the intervening years, Torberg reacted with profound sadness. Shortly thereafter, Adolf Klarmann told him of their mutual friend's final days: "I saw Alma for the last time at the beginning of October. It was already after her last strokes, after which nobody noticed anything physically wrong with her. Only in her face did she really look like an old lady for the first time. Gone were the little curls, and her eyes looked at one wanting a confirmation that nothing had changed. She fantasized. . . . Right to the end she remained clear and fought doggedly for the life she was not about to give up gladly. When I saw her lying in the coffin, her face didn't have the usual relaxed smile of the deceased, but rather seemed to have the expression of somebody suspiciously curious, as if she were trying to figure out just where she was."[2]

On December 13, 1964—two days after Alma's death—the obsequies took place at the Frank E. Campbell Funeral Church. The brick building on the corner of Madison Avenue and East Eighty-First Street was the headquarters of the Frank E. Campbell Burial and Cremation Company, founded in 1898, a well-known New York undertaking firm. "The service at Campbell's with an open casket was mawkish," Adolf Klarmann remembered. Significantly, no picture of the deceased hung behind the coffin, but rather a painting showing her father, Emil Jakob Schindler. A sizable number of bouquets and memorial wreaths nearly filled the small room. All in all, the funeral on that Sunday afternoon promised to run a dignified course. Only the music program lent the service an embarrassing note. Adolf Klarmann wrote: "For the musically sensitive departed, Gounod's 'Ave Maria' was uninspiredly whimpered on a harmonium. The eulogy was given by Soma Morgenstern. Of the famous names who had idolized her up to the end only the conductor William Steinberg was

present.—Not even the Arlts were there. They couldn't land because of fog."[3] The critic, novelist, and playwright Soma Morgenstern, born in East Galicia in 1890, had met Alma back in the twenties through Alban Berg, but they didn't grow close until toward the end of Alma's life, decades later in New York. In his short homily, Morgenstern sketched the various phases of Alma's life, particularly remembering the marriage with Gustav Mahler and describing in intimate terms his last meeting with Alma—a few weeks before her death. "I could feel it was the last farewell. The time for mourning was near."[4]

Soon after the funeral a dispute arose between Ida "Schulli" Gebauer and Anna Mahler over how and where Alma was to be interred. While Gebauer maintained Alma had wanted the Grinzing Cemetery near Vienna as her final resting place, Anna preferred an interment in the United States "Of course, Schulli is wonderful," Anna wrote to Gusti Arlt about the disagreement, "but we know well enough that she is also insane. . . . I don't see why we should take Schulli's Vienna patriotism all that seriously."[5] When, however, Anna noticed that Friedrich Torberg, Adolf Klarmann, and Alma's friend of many years Franz Theodor Csokor all stated their preference for a burial in Vienna, she reluctantly agreed. "The body will be flown to Vienna on Pan Am at the beginning of February,"[6] Klarmann then informed Friedrich Torberg.

Alma Mahler-Werfel was buried beside her daughter Manon on Monday, February 8, 1965, at 2 p.m. "The prayers for the deceased in the Grinzing Cemetery Chapel, where the mortal remains of Alma Mahler-Werfel reposed on a catafalque, sounded more fervent than ever," wrote Hilde Spiel in the *Frankfurter Allgemeine Zeitung*. "Whoever showed up for her funeral knew her life like an open book—that book in which she unrestrainedly exposed herself, her husbands, and her children. 'Lord,' it said in the prayer, 'do not judge Thy servant harshly. May Thy judgment not cast her down, but rather grant that Thy great mercy might come to her aid and allow her to escape the avenging tribunals, as during her lifetime she was marked with the sign of the holy trinity.'"[7] After the benediction, members of the Vienna Philharmonic played a movement from a Mozart string quartet. "The funeral was attended by a number of celebrities,"[8] it said in the *Wiener Zeitung*. Although Alma had fought many a legal battle with the Austrian state over the years, she now received a fitting *pompe funèbre*. Undersecretary Dr. Ludwig Kleinwächter from the Education Ministry, the board of the Vienna Philharmonic, the architect Clemens Holzmeister, the conductor Hans Swarowsky, as well as Dr. Egon Hilbert, director of the Vienna State Opera, all came to pay their last respects. Initially Alma's friend of many years, Carl Zuckmayer, was supposed to deliver the eulogy, but he canceled

at the last minute. In December 1964, he and his wife, Alice, might have been in New York, Zuckmayer wrote to Albrecht Joseph, but had not visited Alma, "as we had heard from mutual acquaintances that she no longer recognized anybody and should be left in peace." Zuckmayer went on:

> Frankly . . . I had no desire to see her again anyway—as much as I had always valued and admired her strength, and the uniqueness of her personality. Still, for all the fun one could have with her diversity, colorfulness, talent for living, even her brash, violent nature, she has become pretty repulsive to me because of that all too uninhibited book of memoirs (which nevertheless has something gigantic about it, namely tactlessness and falsification). . . . So the news of her death may have evoked many memories in us, good ones, funny ones, nightmarish ones, but no explicit sense of bereavement. She herself used to say all the time: "A person should die while he is still sufficiently handsome that people can look at the corpse without getting disgusted"—he should not reach the point where people start complaining that he has lived beyond his time. Well—it was enough.

And further: "I'll suggest to Anna that she have old Csokor speak.—He is the grand old man of Vienna, he'll be eighty in September, president of the Austrian PEN Club, etc., and has been living, since he turned seventy-five, for the first time in his life without money troubles thanks to an honorary state pension and other fixed donations. . . . Otherwise he is unaltered, also unalterably funny (which the younger generation doesn't even notice anymore, they think we were all like that), keeps on writing plays that don't get put on but do get printed by subsidized publishers; his Eichmann drama was finished faster than the Eichmann trial. He lives in the same old dump he had before March '38."[9] Franz Theodor Csokor did in fact agree to speak and ultimately gave the official eulogy, describing Alma as an equal partner to her men, "the muse for the musician, the Bride of the Wind for the painter, the Egeria for the writer."[10]

The news of Alma Mahler-Werfel's death spread like wildfire, and all the major American and European daily papers printed obituaries in the weeks that followed. "Mrs. Mahler-Werfel recalled in her autobiography that she had always been attracted to genius. Genius also seemed to have been attracted to Mrs. Werfel,"[11] was the whimsical comment in the *New York Times*. The *Washington Post* also published a remarkable assessment: "Alma Mahler-Werfel, 85, who was married to, or, by her own admission, had love affairs with many of Europe's great men in the early 1900s, was the widow of the composer Gustav

Mahler, and was called 'the most beautiful woman in Vienna' at the turn of the century."[12]

Alma herself bore some of the responsibility for the fact that many of the obituaries presented her as a femme fatale and reduced her life to her marriages and love affairs. In the end, with the publication of two autobiographies, the tabloids had discovered Alma's life as a good story, and the protagonist advanced to the status of a cult object. "She Could Only Love Geniuses"[13] was the headline on one of the many lurid articles, while another no less audience-pleasing one stated: "Alma Werfel Has Died; a Gallery of Geniuses."[14]

When Tom Lehrer, at the time a professor of mathematics at prestigious Harvard University, who moonlighted as a satirical nightclub entertainer, read one of these "juicy, hot, racy" obituaries, he was sure that "Alma's life was the stuff that ballads are made of."[15] Lehrer's "Alma" topped the American charts for weeks on end.

The loveliest girl in Vienna
Was Alma, the smartest as well.
Once you picked her up on your antenna,
You'd never be free of her spell.

Her lovers were many and varied,
From the day she began her—beguine.
There were three famous ones that she married,
And God knows how many between.

Alma, tell us!
All modern women are jealous.
Which of your magical wands
Got you Gustav and Walter and Franz?

The first one she married was Mahler,
Whose buddies all knew him as Gustav.
And each time he saw her he'd holler:
"Ach, that is the Fräulein I moost have!"

Their marriage, however, was murder.
He'd scream to the heavens above,
"I'm writing *Das Lied von der Erde*,
And she only wants to make love!"

Alma, tell us!
All modern women are jealous.
You should have a statue in bronze
For bagging Gustav and Walter and Franz.

While married to Gus she met Gropius,
And soon she was swinging with Walter.
Gus died, and her teardrops were copious.
She cried all the way to the altar.

But he would work late at the Bauhaus,
And only come home now and then.
She said: "What am I running? A chowhouse?
It's time to change partners again."

Alma, tell us!
All modern women are jealous.
Though you didn't even use Ponds,
You got Gustav and Walter and Franz.

While married to Walt, she met Werfel,
And he too was caught in her net.
He married her, but he was carefel,
'Cause Alma was no Bernadette.

And that is the story of Alma,
Who knew how to receive and to give.
The body that reached her embalma'
Was one that had known how to live.

Alma, tell us,
How can they help being jealous?
Ducks always envy the swans
Who get Gustav and Walter,
you never did falter,
With Gustav and Walter and Franz.

On Valentine's Day 1982, a short interview with Tom Lehrer appeared under the headline "Alma Mahler" in the *Washington Post*. Sandy Rovner, the author of the article, wanted to know why the Alma song had been left out of "Tomfoolery," his latest show.

"Oh," he said, "there does seem to be an Alma cult, but for most people it would need too much explaining . . ."

So much, you might think, for Alma.

But there, lo and behold, at the base of the railroad trestle at the foot of Arizona Avenue and Canal Road, someone had spray-painted against the background of endless years of mostly unintelligible graffiti (and just in time for Valentine's Day):

"GUSTAV MAHLER ♥ ALMA"

Oh, Gustav Mahler loved her all right, but so did Walter Gropius, Franz Werfel, and, as Lehrer says: "practically all the top creative men in Central Europe." Alma Schindler Mahler Gropius Werfel was what you might call the Liz Taylor of the Bauhaus.[16]

Over the course of time, Alma became "one of the Great Lovers of the Ages"; Albrecht Joseph remembered "a super-woman in Renaissance style, a demi-goddess."[17] While Tom Lehrer—albeit with a twinkle in his eye—may have expressed doubt about this perception, the Viennese columnist Hans Weigel parodied Alma's self-stylizations and took them *ad absurdum*, even inserting Peter Kreuder, a composer of pop tunes, into his fanciful equation. Alma discovers that Kreuder wants to marry her: "I'm undecided. I have stated my condition: he must give up composing. I am very miserable. But I want clarity. Igor Stravinsky saw some sheet music at my home. He played the piece, then knelt down and begged for a kiss. It was my composition. He said: 'I've never seen anything like it.' I caressed him. Kreuder got jealous and walked out. I have a great need to protest against anyone who doesn't kneel down before me. I have to break up with Kreuder. He keeps weeping incessantly for days."[18]

What Hans Weigel parodied with the sharp pen of the satirist, namely Alma's autobiography *Mein Leben*, was for Hans Wollschläger "pompous babble, confused to the point of craziness." Annoyance spread. "This was supposed to be—as plausible as it might be in the case of Kokoschka or Werfel—the person closest to Gustav Mahler, the 'valiant companion on every step of my path'?"[19] Even Albrecht Joseph, who doubtless knew Alma well, felt embarrassed by many things in Alma's memoirs; nevertheless he stood up for the author: "She wrote the book in innocence, believing that she was telling nothing but the truth. . . . Whatever she did, said or wrote was correct in her eyes because she was the one who had lived it." For all this, she regarded herself as "the muse of the great artists without being it," as Albrecht Joseph said, summing things up: "She did, of course, not discover Mahler and was in

no position to help him. Kokoschka was well on his way to being one of the most important young painters of his period when he fell in love with her, and after their break-up he continued being a great painter. Aside from the fact that he portrayed her in a few of his canvasses, there is nothing to indicate any influence she might have had on him. Of Werfel I'll have to say more shortly, but he also was well known and famous as one of the most gifted young poets before he met Alma. Her marriage to Gropius was short-lived and I cannot imagine anyone claiming that she had any influence on the Bauhaus or Gropius' architectural style."[20]

So what remains now—fifty years after her death—of Alma Mahler-Werfel? Is it really just that "little bit of pelvis"? Was she simply "a sparkling apparition, changing colors between pink and gas-green,"[21] as Hans Wollschläger wisecracked—even a total monstrosity? No. Alma's life achievement consisted of the composition of her own legend. "That should rank as her masterwork," Soma Morgenstern recalled in his eulogy: "She was married three times. She was wed only once. Wed with her life. With her own life. This life had her style, her own value, her own dignity, her own generosity."[22] Alma was already a myth during her lifetime, a monument to herself, a surface on which her admirers and enemies alike could project love and hate, veneration and rejection, fascination and abomination. Certainly, when Alma showed her friend Friedrich Torberg her diaries, he also suspected and feared that many details of her life-drama do not stand up to a comparison with reality, even more, that many episodes do not put the heroine in a favorable light. When Alma once gave her friend her diary to read, he reacted with great embarrassment. "Alma! What am I supposed to say about this?" Torberg finally succeeded with charm and wit to extricate himself from this delicate situation. Let the final word, then, be his: "Alma, you are the best partner life ever had, and I believe it is not you who should be congratulated for this life, but rather life should be congratulated for you."[23]

ACKNOWLEDGMENTS

In my work, I have received a great deal of assistance, for which I would like to express my heartfelt thanks, especially to the staff of the archives and collections consulted. Contemporary witnesses, such as Professor Johannes Trentini, Lady Isolde Radzinowicz (widow of Adolf Klarmann), and Katharine Scherman-Rosin shared memories of Alma that allowed me to take an important look behind the scenes. I would like to thank Paulus Manker and Peter Stephan Jungk most heartily for good conversations and suggestions and for placing copies of the partially unpublished interview material at my disposal (interviews by Peter Stephan Jungk with Gottfried Bermann-Fischer, Ernst Krenek, and Anna Mahler). The following ladies and gentlemen kindly made themselves available for interviews, evaluations, and statements: Leon Askin (Vienna), Dr. Herta Haas (Hamburg), Lady Isolde Radzinowicz (Haverford, Pennsylvania), Erich Rietenauer (Vienna), Katharine Scherman-Rosin (New York), Professor Johannes B. Trentini (Innsbruck), and Alma Zsolnay (Vienna). Beyond this—for a number of different reasons—I would like to extend my profound gratitude to Ruth W. Arlt, Antony Beaumont, Dr. Karl Corino, Dr. Maria-Magdalena Cyhlar, Lübbe Gerdes, Hermann Gieselbusch, Dr. Herta Haas, Wilfried and Ilona Hilmes, Dr. Annemarie Jaeggi, Professor Eva Jaeggi, Thilo Koch, Anne König, Michael König, Dr. Hermann Köstler, Professor Henry-Louis de La Grange, Maximilian Lautenschläger, Marina Mahler, Fred K. Prieberg, Erich Rietenauer, Dr. Thomas Schinköth, Professor Guy Stern, Barbara and Stefan Weidle, Susanne Zobl, and Alma Zsolnay. Finally my deep appreciation to the critical readers of the manuscript as it came into being; my very special thanks go to Mr. Peter Franzek for his input and countless constructive and thought-provoking suggestions.

NOTES

Abbreviations used in the notes appear at the beginning of the bibliography.

PROLOGUE

1. Hans Wollschläger, "Scharf angeschlossener Kettenschmerz: Gustav Mahlers Briefe an Alma," *Frankfurter Allgemeine Zeitung*, December 5, 1995, L9.
2. Ibid.
3. Quoted in *Ein Glück ohne Ruh': Die Briefe Gustav Mahlers an Alma*, ed. Henry-Louis de La Grange and Günther Weiss (Berlin, 1997), 128.
4. Claire Goll, *Ich verzeihe keinem: Eine literarische chronique scandaleuse unserer Zeit* (Berlin, 1987), 226.
5. *Erinnerungen an Österreich, Gespräche mit österreichischen Emigranten*, a film by Rudolf Stoiber, ORF (Austrian Broadcasting), 1978.
6. Gina Kaus, *Von Wien nach Hollywood* (Frankfurt am Main, 1990), 55.
7. Elias Canetti, *Das Augenspiel: Lebensgeschichte, 1931–1937* (Frankfurt am Main, 1999), 52.
8. Goll, *Ich verzeihe keinem*, 229.
9. Ulrich Weinzierl, "Eine tolle Madame, Friedrich Torbergs Briefwechsel mit Alma Mahler-Werfel," *Frankfurter Allgemeine Zeitung*, October 6, 1987.
10. *Erinnerungen an Österreich.*
11. Interview with Marietta Torberg, video recording of unknown origin, privately owned.
12. La Grange and Weiss, *Ein Glück ohne Ruh'*, 474.
13. Brassaï, *The Artists of My Life* (New York, 1982), 73.
14. Paul Kammerer to Alma Mahler-Werfel (hereafter AMW), undated, MWC.
15. Franz Werfel to AMW, January 1918, FWC.
16. Franz Werfel to AMW, undated.
17. Ludwig Karpath to AMW, May 13, 1932, MWC.
18. Friedrich Torberg, *Die Erben der Tante Jolesch* (Munich, 1996), 244.
19. Diary entry, August 13, 1942, in Erich Maria Remarque, *Das unbekannte Werk: Briefe und Tagebücher*, vol. 5 (Cologne, 1998), 368.
20. Quoted in Peter Stephan Jungk, *Franz Werfel: Eine Lebensgeschichte* (Frankfurt am Main, 1987), 195.
21. Canetti, *Das Augenspiel*, 55.
22. Cf. From the property of Alma Mahler-Werfel and Franz Werfel, August 29, 1945,

WSA, District Court, Döbling, Absentee Guardianship Alma Mahler-Werfel. 6P 126/42, 81–135.

23. AMW, *Tagebuch*, 273–74, MWC.

24. AMW, "Der schimmernde Weg," 416, MWC.

1. CHILDHOOD AND YOUTH

1. Max Nordau, *Entartung*, vol. 1 (Berlin, 1892), 17–18.

2. Quoted in Heinrich Fuchs, *Emil Jakob Schindler* (Vienna, 1970), 20.

3. Carl Moll, "Mein Leben," 58, BB.

4. Anna Schindler to Carl Moll, undated, MWC.

5. Marie Egner, quoted in Peter Weniger and Peter Müller, *Die Schule von Plankenberg: Emil Jakob Schindler und der österreichische Stimmungsimpressionismus* (Graz, 1991), 21.

6. Moll, "Mein Leben," 65, BB.

7. AMW, "Der schimmernde Weg," 5, MWC.

8. Ibid.

9. Ibid.

10. Ibid., 6.

11. Ibid., 7.

12. Ibid.

13. Ibid., 8.

14. Cf. *Sylter Kurzeitung*, August 6 (1892).

15. Moll, "Mein Leben," 96, BB.

16. AMW, "Der schimmernde Weg," 8, MWC.

17. Ibid., 9.

18. Ibid.

19. Ibid.

20. Ibid.

21. AMW, *Tagebuch*, 34, undated, MWC.

22. Moll, "Mein Leben," 97, BB.

23. AMW, "Der schimmernde Weg," 10, MWC.

24. Cf. esp. Hansjörg Krug, "'Alma, meine Alma': Gustav Mahler und Alma Schindler," in *Klimt und die Frauen*, ed. Tobias G. Natter and Gerbert Frodl (Cologne, 2000), 38–42.

25. AMW, *Tagebuch-Suiten, 1898–1902*, ed. Antony Beaumont and Susanne Rode-Breymann (Frankfurt am Main, 1997), 74, July 6, 1898.

26. Ibid., 69, June 19, 1898.

27. Ibid., 189, February 14, 1899.

28. Ibid., 205, March 15, 1899.

29. Moll, "Mein Leben," 123, BB.

30. AMW, *Tagebuch-Suiten*, 242, April 25, 1899.

31. Ibid., 242, April 26, 1899.

32. Ibid., 243, April 27, 1899.

33. Ibid., 244, April 29, 1899.

34. Ibid., 245, May 1, 1899.

35. Ibid., 251, May 5, 1899.

36. Ibid., 250, May 4, 1899.

37. Ibid., 260ff., May 15, 1899.

38. La Grange and Weiss, *Ein Glück ohne Ruh'*, 473ff.

39. AMW, *Tagebuch-Suiten*, 262, May 15, 1899.

40. AMW, "Der schimmernde Weg," 13, MWC.

41. AMW, *Tagebuch-Suiten*, 203, March 12, 1899.

42. Ibid., 343, August 9, 1899.

43. Ibid., 366, September 6, 1899.

44. Ibid., 511, June 13, 1900.

45. Ibid., 90, August 2, 1899.

46. Ibid., 188, February 13, 1899.

47. Ibid., 188, February 14, 1899.

48. Ibid., 104, August 20, 1898.

49. Cf. Nike Wagner, *Geist und Geschlecht: Karl Kraus und die Erotik der Wiener Moderne* (Frankfur am Main, 1982), 24.

50. AMW, *Tagebuch*, 32, undated, MWC.

51. On Alma's musical career see Susanne Rode-Breymann, *Die Komponistin Alma Mahler-Werfel* (Hannover, 1999).

52. AMW, *Tagebuch-Suiten*, 149, November 23, 1898.

53. Ibid., 716, October 15, 1901.

54. Ibid., 11, February 9, 1898.

55. Ibid., 165, December 21, 1898.

56. Ibid., 539, August 7, 1900.

57. Ibid., 436, January 23, 1900.

58. Ibid., 451, February 11, 1900.

59. Ibid., 463f., February 26, 1900.

60. Ibid., 506, May 22, 1900.

61. Alexander von Zemlinsky to AMW, August 9, 1900, MWC.

62. AMW, *Tagebuch-Suiten*, 632, March 4, 1901.

63. Ibid., 569, October 18, 1900.

64. Ibid., 470, March 10, 1900.

65. Ibid., 569, October 18, 1900.

66. Ibid., 628, February 24, 1901.

67. Ibid., 654, April 10, 1901.

68. Ibid., 654, April 11, 1901.

69. Ibid., 656, April 13, 1901.

70. Ibid., 660, April 21, 1901.

71. Ibid., 667, May 4, 1901.

72. Ibid., 694, July 28, 1901.

73. Ibid., 693, July 24, 1901.

74. Ibid., 694, July 28, 1901.

75. Alexander von Zemlinsky to AMW, May 22, 1901, MWC.

76. AMW, *Tagebuch-Suiten*, 673, May 25, 1901.

77. Alexander von Zemlinsky to AMW, May 27, 1901, MWC.

78. AMW, *Tagebuch-Suiten*, 710, September 24, 1901.

79. Ibid., 713, October 7, 1901.

80. Ibid., 712, October 4, 1901.

81. Alexander von Zemlinsky to AMW, November 2, 1901, MWC.

82. Alexander von Zemlinsky to AMW, November 4, 1901, MWC.

83. Brigitte Hamann, *Hitlers Wien: Lehrjahre eines Diktators* (Munich, 2003), 410ff.

84. Cf. ibid., 417.

85. Houston Stewart Chamberlain, *Richard Wagner* (Munich, 1919), 229.

86. AMW, *Tagebuch-Suiten*, 371, September 22, 1899.

87. Ibid., 316, July 9, 1899.

88. Albrecht Joseph, "Werfel, Alma, Kokoschka, the Actor George" (taken from a typescript of Albrecht Joseph's document), 11, WMC.

89. Cf. PTT—Persönlichkeitsstörungen, Theorie und Therapie, vol. 3/2000.

90. Quoted in Sven Olaf Hoffmann and Annegret Eckhardt-Henn, "Von der Hysterie zur histrionischen Persölichkeitsstörung, ein historischer und konzeptueller Überblick," ibid., 130.

91. Karl Jaspers, *Allgemeine Psychopathologie* (Berlin, 1953), 370.

92. AMW, *Tagebuch-Suiten*, 469, March 10, 1900.

93. Interview: Peter Stephan Jungk with Anna Mahler, video recording, privately owned, no date.

94. Ibid.

95. Walter Bräutigam, "Hysterie," in *Lexikon der Psychiatrie* (Berlin, 1986), 341.

96. AMW, *Tagebuch-Suiten*, 204, March 14, 1898.

2. MAHLER

1. La Grange and Weiss, *Ein Glück ohne Ruh'*, 49ff.

2. AMW, *Tagebuch-Suiten*, 318, July 11, 1899.

3. Ibid., 723, November 7, 1901.

4. Ibid., 724, November 7, 1901.

5. AMW, *Gustav Mahler: Erinnerungen und Briefe* (Amsterdam, 1940), 24.

6. AMW, *Tagebuch-Suiten*, 725, November 8, 1901.

7. Ibid., 727, November 20, 1901.

8. Ibid., 728, November 28, 1901.

9. AMW, *Erinnerungen und Briefe*, 29.

10. Ibid., 30.

11. AMW, *Tagebuch-Suiten*, 730, December 2, 1901.

12. Ibid., 731, December 3, 1901.

13. Ibid., 730, December 1, 1901.

14. Cf. ibid., 738, December 9, 1901.

15. AMW, *Erinnerungen und Briefe*, 34.

16. AMW, *Tagebuch-Suiten*, 746ff., December 22, 1901.

17. La Grange and Weiss, *Ein Glück ohne Ruh'*, 93, December 14, 1901.

18. Ibid., 95, December 15, 1901.

19. Ibid., 85, December 13, 1901.

20. Ibid., 97, December 15, 1901.

21. Ibid., 100, December 16, 1901.

22. AMW, *Tagebuch-Suiten*, 740, December 12, 1901.

23. Ibid., 742, December 16, 1901.

24. Ibid., 732, December 3, 1901.

25. Ibid., 744ff., December 19, 1901.

26. La Grange and Weiss, *Ein Glück ohne Ruh'*, 104–111, December 19, 1901.

27. Kurt Blaukopf, *Gustav Mahler oder der Zeitgenosse der Zukunft* (Vienna, 1969), 143.

28. AMW, *Tagebuch-Suiten*, 745, December 20, 1901.

29. Ibid., 745, December 21, 1901.

30. AMW, *Erinnerungen und Briefe*, 34.

31. AMW, *Tagebuch-Suiten*, 747, December 23, 1901.

32. Ibid., 749, December 28, 1901.

33. Ibid., 751, January 1, 1902.

34. Ibid.

35. Ibid., 751, January 3, 1902.

36. Ibid., 751, January 4, 1902.

37. Ibid., 751, January 5, 1902.

38. AMW, *Erinnerungen und Briefe*, 38.

39. Ibid., 39.

40. La Grange and Weiss, *Ein Glück ohne Ruh'*, 120.

41. Quoted ibid., 133.

42. AMW, *Erinnerungen und Briefe*, 58.

43. Ibid.

44. AMW, *Tagebuch*, 2, July 10, 1902, MWC.

45. Ibid., 3f., July 13, 1902.

46. Ibid., 4, August 10, 1902.

47. AMW, *Erinnerungen und Briefe*, 65f.

48. AMW, *Tagebuch*, 5, November 25, 1902, MWC.

49. Ibid., 5, December 15, 1902.

50. Ibid., 6, January 8, 1903.

51. Ibid., 7f., January 20, 1903.

52. AMW, *Erinnerungen und Briefe*, 85.

53. Ibid., 59.

54. AMW, *Tagebuch*, 6, December 16, 1902, MWC.

55. Cf. AMW, *Erinnerungen und Briefe*, 49.

56. Cf. Jens Malte Fischer, *Gustav Mahler: Der fremde Vertraute* (Vienna, 2003), 539f.

57. AMW, *Tagebuch*, 9, June 15, 1903, MWC.

58. AMW, *Erinnerungen und Briefe*, 78.

59. AMW, *Tagebuch*, 9, February 25, 1904, MWC.

60. Alexander von Zemlinsky to AMW, undated [spring 1904], MWC.

61. Alexander von Zemlinsky to AMW, undated [early March 1905], MWC.

62. Alexander von Zemlinsky to AMW, undated [ca. 1906]. MWC.

63. AMW, *Tagebuch*, 10, September 10, 1904, MWC.

64. Ibid., 11f., January 5, 1905.

65. Ibid., 16, July 6, 1905.

66. Ibid., 168, June 4, 1920.

67. Ibid., 15, January 23, 1905.

68. Interview: Peter Stephan Jungk with Anna Mahler, MKB.

69. AMW, *Erinnerungen und Briefe*, 135.

70. Cf. Fischer, *Gustav Mahler*, 653.

71. *Ein Glück ohne Ruh'*, 313, January 17, 1907.

72. AMW, *Erinnerungen und Briefe*, 148f.

73. The precise background for Mahler's resignation from the Vienna Opera was described in thoroughgoing detail by Jens Malte Fischer; cf. Fischer, *Gustav Mahler*, 644f.

74. Cf. ibid., 658f.

75. La Grange and Weiss, *Ein Glück ohne Ruh'*, 323.

76. AMW, *Erinnerungen und Briefe*, 153f.

77. Ibid., 155.

78. Ibid.

79. Quoted in *Ein Gluck ohne Ruh'*, 323.

80. AMW, *Tagebuch*, 171, July 27, 1920, MWC.

81. AMW, *Erinnerungen und Briefe*, 163.

82. Ibid., 160.

83. Cf. Fischer, *Gustav Mahler*, 689.

84. AMW, *Erinnerungen und Briefe*, 164.

85. Ibid., 173.

86. AMW to Margarete Hauptmann, February 15, 1908, MWC.

87. AMW, *Erinnerungen und Briefe*, 187.

88. Ibid., 191.

89. Herta Blaukopf, ed., *Gustav Mahler: Briefe* (Vienna, 1996), 381.

90. AMW, *Erinnerungen und Briefe*, 191.

91. Ibid., 191f.

92. Blaukopf, *Gustav Mahler: Briefe*, 398ff.

93. AMW, *Erinnerungen und Briefe*, 193.

94. Blaukopf, *Gustav Mahler: Briefe*, 395ff.

95. AMW, *Erinnerungen und Briefe*, 215.

96. Ibid.

97. Cf. Reginald Isaacs, *Walter Gropius: Der Mensch und sein Werk*, vol. 1 (Frankfurt am Main, 1985), 98ff.

98. La Grange and Weiss, *Ein Glück ohne Ruh'*, 432, June 21, 1910.

99. Ibid., 434, June 25, 1910.

100. Blaukopf, *Gustav Mahler: Briefe*, 410.

101. Ibid., 407.

102. AMW, *Erinnerungen und Briefe*, 215.

103. AMW to Walter Gropius, Sunday [July 31, 1910], BHA.

104. AMW, *Erinnerungen und Briefe*, 216.

105. AMW to Walter Gropius, undated, BHA.

106. Cf. Walter Gropius to AMW, draft of a letter, Wednesday [August 3, 1910]. BHA.

107. AMW, *Erinnerungen und Briefe*, 218.

108. AMW to Walter Gropius, undated, BHA.

109. AMW to Walter Gropius, Thursday [August 11, 1910], BHA.

110. Anna Moll to Walter Gropius, undated [summer 1910], BHA.

111. Anna Moll to Walter Gropius, August 18, 1910, BHA.

112. AMW, *Tagebuch*, 171, July 27, 1920, MWC.

113. Cf. Jörg Rothkamm, "Wer komponierte die unter Alma Mahlers Namen veröffentlichten Lieder? Unbekannte Briefe der Komponistin zur Revision ihrer Werke im Jahre 1910," *Die Musikforschung*, April 2000 issue, 432–445.

114. Cf. AMW, *Erinnerungen und Briefe*, 216.

115. AMW to Walter Gropius, undated [presumably mid-August 1910], BHA.

116. Cf. Jörg Rothkamm, *Gustav Mahlers Zehnte Symphonie: Entstehung, Analyse, Rezeption* (Frankfurt am Main, 2003).

117. La Grange and Weiss, *Ein Glück ohne Ruh'*, 446, August 1910.

118. Ibid., 449, August 17, 1910.

119. AMW to Walter Gropius, undated, BHA.

120. AMW to Walter Gropius, Wednesday [August 23, 1910], BHA.

121. Quoted in Theodor Reik, *Dreissig Jahre mit Sigmund Freud* (Munich, 1976), 115.

122. AMW, *Erinnerungen und Briefe*, 219.

123. La Grange and Weiss, *Ein Glück ohne Ruh'*, 451, August 27, 1910.

124. AMW, *Erinnerungen und Briefe*, 223.

125. Anna Moll to Walter Gropius, undated [summer 1910], BHA.

126. Interview: Peter Stephan Jungk with Anna Mahler, video recording, privately owned.

127. AMW to Walter Gropius, September 19, 1910, quoted in Isaacs, *Walter Gropius*, 1:103.

128. Interview: Peter Stephan Jungk with Anna Mahler, video recording, privately owned.

129. AMW to Walter Gropius, undated (postmarked October 12, 1910), BHA.

130. AMW to Walter Gropius, October 27, 1910, quoted in Isaacs, *Walter Gropius*, 1:104.

131. Anna Moll to Walter Gropius, undated [presumably November 13, 1910], BHA.

132. Blaukopf, *Gustav Mahler: Briefe*, 423.

133. AMW, *Erinnerungen und Briefe*, 232.

134. Quoted in Anton Neumayr, *Musik und Medizin* (Vienna, 1991), 228.

135. AMW to Walter Gropius, March 25, 1911, BHA.

136. AMW, *Erinnerungen und Briefe*, 243.

137. Ibid., 245.

138. Cf. Moll, "Mein Leben," 173, BB.

3. EXCESSES

1. AMW, "Der schimmernde Weg," 41, MWC.

2. Ibid.

3. Communication from Professor Guy Stern to the author, February 26, 2001.

4. Walter Gropius to AMW, undated, quoted in Isaacs, *Walter Gropius*, 1:112.

5. Walter Gropius to AMW, September 18, 1911; cf. ibid., 113.

6. AMW, "Der schimmernde Weg," 42, MWC.

7. Ibid.

8. Ibid., 39.

9. On Kammerer's biography: Arthur Koestler, *Der Krötenküsser: Der Fall des Biologen Paul Kammerer* (Reinbek, 1974).

10. AMW, "Der schimmernde Weg," 44, MWC.

11. Paul Kammerer to AMW, October 31, 1911.

12. AMW, "Der schimmernde Weg," 45f., MWC.

13. Ibid.

14. Ibid., 46.

15. Ibid., 45.

16. Medical record, Margarethe Legler, SAF.

17. Communication from the Pirna-Sonnenstein memorial site to the author, April 2003.

18. Expert opinion: June 30, 1912, medical record, Margarethe Legler, SAE.

19. Carl Moll, "Mein Leben," 141, BB.

20. Wilhelm Legler to Privy Councilor Schüle, March 10, 1912, in medical record Margarethe Legler, SAF.

21. AMW, *Tagebuch*, 243, August 31, 1930, MWC.

22. Ibid., 243f.

23. On Kokoschka's biography see Heinz Spielmann, *Oskar Kokoschka: Leben und Werk* (Cologne, 2003).

24. AMW, "Der schimmernde Weg," 51, MWC.

25. Brassaï, *Artists of My Life*, 73.

26. AMW, "Der schimmernde Weg," 48, MWC.

27. Oskar Kokoschka to AMW, April 15, 1912, quoted in Oskar Kokoschka, *Briefe*, vol. 1, *1905–1919* (Düsseldorf, 1984), 29f.

28. Oskar Kokoschka to AMW, May 8, 1913, quoted ibid., 107.

29. Oskar Kokoschka to AMW, undated [late May 1913], quoted ibid., 113.

30. AMW, "Der schimmernde Weg," 50, MWC.

31. Oskar Kokoschka to AMW, May 7, 1912, Kokoschka, *Briefe*, 1:37.

32. AMW, "Der schimmernde Weg," 53, MWC.

33. Oskar Kokoschka to AMW, undated [May 1912], quoted in Kokoschka, *Briefe*, 1:41.

34. Oskar Kokoschka to AMW, undated [June, 1912], quoted ibid., 42.

35. AMW, "Der schimmernde Weg," 58, MWC.

36. Oskar Kokoschka to AMW, July 9, 1912, quoted in Kokoschka, *Briefe*, 1:44.

37. La Grange and Weiss, *Ein Glück ohne Ruh'*, 440, July 9, 1910.

38. Cf. Michel König, "Ein Harmonium für Arnold Schönberg," *Arbeitskreis Harmonium der GdO*, issue 2 (November 2000): 8–22.

39. Cf. WSA, District Civil Court, 48 T 163/47.

40. AMW, "Der schimmernde Weg," 54, MWC.

41. AMW, *Tagebuch*, 168f., June 4, 1920, MWC.

42. Oskar Kokoschka to AMW, May 14, 1913, quoted in Kokoschka, *Briefe*, 1:100.

43. Oskar Kokoschka, *Mein Leben* (Munich, 1971), 34.

44. Oskar Kokoschka to AMW, undated [autumn 1913], MWC.

45. Oskar Kokoschka to AMW, July 25, 1912, quoted in Kokoschka, *Briefe*, 1:59.

46. Quoted in Alfred Weidinger, *Kokoschka und Alma Mahler: Dokumente einer leidenschaftlichen Begegnung* (Munich, 1996), 10.

47. Kokoschka, *Mein Leben*, 132.

48. Oskar Kokoschka to AMW, July 20, 1912, quoted in Kokoschka, *Briefe*, 1:53.

49. Oskar Kokoschka to AMW, July 27, 1912, quoted ibid., 59.

50. AMW, "Der schimmernde Weg," 55, MWC.

51. AMW, 1913, Aus der Zeit meiner Liebe zu Oskar Kokoschka und der seinen zu mir, 43f., ZBZ.

52. Ibid., 44f.

53. Ibid., 20f.

54. Ibid., 46f.

55. Kokoschka, *Mein Leben*, 132.

56. Oskar Kokoschka to AMW, undated [December 1912], quoted in Kokoschka, *Briefe*, 1:67.

57. Oskar Kokoschka to AMW, October 1, 1912, MWC.

58. AMW, "Der schimmernde Weg," 51, MWC.

59. Cf. Catalog der Berliner Secession, no. 26, Berlin 1913.

60. Oskar Kokoschka to AMW, undated [March 1913], cf. Kokoschka, *Briefe*, 1:102.

61. AMW, "Der schimmernde Weg," 56, MWC.

62. AMW to Walter Gropius, July 26, 1913, BHA.

63. AMW, "Der schimmernde Weg," 56, MWC.

64. Oskar Kokoschka to AMW, undated [July 1913], cf. Kokoschka, *Briefe*, 1:128.

65. Oskar Kokoschka to AMW, July 1913, quoted ibid., 127.

66. Oskar Kokoschka to AMW, undated [July 1913], MWC.

67. Oskar Kokoschka to AMW, August 21, 1913, cf. Kokoschka, *Briefe*, 1:135.

68. AMW, "Der schimmernde Weg," 71, MWC.

69. Ernst Krenek, *Im Atem der Zeit: Erinnerungen an die Moderne* (Munich, 1999), 413.

70. AMW, "Der schimmernde Weg," 71, MWC.

71. Cf. Kokoschka, *Mein Leben*, 135.

72. Oskar Kokoschka to AMW, undated [March 6, 1914], quoted in Kokoschka, *Briefe*, 1:144.

73. Oskar Kokoschka to AMW, May 10, 1914, quoted ibid., 159f.

74. AMW, *Tagebuch*, 45, May 17, 1914, MWC.

75. AMW to Walter Gropius, May 6, 1914, quoted in Isaacs, *Walter Gropius*, 1:115.

76. Oskar Kokoschka to AMW, undated [1914], MWC.

77. AMW, *Tagebuch*, 50, July 1914, MWC.

78. Ibid.

79. Oskar Kokoschka to AMW, August 1, 1914, quoted in Kokoschka, *Briefe*, 1:178.

80. AMW, *Tagebuch*, 51f., undated [August 1914], MWC.

81. Oskar Kokoschka to AMW, September 24, 1914, quoted in Kokoschka, *Briefe*, 1:180.

82. AMW, *Tagebuch*, 52, September 1914, MWC.

83. AMW to Walter Gropius, September 4, 1914, quoted in Isaacs, *Walter Gropius*, 1:140.

84. AMW, *Tagebuch*, 55, November 12, 1914, MWC.

85. Ibid., 54, October 6, 1914.

86. Ibid., 54, October 6, 1914.

87. Ibid., 54, late October 1914.

88. Ibid., 57, November 17, 1914.

89. Ibid., 58, undated [November/December 1914].

4. MARRIAGE AT A DISTANCE

1. Kokoschka, *Mein Leben*, 144.

2. Anna Mahler, quoted in Jungk, *Franz Werfel*, 106.

3. Oskar Kokoschka to AMW, December 5, 1914, quoted in Kokoschka, *Briefe*, 1:185.

4. Kokoschka, *Mein Leben*, 145.

5. Oskar Kokoschka to AMW, January 2, 1915, quoted in Kokoschka, *Briefe*, 1:188.

6. AMW to Walter Gropius, December 31, 1914, quoted in Isaacs, *Walter Gropius*, 1:140.

7. Oskar Kokoschka to AMW, January 7, 1915, MWC.

8. Cf. Oskar Kokoschka to AMW, undated [first half of February 1915], quoted in Kokoschka, *Briefe*, 1:200.

9. Oskar Kokoschka to AMW, undated [late January 1915], quoted ibid., 196.

10. Oskar Kokoschka to AMW, undated [ca. April 1, 1915], quoted ibid., 216.

11. AMW, *Tagebuch*, 62–64, February 22, 1915, MWC.

12. Ibid., 63, February 22, 1915.

13. Ibid., 67f., March 5, 1915.

14. AMW to Walter Gropius, undated [February/March 1915], BHA.

15. Paul Kammerer to AMW, March 20, 1915.

16. AMW, *Tagebuch*, 69, late March 1915, MWC.

17. Ibid., 71f., April 1, 1915.

18. Ibid., 73, April 6, 1915.

19. Ibid., 74, April 8, 1915.

20. Ibid., 75, April 9, 1915.

21. Peter Altenberg, *Fechsung* (Berlin, 1915), 231f.

22. Cf. Paul Kammerer to AMW, March 24, 1915, MWC.

23. AMW to Oskar Kokoschka, April 17, 1915, quoted in Weidinger, *Kokoschka und Alma Mahler*, 82.

24. Oskar Kokoschka to AMW, [April] 24, 1915, MWC.

25. AMW, *Tagebuch*, 76, June 8, 1915, MWC.

26. Interview, Peter Stephan Jungk with Alma Mahler video recording, privately owned.

27. AMW to Walter Gropius, undated [June 1915], quoted in Isaacs, *Walter Gropius*, 1:142.

28. AMW, *Tagebuch*, 76f., June 18, 1915, MWC.

29. AMW to Walter Gropius, undated [May/June 1915], quoted in Isaacs, *Walter Gropius*, 1:142.

30. AMW to Walter Gropius, undated, BHA.

31. Cf. Registry Office, Berlin-Mitte, marriage certificate, no. 411/1915.

32. AMW, *Tagebuch*, 80, August 19, 1915, MWC.

33. Adolf Loos to Herwarth Walden, October 18, 1915, quoted in Weidinger, *Kokoschka und Alma Mahler*, 86.

34. Kokoschka, *Mein Leben*, 130.

35. Ibid., 131.

36. AMW to Walter Gropius, undated, BHA.

37. AMW, *Tagebuch*, 80, September 26, 1915, MWC.

38. AMW to Walter Gropius, undated, BHA.

39. AMW to Walter Gropius. undated [probably late September 1915], quoted in Isaacs, *Walter Gropius*, 1:156f.

40. AMW to Walter Gropius, undated, BHA.

41. Ibid.

42. Ibid.

43. Ibid.

44. Ibid.

45. Ibid.

46. Ibid.

47. AMW to Margarete Hauptmann, undated [postmark February 9, 1916], SBB.

48. AMW, *Tagebuch*, 86, February 10, 1916, MWC.

49. Ibid., 86, March 4, 1916.

50. Ibid., 87, June 11, 1916.

51. AMW to Walter Gropius, undated, quoted in Isaacs, *Walter Gropius*, 1:160f.

52. AMW to Walter Gropius, undated, quoted ibid., 163.

53. AMW, *Tagebuch*, 87, September 19, 1916, MWC.

54. Ibid., 88, undated [winter 1916/17].

55. Walter Gropius to Manon Gropius, undated, quoted in Isaacs *Walter Gropius*, 1:170.

56. AMW to Manon Gropius, New Year's Eve 1916, quoted ibid., 170.

57. Cf. AMW to Margarete Hauptmann, November 13, 1916, SBB.

58. AMW, *Tagebuch*, 88, undated [winter 1916/17], MWC.

59. AMW to Walter Gropius, undated [probably spring/summer 1917], BHA.

60. Ibid.

61. Ibid.

62. AMW, *Tagebuch*, 96, undated [October 1917], MWC.

63. Ibid., 97, November 1917.

5. LOVE-HATE

1. On Werfel's biography see Jungk, *Franz Werfel.*

2. AMW, *Tagebuch*, 98f. November 1917, MWC.

3. Interview: Peter Stephan Jungk with Anna Mahler, video recording, privately owned.

4. AMW, *Tagebuch*, 105, undated [December 1917], MWC.

5. AMW to Walter Gropius, undated, quoted in Isaacs, *Walter Gropius*, 1:175.

6. AMW, *Tagebuch*, 107, undated, MWC.

7. Ibid., 109, January 1, 1918.

8. Ibid., 109, January 5, 1918.

9. Cf. Jungk, *Franz Werfel*, 87.

10. AMW, *Tagebuch*, 119, undated, MWC.

11. Secret diary, quoted in Franz Werfel, *Zwischen Oben und Unten* (Munich, 1975), 634.

12. AMW, *Tagebuch*, 120, undated, MWC.

13. Ibid.

14. Franz Werfel to AMW, August 2, 1918, FWC.

15. AMW to Franz Werfel, undated, MWC.

16. Ibid.

17. Ibid.

18. Franz Werfel to AMW, undated, FWC.

19. AMW, *Tagebuch*, 114, October 24, 1918, MWC.

20. Ibid., 113f., October 26, 1918.

21. Ibid., 117, undated.

22. Ibid., 135, February 1, 1919.

23. Ibid., 136, February 14, 1919.

24. Milan Dubrovic, quoted in Jungk, *Franz Werfel*, 142.

25. AMW, *Tagebuch*, 136, February 14, 1919, MWC.

26. Ibid., 139, March 15, 1919.

27. Ibid., 142, April 5, 1919.

28. Ibid., 138a, March 23, 1919.

29. Ibid., 141, March 27, 1919.

30. Oskar Kokoschka to Hermine Moos, August 20, 1918, quoted in Kokoschka, *Briefe*, 1:293.

31. Oskar Kokoschka to Hermine Moos, April 6, 1919, quoted ibid., 312.

32. Kokoschka, *Mein Leben*, 191.

33. Ibid., 192.

34. AMW, *Tagebuch*, 144, May 1, 1919, MWC.

35. Franz Werfel to AMW, undated [mid-May 1919], FWC.

36. AMW, *Tagebuch*, 146, July 3, 1919, MWC.

37. Ibid., 147, July 27, 1919.

38. AMW to Walter Gropius, undated, BHA.

39. AMW, *Tagebuch*, 149, September 15, 1919, MWC.

40. Ibid., 149, June 16, 1919.

41. Ibid., 154, November 11, 1919.

42. Ibid., 168, June 4, 1920.

43. Ibid., 160, March 5, 1920.

44. Ibid., 161, March 6, 1920.

45. Franz Werfel to AMW, undated [mid-March 1920], FWC.

46. Franz Werfel to AMW, undated [March 1920], FWC.

47. Cf. Jungk, *Franz Werfel*, 124.

48. AMW to Walter Gropius, undated [late March 1920], BHA.

49. AMW, *Tagebuch*, 167, May 13, 1920, MWC.

50. Ibid., 168, June 4, 1920.

51. Cf. Isaacs, *Walter Gropius*, 1:248.

52. Franz Werfel to AMW, undated, FWC.

53. Ibid.

54. AMW, *Tagebuch*, 180, February 21, 1922, MWC.

55. Ibid., 173, undated [July 1920].

56. Krenek, *Im Atem der Zeit*, 393.

57. Interview: Peter Stephan Jungk with Anna Mahler, video recording, privately owned.

58. Ernst Krenek to Ernst Josef Krenek, undated [February 28, 1922], WSB, Ernst Krenek Collection.

59. Krenek, *Im Atem der Zeit*, 379.

60. AMW, *Tagebuch*, 182, undated, MWC.

61. Krenek, *Im Atem der Zeit*, 394ff.

62. Ibid., 395.

63. Ibid. 420.

64. Ibid., 430.

65. Ibid., 423.

66. Ibid., 396.

67. Ibid., 432.

68. Ibid., 432.

69. Regional Civil Court, Divorce decree, August 28, 1926, WSA, XXIII/722/25.

70. Krenek, *Im Atem der Zeit*, 394.

71. Cf. Jungk, *Franz Werfel*, 141.

72. Franz Werfel to AMW, undated, FWC.

73. AMW, *Tagebuch*, 185, March 23, 1923, MWC.

74. Ibid., 186, April 1923.

75. Wassily Kandinsky to Arnold Schönberg, April 15, 1923, quoted in *Wassily Kandinsky und Arnold Schönberg: Der Briefwechsel*, ed. Jelena Hahl-Koch (Stuttgart, 1993), 70.

76. Arnold Schönberg to Wassily Kandinsky, April 19, 1923, quoted ibid., 80.

77. Wassily Kandinsky to Arnold Schönberg, April 24, 1923, quoted ibid., 81.

78. Nina Kandinsky, *Kandinsky und ich* (Munich, 1976), 193.

79. Ibid., 192.

80. Arnold Schönberg to AMW, May 11, 1923, MWC.

81. AMW, *Tagebuch*, 186, September 21, 1923, MWC.

82. Cf. Fritz Blaich, *Der schwarze Freitag: Inflation und Wirtschaftskrise* (Munich, 1990), 29ff.

83. Krenek, *Im Atem der Zeit*, 414.

84. Interview: Peter Stephan Jungk with Anna Mahler, video recording, privately owned.

85. AMW to Emil Hertzka, undated [ca. 1919], WSBM, Universal Edition Collection.

86. Krenek, *Im Atem der Zeit*, 456.

87. Ibid., 457.

88. Ibid.

89. Ibid., 458.

90. Cf. Jungk, *Franz Werfel*, 145ff.

91. Krenek, *Im Atem der Zeit*, 414.

92. Cf. Murray G. Hall, *Der Paul Zsolnay Verlag: Von der Gründung bis zur Rückkehr aus dem Exil* (Tübingen, 1994).

93. Cf. Author's contract, AMW, January 15, 1925, PZV.

94. Krenek, *Im Atem der Zeit*, 459.

95. AMW, *Tagebuch*, 188, January 22, 1924, MWC.

96. Cf. Hall, *Der Paul Zsolnay Verlag*, 44.

97. Cf. Rothkamm, *Gustav Mahlers zehnte Symphonie*, 207ff.

98. AMW to Willem Mengelberg, October 7, 1923, quoted in Robert Becqué, "Die Korrespondenz zwischen Alma Mahler und Willem Mengelberg über die niederländische Erstaufführung von zwei Sätzen der zehnten Symphonie," in *Fragment or Completion? Proceedings of the Mahler X Symposium*, ed. Paul Op de Coul (Utrecht, 1986), 221.

99. AMW, *Tagebuch*, 190f., August 2, 1924, MWC.

100. Ibid., 193, undated.

101. Cf. Rothkamm, *Gustav Mahlers zehnte Symphonie*, 212.

102. Ernst Decsey, "Mahlers Zehnte und *Die Fledermaus*," *Neues 8-Uhr Blatt*, October 13, 1924.

103. AMW, *Tagebuch*, 193, November 9, 1925, MWC.

104. Werfel documented this trip in his diary; cf. Egyptian Diary, quoted in Werfel, *Zwischen Oben und Unten*, 705–742.

105. Ibid., 739.

106. AMW, *Tagebuch*, 193, November 9, 1925, MWC.

107. Cf. Jungk, *Franz Werfel*, 164.

108. Cf. Verlag Ullstein to Franz Werfel, January 5, 1925, FWC.

109. Cf. Jungk, *Franz Werfel*, 166.

110. AMW, "Der schimmernde Weg," 298, MWC.

111. Cf. Jungk, *Franz Werfel*, 166.

112. Cf. Hall, *Der Paul Zsolnay Verlag*, 485ff.

113. Anna Mahler, quoted in Jungk, *Franz Werfel*, 107.

114. Ibid., 245.

115. Krenek, *Im Atem der Zeit*, 414.

116. Hans Mayer, quoted in Jungk, *Franz Werfel*, 173.

117. Milan Dubrovic, quoted in Jungk, *Franz Werfel*, 143f.

118. AMW, *Tagebuch*, 194, July 14, 1926, MWC.

119. Interview: Peter Stephan Jungk with Anna Mahler, video recording, privately owned.

120. AMW, *Tagebuch*, 196. July 15, 1927, MWC.

121. Ibid., 197, July 15, 1927.

122. Ibid., 205, October 6, 1927.

123. Ibid., 206, October 13, 1927.

124. Ibid., 208, December 25, 1927.

125. Ibid. 211, January 4, 1928.

126. Ibid., 217, February 8, 1928.

127. Ibid., 222. April 2, 1928.

128. Ibid., 224, undated [April 1928].

129. Ibid., 227, August 3, 1928.

130. Ibid., 228, August 25, 1928.

131. Ibid., 228, October 7, 1928.

132. Ibid., 230, March 4, 1929.

133. Ibid.

134. Bulletin from the Jewish Community, Vienna, Rz. 258/1929.

135. AMW, *Tagebuch*, 231f., July 5, 1929, MWC.

136. Ibid., 237, August 14, 1929.

137. Ibid., 237, August 15, 1929.

138. Ibid., 233, July 19, 1929.

139. Ibid., 239, August 24, 1929.

140. Cf. Hall, *Der Paul Zsolnay Verlag*, 488.

141. Felix Costa to AMW, August 3, 1929, MWC.

142. Paul von Zsolnay to August von Kral, January 17, 1930, PZV.

143. AMW, "Der schimmernde Weg," 373, MWC.

144. Paul von Zsolnay to August von Kral, January 17, 1930, PZV.

145. AMW, "Der schimmernde Weg," 368, MWC.

146. Ibid.

147. AMW, *Tagebuch*, 242, August 8, 1930, MWC.

148. Ibid., 242f., August 19, 1930.

149. Ibid., 243, August 31, 1930.

150. Interview by the author with Johannes Trentini.

151. AMW, *Tagebuch*, 247f., November 28, 1930, MWC.

6. RADICALIZATION

1. On the architecture of the Villa Ast see Eduard Franz Sekler, *Josef Hofmann: Das architektonische Werk* (Salzburg, 1982), 134ff. and 332ff.

2. Cf. Jungk, *Franz Werfel*, 196.

3. AMW, *Tagebuch*, 257, March 29, 1931, MWC.

4. Ibid.

5. Interview by the author with Johannes Trentini.

6. AMW, *Tagebuch*, 259, May 26, 1931, MWC.

7. Ibid., 262, September 24, 1931.

8. Cf. Hall, *Der Paul Zsolnay Verlag*, 488.

9. AMW, *Tagebuch*, 263, December 1931, MWC.

10. Ibid.

11. Cf. Hall, *Der Paul Zsolnay Verlag*, 327f.

12. AMW, *Tagebuch*, 263, December 1931, MWC.

13. Ibid., 264a, March 20, 1932.

14. Interview by the author with Johannes Trentini.

15. AMW, *Tagebuch*, 264a, March 20, 1932, MWC.

16. Quoted in Emmerich Tálos and Wolfgang Neugebauer, eds., *Austrofaschismus: Beiträge über Politik, Ökonomie und Kultur, 1934–1938* (Vienna, 1984), 57.

17. Quoted in Klaus Berchtold, *Österreichische Parteiprogramme 1868–1966* (Munich, 1967), 427.

18. AMW, *Tagebuch*, 265, May 31, 1932, MWC.

19. Ibid., 267f., July 1932.

20. Ibid., 266, July 21, 1932.

21. Ibid., 266f.

22. Ibid., 267, August 6, 1932.

23. Ibid., 268, September 23, 1932.

24. Quoted in Jungk, *Franz Werfel*, 154.

25. AMW, *Tagebuch*, 271, October 15, 1932. MWC.

26. Ibid., 270, October 12, 1932.

27. AMW to Margarete Hauptmann, undated, SBB.

28. AMW to Gerhart Hauptmann, undated, SBB.

29. AMW, *Tagebuch*, 272, December 16, 1932, MWC.

30. Ibid., 273, December 16, 1932.

31. Ibid.

32. Ibid.

33. Ibid., 273b, December 16, 1932.

34. Ibid., 284, undated.

35. Klaus Mann, *Der Wendepunkt, Ein Lebensbericht* (Munich, 1989), 370.

36. AMW, *Tagebuch*, 275, February 5, 1933, MWC.

37. On Hollnsteiner's biography see Friedrich Buchmayr, *Der Priester in Almas Salon: Johannes Hollnsteiners Weg von der Elite des Ständestaates zum NS-Bibliothekar* (Weitra, Austria, 2003).

38. Interview by the author with Johannes Trentini.

39. Ibid.

40. This comes, for example, from Alma's "pocket date book" for the year 1933.

41. Interview, Peter Stephan Jungk with Anna Mahler, video recording, privately owned.

42. Interview by the author with Johannes Trentini.

43. AMW, *Tagebuch*, 278, March 5, 1933, MWC.

44. Ibid., 277, undated.

45. Quoted in Inge Jens, *Dichter zwischen rechts und links* (Leipzig, 1994), 240f.

46. Ibid., 244.

47. Cf. Lore B. Foltin, *Franz Werfel* (Stuttgart, 1972), 75.

48. Jens, *Dichter zwischen rechts und links*, 255.

49. AMW, *Tagebuch*, 280, May 2, 1933, MWC.

50. Ibid., 281, June 25, 1933.

51. Canetti, *Das Augenspiel*, 52.

52. Ibid., 53.

53. Ibid., 54.

54. Ibid., 56.

55. Ibid., 54.

56. Ibid., 56.

57. AMW, *Tagebuch*, 278, March 5, 1933, MWC.

58. Ibid., 283, July 24, 1933.

59. Ibid.

60. Franz Werfel to AMW, undated, FWC.

61. Ibid.

62. AMW, *Tagebuch*, 286, October 10, 1933, MWC.

63. Interview by the author with Johannes Trentini.

64. AMW, *Tagebuch*, 286, October 22, 1933, MWC.

65. AMW, "Der schimmernde Weg," 433, MWC.

66. AMW to Anton Rintelen, undated, ÖSA, Anton Rintelen Estate.

67. AMW to Walter Gropius, undated, BHA.

68. AMW, *Tagebuch*, 287, November 16, 1933, MWC.

69. Ibid., 288, December 24, 1933.

70. Ibid., 289, February 1934.

71. Cf. Hilde Spiel, *Glanz und Untergang: Wien, 1866–1938* (Munich, 1987), 220.

72. AMW to Anton Rintelen, February 23, 1933, ÖSA, Anton Rintelen Estate.

73. AMW, *Tagebuch*, 290f., March 28, 1934, MWC.

74. AMW, "Der schimmernde Weg," 439, undated, MWC.

75. AMW, *Tagebuch*, 293, undated, MWC.

76. Ibid., 294, undated.

77. AMW to Anton Rintelen, undated, ÖSA, Anton Rintelen Estate.

78. Ibid.

79. Manon Gropius to Walter Gropius, undated, BHA.

80. AMW to Anton Rintelen, undated (Thursday), ÖSA, Anton Rintelen Estate.

81. Manon Gropius to Walter Gropius, August 10, 1934, BHA.

82. Message from Katharine Scherman-Rosin to the author, February 8, 2001.

83. Interview by the author with Johannes Trentini.

84. Canetti, *Das Augenspiel*, 187.

85. Ibid.

86. Ibid., 188.

87. AMW, *Tagebuch*, 291f., March 9, 1935, MWC.

88. Cf. Coroner's report, Manon Gropius, WSA.

89. AMW, *Tagebuch*, 292, undated, MWC.

90. Johannes Hollnsteiner to Walter Gropius, April 25, 1935, BHA.

91. Ibid.

92. Reginald R. Isaacs, *Walter Gropius: Der Mensch und sein Werk*, vol. 1 (Frankfurt am Main), 1986, 740.

93. "Eine Tochter Alma Maher-Werfels gestorben," *Neue Freie Presse*, evening edition, April 23, 1935.

94. "Manon Gropius-Werfel gestorben," *Neues Wiener Journal*, April 24, 1935, 9.

95. Interview by the author with Johannes Trentini.

96. Canetti, *Das Augenspiel*, 189.

97. Ibid., 190.

98. Interview by the author with Erich Rietenauer.

99. Albrecht Joseph, quoted in "Baptism by Desire," *New York Times*, April 29, 1990, BR 15.

100. Johannes Hollnsteiner, eulogy for "Mutzi," MWC.

101. Bruno Walter to AMW, April 22, 1935, MWC.

102. Bruno Walter, *Thema und Variationen: Erinnerungen und Gedanken* (Frankfurt am Main, 1960), 411.

103. AMW, "Der schimmernde Weg," 442, undated, MWC.

104. Ludwig Karpath, "Manon Gropius: Ein Wort des Gedenkens," *Wiener Sonn- und Montagszeitung*, April 29, 1935, 9.

105. Interview by the author with Johannes Trentini.

106. AMW, *Tagebuch*, 296, July 31, 1935, MWC.

107. Goll, *Ich verzeihe keinem*, 228.

108. AMW, "Der schimmernde Weg," 444, March 1935, MWC.

109. Franz Werfel, "Die Harmonie des österreichischen Wesens," *Wiener Sonn- und Montags-Zeitung*, August 6, 1934, 7.

110. Wilhelm Stefan [Willi Schlamm], "Franz Werfel oder Die nächste Bücherverbrennung," *Europäische Hefte, vereinigt mit Aufruf*, September 27, 1934, 358.

111. AMW, *Tagebuch*, 294, undated, MWC.

112. Peter Stephan Jungk, "Fragmente, Momente, Minuten: Ein Besuch bei Elias Canetti," *Neue Rundschau*, January 1995, 97.

113. Franz Werfel, "Herma von Schuschnigg," *Wiener Sonn- und Montags-Zeitung*, July 15, 1935, 1.

114. *Arbeiterzeitung*, July 21, 1935, quoted in Jungk, *Franz Werfel*, 406.

115. AMW, *Tagebuch*, 296, July 31, 1935, MWC.

116. Ibid., 297, September 11, 1935.

117. Canetti, *Das Augenspiel*, 189.

118. Johannes Hollnsteiner to AMW, December 24, 1935, MWC.

119. Cf. Regional Court for Civil Cases to the Magistrate of the City of Vienna, January 25, 1937, in WSA, HA-files, small holdings, boxes 33–6.

120. Cf. WSA, Court Register 16 cg/1936.

121. Fritz Wotruba, "Autobiographische Aufzeichnungen," September 28, 1946, Wotruba Archive, Vienna.

122. AMW, *Tagebuch*, 297, February 5, 1936, MWC.

123. Cf. Friedrich Buchmayr, "Exil in Österreich? Johannes Hollnsteiners Engagement für Thomas Mann," in *Thomas Mann Jahrbuch*, vol. 13 (Frankfurt am Main, 2001), 147–163.

124. Thomas Mann, *Tagebücher, 1935–1936*, ed. Peter de Mendelssohn (Frankfurt am Main, 1978), 289, April 9, 1936.

125. AMW, *Tagebuch*, 298, April 22, 1936, MWC.

126. "Alma Mahler-Werfel und Franz Werfel geben Rout zu Ehren Bruno Walters," *Neues Wiener Journal*, May 19, 1936, 6.

127. Johannes Hollnsteiner to Kurt von Schuschnigg, June 18, 1935, copy, MWC.

128. Ibid.

129. Felix Weingartner to AMW, June 19, 1936, copy, ÖSA, GZ 694/36, 3446f.

130. AMW, *Tagebuch*, 299, June 4, 1936, MWC.

131. Anna Mahler, quoted in Jungk, *Franz Werfel*, 244.

132. Interview, Peter Stephan Jungk with Anna Mahler, video recording, privately owned.

133. AMW, *Tagebuch*, 299, September 19, 1936, MWC.

134. Ibid., 300, September 24, 1936.

135. Ibid., 301, April 6, 1937.

136. Anna Mahler, quoted in Jungk, *Franz Werfel*, 244.

137. AMW, *Tagebuch*, 301, June 15, 1937, MWC.

138. "Empfang bei Alma Mahler-Werfel und Franz Werfel," *Neues Wiener Journal*, June 13, 1937, 5.

139. Cf. interview Peter Stephan Jungk with Gottfried Bermann-Fischer, MKB.

140. WSA, registry form.

141. AMW, *Tagebuch*, 303, July 11, 1937, MWC.

142. Ibid., 305, August 20, 1937.

143. AMW, "Der schimmernde Weg," 519, undated, MWC.

144. Cf. interview Peter Stephan Jungk with Anna Mahler, video recording, privately owned.

145. AMW, *Tagebuch*, 307, November 26, 1937, MWC.

7. THE INVOLUNTARY ESCAPE

1. AMW, *Tagebuch*, 309, undated, MWC.

2. AMW, "Der schimmernde Weg," 480, undated, MWC.

3. Ibid.

4. Ibid., 484, undated.

5. Ibid., 485, undated.

6. Ibid.

7. Ibid., 487, undated.

8. Ibid., 488, undated.

9. Ibid., 489, undated.

10. AMW, *Tagebuch*, 311, June 3, 1938, MWC.

11. Ibid., 312, June 23, 1938.

12. Johannes Hollnsteiner, "Ein Österrereicher erlebt den Nazionalsozialismus," quoted in Buchmayr, *Der Priester in Almas Salon*, 183.

13. Politische Beurteilung, April 1, 1939; in ÖSA, Gauakte, No. 11725.

14. Bruno Walter to AMW, April 19, 1938, MWC.

15. Individual diary entries quoted in Werfel, *Zwischen Oben und Unten*, 743.

16. AMW, *Tagebuch*, 313, August 31, 1938, MWC.

17. Ibid., 313, September 1, 1938.

18. Ibid., 314, September 27, 1938.

19. Interview: Peter Stephan Jungk with Marta Feuchtwanger, MKB.

20. AMW, *Tagebuch*, 314, October 9, 1938, MWC.

21. Ibid., 314f. October 16, 1938.

22. Reich Propaganda Office, Vienna, to the personnel office of the Nazi Party, October 5, 1938, Vienna, 10, in ÖSA, Gauakte Nr. 24470.

23. Personnel office of the Nazi Party, Vienna, to the Reich Propaganda Office, Vienna, December 4, 1938, ibid.

24. Stephan Lehner to the Secret State Police (Gestapo), Vienna, October 16, 1940, ÖSA, Aryanization File, Franz Werfel.

25. Friedrich Werner to Heinz Drewes, March 30, 1938, BAB, R 55/20583, 2.

26. Friedrich Werner to Heinz Drewes, October 21, 1938, ibid., 100.

27. Cf. AMW to Friedrich Werner, February 2, 1939, ibid., 152.

28. AMW, "Der schimmernde Weg," 504, undated, MWC.

29. Friedrich Werner to Heinz Drewes, December 13, 1940, BAB, R 55/20583, 545.

30. Dr. Hopf to Dr. Leinveber, January 16, 1941, ibid., 548.

31. AMW, *Tagebuch*, 315, November 28, 1938, MWC.

32. Cf. Coroner's report, Anna Moll, WSA.

33. AMW, *Tagebuch*, 315, November 28, 1938, MWC.

34. AMW, "Der schimmernde Weg," 501, December 1938, MWC.

35. AMW, *Tagebuch*, 337, undated, MWC.

36. Ibid., 319, March 23, 1939.

37. Ibid., 320, April 16, 1939.

38. AMW, *Erinnerungen und Briefe*, 5.

39. Thomas Mann, *Tagebücher, 1940–1943*, ed. Peter de Mendelssohn (Frankfurt am Main, 1982), 72, May 9, 1940.

40. Cf. foreword to La Grange and Weiss, *Ein Glück ohne Ruh'*, 10.

41. Individual diary entries, quoted in Werfel, *Zwischen Oben und Unten*, 744.

42. Ibid.

43. Cf. ibid.

44. AMW, *Tagebuch*, 338, undated, MWC.

45. Ibid., 320, November 11, 1939.

46. Ibid., 340, undated.

47. Ibid.

48. Ibid., 344, undated.

49. Cf. Jungk, *Franz Werfel*, 276.

50. AMW, *Tagebuch*, 349, August 24, 1940, MWC.

51. Ibid.

52. Varian Fry, *Auslieferung auf Verlangen: Die Rettung deutscher Emigranten in Marseille* (Munich, 1986), 79.

53. Ibid., 91.

54. Ibid., 82.

55. Carl Zuckmayer to Albrecht Joseph, October 16, 1940, DLA.

56. AMW, *Tagebuch*, 351, undated, MWC.

57. Ibid., 352, undated.

58. Ibid., 351, undated.

59. Ibid., 352, undated.

60. Ibid., 353, undated.

61. Ibid., 324, undated.

8. IN SAFETY—AND UNHAPPY

1. AMW, *Tagebuch*, 324, undated, MWC.

2. Carl Zuckmayer to Albrecht Joseph, October 16, 1940, DLA.

3. Cf. Jungk, *Franz Werfel*, 285ff.

4. Albrecht Joseph, "August Hess," WVB.

5. Ibid.

6. AMW, *Tagebuch*, 326, January 12, 1941, MWC.

7. Ibid., 325, January 3, 1941.

8. Ibid., 326, January 14, 1941.

9. Albrecht Joseph, "Werfel, Alma, Kokoschka, the Actor George," 39, WMC.

10. Albrecht Joseph, quoted in Jungk, *Franz Werfel*, 301.

11. Ibid.

12. Albrecht Joseph, "Werfel, Alma, Kokoschka, the Actor George," 22f., WMC.

13. Ibid., 25.

14. Ibid.

15. Albrecht Joseph, "August Hess," WVB.

16. Albrecht Joseph, "Werfel, Alma, Kokoschka, the Actor George," 25, WMC.

17. AMW to Friedrich Torberg, October 29, 1941, quoted in Friedrich Torberg, *Liebste Freundin und Alma: Briefwechsel mit Alma Mahler-Werfel* (Munich, 1987), 32.

18. Friedrich Torberg to AMW, May 29, 1942, quoted ibid., 57.

19. AMW to Friedrich Torberg, December 8, 1944, quoted ibid., 166.

20. Friedrich Torberg to AMW, December 19, 1944, quoted ibid., 169.

21. AMW to Friedrich Torberg, December 20, 1941, quoted ibid., 46.

22. AMW, *Tagebuch*, 356, March 13, 1942, MWC.

23. Thomas Mann, *Tagebücher, 1940–1943*, 412, April 1, 1942.

24. Ibid.

25. Albrecht Joseph, "August Hess," WVB.

26. Thomas Mann, *Tagebücher, 1940–1943*, 412, April 1, 1942.

27. AMW, *Tagebuch*, 357, April 28, 1942, MWC.

28. Cf. Jungk, *Franz Werfel*, 297.

29. AMW, *Tagebuch*, 357, June 23, 1942, MWC.

30. Thomas Mann, *Tagebücher, 1940–1943*, 450, July 11, 1942.

31. AMW, *Tagebuch*, 358, July 27, 1942. MWC.

32. Albrecht Joseph, "Werfel, Alma, Kokoschka, the Actor George," 26f., WMC.

33. AMW, *Tagebuch*, 360, September 25, 1942, MWC.

34. Albrecht Joseph, "Werfel, Alma, Kokoschka, the Actor George," 26, WMC.

35. AMW to Carl Zuckmayer, August 24, 1942, quoted in Hans Wagener, ed., "Alice und Carl Zuckmayer—Alma und Franz Werfel, Briefwechsel," in *Zuckmayer Jahrbuch*, vol. 6 (Göttingen, 2003), 134.

36. Diary entry, August 13, 1942, in Remarque, *Das unbekannte Werk*, 368.

37. Erich Maria Remarque to AMW, undated, MWC.

38. Thomas Mann, *Tagebücher, 1940–1943*, 484, October 11, 1842.

39. AMW, *Tagebuch*, 359, October 1942, MWC.

40. Ibid., 369, October 1942.

41. AMW to Friedrich Torberg, February 9, 1943, quoted Torberg, *Liebste Freundin*, 87.

42. AMW to Friedrich Torberg, February 26, 1943, quoted ibid., 91.

43. AMW, *Tagebuch*, 369, August 31, 1943, MWC.

44. AMW, "Der schimmernde Weg," 575, September 1943, MWC.

45. AMW, *Tagebuch*, 372, October 2, 1943, MWC.

46. Ibid., 373, October 21, 1943.

40. Ibid., 5.

41. Ibid., 6.

42. Interview with Marietta Torberg, video recording of unknown origin, privately owned.

43. Weidinger, *Kokoschka und Alma Mahler*, 73ff.

44. AMW, "Zwischen zwei Kriegen," 27, MWC.

45. Ibid., 25.

46. Ibid., 60.

47. Ibid., 83f.

48. Mann, *Tagebücher, 5/28/1946–12/31/1948*, 115, April 15, 1947.

49. Cf. Berthold Schmid, "Neues zum 'Doktor Faustus-Streit' zwischen Arnold Schönberg und Thomas Mann," in *Augsburger Jahrbuch für Musikwissenschaft*, vol. 6, (1989), 149–179, as well as Berthold Schmid, "Neues zum 'Doktor Faustus'-Streit zwischen Arnold Schönberg und Thomas Mann: Ein Nachtrag," *Augsburger Jahrbuch für Musikwissenschaft*, vol. 7 (1990), 177–192.

50. Quoted in Eberhard Freitag, *Arnold Schönberg in Selbstzeugnissen und Dokumenten* (Reinbek, 1973), 152.

51. Mann, *Tagebücher, 5/28/1946–12/31/1948*, 226, February 21, 1948.

52. Ibid., 228, February 24, 1948.

53. Schönberg's thank-you letter to Mann is printed in Schmid, "Neues zum 'Doktor Faustus'-Streit zwischen Arnold Schönberg und Thomas Mann: Ein Nachtrag," 190.

54. Arnold Schönberg, in *Saturday Review of Literature*, January 1, 1949, 22.

55. Ibid.

56. Thomas Mann, *Tagebücher, 5/28/1946–12/31/1948*, 339, December 9, 1948.

57. Albrecht Joseph, "Werfel, Alma, Kokoschka, the Actor George," 35, WMC.

58. Thomas Mann, *Tagebücher, 5/28/1946–12/31/1948*, 339, December 10, 1948.

59. Thomas Mann in *Saturday Review of Literature*, January 1, 1949, 22f.

60. Cf. Thomas Mann, *Tagebücher, 1949–1950*, ed. Inge Jens (Frankfurt am Main, 1991), 29, March 3, 1949.

61. Arnold Schönberg to AMW, March 12, 1949, MWC.

62. Willy Haas in Birthday Book to AMW, PSU; I would like to express my gratitude to Ms. Anne König for this electronic copy of the Birthday Book.

63. Thomas Mann, ibid.

64. Albrecht Joseph, "Werfel, Alma, Kokoschka, the Actor George," 35, WMC.

65. Walter Gropius, in Birthday Book for AMW, PSU.

66. Oskar Kokoschka, ibid.

67. Cf. Mann, *Tagebücher, 1949–1950*, 92, August 30, 1949.

68. Ibid., 98, September 14, 1949.

69. Arnold Schönberg to AMW, message from the Arnold Schönberg Center, Vienna.

70. Mann, *Tagebücher, 1949–1950*, 270, September 22, 1950.

71. Ibid., 310, December 20, 1950.

72. AMW to Friedrich Torberg, June 23, 1949, quoted in Torberg, *Liebste Freundin*, 269f.

73. Cf. "Anna Mahler to Be UCLA Art Lecturer," *Los Angeles Times*, September 27, 1951, A2.

74. Albrecht Joseph, "Werfel, Alma, Kokoschka, the Actor George," 17, WMC.

75. AMW to Gusti Arlt, March 30, 1954, privately owned.

76. Interview: Peter Stephan Jungk with Anna Mahler, video recording, privately owned.

77. Ibid.

78. AMW to Gusti Arlt, March 14, 1951, privately owned.

79. Quoted in Walter Slezak, *Wann geht der nächste Schwan?* (Munich, 1964), 319.

80. AMW to Gustave and Gusti Arlt, undated, privately owned.

81. AMW to Friedrich Torberg, January 5, 1945, quoted in Torberg, *Liebste Freundin*, 177.

82. AMW to Friedrich Torberg, June 30, 1945, quoted ibid., 219.

83. Ibid.

84. Thomas Mann, *Tagebücher, 1944–4/1/1946*, 228, July 15, 1945.

85. Paul von Zsolnay to AMW, August 11, 1947, MWC.

86. Paul von Zsolnay to AMW, November 25, 1947, MWC.

87. Paul Frischauer to AMW, December 15, 1947, MWC.

88. AMW to Hertha Pauli, undated, copy, MWC.

89. E. B. Ashton, some notes on Alma Maria's memoirs, MWC.

90. AMW to Walter Gropius, August 20, 1958, BHA.

91. AMW to Lion Feuchtwanger, June 5, 1958, FML.

92. Paul von Zsolnay to AMW, September 22, 1958, MWC.

93. Walter Gropius to AMW, August 17, 1958, privately owned.

94. AMW to Walter Gropius, August 20, 1958, BHA.

95. AMW to Walter Gropius, April 6, 1960, BHA.

96. Thilo Koch, *Ähnlichkeit mit lebenden Personen ist beabsichtigt* (Reinbek, 1972), 212.

97. Willy Haas to AMW, September 24, 1958, UPenn, MS coll. 10.

98. AMW to Willy Haas, undated [March 1959], ibid.

99. AMW to Willy Haas, May 15, 1959, ibid.

100. AMW to Willy Haas, January 4, 1959, ibid.

101. AMW, *Mein Leben*, 10, foreword by Willy Haas.

102. Albrecht Joseph, "Werfel, Alma, Kokoschka, the Actor George," 10, WMC.

103. Interview: Peter Stephan Jungk with Ernst Krenek, MKB.

104. AMW to Oskar Kokoschka, undated [spring 1946], ZBZ.

105. AMW to Oskar Kokoschka, September 25, 1946, ZBZ.

106. AMW to Oskar Kokoschka, undated, ZBZ.

107. AMW to Oskar Kokoschka, December 2, 1946, ZBZ.

108. AMW to Oskar Kokoschka, May 28, 1955, ZBZ.

109. Oskar Kokoschka to AMW, August 24, 1956, ZBZ.

110. Oskar Kokoschka to AMW, October 5 [1949], ZBZ.

111. Oskar Kokoschka to AMW, June 7, 1951, ZBZ.

112. Albrecht Joseph, "August Hess," WVB.

113. Interview: Peter Stephan Jungk with Anna Mahler, MKB.

114. AMW to Gusti Arlt, undated, privately owned.

115. Koch, *Ähnlichkeit mit lebenden Personen*, 208f.

116. Interview: Peter Stephan Jungk with Anna Mahler, MKB.

117. Ibid.

118. Anna Mahler to Gusti Arlt, undated, privately owned.

119. Anna Mahler, quoted in "Mich hat auch der Mensch ungemein interessiert, der hinter dieser Musik steht," in *Österreichische Musikzeitschrift*, Jahrgang 45, 1:20.

EPILOGUE

1. Anna Mahler to Gustave and Gusti Arlt, telegram, privately owned.

2. Adolf Klarmann to Friedrich Torberg, December 24, 1964, WSB, Friedrich Torberg Estate.

3. Ibid.

4. Soma Morgenstern, obituary of Alma Mahler, 4, DBF.

5. Anna Mahler to Gusti Arlt, undated, privately owned.

6. Adolf Klarmann to Friedrich Torberg, December 24, 1964, WSB, Friedrich Torberg Estate.

7. Hilde Spiel, "Die Heimkehr," *Frankfurter Allgemeine Zeitung*, February 10, 1965.

8. "Alma Mahler-Werfel beigesetzt," *Wiener Zeitung*, February 9, 1965, 5.

9. Carl Zuckmayer to Albrecht Joseph, January 19, 1965, copy, DLA.

10. Spiel, "Die Heimkehr".

11. *New York Times* International Edition, December 14, 1964, 6.

12. *Washington Post*, December 13, 1964, B12.

13. Newspaper article of unknown origin, privately owned.

14. John Rosenfield, "Alma Werfel Has Died: A Gallery of Geniuses," *Dallas Morning News*, January 9, 1965.

15. Quoted from the CD *Tom Lehrer: That Was the Year That Was*, recorded around July 1965 in San Francisco, Reprise Records.

16. Sandy Rovner, "Alma Mahler," *Washington Post*, February 14, 1982, A1.

17. Albrecht Joseph, "Werfel, Alma, Kokoschka, the Actor George," 10, WMC.

18. Hans Weigel, "Alma Mahler und Söhne," in *Ad absurdum, Parodien dieses Jahrhunderts*, ed. Elisabeth Pablé (Munich, 1968), 137f.

19. Wollschläger, "Scharf angeschlossener Kettenschmerz," L9.

20. Albrecht Joseph, "Werfel, Alma, Kokoschka, the Actor George," 9f., WMC.

21. Wollschläger, "Scharf angeschlossener Kettenschmerz," L9.

22. Soma Morgenstern, obituary of Alma Mahler, 2, DBF.

23. Friedrich Torberg to AMW, July 10, 1943, quoted in Torberg, *Liebste Freundin*, 99f.

BIBLIOGRAPHY

ARCHIVES AND COLLECTIONS

BAB Bundesarchiv, Berlin (German Federal Archives, Berlin)
 R 55/20583

BB Österreichische Galerie Belvedere, Bibliothek (Austrian Belvedere Gallery,
 Library), Carl Moll, "Mein Leben" (typescript)

BHA Bauhaus-Archiv Berlin, Museum für Gestaltung (Bauhaus Archive, Berlin,
 Design Museum)
 Walter Gropius Estate (Nachlass Walter Gropius)

DBF Deutsche Bibliothek, Frankfurt am Main, Deutsches Exil-Archiv (1933–1945)
 (German Library, Frankfurt am Main, German Exile Archives [1933–1945])
 Soma Morgenstern Estate (Nachlass Soma Morgenstern)

DLA Deutsches Literaturarchiv, Marbach am Neckar, Handschriftenabteilung
 (German Literature Archive, Marbach am Neckar, Division of Handwritten
 Documents)
 Carl Zuckmayer Estate (Nachlass Carl Zuckmayer)

FML University of Southern California, Feuchtwanger Memorial Library
 Marta and Lion Feuchtwanger Estate

FWC *See* UCLA

Jewish Community, Vienna, Rz. 258/1929 (Israelitische Kultusgemeinde, Wien, Rz
 258/1929)

KWC *See* UPenn

MKB Mechitaristenkloster, Wien, Bibliothek, Depositum Peter Stephan Jungk
 (Mechitarist Monastery, Vienna, Peter Stephan Jungk depository)
 Interview by Peter Stephan Jungk with Gottfried Bermann-Fischer
 (transcript)
 Interview by Peter Stephan Jungk with Marta Feuchtwanger (transcript)
 Interview by Peter Stephan Jungk with Ernst Krenek (transcript)
 Interview by Peter Stephan Jungk with Anna Mahler (transcript)

MWC *See* UPenn

ÖNB Österreichische Nationalbibliothek, Wien, Handschriftenabteilung (Austrian
 National Library, Vienna, Division of Handwritten Documents
 Hertha Pauli and E. B. Ashton Estate (Nachlass Hertha Pauli und E. B.
 Ashton)

ÖSA Österreichisches Staatsarchiv, Wien (Austrian State Archives, Vienna)

 Anton Rintelen Estate (Nachlass Anton Rintelen)

 Aryanization file, Franz Werfel (Arisierungsakte Franz Werfel)

 Bundesministerium für Unterricht / Bundestheaterverband, Direktion, Wiener Staatsoper (Federal Ministry of Education / Federal Theater Association Administration–Vienna State Opera), GZ 693/36

 Gauleitung Wien, Gauakte Nr. 24470 (Gauleiter's office, Vienna, District file no. 24470) (Alma Mahler-Werfel)

 Gauleitung Wien, Gauakte Nr. 11725 (Gauleiter's office, Vienna, District file no. 11725) (Johannes Hollnsteiner)

Private ownership

 Alma Mahler-Werfel, "Meine vielen Leben" (My many lives), typescript

 Gustave and Gusti Arlt partial estate (Teilnachlass)

 Interview by Peter Stephan Jungk with Anna Mahler (video recording)

PSU Pennsylvania State University Libraries, Alma Mahler Werfel's Birthday Book

PZV Paul von Zsolnay Verlag

 Company correspondence (Verlagskorrespondenz)

 Contract file (Vertragsmappe) Alma Mahler-Werfel

Regional Civil Court (Landgericht für Zivilrechtssachen), 21 Cg. 294/1947

 Divorce decree (Scheidungsurkunde) XXIII, 722/25

 Testimony, 63 RK 1372/48

Registry Office, Berlin-Mitte, marriage certificate, no. 411/1915 (Berlin Mitte Standesamt, Heiratsurkunde Nr. 411/1915)

SAF Staatsarchiv Freiburg/Breisgau (State Archives, Freiburg im Breisgau), Portfolio B 821/2, medical record for Margarethe Legler (Bestand B 821/2, Krankenakte Margarethe Legler)

SBB Staatsbibliothek zu Berlin, Preussischer Kulturbesitz (Berlin State Library, Prussian Cultural Heritage), Gerhart and Margarete Hauptmann Estate (Nachlass Gerhart und Margarete Hauptmann)

Society of Friends for the Preservation and Care of the Artistic Legacy of Fritz Wotruba, Vienna (Verein der Freunde zur Erhaltung und Betreuung des künstlerischen Nachlasses von Fritz Wotruba, Wien)

 Fritz Wotruba Estate (Nachlass Fritz Wotruba)

UCLA University of California, Los Angeles, Charles E. Young Research Library

 FWC Franz Werfel Collection

 WMC William Melnitz Collection

UPenn University of Pennsylvania, Philadelphia, van Pelt–Dietrich Library Center

 KWC Klarmann-Werfel Collection

 MWC Alma Mahler-Werfel Collection

 Ms. Collection 10

WMC *See* UCLA

WSA Landes- und Staatsarchiv, Wien (Municipal and Rural Archives, Vienna)

 Coroner's report, Anna Moll (Totenbeschau für Anna Moll)

 Coroner's report, Manon Gropius (Totenbeschau für Manon Gropius)

 Court Register 16 Cg/1936 (Gerichtsregister 16 Cg/1936)

 District Court, Döbling, Absentee Guardianship, Alma Mahler-Werfel
 (Bezirksgericht Döbling, Abwesenheitskuratel, Alma Mahler-Werfel),
 6 P 126/42

 HA File: small inventory boxes 33–6 (HA-Akte kleine Bestände, Schachtel
 33–6)

 Meldeunterlagen Manon Gropius (Registration documents for Manon
 Gropius)

 Meldeunterlagen Alma Mahler-Werfel (Registration documents for Alma
 Mahler-Werfel)

 Meldeunterlagen Franz Werfel (Registration documents for Franz Werfel)

WSB Stadt- und Landesbibliothek Wien (Municipal and Rural Library, Vienna)

 Ernst Krenek Estate (Nachlass Ernst Krenek)

 Friedrich Torberg Estate (Nachlass Friedrich Torberg)

WSBM Stadt- und Landesbibliothek, Wien, Musikabteilung (Municipal and Rural
 Library, Vienna), Music Division, Depositur Universal-Edition, Wien
 (Depository Universal Edition AG), correspondence with Alma Mahler-Werfel

WVB Weidle-Verlag Bonn

 Albrecht Joseph, August Hess (typescript)

ZBZ Zentralbibliothek Zürich (Central Library, Zurich)

 Oskar Kokoschka Estate (Nachlass Oskar Kokoschka)

PRIMARY AND SECONDARY SOURCES

Abels, Norbert. *Franz Werfel*. Reinbek bei Hamburg, 1990.

"Anna Mahler to be UCLA Art Lecturer." *Los Angeles Times*, September 27, 1951, A2.

"Anna Mahler-Werfel beigesetzt" (AMW interred). *Wiener Zeitung*, February 9, 1965.

"Baptism by Desire." *New York Times*, April 29, 1990, BR15.

Becqué, Robert. "Die Korrespondenz zwischen Alma Mahler und Willem Mengelberg
 über die niederländische Erstaufführung von zwei Sätzen der zehnten Symphonie."
 In *Fragment or Completion? Proceedings of the Mahler X Symposium*, edited by Paul Op de
 Coul, 217–239. Utrecht, 1986.

Berchtold, Klaus. *Österreichische Parteiprogramme, 1868–1966*. Munich, 1967.

Berger, Hilde. *Ob es Hass ist, solche Liebe? Oskar Kokoschka und Alma Mahler-Werfel*. Vienna,
 1999.

Blaich, Fritz. *Der schwarze Freitag: Inflation und Wirtschaftskrise*. Munich, 1990.

Blaukopf, Herta, ed. *Gustav Mahler: Briefe*. Vienna, 1996.

Blaukopf, Kurt. *Gustav Mahler oder der Zeitgenosse der Zukunft*. Vienna, 1969.

Brassaï. *The Artists of My Life.* New York, 1982.

Buchmayr, Friedrich. *Der Priester in Almas Salon: Johannes Hollnsteiners Weg von der Elite des Ständestaats zur NS-Bibliothekar.* Vienna, 2003.

———. "Exil in Österreich: Johannes Engagement für Thomas Mann." In *Thomas Mann Jahrbuch,* vol. 13. Frankfurt am Main, 2001.

Canetti, Elias. *Das Augenspiel:, Lebensgeschichte, 1931–1937.* Frankfurt am Main, 1999.

Chamberlain, Houston Stewart. *Richard Wagner.* Munich, 1919.

Dubrovic, Milan. *Veruntreute Geschichte.* Vienna, 1985.

"Empfang bei Alma Mahler-Werfel und Franz Werfel." *Neues Wiener Journal,* June 13, 1837, 5.

Fischer, Jens Malte. *Gustav Mahler, der fremde Vertraute.* Vienna, 2003.

———. *Jahrhundertdämmerung: Ansichten eines anderen Fin de Siècle.* Vienna, 2000.

Foltin, Lore B. *Franz Werfel.* Stuttgart, 1972.

Freitag, Eberhard. *Arnold Schönberg in Selbstzeugnissen und Dokumenten.* Reinbek, 1973.

Fry, Varian. *Auslieferung auf Verlangen: Die Rettung deutscher Emigranten in Marseille, 1940/41.* Munich, 1986.

Fuchs, Heinrich. *Emil Jakob Schindler.* Vienna, 1970.

Giroud, Françoise. *Alma Mahler oder die Kunst, geliebt zu werden.* Munich, 2000.

Goll, Claire. *Ich verzeihe keinem: Eine literarische Chronique scandaleuse unserer Zeit.* Berlin, 1987.

Gustav Mahler, Briefe, 1875–1911. Edited by Alma Maria Mahler. Vienna, 1925.

Hall, Murray G. *Der Paul Zsolnay Verlag, von der Gründung bis zur Rückkehr aus dem Exil.* Tübingen, 1994.

Hamann, Briggitte. *Hitlers Wien: Lehrjahre eines Diktators.* Munich, 2003.

Hilmes, Oliver. *Im Fadenkreuz: Politische Gustav-Mahler-Rezeption, 1919–1945; Eine Studie über den Zusammenhang von Antisemitismus und Kritik in der Moderne.* Frankfurt am Main, 2003.

Hoffmann, Sven Olaf, and Annegret Eckhardt-Henn. "Von der Hysterie zur histrionischen Persönlichkeitstörung: Ein historischer und konzeptueller Überblick." *Persönlichkeitsstörungen, Theorie und Therapie,* vol. 3/2000: 128–137.

Isaacs, Reginald. *Walter Gropius: Der Mensch und sein Werk.* Frankfurt am Main, 1985.

Jaspers, Karl. *Allgemeine Psychopathologie.* Berlin, 1953.

Jens, Inge. *Dichter zwischen rechts und links.* Leipzig, 1994.

Joseph, Albrecht. "Werfel, Alma, Kokoschka, the Actor George." Alma Mahler-Werfel Collection, University of Pennsylvania.

Jungk, Peter Stephan. "Alma-Maria Mahler-Werfel: Einfluss und Wirkung." In *Franz Werfel im Exil,* edited by Wolfgang Nehring and Hans Wagener, 21–31. Bonn, 1992.

———. *Fragmente, Momente, Minuten: Ein Besuch bei Elias Canetti. Neue Rundschau,* no. 1 (1996).

———. *Franz Werfel: Eine Lebensgeschichte.* Frankfurt am Main, 1987.

Kandinsky, Nina. *Kandinsky und ich.* Munich, 1976.

Karpath, Ludwig. "Manon Gropius: Ein Wort des Gedenkens." *Wiener Sonn- und Montagszeitung,* April 29, 1935, 9.

Kaus, Gina. *Von Wien nach Hollywood.* Frankfurt am Main, 1999.

Keegan, Susan. *The Bride of the Wind: The Life of Alma Mahler.* New York, 1992.

Koch, Thilo. *Ähnlichkeit mit lebenden Personen ist beabsichtigt*. Reinbek, 1972.

König, Michel. "Ein Harmonium für Arnold Schönberg." In *Arbeitskreis Harmonium der GdO*, vol. 2, November 2000, 8–22.

Kokoschka, Oskar. *Briefe*. Vol. 1, *1905–1919*. Düsseldorf, 1984.

———. *Mein Leben*. Munich, 1971.

Krenek, Ernst. *Im Atem der Zeit: Erinnerungen an die Moderne*. Munich, 1999.

La Grange, Henry-Louis de. *Gustav Mahler, chronique d'une vie*. Vol. 2, *L'âge d'or de Vienne, 1900–1907*. Paris, 1984.

———. *Gustav Mahler, chronique d'une vie*. Vol. 3, *Le génie foudroyé, 1907*. Paris, 1983.

La Grange, Henry-Louis de, and Günther Weiss, eds. *Ein Glück ohne Ruh': Die Briefe Gustav Mahlers an Alma*. Berlin, 1997.

Mahler-Werfel, Alma. *And the Bridge Is Love*. London, 1958.

———. "Der schimmernde Weg." Typescript. Alma Mahler-Werfel Collection, University of Pennsylvania.

———. *Gustav Mahler: Erinnerungen und Briefe*. Amsterdam, 1940.

———. *Mein Leben*. Frankfurt am Main, 1960.

———. *Tagebuch-Suiten, 1898–1902*. Edited by Antony Beaumont and Susanne Rode-Breymann. Frankfurt am Main, 1997.

Mann, Katia. *Meine ungeschriebene Memoiren*. Frankfurt am Main, 1995.

Mann, Klaus. *Der Wendepunkt: Ein Lebensbericht*. Munich, 1989.

Mann, Thomas. *Tagebücher, 1935–1935*. Edited by Peter de Mendelssohn. Frankfurt am Main, 1978.

———. *Tagebücher, 1940–1943*. Edited by Peter de Mendelssohn. Frankfurt am Main, 1982.

———. *Tagebücher, 1944–4/1/1946*. Edited by Inge Jens. Frankfurt am Main, 1986.

———. *Tagebücher, 5/28/1946–12/31/1949*. Edited by Inge Jens. Frankfurt am Main, 1989.

———. *Tagebücher, 1949–1950*. Edited by Inge Jens. Frankfurt am Main, 1991.

"Manon Gropius-Werfel gestorben." *Neues Wiener Journal*, April 24, 1935, 9.

Martner, Knud, ed. *Gustav Mahler im Konzertsaal: Eine Dokumentation seiner Konzerttätigkeit, 1876–1911*. Copenhagen, 1985.

Mentzos, Stavros. *Hysterie: Zur Psychodynamik unbewusster Inszenierungen*. Frankfurt am Main, 1986.

Moll, Carl. "Mein Leben." Typescript. Austrian Belvedere Gallery Library, Vienna.

Monson, Karen. *Alma Mahler-Werfel: Die unbezähmbare Muse*. Munich, 1985.

Natter, Tobias G., and Gerbert Frodl, eds. *Klimt und die Frauen*. Cologne, 2000.

Neumayr, Anton. *Musik und Medizin*. Vienna, 1991.

Nordau, Max. *Entartung*. Vol. 1. Berlin, 1982.

Reik, Theodor. *Dreissig Jahre mit Sigmund Freud*. Munich, 1976.

Reinhardt, Gottfied. *Der Liebhaber: Erinnerungen an Max Reinhardt*. Munich, 1973.

Remarque, Erich Maria. *Das unbekannte Werk: Briefe und Tagebücher*. Vol. 5. Cologne, 1998.

Rode-Breymann, Susanne. *Die Komponistin Alma Mahler-Werfel*. Hannover, 1999.

Rosenfield, John. "Alma Werfel Has Died: A Gallery of Geniuses." *Dallas Morning News*, January 9, 1965.

Rothkamm, Jörg. *Gustav Mahlers zehnte Symphonie: Entstehung, Analyse, Rezeption.* Frankfurt am Main, 2003.

———. "Wer komponierte die unter Alma Mahlers Namen veröffentlichten Lieder? Unbekannte Briefe der Komponistin zur Revision ihrer Werke im Jahre 1910." *Die Musikforschung,* vol. 4/2000: 432–445.

Rovner, Sandy. "Alma Mater," *Washington Post,* February 14, 1986.

Schmid, Berthold. "Neues zum 'Doktor Faustus-Streit' zwischen Arnold Schönberg und Thomas Mann," *Augsburger Jahrbuch für Musikwissenschaft* 6 (1989): 149–179.

———."Neues zum 'Dokor Faustus'-Streit zwischen Arnold Schönberg und Thomas Mann: Ein Nachtrag," *Augsburger Jahrbuch für Musikwissenschaft* 7 (1990): 177–192.

Seele, Astrid. *Alma Mahler-Werfel.* Reinbek near Hamburg, 2001.

Sekler, Eduard Franz. *Josef Hofmann: Das architektonische Werk.* Salzburg, 1982.

Slezak, Walter. *Wann geht der nächste Schwan?* Munich, 1964.

Sorell, Walter. *Three Women: Lives of Sex and Genius.* London, 1977.

Spiel, Hilde. "Die Heimkehr." *Frankfurter Allgemeine Zeitung,* February 10, 1965.

———. *Glanz und Untergang: Wien, 1866–1938.* Munich, 1987.

Stefan, Paul. *Gustav Mahler.* Vienna, 1920.

Stefan, Wilhelm [Will Schlamm]. "Franz Werfel oder die nächste Bücherverbrennung." *Europäische Hefte,* vereinigt mit Aufruf, September 27, 1934, 358–360.

Tálos, Emmerich, and Wolfgang Neugebauer, eds. *Austrofaschismus: Beiträge über Politik, Ökonomie und Kultur, 1934–1938.* Vienna, 1984.

Torberg, Friedrich. *Die Erben der Tante Jolesch.* Munich, 1996.

———. *Liebste Freundin und Alma: Briefewechsel mit Alma Mahler-Werfel.* Munich, 1987.

Wagner, Hans, ed. "Alice und Carl Zuckmayer—Alma und Franz Werfel—Briefwechsel." In *Zuckmayer-Jahrbuch,* vol. 6, pp. 89–219. Göttingen, 2003.

Wagner, Nike. *Geist und Geschlecht: Karl Kraus und die Erotik der Wiener Moderne.* Frankfurt am Main, 1982.

Walter, Bruno. *Thema und Variationen: Erinnerungen und Gedanken.* Frankfurt am Main, 1960.

Wassily Kandinsky und Arnold Schönberg: Der Briefwechsel. Edited by Jelena Hahl-Koch. Stuttgart, 1993.

Weidinger, Alfred. *Kokoschka und Alma Mahler: Dokumente einer leidenschaftliche Begegnung.* Munich, 1996.

Weigel, Hans. "Alma Mahler und Söhne." In *Ad absurdum, Parodien dieses Jahrhunderts,* edited by Elisabeth Pablé, 136–138. Munich, 1968.

Weinzierl, Ulrich. "Eine tolle Madame: Friedrich Torbergs Briefwechsel mit Alma Mahler-Werfel." *Frankfurter Allgemeine Zeitung,* October 6, 1987.

Weniger, Peter, and Peter Müller. *Die Schule von Plankenberg: Emil Jakob Schindler und der österreichische Stimmungsimpressionismus.* Graz, 1991.

Werfel, Franz. "Die Harmonie des österreichischen Wesens." *Wiener Sonn- und Montagszeitung,* August 6, 1934.

———. Herma von Schuschnigg obituary. *Wiener Sonn- und Montagszeitung,* July 15, 1935.

———. *Zwischen oben und unten.* Munich, 1975.

Wollschläger, Hans. "Scharf angeschlossener Kettenschmerz: Gustav Mahlers Briefe an Alma." *Frankfurter Allgemeine Zeitung*, December 5, 1955, L9.

Zuckerkandl, Berta. *Ich erlebte fünfzig Jahre Weltgeschichte*. Stockholm, 1939.

———. *Österreich intim: Erinnerungen, 1892–1942*. Frankfurt am Main, 1970.

Zuckmayer, Carl. *Als wär's ein Stück von mir*. Frankfurt am Main, 1966.

IMAGE CREDITS

FIGURE 1.1. Alma Schindler, circa 1890. © Alma-Production, Vienna.

FIGURE 1.2. Her father, Emil Jakob Schindler. Mahler-Werfel Papers, Kislak Center for Special Collections, Rare Books and Manuscripts, University of Pennsylvania, Philadelphia.

FIGURE 1.3. Anna Schindler and her daughters, Alma and Gretel. Mahler-Werfel Papers, Kislak Center for Special Collections, Rare Books and Manuscripts, University of Pennsylvania. Philadelphia.

FIGURE 1.4. Alma at nineteen, "The loveliest girl in Vienna." © Alma-Production, Vienna.

FIGURE 2.1. Alma Mahler around 1902. © Alma-Production, Vienna.

FIGURE 2.2. Alma in 1906 with her daughters, Maria and Anna. © Alma-Production, Vienna.

FIGURE 2.3. Auguste Rodin's bust of Gustav Mahler in the foyer of the Vienna State Opera. akg-images.

FIGURE 3.1. Alma and Anna Mahler, circa 1912. © Alma-Production, Vienna.

FIGURE 3.2. Anna and Alma Mahler. © Alma-Production, Vienna.

FIGURE 3.3. Alma and Oskar Kokoschka, drawing by Oskar Kokoschka. akg-images.

FIGURE 3.4. Oskar Kokoschka's *The Bride of the Wind*, 1913. akg-images.

FIGURE 4.1. Alma Mahler-Gropius, 1915. akg-images.

FIGURE 4.2. Walter Gropius. akg-images.

FIGURE 5.1. Alma Mahler-Werfel. Mahler-Werfel Papers, Kislak Center for Special Collections, Rare Books and Manuscripts, University of Pennsylvania, Philadelphia.

FIGURE 5.2. Alma Mahler and Franz Werfel, circa 1920. Mahler-Werfel Papers, Kislak Center for Special Collections, Rare Books and Manuscripts, University of Pennsylvania, Philadelphia.

FIGURE 5.3. The dysfunctional family, Carl Moll, Franz Werfel, Alma Mahler, and Anna Moll, 1925 in Venice. Mahler-Werfel Papers, Kislak Center for Special Collections, Rare Books and Manuscripts, University of Pennsylvania. Philadelphia.

FIGURE 5.4. Manon and Alma. Mahler-Werfel Papers, Kislak Center for Special Collections, Rare Books and Manuscripts, University of Pennsylvania, Philadelphia.

FIGURE 5.5. Costume party in Breitenstein, with Anna Mahler dressed as a boy. Mahler-Werfel Papers, Kislak Center for Special Collections, Rare Books and Manuscripts, University of Pennsylvania, Philadelphia.

NAME INDEX

Page numbers in *italics* refer to the illustrations.